The Business of

MW00777320

The updated second edition of this text introduces readers to the business of film at every stage of the filmmaking lifecycle, from planning and production to distribution. Authors Paula Landry and Stephen R. Greenwald offer a practical, hands-on guide to the business aspects of this evolving industry, exploring development, financing, regional/global/online distribution, business models, exhibition, multi-platform delivery, marketing, film festivals, production incentives, VR/AR, accounting, and more. The book is illustrated throughout with sample financing scenarios, charts/graphics, and includes detailed case studies from projects of different budgets and markets.

This new and expanded edition has further been updated to reflect the contemporary media landscape, including analysis on major new players and platforms like Netflix, Amazon, Google, and Vimeo, shifting trends due to convergence and disruption from new technology, as well as the rise of independent distribution and emergent mobile and online formats. A companion website also includes downloadable forms and templates, PowerPoint slides, quizzes and test banks, and other additional resources.

Paula Landry, MBA is a writer/producer and film business and media consultant, interested in disruptive business models. Landry crafts feature films and episodic content, business plans, budgets and schedules, as well as branded content for Fortune 500 companies and non-profits. Landry is president of IdeaBlizzard Productions and is also the author of *Scheduling and Budgeting Your Film: A Panic-Free Guide*, now in its second edition. An active member of New York Women in Film and Television (NYWIFT), Landry conducts media seminars worldwide, coaching creative entrepreneurs and teaching MBA students in various colleges in New York City.

Stephen R. Greenwald has served as an executive, financier, consultant, and lawyer within the motion-picture industry. He is currently the managing partner of G&H Media LLC, Chief Operating Officer of Grey Eagle Films LLC, and Director of Media Studies at Wagner College in New York City. Greenwald has worked widely in the movie business, and from 1999 to 2007 was president of the Metropolitan College of New York, where he launched an innovative graduate business program in media management, the first of its kind in the country.

The Business of Film

A Practical Introduction

Second Edition

Paula Landry
Stephen R. Greenwald
with additional content by Michael Kalb
and Robert Garson Esq.

Routledge
Taylor & Francis Group

NEW YORK AND LONDON

First published 2018
by Routledge
711 Third Avenue, New York, NY 10017

and by Routledge
2 Park Square, Milton Park, Abingdon, Oxon, OX14 4RN

Routledge is an imprint of the Taylor & Francis Group, an informa business

Library of Congress Cataloging-in-Publication Data
A catalog record for this title has been requested

ISBN: 978-1-138-57140-2 (hbk)
ISBN: 978-1-138-57141-9 (pbk)
ISBN: 978-0-203-70284-0 (ebk)

Typeset in Times New Roman
by Wearset Ltd, Boldon, Tyne and Wear

eResource: www.routledge.com/9781138571419

Contents

Notes on Authors

Stephen R. Greenwald's experience has encompassed many aspects of the entertainment business, including development, production, international distribution, film financing, film and film library and literary work valuations, media company reorganizations, and film studio construction and operation. He has arranged financing for film production and distribution in the US, Europe, and Australia. He has also served as a consultant and expert witness in litigation involving film and television and other intellectual property matters, including valuations of intellectual property. From 1980 to 1985, Mr. Greenwald, along with a partner, served as a principal and general partner for some 20 partnerships formed to invest in motion pictures and real estate. In 1985 he joined the producer Dino De Laurentiis to acquire the assets of Embassy Pictures Corp. from its then owner, Coca-Cola, Inc. (through its subsidiary Columbia Pictures). Mr. Greenwald then became President of the corporate division of De Laurentiis Entertainment Group, the company formed to acquire the Embassy assets. In 1988, Mr. Greenwald became Chairman, President, and CEO of DEG where he oversaw the restructuring and reorganization of the company. He also served as CEO of the film distribution companies Odyssey Pictures and Vision International. Since 1990, Mr. Greenwald has worked as a consultant to major US and European banks and to US media companies in connection with film industry matters. His clients have included Bank of America, Credit Lyonnais Bank, Sony Pictures, Imperial Kapital GMBH, and MGM/UA. He has also been retained to value intellectual property including literary works and films by the owners of such works and/or potential acquirers, including the valuation of the Thom-EMI library of 1,600 films, the Filmation animated film library, the Elia Kazan film library, and the Truman Capote Literary Trust. Presently, Mr. Greenwald is a partner in Grey Eagle Films LLC, a film and television development and production company. In addition, Mr. Greenwald has lectured on film financing and distribution before various groups, and has taught courses on entertainment financing, entertainment law, and the film industry, at Wagner College, at the Cardozo School of Law, Metropolitan College of New York and The College of Management Law in Israel. His columns have been featured on the Huffington Post.

Paula Landry, MBA is an author and award-winning writer/producer. Recent film projects include VR film *Abracadabra!*, feature film *A Cat's Tale*, and projects in development include the Irish-themed dark comedy *Last Pint*, as well as *The Entitled*, based on best-selling author Frank Deford's novel of the same name. Ms. Landry creates budgets, schedules, business and marketing plans, and has conducted film and television library valuations in association with G&H Media for the Truman Capote Estate, Grey Eagle Fund, Cinema 7, and the Australian Government. Ms. Landry enjoys teaching media in NYC to MBA graduate students at Metropolitan College of New York where she is the Director of the Media Program, and Wagner College; also conducting seminars at NYU, NYWIFT, SVA, and worldwide at seminars in Cuba, Haifa, Paris, and London. She is the author of the second edition of *Scheduling and Budgeting Your Film: A Panic-Free Guide* (Focal Press). Landry's clients include Fortune 500 companies, creative entrepreneurs and non-profits, from Forbes, Deutsche Bank, Christie's, Pearson Television, Entertainment Weekly, The Game Show Channel, Tribe Pictures, Fit TV to The Actors Fund, Smile Train, and individual media makers. Her films have debuted at Sundance, Chelsea Film Festival, CineVegas, winning awards from the Best Actors Film Fest, Columbia Pictures Screen Gems, Time Warner Showtime Audience Award, and WorldFest Houston Film Festival. Ms. Landry is a creative coach, mentoring entrepreneurs, writers, filmmakers in VR, as well as creative entrepreneurship, scheduling, and budgeting. Connect with her @paulalandry on FB, Twitter, and LinkedIn, at *Script* magazine, and at paulalandry.com and aflickchick.com.

With Additional Content by Michael Kalb Michael Kalb, born 1989, is a German filmmaker and graduate of the University of Television and Film in Munich, working world-wide. He has studied and worked on a variety of film projects in Los Angeles, San Diego, and New York City, working with companies such as Voltage, Augsburg TV, and the Bavarian Film Studios. Currently working as a producer, Mr. Kalb has won a variety of scholarships and nominations for his films, including a nomination at the Karlovy Vary International Film Festival.

Appendix Legal Forms Courtesy of Garson Segal Steinmetz and Fladgate LLC. All legal agreements courtesy of Robert Garson, Attorney & Barrister, and Managing Partner of Garson Segal Steinmetz and Fladgate LLC. Robert Garson BA (Hons), Dip. Law. LLM is a dually qualified barrister and New York attorney, having led a successful career in the UK before moving to New York City to found GS2Law, where he has served as Managing Partner for over seven years. On completing an LLM at Cardozo, Mr. Garson quickly established himself as a dynamic advocate before courts and arbitral panels alike, and has amassed experience in transactions that focus on intellectual property and international law. One focus of Mr. Garson's practice is the representation of independent movie producers and film funds where he has

negotiated and drafted the full panoply of contracts that are routinely encountered in the business of film—from literary options, to key cast and crew, through to distribution agreements. Rather than accepting Hollywood "standard" clauses, Mr. Garson places a premium on providing innovative, worldly, and sensible thinking, such as the creation of the "Musketeer's clause" for multi-handed writing teams. Mr. Garson is a regular contributing author on privacy, First Amendment, and intellectual property law in *The Observer* and in his spare time is an award-winning voice actor.

Preface

For some years the authors have taught a course on the film industry at Wagner College in New York City and Metropolitan College of New York as part of the College's Masters of Business Administration in Media Management Program. The content and structure of this book is based on that course.

We wanted a single book that provided a linear overview of all aspects of the industry—with development, financing, production, distribution and marketing, exhibition, legal and business affairs—in an integrated way and from primarily a business, rather than creative, artistic, or legal perspective. So we took up the challenge of writing such a book.

The organization and structure of the book follows the steps involved in making and exploiting a film. After a survey of the history of the industry and an overview of its current structure, we follow those steps through development, financing, production, distribution, exhibition, marketing, and finally accounting for costs and revenues, highlighting the latest trends and how they affect the industry.

While our goal is to provide the broadest possible overview of the movies as a business, we have tried to include enough specifics and details in each subject area to hopefully give guidance to readers on how the industry works on a pragmatic, "nuts and bolts" level, especially for readers with an interest in pursuing a career in the business.

There are several large themes we try to stress throughout the book; themes related to characteristics about the film industry that make it different in some ways than other businesses and that offer insight into the past and future. First, that film is both an art form and a business and that success in the industry requires an ability to navigate and mediate between those two sometimes warring and opposing poles. Closely related is that an ability to manage creative talent is a sine qua non for reaching the top in the business. Second, that film, as an art and a business, is technologically driven and that technological developments have shaped and will continue to shape, the way films are made and distributed and, not so obviously perhaps, the very nature and kinds of films that are made. Third, that there are recurring phenomena in the history of the business that, if observed, point to an understanding of the future. An example is the reluctance

of the industry, and particularly its major players, to embrace technological change but rather to at first fear and fight it, then to let other entrepreneurs take the risk and rewards, if any, of proving the value of the new technology, and then, after it has been proven, taking it over and co-opting those who took the risks, turning the technology to the service of the industry. In that drama lie clues to both risks and rewards for the future. Fourth, and related, is that in the film industry, as in other activities and enterprises, a knowledge of the past is the key to the future, and an understanding of how the industry has responded and adapted to change, economic, political, and cultural as well as technological, will help form an understanding of how the industry will adapt to the change that is inevitably coming. Those who have studied the past will be in a better position to take advantage of future change.

The final theme is that the film business, like other media businesses, is now at the threshold of radical change, at least as significant if not more so than many of the changes of the past, and that this transformative change, driven by the extraordinary advances in new forms of production and particularly distribution, enabled by the digital revolution, will alter the basic architecture of the industry that has prevailed almost since its beginnings, in dramatic and possibly unforeseen ways.

This radical change offers challenges and rewards to those who embrace it.

Both authors have had the privilege of working in the film industry and in the course of that work meeting and dealing with the many extraordinarily talented and dedicated people in the movie business. It is an exciting and vibrant industry, and an important one as well, serving as a repository of much of our cultural and social history and as a powerful force for the transmission of ideas and social commentary, both good and bad. While demanding, the movie business is also an enjoyable place to work, full of interesting and passionate people. And in the end, it is all about telling stories people want to see and hear. We hope we have told a story that you will enjoy as well.

We'd like to thank Rebecca Sullivan and Rick Mowat for their patience, good humor, and unwavering support; Harv Zimmel, the master of the pitch; Michael Kalb and Robert Garson for their expertise and contributions to the book; and Simon Jacobs and John Makowski for their advice and guidance.

Chapter 1

A Brief History of the Film Industry

This is a book about the film industry and how it functions as a business, how it is changing, and why. Movies have been made and sold for over 100 years and a study of the history of the business shows that there are recurring trends, technological developments, and inflection points that impact and foretell the future of film. An understanding of this history will help a student of, and participant in, the industry to anticipate what is coming next. This book will cover the basic components of the industry providing the reader with an understanding of how movies are created and sold, and how those basic components interact.

In the popular imagination, the movie business is a handful of big, well-known studios located in Los Angeles, the films these studios release, and the movie stars that appear in them. While it is true that the studios are responsible for producing and distributing the movies that receive the most public attention and generate the most revenue, the film business encompasses much more than just the studios and their output including: Internet companies streaming film and television shows like Amazon, Netflix and Google and others; numerous online film platforms; independent filmmakers working outside the studio system and producing some of the most interesting and thought-provoking films; documentarians focusing on social and political issues; animators; producers and distributors of films made for television, video, and DVD (digital video disc); producers creating corporate films, web videos and webisodes, virtual reality films, and educational films; independent distributors; technology companies expanding into media distribution; foreign sales agents; theatrical exhibitors; talent agents and managers; as well as the thousands of vendors providing services required to create, market, and distribute these films. Here are the basics of the industry: what; where; when; who; and how.

- **What** is it? The core function and activity of the film business is producing and distributing films for profit.
- **Where** is the film business? While the American film industry is still based in Los Angeles, the business is now a truly global enterprise.
- **When** did the film business start? In the 1890s with the invention of the movie camera (Kinetograph) and projector (Kinetoscope) by Thomas Edison in the US and at the same time in France.

- **Who** are major players? Currently dominating the industry, the big six studios in the US are: Disney; Universal; Paramount; Sony; Warner Bros.; and Fox, and together they produce and distribute the films that earn the most revenue worldwide.
- Lionsgate, Amazon, and Netflix are rising players in production and distribution, while Chinese company Wanda (owner of the AMC theater chain) is the biggest movie exhibitor in the world, with 636 theaters and 8,128 screens across eight countries.
- **How** does it operate and how is it changing? Today, movies are made (produced) and licensed (distributed and marketed) all over the world in multiple media formats. Global markets, consumer demand, availability of financing, and technological developments are constantly changing how the business operates.

Movie Industry Themes

A Global Business

American films generate the highest box-office grosses, dominating the world market. Film is a dominant force within the overall media and entertainment industry, which generated $635 billion in revenue in 2016, nearly a third of global media and entertainment revenue.[1] The US is the third largest film market in the world in terms of tickets sold, behind China and India. The international market is increasingly important to US film companies, with over 71 percent of the $39 billion global box-office revenue for US films in 2016 coming from abroad.[2] Surging international revenue reflects an increasing worldwide appetite for franchises, sequels, and movie stars. Success in the movie business requires a keen understanding of evolving markets, cultural factors, and economic developments throughout the world. The rapid growth of the entertainment industry in China is impacting the US industry in major ways, affecting development and production, financing, and distribution. The US population of 350 million makes up only 5 percent of the nearly eight billion world population, which means that creating films for customers outside of the US is of growing importance and is changing the business.

Both a Business and an Art Form

Balancing the interests and demands of business and art is a challenge. The American film industry is profit-driven and business interests have almost always dominated filmmaking since it began. In much of the rest of the world, particularly Europe, art and the interests of artists have often trumped business interests, although this is changing. Many believe that it is the supremacy of the profit motive that explains the worldwide dominance of American films. From its beginnings, the American film industry was financed by the private sector as a

commercial profit-making enterprise. Success was measured by the imperatives of the private capital markets: a return on capital and wealth creation. In Europe and much of the rest of the world, from its beginnings film was considered more an art form than a commercial product, supported by public funding rather than private capital.

Profit-Driven

The businessmen and investors who financed and often ran the film industry were interested in making money, which meant making films that appealed to the largest possible audiences. American filmmakers became adept at turning out movies that satisfied the tastes of the broadest audiences. What counted was box-office success, not critical acclaim. Today, approval from press, reviewers, and "tastemakers" are only important as marketing tools for a movie. The producers, writers, and directors who could make commercially successful movies were rewarded financially and with more work, reinforcing the dominance of movies that had broad appeal. In this system the producer, who was often the investor or who represented the interest of the investors, had control over the filmmaking process. He or she had the power to hire and fire the creative talent, and to make whatever changes they deemed necessary during the production or editing process in order to make a film more commercial. These commercially savvy producers—men like Daryl Zanuck, David O. Selznick, Irving Thalberg, and Robert Evans—often ended up as heads of film studios.

Outside the United States, and particularly in continental Europe, where there was a tradition of governmental support for the creative arts, filmmaking was financially supported from its early beginnings by the public sector. This meant that filmmakers from these countries had less need than their American counterparts to be concerned with catering to the tastes of the general public. Their ability to get funding for future films did not necessarily depend upon success at the box office, but rather on acceptance and recognition by those who made the decisions about which artists and what art was worthy of government support. This subsidized system, which elevated artistic merit and recognition over mere commercial success, also led to the concept of the director as the "auteur," or author, of a film, with total control over the filmmaking process. In the US model, the producer has total control. Public financing often restricted the choice of screenwriters, directors, and other professionals to local filmmakers, precluding the use of creative talent from other countries. American producers, free to choose the best without restrictions, drew talent from around the world, helping to give American movies an international flavor and dimension lacking in the more parochial films that emanated from other countries. In countries controlled by restrictive governments, film content was dictated by strict rules to be used as propaganda, artistic content an afterthought.

With control lodged firmly in the hands of profit-driven producers and studio heads, and career success linked closely to commercial results, the American

industry was and still is unrivaled in turning out films as popular art—movies that appeal to the widest possible audiences worldwide.

The state-subsidized model that prevailed in Europe (and in many other countries such as the Soviet Union and China), with control in the hands of the director and success linked to artistic recognition, resulted in artistically acclaimed films from directors like Ingmar Bergman, Federico Fellini, Jean-Luc Godard, Luis Bunuel, and others; films that garnered worldwide recognition as great art, but generally were unprofitable or minor commercial successes, with limited appeal to audiences from other countries.

Film industries in other countries outside Europe and the US tended to follow the European model of public financing, although privately financed film companies did emerge in countries such as India, Japan, Korea, and in Latin America, in the period following World War II.

Film Is Collaborative

A writer, painter, or musician can create her or his art alone—and with limited and relatively inexpensive tools such as pen and paper (or today, a computer), paint and canvas, or an instrument. However, movies are more complicated. As an art form film has characteristics that distinguish it from other art forms and, in a sense, force filmmakers into collaborations and compromises with, as well as a dependency on, business and financial interests. With the advent of digital technology, filmmakers are taking more of the process into their own hands, but must still rely on others throughout the process.

Filmmaking is a highly collaborative enterprise involving many craftspeople with specialized skills. Film production and distribution also entail the use of equipment, materials, and processes that are expensive to design, develop, and manufacture such as cameras, film or video stock, editing equipment, sound systems, projection devices, and so forth. Few, if any, filmmakers have the human or financial resources, or the organizational support, to produce and to distribute a commercially viable motion picture on their own; however, with the Internet and do-it-yourself distribution services available, filmmakers are now able to market and sell their movies in many ways to audiences without going through a traditional distribution company.

Annually, the top earning 40–50 films yield about half of global box-office revenue, and typically, top grossing films have the largest production budgets. Ranging from $1 million to $225 million, the polarity in budgets is increasing, with the average production cost of a studio film at $93 million in 2013, and marketing costs an additional $48 million.[3] Over one-third of Hollywood films released in 2016 were budgeted from $100 to $250 million, averaging $120 million. Movies at the top of the spectrum are getting more expensive, with the highest budgets at $425 million (*Avatar*) and $306 million, (*Star Wars: Episode VII—The Force Awakens*), according to Box Office Mojo. Even a so-called "low-budget" film from a studio would entail a budget of at least $15 million in

order to have the minimum production values and look needed to compete commercially.

The franchise model of movies with budgets over $100 million, based on popular comic book characters, previous hit films, video games, and best-selling books, is becoming the prevailing staple of studio filmmaking.

Made-for-television movies have budgets in the low millions, and are increasing. Faced with the high cost of production and the organizational support needed to fulfill their artistic visions, throughout the history of the industry filmmakers have had to turn to others to provide these resources, such as the major studios or other media companies or private investors.

Film Is an Art Form that Is Technologically Driven

Unlike music, visual art, and literature—art forms that long predated the age of technology—motion pictures became possible only after the development of the camera, the projector, and film itself. Film as both an art and a business has continued to be shaped by technology, not only in the manner of its delivery and distribution, but in the way in which films are produced as well as what sort of films are made. This dependence on technology, and the risk capital required to develop it, has historically strengthened the role of business and finance in the industry.

Trends in technology push the art form in two opposite directions, to be more real and lifelike in one direction, and more fantastic and as far from reality as possible, in the other.

Each significant advance in technology (see Figure 1.1), whether in the production process, such as IMAX, 3D, 4D, augmented and virtual reality; or in distribution, such as mobile viewing or bit torrent streaming pushes the boundaries of the medium. Movies and their stories change as the technology is favored by audiences, exemplified by the popularity of internet platforms like Amazon Prime, watching movies on mobile phones, the growth of VR headsets, and the prevalence of comic book movies laden with computer special effects.

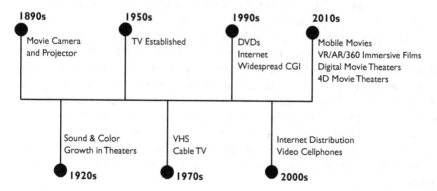

Figure 1.1 Major Advances in Movie Industry Technology.

Capital-Intensive

The need for large amounts of money to produce and distribute commercially viable movies has shaped the industry and, at times, influenced the kinds of films that were made. Currently, as an example, American film companies seeking funding from China are collaborating with individual and corporate investors from China, which is impacting decisions about story lines, which actors are starring in the films, and the selection of shooting locations.

The number of films produced each year budgeted at over $100 million has fallen from a high of 34 in 2011 to approximately 20 movies per year. In the first decades of movies, production funding came from theater owners who needed more product. Later, as production and distribution costs increased, in part because of technological improvements, financing came from the money markets in the form of equity and debt capital. In recent decades, while continuing to rely on these markets, the industry has turned to partnerships with private investors and strategic partners like foreign distribution companies. In addition, financing has resulted from mergers with better-funded companies. To satisfy the interests of investors, the "mom-and-pop" type of individual ownership that prevailed in the early years of the business gave way as the film industry organized itself into an efficient corporate form where the demands of capital usually trumped those of art. One advantage that the film business has always enjoyed in terms of outside financing is the "glamour" factor: the attraction of movies as an investment for both individual and corporate investors. Despite the inherent risks of the business, the industry has learned over the years how to play this card adroitly to interest outsiders in putting money into movies.

Much of the film business has been shaped by the need for capital, the impact of technology, and the dynamic tension between art and business. Today, new technological developments such as affordable video cameras and editing systems, internet-related delivery platforms and mobile technology that allow filmmakers to reach moviegoers directly, and content aggregation systems like YouTube and Vimeo, as well as internet media film and video providers iTunes, Amazon, and Netflix, are exerting enormous pressure on the industry. Government-funded production incentives, which offer financing based on expenditures in a certain area, are influencing where films are being made.

Essentially, movies have been produced and distributed in the same way almost since the beginning of the industry, with the major film studios or television networks acting as gatekeepers for product flow to consumers. Today, the studios (also called the "majors") and other traditional gatekeepers are confronting these new formats and delivery systems, forcing a rethinking of this model and a redefinition of their role in mediating between filmmakers and consumers. As in any time of transformation and upheaval, opportunities abound. One of the premises of this book is that those who learn from the past will be best positioned to seize opportunities in the future.

A Brief Business History of Film

There is a substantial literature on the history of film as an art form; our recommendations can be found on our website (www.ThisBusinessofFilm.com). Since this book is about the business side of cinema, the following brief overview will focus on key developments in that history that affected the business and recurring themes that have emerged from those developments.

The Early Years

While the answer to the question of who invented the motion picture in the 1890s is still a contested one, with the French giving the credit to the Lumiere brothers and the Americans to Thomas Edison, there is no doubt that film as a business originated in the United States. In Europe, particularly on the continent, film was perceived as a new form of artistic expression, suitable primarily for the aristocratic and social elites, like painting, classical music, opera, and ballet—profits were an afterthought. In America, however, the opposite was the case. Merchants and small businessmen like Samuel Goldwyn, Adolph Zukor, and William Fox quickly grasped the potential of movies as an entertainment diversion—and as another type of merchandise to sell to the masses crowding the large eastern and midwestern cities. First appearing in retail stores, nickelodeons were the first movie theaters, where one-reelers could be seen by one person at a time for five cents. Early films attracted the masses, especially recent immigrants for whom the movies were an introduction to American life, language, and lore.

Retailers needed more films to meet demand, and in response, nascent film production facilities sprang up, centered in New York and New Jersey. As demand for movies grew, including demand for longer films that told stories, the theater owners realized that to have enough product, they would have to start financing and producing movies themselves. These newly minted producers were first and foremost businessmen, with a focus on profit, not art. From the outset of what became the film studio system, business interests were paramount.

The Birth of Distribution

The process of transforming a film from a script to a commercial movie goes through five steps:

1. **Development:** an idea transformed into a script, the attachment of key players (producer, director, stars), creation of a budget; in order to seek:
2. **Financing:** securing the funds necessary to make the film.
3. **Production:** making the film so it's ready to be seen and sold.

4. **Distribution** and **Marketing:** creating the maximum **availability** (distribution) of the movie for sale in as many media and places as possible; while generating **awareness** (marketing) so people want to see the movie, which is called:
5. **Exhibition:** the point of purchase where people buy and consume a movie—in movie theaters, online or DVD, through pay-per-view (PPV) and video-on-demand (VOD) systems, on cable or television.

When theater owners began to produce movies in order to keep up with customer demand, it was a first step toward vertical integration, that is, the common ownership and control of both production and exhibition facilities, and the beginning of what eventually became the film studios.

A number of these production-exhibition companies then took the next step of renting the films they owned to other theater owners—creating the distribution side of the business.

The phenomenon of exhibitors or other licensees of content becoming producers in order to ensure a flow of product for their distribution systems is one that repeated itself over the ensuing decades, with television networks and video distributors, and even consumer products manufacturers like Sony, entering the production business. In many cases, these attempts to go "upstream," that is, from being a content exhibitor, or licensee, to a content creator, failed.[4] The primary reasons for this failure were the significantly larger amounts of capital required to compete on the production side of the business, which many downstream exhibitors or distributors lacked, and the much different management skills needed to succeed as a producer, including the ability to manage creative talent.

With the new wave of internet distribution companies such as Netflix, Amazon, Google, and Apple expanding rapidly into the media business, we are seeing new efforts to go "upstream"; time will tell whether these new distribution players can successfully make the transition to production.

Thomas Edison's Monopoly

Thomas Edison, the inventor of the Kinetoscope (first film viewer) and Kinetograph (first film camera), held patents on the equipment needed to make and exhibit films. In 1908, in an effort to control the film business in the United States and to drive out competitors, Edison went into business with a number of exhibition and production companies to form a monopoly; no film production company or exhibitor outside the monopoly would be able to buy the equipment needed to make or exhibit films. The monopoly was called the Motion Picture Patents Company, better known as the Edison Trust. The Edison Trust was a cloud over the growth of the film business in its early years. The Trust, which held Edison's patents, would not sell film equipment to filmmakers, but only rent it for fees that became increasingly exorbitant. The Trust's power was such that

it was able to force Eastman Kodak to withhold raw film stock from producers who weren't licensed by the Trust.[5]

Independent producers fought the Edison Trust monopoly by buying equipment and film outside the United States and moving production operations from the East Coast to the West Coast. At that time, California was far enough away to avoid the effective legal reach of the Trust, making it difficult for the Trust to monitor the producers' activities and to enforce its patents through injunctions or other legal measures. Once there, the producers found a hospitable environment for filmmaking: low-cost labor and facilities, wide-open spaces for location shooting, and good weather year round. They stayed, and the center of the film business has remained in Southern California. Eventually, in 1915, the federal courts ruled that the Edison Trust was an illegal monopoly, and it was dissolved.

The Birth of the Studio System

The period from 1908 through the 1920s saw the emergence of the companies that came to dominate the industry for the rest of the twentieth century. It was during this period as well that the "star system" developed—with studios perfecting the art of publicity to glamorize and glorify certain actors as larger-than-life figures and then using them to sell their movies to the public. Actors like Mary Pickford, Lillian Gish, Douglas Fairbanks, Charlie Chaplin, and Rudolph Valentino became fan favorites, huge celebrities, and big moneymakers for the studios, with the public clamoring to see their films. In effect, the actors became the draw, more than the films. It was during this period that the full-length feature film, telling novelistic stories, became the norm.

By the end of the industry's third decade the studio business model, with full vertical integration, had emerged as the prevailing form of business organization. The five major studios, which came to be known as the "Big Five"— Warner Bros., Paramount, RKO, Metro-Goldwyn-Mayer, and the Fox Film Corporation/Foundation[6]—owned the production facilities, distribution systems, and major theater operations, as well as the talent, including the actors, directors, producers, and writers who were salaried employees under contract to produce or appear in several films a year. These were high-paid employees, to be sure, but employees nonetheless. This business model would prevail until the 1950s.

The Marriage of Sight and Sound

The first major technological advance in film was sound. *The Jazz Singer*, released in 1927, was the first feature "talkie" and the film business was changed forever. The history of the transformation to sound captures a number of themes that recur at each point of major technological change in the industry.

Adding sound to film became feasible by 1921. The research and development work that led to sound was carried out by companies outside the industry, which had the necessary capital and research capability, including Western

Electric and General Electric. Once the talkies were introduced to the public, the silent era was over. Countless actors who could not make the transition to sound saw their careers ended (Clara Bow, Emil Jannings). A movie that illustrates this pivotal changeover in the industry is *The Artist*.

Smaller production companies that could not afford to make the transition went out of business. The shift to sound solidified the Big Five studios' hold on the industry, but even they had to seek outside capital to finance the cost of converting their production operations and theaters to talkies. This need for outside capital led to the first major investments in the film business by Wall Street financiers, further solidifying filmmaking's dependence on business interests.

The introduction of sound changed not only the way films were produced and exhibited but also the kinds of films that were made. Sound allowed filmmakers to create movies that were dialogue-driven, vastly expanding the types of stories that could be told and the power of film to convey the human experience. This impact of new technology—changing films in kind and nature—recurred with later technological developments as well.

The Influence of Capital

The need for capital affected the film business in diverse ways. Beside driving out smaller players and consolidating the dominance of the major studios, the need to account to outside investors brought greater fiscal discipline and organization to the industry, entrenching the studio-business model of full vertical integration and tight control over talent as the dominant model. And again, as with sound, this external influence had an impact on what sorts of films were made. Eager to please their new investors from the world of finance and cultural conservatism, the studios turned out movies with patriotic themes, celebrating the perceived virtues of small-town, middle-class, hard-working America.[7] During this period the first stirrings of censorship were experienced by the industry, leading to the creation in 1922 of the Motion Picture Producers and Distributors of America. Created by the film companies and headed by Will H. Hays, the Hays Office, as it came to be known, enforced a reign of strict self-censorship, so as not to offend the guardians of morality, often allied with centers of finance and capital.[8]

This influence of capital and ownership on the kinds of films that were made was a phenomenon that recurred later in the century when ownership of the majors was restructured, and the studios became divisions of large media conglomerates with a wide variety of businesses aside from movies.

Funding Research and Development

Another feature of technological change exemplified by the introduction of sound was that the technology itself was developed outside the film industry by companies with the required know-how and capital to take the financial risk that

the research and development would lead to usable products. This, too, became a familiar pattern. Film companies generally preferred to let outsiders take the lead in developing new technologies for the industry or in adapting these technologies to the production and distribution of films. In the case of later advances, like television and video, the studios also allowed other newly formed intermediary companies to take the lead in exploiting the new technologies. One consequence of this risk-averse approach was that the industry gave up part of the economic value of the new technologies to the companies that developed and first exploited it. Another was an initial resistance to certain technologies.

In the cases of television and video, the studio's first reaction was to perceive these inventions as a threat to the very existence of the film business. The studios fought the introduction of television, particularly pay-TV, and home video in the courts, and, by engaging in anticompetitive practices, withheld films from companies that sought to exploit these new delivery systems. Eventually, however, the studios reached accommodations with these companies, licensing their films for exploitation in the new markets. Once these markets proved lucrative and profitable, the studios went a step further, embracing the technologies and directly distributing their product through the new media. Eventually, they took the ultimate step of acquiring former licensees, such as television broadcasting systems and home-video distribution companies.

The Impact of World Events

The decade of the 1930s was a boom period for movie making. Fully integrated and with major talent under contract to write, direct, and act in several films a year, the studios turned out record numbers of movies. The supply of talent was enhanced by an influx of European filmmakers fleeing the worsening political situation in their home countries. The first commercial films in color were released during this era as well.

The film business did not, however, escape the effects of the Great Depression, with theater attendance decreasing in the early part of the decade. During the years of World War II, the industry, like other major industries, contributed to the support of the war effort. While theatrical films continued to be produced and distributed, many were war movies that extolled the bravery and prowess of American forces and demonized the Axis enemy, employing stereotypes of Germans and Japanese that persisted long after the war ended. Many actors and other industry people enlisted or were drafted, and writers and directors turned to producing training films and documentaries about the war.

The Advent of Television

The late 1940s and the decades following were dominated by two interrelated developments: the introduction and growth of television, and the gradual breakdown of the vertically integrated studio system business model.

The introduction and immediate popularity and widespread growth of television from 1948 into the 1950s had a profound impact on the movie business. For the first time in its history, the industry faced a new competitor for consumers' "eyeballs." The notion that people could stay home and watch for free live or filmed entertainment rocked the movie industry. Many predicted the end of the theatrical movie business and the studios' first reaction was non-cooperation, refusing to license films to television networks and broadcasters. But in the early 1950s, Lew Wasserman, chairman of MCA Universal, saw a dual opportunity in television. First, he understood that producing television programs was not that different from producing movies, and with television growing rapidly, the new medium needed more program content that the studios, with their skill, know-how, and facilities, could provide. Second, Wasserman correctly perceived that the thousands of movies in studio film libraries were another source of content for television. With these insights, MCA Universal started producing TV shows and licensing its library films to television, quickly generating revenue and profits from both activities. Other studios soon followed suit. By the late 1950s, the major film studios, as producers and licensors of TV content, were the largest suppliers of television programming, establishing lucrative new streams of revenue for the industry.

The first crack in the business model came in 1948, when the US Supreme Court ruled against the studios in an antitrust case involving the studio ownership of theaters. The case, US vs. Paramount Pictures, began in the late 1930s when the Department of Justice launched an investigation of the industry in response to complaints from independent theater owners about the anticompetitive practices of the studios in booking their films into theaters. After an interruption during the war years, the investigation resumed, and the government filed an antitrust action against the major studios, seeking as a remedy divestiture by the studios of their theaters. After the Supreme Court decision in 1948, the studios entered into a consent decree agreeing to divestiture. The effect was two-fold: the studios were, for some period, no longer fully vertically integrated, and since they no longer had the pressure of filling their own theaters with new product every two weeks or so, they began to produce fewer movies. The eventual result of the Paramount case and the divestiture that followed was a consolidation of theatrical exhibition into a few large companies, like AMC, United Artists Theaters, Carmike Cinemas, and General Cinemas, mirroring the structure of the production and distribution side of the industry. The consent decree was relaxed in the 1990s and the studios were permitted to reenter the theater business, but by that time the share of overall revenue to the studios from theatrical exhibition had dropped significantly, and the existence of strong, well-funded competitors undermined one of the key rationales for the antitrust action.

Television Spurs Media Consolidation and Independent Film Production

To attract the public and lure them out of the comfort of their homes and away from the TV set, the studios began to make fewer, but bigger, films, turning movie-going into an "entertainment experience" worthy of the price of a ticket and a babysitter. Epics of the time included *Cleopatra* (1956) and *Around the World in 80 Days* (1956). Films got longer and more expensive to produce, and the double feature—the practice of offering two movies plus a twenty- to forty-minute "short" (often a live-action comedic film by artists such as Laurel and Hardy, or a newsreel) and a cartoon, for the price of one ticket—became a thing of the past. By the 1960s, average weekly attendance at movie theaters was down 60 percent from attendance in the 1920s[9] (see Figure 1.2). But the studios were able to survive the decline, because revenues from television supplanted reduced revenue from the theatrical market.[10] By 2000, the major film companies' income from theatrical exhibition accounted for approximately 20 percent of total revenue, while income from television represented about 40 percent of revenue. Studios increasingly rely on television revenue (as well as content licensing and video games) to offset the riskiness of inherent on the film side.[11]

By 2000, three of the major television networks were owned by film companies (ABC by Disney, CBS by Paramount, Fox by 20th Century Fox) and the fourth was part of a conglomerate that included a movie company (NBC by GE). Every major film company was part of a group that included ownership of cable television stations and/or cable broadcasting systems. The marriage of the movie business and television, first conceived by Lew Wasserman in 1952, was complete.[12]

Television also opened up new opportunities for writers, actors, and directors. As the majors began to reduce the number of films they produced, the studio

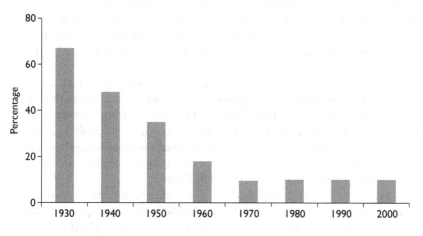

Figure 1.2 Average Weekly Cinema Attendance by Percentage.

business model of having talent on permanent contract or fixed salaries no longer made sense, and it was better to contract for the services of talent when needed. This in turn gave the talent, particularly actors, more independence, allowing them to offer their services to any of the studios and, often, to the highest bidder. This freedom of contract for talent also marked the beginning of what became the independent film sector. Actors, directors, and producers formed their own production companies and began to develop films on their own, acquiring scripts or the rights to novels and plays, and taking these projects to the studios for financing and distribution. This spurred the growth of new independent production companies that, over time, became major suppliers of film projects to the studios.

As in the case of sound, television changed the kinds of films that were made as well. With the licensing of first-run theatrical movies to the television market becoming an ever-greater source of revenue, the studios began to tailor more of their product to what would work successfully on TV. Formats that fit the needs of broadcasters in terms of running time (with room for commercials) became the norm. In the pre-pay television era, broadcast television standards limiting profanity, sexuality, and extreme violence became, in effect, the standards for mainstream commercial film as the importance of the TV market grew; a form of self-censorship that, in part, led to the end of the era of strong external censorship exemplified by the Hays Office.

With well-funded platforms Netflix and Amazon offering increasingly large quantities of television programming, and players like Apple getting into this space, studios will be forced to spend more in an attempt to keep up.

The Expansion and Impact of Cable TV

Cable television (initially CATV—coined after the "Community Antennas" utilized) began in the late 1940s as a way to improve poor television reception in remote areas. It expanded nationally in the 1970s with programming separate from over-the-air television, offering movies that had previously been released into the theaters, sports events, syndicated programming, and all-news formats.[13]

Cable's major impact on the film industry was the creation of additional outlets for the licensing of film libraries, enhancing revenue. Over time, cable networks such as Turner Broadcasting, Lifetime, and the Disney Channel became producers of original films, expanding the non-theatrical film business to the benefit of the industry as a whole, particularly independent producers and creative talent. Almost all cable networks now create original programming based on the specific tastes of their target audience.

As the popularity of cable television grew through the 1970s, two tiers of service emerged: basic cable—a bundle of stations that were provided for the overall price of using cable; and pay-television—stations provided for an additional monthly subscription fee on top of the price for cable. Pay-TV, as a new

and competing window of exploitation for films, first emerged with the formation of Home Box Office (HBO) in 1972. Once again the film industry perceived this new medium as a threat. The industry's response was to form its own cable channel, Premiere, which would hold exclusive pay-TV licensing rights to films from its members (Paramount, Universal, Columbia, Fox, as well as cable/financial interest Getty Oil).[14] This anticompetitive ploy was quickly challenged in the courts and, once again, the studios' efforts to thwart a new technology failed. And as before, the industry quickly adapted and began to license films for pay-TV viewing, which soon became another significant source of non-theatrical revenue.

In the early years of pay-TV the pay-cable networks relied almost entirely on theatrical films for programming. However, as their subscriber base grew (to 16 million households by 1980,[15] then 30 million by 2002)[16] and the cost of licensing films increased, the networks turned more to original programming. This was particularly true of the two biggest networks, HBO and Showtime. While this development reduced the licensing revenue to the studios, as was the case with basic cable it also created new sources of production financing for producers and opportunities for creative talent, further expanding the non-theatrical film business. And, since HBO, Showtime, and a number of other pay networks were or became corporate partners with studios, the revenue and profits from these productions remained within the industry.

The cable industry is undergoing a significant shift, thanks to the Internet. Many cable subscribers have "cut the cord" from their cable packages, preferring to subscribe to individual stations online, whether watching them on their computer, smartphone, iPad, smart TV, or using a gaming system like Nintendo, X-Box, or other device such as Roku, or Apple TV. Cable stations, armed with detailed knowledge of who their subscribers are and exactly what they like to watch, are producing their own content, relying less and less on movies for programming. This convergence of television, cable television, and Internet has contributed to an increasing number of high-quality viewing choices for the public.

The Introduction and Influence of Home Video

The introduction of the home video player in the 1970s marked the next major transition for the film business. As with television, the industry's first reaction to the new technology was fear and resistance. Again, home video was seen as sounding a death knell for the theatrical film business. Commercial-free and with user flexibility for the consumer, home video was also perceived as a threat to the licensing of theatrical films for television broadcasting, which had become a lucrative market for the major studios.

The industry's first response was a lawsuit against home-video manufacturers to enjoin the sale of the devices on the grounds that they could be used to illegally copy films. The manufacturers prevailed.[17]

As in the case of television, the majors then held back from licensing the video rights to their films. But gradually, the studios began to test the waters with selected licensing of home-video rights to intermediary video distributors, ceding some of the economic value of these rights to the intermediaries in exchange for letting them take on the business risks until the market proved viable. With the rapid growth of the home-video market in the 1970s, the studios realized the enormous potential of the new market and established in-house divisions to license video rights directly to wholesalers and retailers, cutting out the intermediary distributors. Within a few years, home-video licensing and sales had become the largest source of revenue for the film industry, by a wide margin.

The home-video boom sparked the birth of several new production and distribution companies as well, including Nelson Entertainment, Vestron, De Laurentiis Entertainment, and Hemdale. These companies financed a large part of their film budgets through advances from independent video distribution companies hungry for product. Almost none of these companies survived the 1980s; their films were unable to compete with studio films in the theatrical market, and as the growth in the video market began to level out in the late 1990s, many of the individual video companies went out of business.

The video market supplanted the free television broadcast market for new theatrical films. To entice consumers to pay for home videos, the window for free television had to be pushed back until after the initial exploitation period for video. Within a short time, television networks stopped licensing new feature films. This reshuffling of the release windows—the order in which films are made available to the public after initial theatrical release—occurs each time a new exploitation format emerges. The essential factor in the ordering of the windows is the cost to the consumer, with each subsequent window being less expensive.

Video cassettes morphed into DVDs, and their popularity offered reliable revenue for movies for a period of time until the internet window began to cannibalize that profit center. The introduction of Blu-ray DVDs has supplemented the flagging DVD market, without providing a real solution to the declining medium. Online viewing is replacing the DVD window, but has not fulfilled the promise of replacing DVD profits yet, but may, in time.

The Restructuring of the Film Studios

The decades of the 1980s and 1990s were marked by realignments and a restructuring of the film industry. The trend away from the classic studio model accelerated. Indeed, the physical studios themselves were used mostly for television production and rarely for films that, more and more, were shot on location. The majors increased their reliance on projects brought to them by independent production companies, serving as "banks" that provided financing in exchange for distribution rights. Production budgets continued to climb, with the average

negative cost of a studio film growing from \$16.8 million in 1985[18] to \$\$93 million in 2013.

Faced with these escalating budgets, the majors sought outside off-balance-sheet financing through investor partnerships and rights deals with foreign distributors, trading a share of potential profits in successful films for less overall risk.

Corporate Consolidation and Risk Aversion

The trend toward reducing risk was also driven by a restructuring of the ownership of most of the majors. By the end of the 1990s only one stand-alone major film company remained—MGM/UA, controlled by financier Kirk Kerkorian. Warner Bros., Paramount, Columbia Pictures, Universal, and Disney—the companies formed in the first half of the twentieth century that dominated the industry and were primarily, if not exclusively, film companies—now operated as divisions of huge media conglomerates, with interests in television, music, publishing, live theater, theme parks, and other activities. In most cases, the film divisions are relatively small contributors to the overall revenue and profit of these media groups. Senior managers of these groups are not inclined to take large risks in the film business due to possible negative consequences on their company's stock price.

As was the case following earlier technological and economic developments, this realignment of ownership in the industry affected the kinds of films that were produced. Seeking to reduce risk, the majors turned to large-budget formula movies, starring actors with proven box-office drawing power. This drove up the asking price for these actors, further driving up the cost of producing the films. Thus, remakes, sequels, and film versions of popular television shows—perceived as less risky—became standard fare.

The Evolution of Film as a Global Business

Another feature of the modern era has been the increasing importance of foreign markets to the American film industry and the evolution of the foreign film industry to a more American-style commercial industry model. Today, film industries from other countries emulate the American model in order to become more competitive, while the American film industry, in creating film production tax incentive programs akin to those in Europe and Canada, is increasing its effectiveness. The rapid growth of wealth in China has created a buying spree of Chinese companies purchasing Hollywood production, finance, and distribution companies from AMC movie theater chain, IM Global, Legendary Entertainment to distributor Voltage Pictures, with price tags from the millions up into the billions, although by mid-2017 the pace of Chinese investment had begun to slow, partly because of pressure form the Chinese government.

The invention of movie-related technology was global from the outset. Almost simultaneously with Thomas Edison's creation and development of motion picture technology in the United States in the 1890s, the Lumiere Brothers in France created similar technologies and launched film as a new art form in Europe. The Lumiere Brothers and their representatives proceeded to demonstrate their Cinematographe around the globe, traveling to Bombay, Saint Petersburg, and Shanghai. From there, it spread quickly to Egypt, Japan, and Australia.[19] So in a sense almost from its beginnings, film was global. But film as a business remained domestic; films produced in a country were generally shown only in that country. The globalization of the business in terms of the exporting of films to other countries did not begin in earnest until after World War II with the expansion of the American film business overseas, in large part to provide entertainment to moviegoers in other countries whose indigenous film industries had been crippled during the war. By the end of the twentieth century, film was truly a global business in every sense, with production and distribution operations and revenue streams all carried out and calculated on a worldwide basis.

American filmmakers, with a huge domestic market and a strong private financial sector, were better positioned than filmmakers in other countries to make big-budget action-adventure movies with substantial production values; the type of movies that appealed to audiences throughout the world. By 1993, almost 50 percent of the studios' film revenue was consistently coming from foreign markets, and foreign distribution contracts represented a major source of financing for independent films produced outside the studio system.[20] In the late 1990s into the 2000s, American film companies also became more aggressive in financing films by foreign directors who are successful in appealing to crossover foreign and American audiences; such as Alfonso Cuaron (*Gravity*); Michel Hazanavicius (*The Artist*); Guillermo Del Toro (*Pacific Rim*); Ang Lee (*Life of Pi, Crouching Tiger, Hidden Dragon*); Bong Joon-ho (*Okja, Snowpiercer*); Pedro Almodovar (*Talk To Her, All About My Mother*), and Michael Gondry (*Eternal Sunshine of the Spotless Mind*), even shooting the films in a foreign language. The studios also began to take direct stakes in foreign production companies, for example Warner Bros.' joint venture Flagship Entertainment Group, a China joint venture with CMC Holdings.

Currently, studios are aggressively expanding into emerging markets with a rapidly rising middle class, such as Brazil, Russia, India, and China, in order to capitalize on the growing economies. All of the studios and major distribution companies are forming joint ventures, or partnerships in these areas; such as NewsCorp and Relativity Media with Chinese partners; DreamWorks in Shanghai; Disney's Marvel in Beijing; Fox in Argentina, India, and Russia; Warner Bros. in Russia, India, and the Middle East; Sony in Russia, China, Mexico, and India; a trend that will continue for the foreseeable future.

The growing focus of the studios on foreign markets is also a function of declining theatrical audiences at home, as the growth of cable television and

streaming services has cut into the American appetite for a theatrical experience. At the same time, the growing middle class in many foreign countries noted above, the expansion of the exhibition industry in those countries, and technological developments that make the distribution of films in foreign territories in all formats easier and less expensive, have further fueled the studios' focus on big-budget action-adventure and fantasy films that foreign audiences crave and only American studios can deliver.

The European movie industry, which had developed as a state-subsidized business producing films primarily local in content, began to evolve in the 1980s and 1990s into a more commercially driven, privately financed market as subsidies for film production were gradually reduced and modified to economically based, rather than artistically driven, models. This evolution was aided by the privatization and expansion of broadcast television throughout Europe, significantly enlarging the secondary markets for films and allowing European filmmakers to produce larger budget, high production value films with export value. International coproductions also flourished during this period, supported by European coproduction funding, and the new interest of American film companies in partnering on large-budget films to reduce risk. A consequence of this shift in the European industry to a more profit-driven, privatized model was that European films became more competitive in their own countries and around the world with international hits like the German-produced *Run Lola Run*, and the French movies *Amelie, Brotherhood of the Wolf*, and Italy's *Life is Beautiful*.

In regions and countries outside the United States and Europe, film as a business developed in ways specific to each region, influenced by local political, economic, cultural, and demographic factors. The potential for the development and growth of a viable film industry in those regions and countries was affected by the existence, or the absence of, underlying conditions needed to nurture and sustain an industry.

Without a large-enough domestic audience base to generate sufficient revenues from within the producing country, filmmakers are constrained in how much they can spend making a film, limiting the production values and the commercial appeal and competitiveness of their films internationally. Vibrant film industries have flourished primarily in countries with relatively large domestic population bases, like the United States, United Kingdom, France, Italy, Germany, Japan, and India.

The development of a film industry also depends on a political environment and social structure that encourages artistic creativity and free enterprise and does not view film as either a useful propaganda tool or a potentially subversive art form. During the film business's growth periods in the last century, many countries like the Soviet Union, China, and the Eastern European countries during the Soviet era, regulated and censored film content for political purposes. In addition, many of the same countries subsidized filmmakers with state funding, similar to the Western European model, imposing content requirements

and barring or limiting the use of non-local creative talent, resulting in the production of parochial films with little interest to audiences outside the producing country.

Finally, given the costs of producing commercially viable movies that can compete in the marketplace and support the growth of a sustainable film industry, sources of private investment capital need to be available to filmmakers.

The lack of one or more of these necessary conditions in most countries in Latin America, Asia, Africa, and the Middle East meant that with a few exceptions, these regions and countries failed to develop a film industry beyond small, highly localized, and generally underfunded operations.

The exceptions were countries in those regions where the necessary conditions prevailed: postwar Japan, India, and South Korea, for example. China and India offer an interesting contrast. In India, the combination of a huge domestic audience base, a democratic political system that imposed few, if any, restrictions on filmmakers, and a private financial sector that supported the film business, resulted in the development of a vibrant film industry over the last few decades of the twentieth century, producing more movies than any other country and, by the start of this century, beginning to export its films around the world. By contrast, China did not develop a viable film business despite a huge population base due to a system of government regulation and censorship of film production and distribution, and, until recently, relatively poor economic conditions and the lack of a private investment sector to support a film industry.

Japan and South Korea, with conditions similar to India, developed strong local film industries, although filmmakers from these countries, with some exceptions, have had limited success in producing movies with export value.

As China's wealth is increasingly spent in developing its movie industry, budgets are rising, more theaters are being built, to take advantage of the vast population of over 1.3 billion people with films like *Kung Fu Yoga*, *Journey to the West: The Demons Strike Back*, and *The Monkey King 2*.

Asia continues to gain as a portion of international box office, compared to other major regions, according to the Motion Picture Association of America (MPAA), as illustrated in the following chart.

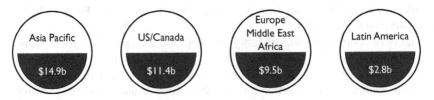

Figure 1.3 International Box Office by Region 2016.

Other Important Developments

Other significant historical developments include the expansion of the independent movie company sector and online distribution, availability of affordable digital production equipment, the rapid digital conversion of theaters, the development of virtual reality and augmented reality films, digital technology and specifically computer-designed digital special effects, the introduction of the DVD, and the potential of Internet Protocol Television and over-the-top (OTT). These topics will be discussed in further detail in the chapters about production and distribution.

Independent Movie Companies

Driven by the breakdown of the studio system and the concentration by the studios on big-budget "tent-pole" movies, the field for smaller budget, more idiosyncratic, artistically focused films was left to independent producers. Successful independent companies, like Pixar, Miramax, and New Line, were eventually acquired by the majors, a development mirroring the majors' acquisition of downstream distributors, such as video companies and cable television systems once the economic viability of these downstream markets had been proven. While the independent sector grew significantly at the end of the twentieth century in terms of the number of films and critical acclaim, exemplified by the many Oscars™ garnered by independent films, the majors continued to dominate the industry in terms of revenue.[21] One consequence of the success of independent cinema, and another example of the majors co-opting a market segment once it has proved successful, is that every studio now has a separate division for the production and distribution of their own "indie" (independent) films: 20th Century Fox (Fox Searchlight), Warner Bros. (New Line), Paramount (Paramount Classics), Disney (Miramax), and Sony Pictures (Sony Pictures Classics). A few companies, patterning themselves on the studio model developing and leveraging independent-style films, have risen to prominence, such as Lionsgate.

Multiplexing

In the 1960s, the theatrical exhibition business began a shift from single-screen theaters to multiple-screen locations—the multiplex. This shift was propelled by the post–World War II growth of suburbs and exurbs, and the emergence of the shopping center as a retail hub, driving large numbers of potential moviegoers to a single location. With a concentration of audiences in one place it made sense to offer a variety of movies suited to different tastes and audiences at that location.

The AMC theater chain (American Multi-Cinema at that time) opened in 1963 the first double-screened movie theater in a shopping center in Kansas City, Missouri, following up with four-screen, then six-screen theaters by 1969.[22]

Some of the biggest multiplexes currently, such as Kineopolis Group, have up to 25 screens in a single theater location in Madrid, Spain, seating 200–1,000 people per screen.[23]

By the 1990s, the multiplex was the dominant retail model, sparking an enormous increase in the number of available screens, leading to ever larger opening weekends and even greater reliance on big-budget films that could be released nationally on 3,000–5,000 screens; 4,468 US screens for the 2010 film *The Twilight Saga: Eclipse*, and 10,152 screens worldwide for 2014's *Transformers: Age of Extinction*. This simultaneously drove up marketing and advertising budgets. At the same time, more screens were available for independent films, supporting the growth of that sector. The development of computer-designed digital special-effects technology opened up extraordinary new possibilities for filmmakers, exemplified by films such as *Pirates of the Caribbean: Dead Man's Chest* ($1 billion worldwide), *Iron Man* ($566 million worldwide, and *Indiana Jones and the Kingdom of the Crystal Skull* ($760 million worldwide).[24] These special effects-driven epics became the most commercially successful movies of all time, with huge global audiences, further entrenching the big-budget "tent-pole" film as the dominant studio product model, and driving production costs even higher. The digital special-effects phenomenon is another example of a new technology that changed not only how films were made, but also what kind of films got made.

Convergence and Disruption

The definition of convergence is moving toward a union, or coming together. There are many examples of convergence in the movie industry, typically caused by developments in technology and access to capital.

Disruption is a radical change in an industry or strategy, involving the introduction of a new product or service that creates a new market. Often, convergence causes disruption, as new business models are formed, disrupting the previous models.

Examples of convergence in film include the transition of cable channels to home-based movie theaters (early cable channels didn't have any original programming and showed Hollywood films almost exclusively). Most impactful and creating huge disruption is the combination of computer and internet, which has vastly increased home viewing possibilities. This has enabled content retailers to use streaming technology, creating new business models—such as Amazon and Netflix—now disrupting the movie industry and forcing change on the studios.

Mobile technology on smartphones and tablets combined with fast internet speeds and a variety of websites offering videos has changed the way we watch movies and television. We can now watch filmed entertainment wherever and whenever we want. This new format has also given rise to the enormous popularity of shorter form videos easily consumed during sporadic commutes.

OTT, or over-the-top viewing (essentially internet video streaming or download) is an example of convergence; content that combines audio, video, and other media transmitted via the Internet without the need for multiple cable or direct-broadcast satellite television systems, resulting in transforming computers into televisions, movie screens, and gaming systems. Whether a consumer has an elaborate home theater system, a smart television, or simply watches programming on their laptop, the ability to use the Internet to screen films represents a convergence of viewing systems. These advances have contributed to the meteoric rise of Netflix, Amazon, YouTube, and Apple.

The convergence of the growth of the independent film market (itself fueled by the declining costs of production and editing for independent filmmakers) and the Internet as a platform to self-distribute one's film has nurtured a new market, particularly for documentary film and do-it-yourself filmmakers.

Disruptors include technologies, like augmented reality, virtual reality, 360-degree films, holograms, gaming, and 4D, or may also include video games that offer potential intellectual property for new films, like *Angry Birds*. When disrupters first appear, it can be difficult to spot whether a condition will be beneficial in the long run to filmmakers and the industry overall.

An additional disrupter is the technology and social media industries as they draw young people with higher salaries and promises of extreme growth from the movie executive talent pool. Even seasoned executives are going digital, for example, Scott Stuber, a former top manager at Universal Pictures, left for Netflix. The battle for talent has become so fierce that Fox has waged a legal battle with Netflix over the aggressive poaching of its executives.[25]

Fast Forward to Present Day

Combined forces of the pressure from increasing global audiences as a dominant revenue source, the popularity of special effects films such as the comic book movies and animated films, with the high salaries of stars and technological advances, have created conditions for a polarity of film budgets. Films at the high end are getting more expensive while lower budget films can be made for less. The vibrant expansion of the indie filmmaking sector offers audiences interesting low-budget movies, adding some small incremental gains to the diversity of content. Changes in technology change the content of movies.

Internet Protocol Television/OTT

The latest challenge to the industry with the possibility of undermining the traditional role of the major studios is the emergence of Internet Protocol Television (IPTV) platforms and formats as a means of content delivery over the Internet. IPTV is television programming and other video provided online using the TCP/IP protocol as opposed to traditional cable or satellite signals. While the first rush of excitement over IPTV in the late 1990s fizzled out along with

the dot-com frenzy, by the early 2000s, filmmakers and studio executives acknowledged the reality and appeal of this new window and were grappling with its meaning for the industry. As of 2017, established studios and new players have changed the game with increased offerings and services, broadening the concept of IPTV to OTT—over-the-top content delivered by services such as Amazon, Netflix, Hulu, Roku, Sling, or Apple TV, where content is provided via the consumer's existing broadband provider that is not responsible for the content. IPTV posed major challenges for the industry with its potential for the democratization of distribution, allowing filmmakers to reach viewers directly by uploading content onto platforms like YouTube, Vimeo, Amazon, Apple iTunes, and Facebook, a niche that is growing rapidly, but has the potential for increasing the risk of piracy via free downloading systems—as happened in the music business. Theater attendance in the crucial 15- to 25-year-old audience segment began dropping in the early 2000s, with strong indications that its primary audience was more inclined to spend time on the Internet and on their cell phones than in movie theaters. The challenge for the film industry, similar to challenges it has faced and successfully met before, is to harness this new technology to the service of the industry's needs and interests. Some were predicting that the prevailing system of production and distribution, with the major distributors serving as gatekeepers for content flow to consumers, was dying—headed for "the dustbin of history"—and that entirely new models would emerge, which would lessen the dominance of the major studios, and which would free filmmakers from their historical reliance on the studios for capital and distribution. Art might yet triumph over business!

Digital Streaming and Downloads

Digital streaming and downloads over the Internet are replacing DVDs, and make up the fastest-growing category as total home-entertainment revenue. Of the $18.3 billion home entertainment revenue in 2016, streaming revenue ($6 billion) eclipsed digital revenue in the US for the first time. Unfortunately streaming is not making up for ongoing declines in sales and rentals of physical DVDs; the total US home-entertainment market remains well below its peak of more than $22 billion in 2004.[26]

While the tech world has created more outlets for people to watch movies, it has not eased the pain for studios losing revenue from DVD sales and television licensing which once helped lift box-office duds into the black. Digital streaming and downloads are usurping DVD as a format, but not as a revenue stream.

From the 1920s until now, the industry has gone from one way of selling movies to the public (in the theater) to many. Digital streaming and downloads over the Internet on computers, smart televisions, and smartphones, are the newest ways to consume movies, changing both distribution and financing architecture. With the rise of this technology and widespread popularity, new players in the movie business; Netflix, Amazon, Google, and Apple are positioned to

threaten the established Hollywood studios. The dominant model in internet streaming is subscription video-on-demand (SVOD) where the consumer pays a fee to subscribe to a service that gives the consumer access to a library of works for viewing at a time and place selected by the subscriber. Netflix is currently the leader in SVOD. The internet download model offers movie downloads which can be watched multiple times whenever a viewer wants, since the movie file is downloaded onto the viewer's computer after it is purchased. Piracy is a concern related to this technology, as are price points, and the impact on other distribution windows.

Mobile

Mobile smartphones, with their ability to play, download, and stream video content, add another moving part to the movie business. Smartphones now have the sufficient storage capacity and internet access, so watching movies on them is becoming more popular. Given several choices, consumers are increasing pressure on the industry to make movies available in multiple media formats.

Movies are not generally produced for such small screens, so experience is very different than on a big screen. A few projects have been made for mobile viewing, like *Rage* (2009) which was designed to be viewed on a phone, and *The Silver Goat* (2012), created exclusively for viewing on the iPad. Students, in particular, watch movies and TV programming primarily on their phones, due to the convenience.

Large Formats

Competition from the combined new media companies—Netflix, Amazon, Google, and Apple—combined with shorter time gaps between when a movie is released in theaters and distributed in the home has put the squeeze on the theater industry.

To remain relevant and competitive, theaters must continue to invest in a combination of technology, comfort, in-theater amenities, and security. The major innovations and improvements implemented by theater owners to maintain and bolster attendance in the television and internet era include: multiple screens (multiplexing); large-format screens like IMAX; modernized theaters with high-end, surround sound systems; stadium seating; reclining chairs and reserved seating; and a transformation to digital projection—bringing back new and improved 3D again.

Theaters and distributors use large and enhanced formats like 3D and IMAX to sell movies at a higher price point to avid moviegoers. IMAX and enhanced formats like 3D and 4D make movies more of an "event" spurring consumers to attend movie theaters when they might otherwise wait. Exhibitors have observed that US attendance has been relatively flat for many years, and if it will not increase long-term, there needs to be an additional draw. Large formats and

premium offerings get more money out of the consumer who would have gone to the movies anyway, as well as drawing viewers who might have waited to see the film online or at home.

New Formats

With the rise of digital production (rather than film) and exhibition, new formats have appeared, influenced by the gaming sectors and need to push the envelope in terms of creating ever-more lifelike movies. Movies made in virtual reality, 360-degree movies, and augmented reality, presenting a virtual dimension over the current reality, are rising in popularity. These formats require headset "smart-glasses" in order to see the experience to its furthest extent. The acceptance of the format will depend on audience appetite for both glasses and the experience. Some 30+ movies are to be released in 3D worldwide in 2018, it seems that increasing the dimensionality of commercial movies will increase, and that virtual and augmented reality may someday become the norm.

In addition to 3D, 4D film is on the rise, utilizing a theater system combining a 3D movie with physical effects, such as vibrating seats, rain, wind, scents, strobe lights that occur in the theater, synchronized to the film.

There is no doubt that new developments, in production, distribution, and exhibition, will arise, influencing how we experience movies and their content in the future.

Notes

1. PricewaterhouseCoopers. (2017) *Global Entertainment and Media Outlook 2017–2021*, p. 5. Retrieved February 22, 2018 from www.pwc.com/us/outlook.
2. Dodd, Christopher J. *Theatrical Market Statistics 2016*, Motion Picture Association of America, Inc. p. 16. Retrieved February 22, 2018 from www.mpaa.org/wp-content/uploads/2017/03/MPAA-Theatrical-Market-Statistics-2016_Final.pdf.
3. Vogel, Harold. (2015) *Entertainment Industry Economics: A Guide for Financial Analysis* (9th ed.). Cambridge, England: Cambridge University Press, p. 136.
4. Ayscough, Suzan. (1993, May 24) "Vestron Heir Wins $100 Mil," *Variety Business.* Reed Business Information, Reed Elsevier Inc. Retrieved December 29, 2007 from www.variety.com/article/VR107090.html?categoryid=18&cs=1.
5. Mintz, Steven. (2007) "Hollywood as History," *Digital History: Using New Technologies to Enhance Teaching and Research.* Retrieved November 29, 2007 from www. digitalhistory.uh.edu/historyonline/hollywood_history.cfm. Gabler, Neal. (1997, June 12) "Bill Gates Goes Vertical," *New York Times.* Retrieved November 11, 2007 from query.nytimes.com/gst/fullpage.html?res=9C02EEDB1F3CF931A25755C0A961958260&sec=&spon=&pagewanted=all.
6. Dirks, Tim. (n.d.) "Film History of the 1920s." Retrieved October 21, 2006 from www.filmsite.org/20sintro.html.
7. Botnick, Vicki. (n.d.) *The First Fifty Years of American Cinema: Fun, Games and the Morning After, 1920–1927*. Los Angeles, CA: American Film Institute. Retrieved November 27, 2007 from www.fathom.com/course/21701779/session4.html.
8. Shindler, Colin. (1996) *Hollywood in Crisis: Cinema and American Society, 1929–1939*. London, England: Routledge, p. 98.

9. Pautz, Michelle. (2017). "The Decline in Average Weekly Cinema Attendance: 1930–2000," *Issues in Political Economy* 11: 16.
10. Franklin, Daniel P. (2006) *Politics and Film: The Political Culture of Film in the United States*. Lanham, MD: Rowman & Littlefield, p. 44.
11. Vogel, Harold. (2004) *Entertainment Industry Economics: A Guide for Financial Analysis* (6th ed.). Cambridge, England: Cambridge University Press, p. 68.
12. McDougal, Dennis. (2001) *The Last Mogul: Lew Wasserman, MCA, and the Hidden History of Hollywood*. New York, NY: Da Capo Press, p. 117.
13. National Cable & Telecommunications Association (n.d.) "History of Cable Television." Retrieved September 21, 2007 from www.ncta.com/ContentView.aspx? contentId=2685.
14. Prince, Stephen. (2002) *History of the American Cinema, Volume 10: A New Pot of Gold; Hollywood Under the Electronic Rainbow, 1980–1989*. Berkeley, CA: University of California Press, p. 29.
15. National Cable & Telecommunications Association. (n.d.) "History of Cable Television." Retrieved September 21, 2007 from www.ncta.com/ContentView.aspx? contentId=2685.
16. Lieberman, David. (2002, May 9) "Premium Cable May Go Digital Only, Cost More," *USA Today*. Retrieved April 14, 2007 from www.usatoday.com/money/ media/2002-05-09-cable-gouge.htm.
17. Holmes, Steve. (2005) "Comment on the Recent Grokster Judgment by the US Supreme Court," *Journal of Intellectual Property Law & Practice* 1 (1): 23–26; www.doi:10.1093/jiplp/jpi013. Oxford, England: Oxford University Press. Retrieved October 12, 2007 from www.jiplp.oxfordjournals.org/cgi/content/full/1/1/23.
18. Lewis, Peter. (1987, February 11) "Business Technology: Advances in Film; Low-Budget Movies Get a High Gloss," *New York Times*. Retrieved September 16, 2007 from www.query.nytimes.com/gst/fullpage.html?res=9B0DEFDF1730F932A25751 C0A961948260.
19. Sklar, Robert. (1993) *Film: An International History of the Medium*. New York, NY: Harry N. Abrams, Inc., p. 27.
20. Vogel, Harold. (2004) *Entertainment Industry Economics: A Guide for Financial Analysis* (6th ed.). Cambridge, England: Cambridge University Press, p. 58.
21. Levy, Emanuel. (1999) *Cinema of Outsiders: The Rise of American Independent Film*. New York, NY: NYU Press, pp. 14–15.
22. AMC corporate website. (n.d.) Retrieved September 7, 2007 from www.amctheatres. com/aboutamc/firsts.html.
23. Kineopolis corporate website. (n.d.) Retrieved September 27, 2017 from https:// corporate.kinepolis.com/en/about-kinepolis.
24. The Numbers. (n.d.) Nash Information Services, LLC. Retrieved August 27, 2017 from www.The-Numbers.com.
25. Faughnder, Ryan. (2017, March 26) "The Reason Hollywood's Studio Leadership Is in Flux: The Business Model Is Changing," *Los Angeles Times*. Retrieved July 18, 2017 from www.latimes.com/business/hollywood/la-fi-ct-studio-disruption-201703 26-story.html.
26. Wallenstein, Andrew. (2017, January 6) "Home Entertainment 2016 Figures: Streaming Eclipses Disc Sales for the First Time," *Variety*. Retrieved June http://variety. com/2017/digital/news/home-entertainment-2016-figures-streaming-eclipses-disc-sales-for-the-first-time-1201954154.

Chapter 2

A Business Overview of Film

The film business has certain characteristics that distinguish it from other types of commercial enterprises, and that demand expertise in, and mastery of, the business consequences that flow from these attributes.

Key Characteristics of the Industry

While the technological side of the film industry has changed dramatically from the very beginning, certain business characteristics remain constant, and patterns have emerged regardless of technology.

These characteristics include:

- film is intellectual property;
- managing creative talent;
- film is a global product;
- film takes a long time to develop, produce, and market;
- market structure—oligopoly versus monopoly;
- cyclical;
- price elasticity.

Film Is Intellectual Property. Film is intellectual property protected by copyright laws. The value of a movie lies in the right to exploit it, and the asset value of film companies lies not in bricks and mortar but in the copyright ownership of its films. The successful exploitation of a film requires a knowledge and understanding of film markets, both primary and secondary. These worldwide markets are always in a state of flux based on economic, cultural, and even political factors. The licensing of both new films and library films requires an understanding of consumer tastes and behavior, and precise timing in releasing and licensing a film in multiple markets and media (theatrical, VOD, PPV, DVD, internet streaming platforms/OTT, cable, television) throughout the world. As intellectual property, movies contain elements that can be further exploited beyond the actual film itself; the characters, story elements, licensing of elements of the production itself, spinoffs and other media, create additional value.

Managing Creative Talent. Every film is a unique product that draws on the creative talents of a large number of people. The film business differs from other commercial enterprises in this almost total reliance on creative artists for the product that it sells. While other media businesses, like music and publishing, also rely on creative talent for product, the complex nature of filmmaking, requiring the melding of the efforts of a variety of creative artists, and the large financial investment at stake in each individual film, put creative artists more at the center of the enterprise than is true of other media businesses. For this reason, the ability to manage creative talent is essential to success in the film business. Besides the copyright value of its films, a film company's major asset is the creative talent it can attract to its projects. Actors, directors, and writers exhibit many of the traits and idiosyncrasies of artists generally and, in the film business, are always surrounded and protected by managers, agents, and lawyers. Understanding the dynamics of these relationships, and an ability to meet the needs and desires of talent, without ceding control and without "giving away the store," are key for business success in the industry.

Film Is A Global Product. Film is now truly a global business. It is one of the leading export industries in the United States, and with more than half of its revenue coming from outside America, the worldwide nature of the business is more significant for domestic film companies than it is for many other businesses. While the center of the film industry in terms of decision-making remains in Hollywood, films are now developed, financed, produced, and distributed on a global basis. The ability to work across borders and within different economic and cultural structures, and an understanding of these structures, particularly given the social power of film, are indispensable to the success of a filmmaker, a business manager, or an entrepreneur in the film industry.

Film Takes a Long Time to Conceive, Create, and Sell. Due to the layers of decision-making and collaboration required to finalize a script, cast, finance, and complete a film, it can take many years from the time a script or story idea is acquired until the film is in the theaters. This reality has consequences, including changing consumer tastes that turn a timely idea at the outset of development into a stale and overused or no longer topical idea by the time of release.

Market Structure—Oligopoly Versus Monopoly. Markets can be structured in various ways. A monopoly occurs when one company controls an industry. For a decade following the invention of the film projector the film industry was a monopoly controlled by the Edison Trust established by Thomas Edison, meaning that anyone who wanted to use the equipment to make and screen a film had to go through his company. When a market is controlled by a handful of companies that generate most of the revenue in that industry it is considered an oligopoly, which has been the state of the film business for the past century. The studios are competitors but they also work together to control pricing, lobby the government for policies advantageous to them, and cooperate on technical standards.

Cyclical. Movie consumption is cyclical. There are patterns of consumption that rise and fall over the year such as the increase in movie attendance during

the summer and school holidays. Film distributors calibrate their releases with these cyclical phenomena.

Price Elasticity. Considerations relating to movie pricing include price elasticity—how much can ticket prices be raised before consumers begin to reduce their consumption of films? Price discrimination occurs when the ticket price varies based on factors such as the buyer's age, time of the screening, screen format, etc. Film distributors, in cooperation with theater owners, are constantly experimenting with ticket pricing, seeking to find the optimum price point. To date, movie pricing has proved to be elastic in that continuing increases in prices has not noticeably reduced consumption. Similar considerations of elasticity apply to the ancillary markets for film such as the home entertainment market.

Structure of the Industry

The structure of the film industry can best be considered from a functional perspective. The principal functional sectors are production, distribution, and exhibition.

The production sector involves the process of making a film. The distribution sector encompasses the licensing or sale of a completed film to media outlets, such as theaters, television and cable broadcasters, internet platforms, VOD and DVD retailers, and related marketing activities. Distribution is the equivalent to the wholesale sector in retail businesses. The exhibition sector involves the delivery of a film to a consumer through various media outlets.

The production and distribution sectors of the industry are dominated by a group of large companies, referred to within the industry as the "studios" (or sometimes alternatively the "majors"). As of this writing, the studios are:

- Warner Bros. Entertainment
- Universal Pictures

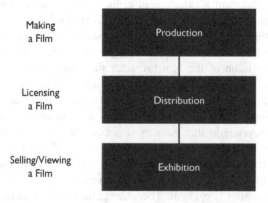

Figure 2.1

- Paramount Pictures
- Walt Disney Pictures
- 20th Century Fox Film Corporation
- Sony Pictures.

Each studio is owned by a public company, which creates and sells vast amounts of media and other goods relating to that media. The studios participate in each sector, producing, distribution, and exhibition and are considered vertically integrated.

To further increase power, and block competition, the studios are also horizontally integrated, acquiring additional businesses at the same level of the value chain; purchasing additional production and distribution companies, as well as exhibition platforms. This activity helps the company grow, prevents rivals from purchasing potentially profitable companies, and offers a means to separate and maintain distinct brands.

The biggest film companies are active in mergers and acquisitions (M&A), constantly buying upcoming firms and selling or spinning off divisions in order to operate more effectively. Studios and non-studios alike are involved in the various sectors of filmmaking: the production, distribution, and exhibition of a film.

There are other companies within the production and distribution sectors, such as production companies owned by major players in the movie business, like the Playtone Company (Tom Hanks), Imagine Entertainment (Ron Howard), Plan B (Brad Pitt); production entities owned by wealthy individuals such as Annapurna Pictures (owned by Meg Ellison); independent distributors Goldcrest, Magnolia, Koch Lorber, Zeitgeist Films; and a few that, similar to the studios, operate in all sectors, like Lionsgate and 2929 Entertainment. In relation

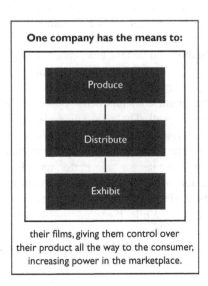

Figure 2.2 Vertical Integration.[1]

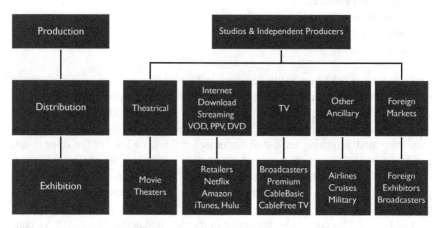

Figure 2.3 Horizontal Integration.

to the theatrical film business, these other non-studio companies represent a minority share of the market. However, other non-studio players do have a major share of the market, both in production and distribution, for projects not intended for theatrical release, such as made-for-TV films and for initial release on DVD or video, documentaries, and educational and corporate films. Both Amazon and Netflix, established in online streaming, are aggressively producing and distributing their own original films, to bypass the studios and build their own content libraries where they own all rights to the films.

The exhibition sector of the industry differs from the production and distribution sectors. The companies that operate in production and distribution are engaged primarily in the production and distribution of films, whether for initial theatrical release or otherwise (generally the studios and certain independent distributors). Players such as Netflix, Amazon, and Sky may exhibit in theaters although it is a negligible part of their release; their primary platform is online streaming. Companies such as Hulu and YouTube offer online content, often supported by advertising and sometimes a subscription fee as well. The new online players such as Netflix, Amazon, Apple, and Google generally bypass the movie theaters.

In the exhibition sector, the theater chains, independent distributors, and DVD retailers are also engaged in exhibiting movies for sale or for rent. But other significant players in the sector, like television networks and broadcasters and cable systems, are not primarily in the business of exhibiting movies as opposed to other products such as TV programs. While these companies contribute revenue to the film business in the form of license fees, they are not themselves in the film business but rather in the business of exhibiting and selling multimedia product, which includes films. As a caveat, however, it must be noted that three of the studios, Universal, Paramount, and Disney are owned by, or own, television cable companies or broadcasters.

In the production and distribution sectors, the studios effectively constitute an oligopoly, that is, a small group of competing companies that together dominate these sectors of the industry and create major barriers to entry for potential competitors. In the United States, these six companies release about 140 films each year, generating approximately 84 percent of the industry revenue,[2] and their decisions about pricing and content affect the decisions of other, smaller, players. International sources are a critical component in film profitability, accounting for more than two-thirds of studios' box office—in 2016, American companies earned revenue of $11 billion from the domestic markets, and $39 billion worldwide, largely due to gains in China (MPAA).

Even though the studios are competitors, they work together to control standards on technology and pricing, lobbying the government on piracy, and other industry-wide issues.[3] The size and structure of the majors creates barriers to entry for new players, the most significant being the large amount of capital needed to compete in the marketplace. A recent example of the difficulty of breaking into the ranks of the majors is DreamWorks SKG, a film studio founded in 1994 with financial backing of $33 million from each of the three main partners and $500 million from Microsoft cofounder Paul Allen. Started and run by brilliant and hugely successful creative professionals (Steven Spielberg, Jeffrey Katzenberg, and David Geffen) with the stated objective of succeeding as a new full-blown major studio, DreamWorks raised $821 million in a public offering, and had a few hits like *American Beauty* and *Shrek*. Nonetheless, in 2006, the owners of DreamWorks conceded its inability to compete, and sold the company to Paramount (owned by Viacom). The company was sold again which then spun off DreamWorks Animation, bought by NBC/Universal (owned by Comcast) for $3.8 billion in 2016.[4]

In spite of the formidable barrier presented by the studios, new players have emerged and are aggressively producing and distributing films, although they are not yet dominant players in the theatrical exhibition sector. Streaming internet services (SVOD) Netflix and Amazon have aggressively moved into financing the production and distribution of films. Since these companies have tremendous cash flow, they are the first serious competitors to the oligopoly of the Hollywood studios with the financial muscle to join and expand that oligopoly.

The studios depend on many smaller support entities, creative talent, and craftspeople to make a movie. Since the demise of the studio system of having talent under contract, every film is produced on a project basis with the necessary talent, and craft elements assembled as needed to complete the film. From the director's unit to craft services, hundreds of employees are hired for each movie, and no two movies have exactly the same personnel. In this sense, every completed movie is a unique, handcrafted product.

Most of the studios were transformed from stand-alone entities to their current status as divisions of large media companies beginning in the late 1960s. Movie studios, which originated as companies that made only movies, are now divisions of large parent companies.

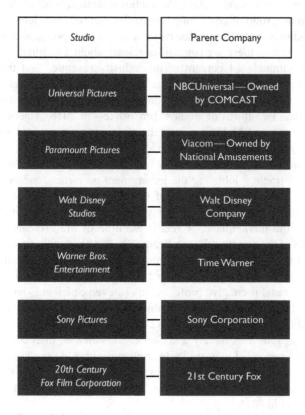

Figure 2.4

The studios' parent companies are involved in many other media and non-media businesses. Sony is in the electronic consumer hardware, gaming, and music business, while Paramount/Viacom is in publishing, broadcasting, and music and owns the CBS network. Universal is owned by NBCUniversal, a subsidiary of Comcast, the cable giant. Besides 20th Century Fox, 21st Century Fox also has cable, broadcasting, and studios. Disney owns theme parks, the ABC network, as well as cruise lines, cable, merchandising, publishing, and radio interests. At the time of this writing the acquisition of Time Warner by AT&T is pending government approval, as is the purchase of Fox by Disney.

The general trend over the past few decades has been a merger of content providers and content distributors, with the largest media groups seeking to return to a robust version of vertical integration, owning all or many of the elements in the chain of production, distribution, and exhibition of a film. As technology continues to expand distribution and exhibition windows, like 3D, 4D, Imax, OTT, and a number of new internet contenders, into new formats like virtual reality, 360, and augmented reality movies, it is likely this trend will continue.

An example of horizontal integration is the Disney distribution arm, composed of several subsidiaries: Buena Vista International, Touchstone Pictures, and Hollywood Pictures. To broaden its reach, in 2006, Disney purchased another company, Pixar, a producer of animated films, further extending its brand and, incidentally, preventing the acquisition of Pixar by one of the other studios. Each of Disney's subsidiaries distributes a type of film product different than the other subsidiaries and aimed at a particular audience niche. Pixar distributes animated films, and Buena Vista, Touchstone, and Hollywood distribute Disney's live-action movies. The advantage of this sort of horizontal integration is the opportunity to establish a "brand" identity for each of the distribution arms.

An example of vertical integration is Viacom's ownership of Paramount—the production company that produces movies, like the *Transformers* franchise, that may ultimately be distributed through its distribution arm, Paramount Pictures and subsequently played on the Viacom-owned cable channel Showtime or its OTT equivalent available on the Internet, Showtime Anytime. An advantage of vertical integration to the studios is the direct link to their consumers, guaranteeing that their movies will be available to their audience.

The Production Sector

Once financing for a film is in place and the components are assembled, such as a script, talent, a director, and crew, the actual shooting of a film takes place. This is followed by the editing and completion process, perfecting sound, color, and adding music. Producing a movie, whether on a large or small budget, is a complex logistical exercise, requiring the collaboration of a large number of creative artists and specialized personnel. Production of a film can span anywhere from a few weeks to over a year depending on the size of the film and the complexity of the production.

The studios—Warner Bros., Universal Pictures, Paramount Pictures, Walt Disney Pictures, 20th Century Fox Films, and Sony Pictures—have a long history in film production, and are involved in the production of between 12 and 20 films per year. Among them the studios accounted for 137 of the 782 new movies released theatrically in the United States in 2015, and typically account for 90–95 percent of total box-office revenue (BoxOfficeMojo.com). The average production cost of a studio film in 2013 was approximately $93 million,[5] and while a big-budget film can cost upwards of $200 million, even a small-budget studio movie generally costs no less than $15 million. With such a high production cost per film, a single studio will spend between $750 million and $2 billion a year on production alone, far more than the entire independent sector.

While most films today are shot on location, all of the major studios own production facilities, where, if needed, they can build sets and environments on soundstages to mimic a locale and avoid traveling expenses.

Studio film production is, by its nature, expensive. The studios maintain large permanent staffs for development, production, distribution, marketing, publicity,

and business and legal-affairs functions, as well as physical facilities, and routinely charge a film production with "overhead" of up to 15 percent of the budget to help defray these costs. Studio films are all-union projects, employing union workers with minimum pay scales.

Besides the studios, the production sector includes a multiplicity of companies that produce theatrical films with or for the studios, or independently. Some of these production companies have long-standing affiliations with studios, and partner with a studio throughout the production, like Jerry Bruckheimer at Disney on movies like *Pearl Harbor* and *Pirates of the Caribbean: Curse of the Black Pearl*; Ron Howard and Brian Grazer's Imagine at Universal, with movies such as *How the Grinch Stole Christmas* and *Cinderella Man*; and Sony's relationship with Revolution Studios, with movies like *The Forgotten* and *Click*. These companies generally bear some of the expenses of production, particularly story acquisition and script development costs, but the bulk of the financing for the films comes from the studio, with the production company earning a fee and receiving a profit interest in the film.

There are a number of well-financed independent companies in the production sector that finance all, or a substantial portion of, the budget of a film, relying on a studio for a portion of the financing, if needed, and for distribution. In these situations, the production company is a full partner with the studio on recoupment of production costs and profits. Such companies, like Mandalay, Lakeshore, New Regency, Alcon Entertainment, and Walden Media, can often employ economies of scale that keep their production costs lower than the studios, and much lower in the case of non-union productions. Over the past decade a number of new production companies were formed by wealthy individuals with the capacity to fund film productions out of their own personal fortunes, including Anna Purna Pictures (Meg Ellison), SkyDance Media (David Ellison), Participant Films (Jeff Skoll), and Oddlot Entertainment (Gigi Pritsker). These companies have become important players in the industry, producing major films like *American Hustle, Her, Foxcatcher,* and *World War Z.*

In addition to these companies, others produce films totally outside the studio system, relying on private financing from investors or through distribution deals. The films produced by these companies are generally very low budget (under $5 million) and rarely receive theatrical distribution, at least in the United States. Such films may be released directly onto television or straight to VOD and internet streaming. Examples of such companies include Filmbuff, Troma Films, Echelon Entertainment, and Brimstone Media. Such films may be released on internet streaming services such as iTunes, Hulu, Amazon, and others.

The production sector also encompasses many companies that produce nontheatrical films, that is, films made for television, direct to DVD, educational films, documentaries, and so forth. These films generally are produced on lower budgets than low-budget theatrical films and may be financed through broadcast licensing agreements, grant funding, or other private sources.

The Distribution Sector

Film distribution consists of the licensing of movies to media outlets, such as theaters, television broadcasters, video and DVD distributors and retailers, and airlines, and the related marketing, advertising, and publicity activities.

As in the production sector, the studios dominate film distribution—their resources, experience, and expertise, and the number of new films they release into the market, give them an enormous competitive advantage over smaller distributors. Plus, the studios' extensive film libraries allow them to control the major share of the secondary markets, such as syndicated television.

The competitive position of the studios is also enhanced by the ownership of some of these media outlets by the studios' parent companies, such as Time Warner and HBO; Viacom and CBS and Showtime; and Disney and ABC television. The studios have the financial resources to support the release of new films with substantial advertising and marketing expenditures. The average cost of marketing a medium-sized studio film like *The Fault In Our Stars* is about $40 million, which had a modest negative cost of $13 million; for the big-budget franchise films like *Transformers: Age of Extinction*, marketing costs are around $200 million per picture.[6] Smaller distributors without such resources are unable to support a national release of a new movie on 1,000 or more screens.

The distribution sector also includes non-studio distributors, of which there are many—companies that distribute independently produced films and foreign films aimed at niche audiences. These companies typically release their movies theatrically on a small number of screens, perhaps one or two in a few major cities, and hope to expand the release if there is good word of mouth and good reviews. The smaller distributors also usually acquire from the producers the ancillary rights, such as DVD and television, and distribute the films in these outlets as well.

In addition, the distribution sector encompasses a number of non-studio companies that, like the studios, are engaged in both production and distribution, including Lionsgate, which releases 15–18 movies theatrically per year; and companies like Participant Media. These companies operate on a much smaller scale than the studios but often are able to come up with commercial successes like *The Hunger Games*, *American Hustle*, and *Zero Dark Thirty*.

The Exhibition Sector

The exhibition of films takes place at a retail level where viewers pay to see a movie, whether in a movie theater, on pay-cable television, buying or renting a DVD, or purchasing a film for streaming or download over the Internet. Other formats such as free and basic cable television are free to the viewer but supported by advertising.

In the early days of the movie business, the studios owned theater chains, but had to sell off the theaters under the Paramount Consent Decree of 1948. The

decree was relaxed in the 1990s and several studios acquired theaters, but by 2016, none of the majors owned movie-theater chains in the United States.

All the studios have long-standing relationships with most theater operators based on a steady flow of movies over the years. Theaters are dependent on the studios for almost all their product and, as a result, the studios enjoy an advantage over smaller distribution competitors in securing screens and in negotiating license terms with the theater owners. With the complete conversion to digital screens, theaters are experimenting with non-movie programming in the form of cultural, gaming, and live sporting events. While studios don't control theater exhibition chains, the studios now directly own, or are part of media groups that own, many of the other media outlets in the US exhibition sector, such as television networks, cable television systems, and video and DVD distributors. The studios' reach in the exhibition sector even extends overseas. For example, 21st Century Fox controls Sky Television, one of the largest television systems in Europe.

The theatrical segment of the exhibition sector is dominated by a handful of large movie-theater chains: AMC Entertainment, which at this writing is under contract to buy the fourth largest chain, Carmike, and once the merger is complete will control 8,380 screens (both will be owned by Chinese giant Wanda which owns AMC); the Regal Entertainment Group, with 7,361 screens; Cinemark, with 4,499 screens; and Cineplex with 1,635 screens. The top five exhibitors account for approximately 57 percent of the North American box office and almost 50 percent of North American screens.[7] The rest of the market is comprised of a myriad of smaller theater owners, including a few mom-and-pop types operating one or a few screens in a single location.

The television segment of the exhibition sector is, of course, dominated by the four networks and the major cable television networks and systems. These companies, many of which are owned by, or are partners with, the studios, license movies from film distribution companies for showing on their systems or networks over periods of time and generally for a fixed license fee. Many of the cable networks also produce movies for original exhibition on the network and then for licensing to free and basic cable networks, television broadcasters, and foreign markets. The most active companies in film production are HBO, Showtime, Lifetime, Syfy, AMC, Turner, Disney, and Court TV.

The DVD sales segment is dominated by a few major chains, primarily the big-box stores, such as Wal-Mart, Target, and Best Buy. Of the $14.1 billion home viewing category, 45 percent is made up of DVD sales, 45 percent is digital sales, rentals, and VOD, with DVD rentals making up only 10 percent.[8] These companies buy films in DVD disk formats either directly from film distributors, like the studios, or through wholesale distributors, who then either rent or sell the DVDs and videos to consumers.

There are a small number of non-studio companies which participate in all three sectors—production, distribution, and exhibition—such as IFC (Independent Film Channel), which produces and distributes independent films,

exhibiting them on cable television and in its one movie theater in New York City, as well as HDNet Films, which produces high-definition movies, distributed theatrically in the Landmark Theaters, shown on the company's cable channel, and released simultaneously on DVD.

Online exhibition of movies is a fast-growing trend, and the internet companies that are the pioneers in this area, such as Apple's iTunes, Netflix, and Amazon, dominate this now established form of exhibition: consuming and watching movies online and for download; whether on a television, computer, tablet, or smartphone. Studios and non-studios alike are working to figure out how this new window of exhibition can become profitable enough to replace the waning DVD business, and what ultimate effect it will have on the production and distribution sectors, and other players in the exhibition sector. The studios are experimenting with creating their own systems and formats, such as Disney Movies Anywhere; Paramount Vault Service on YouTube offering a free selection of a variety of classic films; and the online platform Hulu, jointly owned by Disney, Fox, Time Warner, and Universal.

The exhibition sector is particularly fragmented, since movies can be licensed and sold in so many forms all over the world. Significant emerging technologies will cause shifts in every sector. The studios have an advantage due to their horizontal and vertical integration, but ultimately, audience choice will rule in deciding which companies are successful.

New Media Players and their Impact

The rise of Netflix, and tech players in the movie space, such as Google, Apple, and Amazon, has forced rapid change on the industry, particularly in the distribution sector. And, as these cash-rich companies move into production, the impact on the sector will also be significant. Both Netflix and Amazon have announced annual spending targets for original film production that far exceed what the studios are now spending on new production, representing the greatest threat to the production/distribution oligopoly since its creation in the early twentieth century. This phenomenon would, however, constitute a boon for filmmakers, pumping huge new capital into the film business.

In addition, the growth and expansion of telco companies, AT&T, Verizon, and cash-rich cable entities such as Comcast, all moving aggressively into movies, is shaping the industry from production through exhibition.

Notes

1. Investor Words. (n.d.) "Vertical Integration Definition" (Web Finance, Inc.). Retrieved July 12, 2017 from www.investorwords.com/5977/vertical_integration.html.
2. The Numbers. (n.d.) Nash Information Services, LLC. Retrieved July 2, 2017 from www.The-Numbers.com.
3. Bagdikian, Ben H. (2004) *The New Media Monopoly*. Boston, MA: Beacon Press, p. 5.

4. "Steven Spielberg, Jeffrey Katzenberg, and David Geffen: DreamWorks; SKG," *Business Week* (2004, January 10). The McGraw-Hill Companies, Inc. Retrieved May 13, 2007 from www.businessweek.com/magazine/content/05_02/b3915608.htm.
5. Vogel, Harold. (2015) *Entertainment Industry Economics: A Guide for Financial Analysis* (9th ed.). Cambridge, England: Cambridge University Press, p. 136.
6. McClintock, Pamela. (2014, July 31) "$200 Million and Rising: Hollywood Struggles with Rising Marketing Costs," *Hollywood Reporter*. Retrieved September 31, 2017 from www.hollywoodreporter.com/news/200-million-rising-hollywood-struggles-721818.
7. NATO corporate website. (n.d.) National Association of Theater Owners. Retrieved October 3, 2017 from www.natoonline.org/data/top-10-circuits/.
8. PricewaterhouseCoopers. (2017) *Global Entertainment and Media Outlook 2017–2021*, p. 4. Retrieved February 22, 2018 from www.pwc.com/us/outlook.

Chapter 3

Movie Development

Development is the process of assembling the essential building blocks of a film: a story idea, a script, a director, one or two main cast members (preferably stars), and a budget. The foundation upon which any movie is built is an idea or a story, and studio development personnel, independent producers, directors, actors, and other professionals involved in filmmaking, such as entertainment lawyers and agents, are always seeking ideas and material with the potential to become a movie.

There were 718 films released theatrically in 2016[1] in the United States, and roughly one out of every ten films in development actually makes it from a concept to the screen.[2] At any given time, between the studios and the independent sector, there are thousands of films in development. The odds are stacked against most development projects, and the riskiest money in film financing is invested at the development stage. Many things can impact which films are developed; from personnel and corporate changes, mergers and acquisitions, success of competing studio films, trends in technology, audience tastes, to world events and the political climate—all affect development trends. As of this writing, Disney's potential acquisition of 21st Century Fox is likely to influence the development decisions of both entities.

The steps in the development process include: evaluating a script, idea, or literary property to determine whether the material or idea can be turned into a potentially profitable film; creating a "package" by acquiring a script or having one written; attaching a director and major talent; and creating a budget.

Where Films Come From

Ideas for movies can come from anywhere: news events (*Patriots Day*, *Sully*), personal experiences (*Into the Wild*), books (*Girl On The Train*, *Gone Girl*), radio shows (*Green Hornet*, *The Lone Ranger*), history (*Snowden*, *Spotlight*), short stories (*Children of the Corn*, *The Curious Case of Benjamin Button*), plays (*Doubt*, *Equus*), other movies (*The Producers*), comic books (*Black Panther*, *X-Men*), video games (*Angry Birds*), or original scripts (*Birdman*, *American Hustle*).

As trends and tastes change in the marketplace, film genres rise and fall in popularity, influencing which material is chosen for development. For example, currently popular genres include comic book-based movies such as *Deadpool*, *Captain America*, *X-Men*; biopics, such as *Joy*, *Founder*, *Miles Ahead*, and *Hendrix*; musicals, like *LaLa Land*, *Pitch Perfect 1* and *2*, and *Sing*; and increasingly popular horror films including *Get Out*, *It*, and *Annabelle: Creation*. For producers, an awareness of the marketplace is crucial to the development process.

A movie studio, as a division of a large media company, may transform an idea, character, or product from another division in the company into a movie. Fox capitalized on the character Alvin from the popular children's show *Alvin and the Chipmunks*, and Disney successfully transformed its amusement park ride at Disney World, The Pirates of the Caribbean, into a huge hit movie, with profitable sequels, while its film *Tomorrowland*, also based on its ride, flopped. This type of development activity can create franchises: profitable and highly marketable brands, which build awareness through cross-marketing; however, it can be risky.

Acquisition and development activity within the movie business is publicized in trade magazines such as the *Hollywood Reporter* and *Variety*, which inform producers and studios of other projects in development, including possibly similar projects. In spite of the risks, similar films are often released during the same year. In 2012, two films about Snow White were released with prominent stars, *Snow White and the Huntsman* and *Mirror, Mirror*. *Snow White and the Huntsman*, produced by Universal, was a darker and edgier film, rated PG-13 and released three months later than the other film, rated PG.[3] Although Relativity Media's *Mirror, Mirror* got the jump on the other film, with a potentially larger audience due to its rating, *Snow White and the Huntsman* grossed higher box office.[4]

Different Types of Films

When choosing an idea for development, a filmmaker or producer must consider his or her potential audience and the appropriate initial release window for the film to be made from the material. Different types of films are intended for varying audiences and some story ideas and material may warrant development for an initial release window other than theatrical, such as online, pay-TV or cable television, or DVD. Other ideas may be best suited for the educational or corporate market. Movies with an initial theatrical release generate the most revenue and profits, but are also the most expensive to produce, the most difficult to finance, and carry the greatest risk of loss. If a filmmaker's metric of success is how many people see his or her film, or how many films he or she makes, developing and producing films for other markets, such as cable television, may better fulfill the filmmaker's aspirations.

Narrative Feature—Theatrical. Narrative theatrical feature-length films are fictional, or retellings of factual stories, intended to play first in movie theaters.

Theatrically released films have production and marketing budgets in the millions of dollars, and, generally, experienced and well-known actors and directors working on them. Almost all studio projects are developed for the theatrical market.

A movie that is successful at the box office will generate more revenue in all forms of distribution than a movie without a theatrical release. When a movie is a big hit, like *Spider-Man: Homecoming*, *The Secret Lives of Pets*, *Star Wars*, and *Wonder Woman*, the profits are tremendous, and it is the big theatrical successes, the so-called "tent-pole" pictures, that pay for the studios' other, less successful films. This accounts for the emphasis by the studios on development projects with potential to develop into big theatrical hits, and explains why smaller projects tend to languish for years within the studio system.

Narrative Feature—Straight to VOD/Internet. Both studios and independent producers develop narrative feature movies released in the video-on-demand, online streaming, or DVD markets, without a theatrical release. These may include films developed specifically for one of these markets, as well as films intended for a theatrical release, but that, once completed, lack the necessary quality to succeed in the theaters. Movies intended for first release on the Internet, in VOD, or on DVD format typically target a niche audience. For example, there is a strong market for films in genres like thrillers, sci-fi, horror, and films for ethnic audiences, as well as faith-based films. Budgets for these films are typically less than $5 million. There are many independent companies that specialize in developing movies for this market, such as GKids, Soda Pictures, and Cake Films and the studios have also set up in-house units to produce films for these markets based on previously released feature films in the studio's library. Some of the studios have created home entertainment units to create films based on their existing libraries of previously released theatrical films. Children's films also do well in this market, especially those based on popular children's characters, such as Barbie (*Barbie Video Game Hero*); and films centered on Disney characters, like *Mulan II*, based on the popular sequel to *Mulan* which was a theatrical release. In the early years of video and DVD, the "made-for" market was largely ignored or considered the dumping ground for poor-quality low-budget films that couldn't make the grade in theatrical releases. This perception generally changed as DVD revenues surpassed those of other exhibition windows, because generations of movie watchers grew up watching DVDs before they went to a movie theater (and were predisposed to watch feature-length films first on DVD). While the DVD market is declining, online video streaming has increased, and this remains a viable way to sell a film.

Narrative Films—Shorts. The primary value of narrative shorts is to showcase the work of up-and-coming filmmakers, and create a version or portion of a feature as a short film in order to garner interest and financing for the long-form film. There are a few companies that distribute short films, such as distributor Neon, curating groups of shorts for the theater, or *The New Yorker*, playing shorts online to enhance the magazine's brand, as well as the cable channels

Sundance and IFC Films, but they rarely get theatrical play and generally are not commercially successful as compared to long-form movies. The prospects for shorts has improved with the rise of internet video distribution platforms which allow filmmakers to sell a short film, such as Vimeo, iTunes, Amazon, and crowdfunding sites like Seed & Spark, and a number of online platforms which offer non-exclusive distribution. There are more shorts than ever; however, film-makers typically do all the marketing themselves.

Filmmakers submit their shorts to film festivals to get noticed and to find future work. Academy Awards are given for short films, and an Oscar™ can launch a filmmaker's career. *Luxo Jr.* was an animated short film that won an Oscar™, launching the career of John Lassiter, head of Pixar studios. Martin McDonagh, the 2006 Oscar™ winner for best live action short film, was quickly signed by Focus Features to direct a feature-length film, *In Bruges*. Working on a short film gives a filmmaker experience she or he will need for a feature film.

Shorts can also be used as part of the development process. A filmmaker or producer with an idea or story for a feature-length movie can shoot a segment of the script as a short film, and then use it to interest financiers or distributors. The short film *Gowanus, Brooklyn*, made by Ryan Fleck and Anna Boden, was made into the feature-length, Oscar™-nominated film, *Half Nelson* (2006).[5] Shane Acker's 2005 Oscar™-winning animated short, *9*, brought him to the attention of Tim Burton, who produced a full-length version of the film.[6]

In the United States, short films are not yet a thriving business, but in other countries shorts are commonly shown in theaters, and regularly on broadcast and cable television. The rise of the Internet, YouTube, Facebook, and other stream-ing platforms; along with video capabilities on alternative windows, like smart-phones and tablets, are creating more distribution opportunities for short films worldwide.

Documentaries. Documentaries are non-fiction films, with subjects ranging from history, the arts and sciences, to social issues. The development process differs for documentaries from narrative features in that fundraising is usually sought from grants, cable or television funding through licensing fees (from PBS, Showtime, A&E, WGBH), and private sources. However, since the mid-1990s and the success of films like Errol Morris's *The Thin Blue Line* and Michael Moore's *Roger and Me*, documentaries have grown in popularity, and have achieved commercial success, including theatrical releases like *Fahrenheit 9/11*, *March of the Penguins*, *Winged Migration*, and *Spellbound*. Responding to these successes, the studios, and particularly their independent arms, stepped up the acquisition and development of documentaries. The widespread and diverse selection of cable channels, and the huge DVD market also opened up more outlets for documentaries. Several non-studio companies release documentaries, including Overture, IDP, National Geographic Entertainment, WGBH with the *Nova* series; Lionsgate with movies like *Grizzly Man* and *Rize*; and PBS, which funds many documentaries, including those by acclaimed filmmaker Ken Burns such as *The Vietnam War* and *Jackie Robinson*.

Along with the rise in popularity of documentary films worldwide, and the increased visibility and interest surrounding them, a number of national and international film festivals, like Hot Docs, AFI, True/False, Sheffield DocFest, and the IDFA, dedicated solely to documentaries, have been launched.

Made-for-Television/Cable/Internet Streaming. Movies produced specifically for first release on television are commonly referred to as "made-for-television" films. The first made-for-TV movies appeared in the late 1960s, the brainchild of Barry Diller, then working as a vice president in charge of feature films at the ABC network.[7] Originally generally considered to be of lower quality and the stuff of melodrama, made-for-TV films improved in quality (and cost) with the advent of cable television, particularly the pay networks.

Made-for-TV movies are typically two hours in length, and cost approximately $2–3 million to produce, although films made for the premium pay channels like HBO and Showtime may cost much more, such as the HBO biopics about Anita Hill and *You Don't Know Jack*, about physician-assisted-suicide advocate Dr. Kevorkian starring Al Pacino, made for $18 million.[8] A related format is the multiple-evening miniseries program, which generally runs from four to eight hours in length, and costs $8–10 million or more.

The cable networks are competing against Amazon and Netflix, which are spending heavily to produce original content, both movies and series. There are an increasing number of original movies produced by cable networks such as SyFy Channel (*Annabelle, 3-Headed Shark Attack*), Lifetime (*Mommy I Didn't Do It, Beaches* remake), WWE (*The Marine 5: Battleground, Killing Hasselhoff*), TNT (*Innocent*), to list a few.

Made-for-TV movies and miniseries are either produced directly by a cable network, broadcaster, or by independent producers who are funded by license fees paid by the broadcaster, with the producer usually retaining the right to distribute the films in the aftermarkets of VOD, DVD, and in foreign and syndicated television. Other companies in the field include Herzog & Company which produces many films and shows for television; Scott Free Productions (*Killing Kennedy, Galyntine*) which produces theatrical and television shows and was founded by brothers Tony and Ridley Scott; as well as RHI Entertainment, which develops, produces, and distributes a large number of made-for-TV movies and mini-series, like *Marco Polo* and *Pandemic*; and BBC Worldwide Americas, Alliance Atlantis, and the Hallmark Channel.

The cable networks reached 90 million US households in 2017,[9] relying on original films and shows to define their brand, and to attract viewers and new subscribers. The premium pay systems, like HBO, will often spend substantial dollars on producing films and aggressively market and promote them.

In the non-fiction category, The History Channel and the Investigation Discovery Channel acquire and release many documentaries developed specifically for distribution on the channel. Other cable channels or networks that broadcast original non-feature movie-style programming include The Discovery Channel, AETN, Weather Channel, The Documentary Channel, MTV, OWN, and Tru

TV. Due to the greater latitude in content afforded them by government regulation, cable networks can air movies and other programming with controversial and explicit subjects that would be inappropriate for airing on free broadcast television, giving cable a distinct advantage in the made-for-TV market.

Educational/Training/Corporate/Personal. Many production companies develop and produce educational, training, and corporate films for use by businesses, in schools, and by non-profit organizations. These companies range from large corporations to small companies run by a few people. The development and production of these films plays an important role in providing employment for filmmakers, and media content for a wide variety of end users. Most corporations now have an online presence, and are using multimedia and films on their websites for marketing, training, and press releases, and to disseminate information about their products creatively. In the event category, videos for weddings, bar and bat mitzvahs, retirement and birthday parties, and life events also provide business and employment opportunities within the industry. There is also a growing market in genealogy and family-history biopic videos.

Process

Development is an ongoing task; studios, producers, directors, and actors are constantly on the lookout for good material from which to create a movie—a strong story, distinctive characters, and the potential for both "make-ability" and profitability.

Generally, a producer or would-be producer drives the development process; however, a project may be initiated by a director, actor, agent, or lawyer, who finds the material and partners with a producer to bring it to the screen.

The development process is triggered by the acquisition of a property (a script, or story rights based on a literary property or other source). Before making an investment in acquiring a property, a filmmaker or producer should be committed to see the development process through to the end, otherwise the investment will be wasted. That means that at the outset, a producer must evaluate the project thoroughly for its potential as a profitable film, and she or he should either have the resources needed to take the project all the way through the development stage to the start of production, or have a feasible plan to find the resources.

Prior to purchasing rights to a property, a producer must evaluate the project thoroughly; gauging possible profitability by evaluating the potential performance of this new project against previously released films similar in genre, story subject matter, tone, and budget. Once satisfied that the project has potential, the producer must consider the legal, creative, and financial challenges posed by the project, and be certain that she or he has the necessary passion for the project to stay with it through the entire process, with the full understanding that most development projects never become films.

Length of Development

From the initial phase of development through shooting to theatrical release, making a movie can take several years.[10] The time needed for development varies widely, from several months to several years. The *Harry Potter* series of books were developed for the movies relatively quickly, while *Deadpool* spent almost ten years in development.[11] The development process for independent movies may take longer than that for studio films due to the more modest resources of independent producers, but even potential studio films can take years to develop. Ultimately only one out of ten or so studio development projects are produced, and the ratio for independent projects is even worse.

The term "development hell" was coined to capture the experience of a producer or director trying to get a studio to green-light a film (make the official financing commitment), living through the roller-coaster ride of development; with approvals and changes to a script from the star, executives, producers, and the director.

Personnel Involved in Development

Many individuals are involved in the development process, but it is the role of the producer to initiate and drive the process, eventually overseeing the entire life of the film, through production, to marketing and distribution. While it is common today for a movie to have several "producer" credits, there is usually one real producer, who serves as the guiding hand for the project and makes the necessary creative and business decisions. If the project is developed at a studio, a development executive will be involved. Others involved in development include writers, entertainment lawyers, often directors, and agents for the creative talent attached to the project.

The studios need to keep their "pipelines" filled with enough development projects to yield a steady flow of 15–25 films a year for distribution, so they must be proactive when it comes to development. Studio development executives track current and upcoming production information, watch the trade publications, read manuscripts, cultivate ties to literary agents, and follow theater, book publications, and popular trends, in the search for promising movie ideas. Development departments work to create a slate of films that will satisfy the studios' need for a mix of product; a few big "tent-pole" movies for the holiday and summer seasons, rounded out with a variety of films in different genres and at different budgets, targeting a broad spectrum of audiences. Development departments employ **readers** to evaluate scripts that come in from writers, producers, directors, actors, and agents, summarizing the strong and weak points in their **coverage** of the script, and also indicating whether they believe the project would make a good movie. While a reader's judgment is never enough to "green-light" a film, a positive critique is generally essential for a potential project to move to the next stage.

Studios receive many unsolicited scripts from writers, which tend to get little attention or interest although they may be read eventually. The studios rely almost exclusively on scripts from established screenwriters represented by a talent agent with whom the studio does business. This bias, a practical one from the standpoint of the studios, makes it difficult for new screenwriters to break into the studio system via unsolicited script submissions.

While it is sometimes possible to sell an idea without a script, as in the case of a best-selling book or a submission by a well-known screenwriter, director, or actor, it is the rare exception. Without a script, most projects will not be seriously considered by a studio, a director, an actor, or a financial backer. A strong script will make it easier for the producer to attach an accomplished director, who in turn will attract experienced and well-known actors to the project. Demand for the top professionals makes it difficult for a producer to attach the most sought-after directors and talent, and it becomes a question of leverage. A well-known producer with a successful track record will generally get his or her material considered before an unknown.

The Advisers: Entertainment Attorneys, Agents, Managers. Dealing with entertainment attorneys, talent agents, and business managers is an integral part of the development process and they play a critical role in the industry. Writers, actors, directors, and other creative talent rely on them for professional and career advice, relationship building, access to projects, and insider knowledge. It is very difficult to get material to an actor or a director without going through his or her agent or manager, who performs a screening or gatekeeper function for the artist. Establishing relationships with these professionals is one key to success in the industry.

A filmmaker developing a project should consult an entertainment attorney who is experienced in the law pertaining to intellectual property, copyright, and film production. This practice is very different from the law practiced by other attorneys. Entertainment attorneys protect their clients' interests, negotiate on their behalf, and often facilitate relationships that prove beneficial to the client's career.

The role of an agent is to find work for her client, and then to negotiate the most favorable terms on each picture. An agent's fee for services is 10 percent (mandatory maximum in California) to 15 percent of the client's fee. Agents have become extremely powerful but have a mixed reputation in Hollywood. Their job is to enhance their clients' careers and increase their fees, and agents are often criticized for withholding information from their clients about lower-paying projects, which may have more creative interest to the client. "Ten-percenters" and "gatekeepers" are among the more polite nicknames given to agents. Regulated by state law, the work an agent is and is not allowed to perform is clearly defined. Under California law, for example, an agent cannot act as producer for her client's projects, since performing both roles would place her in a conflict (an agent intent on getting the client the highest fees versus the interest of a producer in keeping costs as low as possible). A first contract

between an agent and a client cannot last longer than one year. The big agencies in the film business, Paradigm, International Creative Management (ICM), Creative Artists Agency (CAA), William Morris Endeavor, United Talent Agency (UTA), have hundreds of agents, and compete for the top work in the industry. The best agents are known for aggressively finding work and packaging projects for their clients, as well as trying to take talent away from other agencies. There is also a lot of mobility among agents; many move to other agencies, often taking their clients with them.

In the 1990s, talent agencies began to branch out and become more proactive, creating business opportunities that could mean more work for their clients and more fees for the agency. "Packaging" film and television projects by assembling the elements of the project—writer, director, stars—from within the agency's client pool, and then pitching it to a studio or network, became common. If successful, the agency got a packaging fee on top of its client fees. Agencies like ICM and William Morris hired dealmakers who could help structure financing deals for movies that used clients of the agency, and for which the agency would get additional fees. CAA, under Michael Ovitz, began representing major companies, like Coca-Cola, and Matsushita, which the agency represented in its acquisition of Universal Studios. These activities enhanced the power of the agencies within the business, enabling them to drive better deals for their clients. As the costs of studio films continued to escalate through the 1990s and 2000s, driven in large part by enormous salaries for stars, many in the industry pointed a finger at the agencies for sacrificing the long-term health of the business to the short-term gain of the agencies' clients. In recent years, talent agencies have been recipients of Wall Street investment, and they are diversifying beyond movies, expanding into sports, technology, fashion, and food.

Managers typically have only one or two clients and provide career guidance, direction, overall career management, helping with business affairs, and financial planning. Managers cannot negotiate contracts for their clients, but are less restricted legally in the range of services they may provide, although they are not permitted to act as both manager and agent. For example, a manager may act as a producer on a client's film, and many do. A manager typically gets 15 percent of his or her client's income, although there are no limits or rules about what a manager can earn. Due to a manager's involvement in so many aspects of a client's life and work, the client–manager relationship is usually a very close and personal one.

Development Evaluation Criteria

In evaluating a development project, studios and independent producers look at the potential marketability of a film developed from the material. They will consider genre, the adaptability of the material to the screen, the presence of major characters with whom the audience can identify, whether a clear story line exists, and the potential cost of production. An essential question is: Who

exactly is the audience for this film? If there is no clear answer (for example, teenagers, 18–25 year-olds, older audiences, preteens), that signals a potential marketing problem.

Pitch/Story Line/Heroes and Villains. A filmmaker or producer should be able to summarize the key elements of the film to be developed from the idea or material, in a short "pitch," whether to talent, agents, studios, or investors, piquing their interest and securing their involvement. Studios and independent producers do not usually buy an idea or fund a project based solely on a pitch, but it occasionally happens (such as the Universal acquisition of an untitled comedy pitch by writer Brendan O'Brien about an escaped convict who teams up with an unlikely partner (Will Ferrell) to stop his girlfriend from getting married, for $1 million+ in 2016)[12] and a bad pitch may kill the project then and there. The primary components of a good movie are an interesting story with plot twists and turns, a hero with whom the audience can identify, and dramatic conflict. The industry is built on pitch meetings, with writers pitching producers, agents and managers pitching their clients, producers pitching friends of talent, financiers, and development execs, all in the hopes of spurring interest and involvement. Pitching is a high-stakes game. A writer or producer pitching their project must have at their fingertips the basic story, genre, target audience, budget range, and comparable successful movies. Those pitching should be "good in a room" as it's called, personable, pitching easily, and they should be able to take criticism in the form of "coverage," feedback, or "notes" from those reading or listening to the pitch.

Here are examples of two pitches:

Ship of State is an action thriller about a billionaire philanthropist who uses his technological prowess to locate a large group of schoolgirls abducted by terrorists, something the world's intelligence services are unable to do. When it becomes clear the CIA has no intention of launching a rescue mission he's forced to take action himself.

It's the adventure of a lifetime when three youngsters find Captain Nemo's fabulous submarine, the *Nautilus*, and use it to save their New England fishing village from certain destruction. A classic kid's adventure. Thrills, spills, and lots of good-natured action and special effects.

Visual/Hooks. It is important to consider whether a story or idea can be adapted to the visual medium of film before embarking on development. Stories that are told through internal "stream of consciousness" narrative may make good reading, but are challenging to develop as a motion picture. Similarly, stories that are "static," consisting of little physical action or movement, but mostly dialogue, or that have lengthy and complicated plots, are also difficult to adapt. Closely connected is the notion of a "hook"; a plot device or theme that can be stated succinctly and has obvious audience appeal, such as *Power Rangers* (teen friends must save the planet from obliteration), *Paranormal Activity* (fear of an evil presence in your home), or *Bridesmaids* (a Maid of Honor gone wrong).

Definable Target Audience/Exportability. The ability to define the target audience for a proposed film is essential. Descriptions may include demographics (age, gender, marital status, income, education level, where you live) and psychographics (hobbies, beliefs, values, and interests). Who will want to see this movie: teenagers, women, older people, particular ethnic groups, singles, or married couples? If a producer cannot answer that question, the project should probably be dropped. Knowing the target audience informs many of the decisions that have to be made in producing a film: cast, budget, size and timing of release, and the advertising strategy. An important consideration today is how well a film will perform worldwide. Since American distributors generate more than 70 percent of their revenue from foreign markets, particularly with big blockbuster films[13] such as *Despicable Me 3* (73 percent from foreign revenue), *The Fate of the Furious* (82 percent), and *Pirates of the Caribbean: Dead Men Tell No Tales* (78 percent),[14] the marketability and appeal of a potential film in development to other cultures, tastes, and sensibilities is another key consideration. The shift in Hollywood development emphasizes movies with the largest potential audiences, PG-13-rated, four-quadrant movies, so-called for their appeal to four distinct audience quadrants, female and male, both under-25s and over-25. Examples of four-quadrant movies include *Titanic, Toy Story, The Wizard of Oz*, and *Jumanji: Welcome to the Jungle*.

Genre/MPAA Rating. Both the genre and rating of a movie plays an important role in its marketing, and must be clearly defined during development. Examples of genre categories include: comedy; action; drama; horror; sci-fi; action-adventure; and romantic comedy. There are many more genres and increasingly hybrid genres. Movies that often blend two or more, however, are often marketed as one primary genre. A film that does not clearly fall into a recognized genre will have difficulty finding its audience.

The industry regulates itself through the Motion Picture Association of America (MPAA) ratings system, assigning G, PG, PG-13, R, and NC-17 ratings based on language, violence, sexual content, drug use, and other sorts of anti-social or behavioral content in a given film. PG-13-rated films historically draw the highest revenue, due to the breadth of their potential audience. G-rated and PG-rated films signal to audiences that they are for young kids, while R-rated films may only be seen by adults, leaving most PG-13-rated movies straddling adults and kids.

The MPAA system has been in place since the late 1960s, and the ratings decisions are made by a panel of parents whose identities are kept secret, known as CARA, the Classification and Ratings Administration. Most production/distribution agreements require the producer to deliver a film with a certain rating. NC-17-rated movies are usually not distributed theatrically and cannot be advertised on TV or in most mainstream publications, so many filmmakers would rather get a "no rating" for their films than an NC-17 rating. There are a number of parental watch groups now rating the movie ratings, using websites to warn parents about movies that the groups feel are not properly rated, including

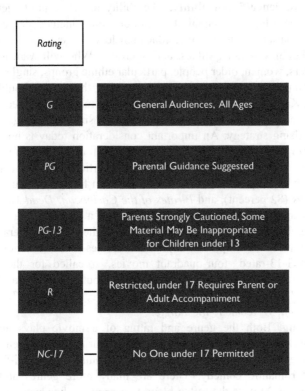

Rating	
G	— General Audiences, All Ages
PG	— Parental Guidance Suggested
PG-13	— Parents Strongly Cautioned, Some Material May Be Inappropriate for Children under 13
R	— Restricted, under 17 Requires Parent or Adult Accompaniment
NC-17	— No One under 17 Permitted

Figure 3.1 Definition of MPAA Ratings.

Common Sense Media, fosi.org, screenit.com, and kids-in-mind.com. Rating systems around the world vary, and in many countries the violence in American movies rated PG-13 is considered too intense for children. In regard to sexual content, European countries tend to be much more liberal than the United States in restricting such content, whereas in other regions of the world, like the Middle East, sexual content will be strictly limited, and the films may be more severely rated in these countries.

Cost and Projected Revenue. In the early stages of development, an essential step is to estimate the budget range of a proposed film. An experienced producer can read a script and make such an estimate, but at some point a production manager or a line producer will be assigned to prepare a detailed budget of the physical cost of producing a film based on the script, even without the cost of star salaries. The producer can then look at previously released movies similar in genre, budget, and casting, and project average, worst-case, and best-case revenue, and financial-return scenarios that will be needed to raise financing. Casting affects the overall budget for a film, and it is generally thought that a more expensive cast will result in higher revenue—however, there are no guarantees.

Franchises and Trends. Audience and marketplace trends influence the profitability of a film, and may indicate whether it is the right time to develop and produce a certain movie. A backlash against the lack of diversity in movies and in power in general, whether political, economic, or otherwise, helped fuel support of *Wonder Woman*, by female director Patty Jenkins, which grossed $810 million worldwide. As of this writing, the sequel, *Wonder Woman 2*, is in development. The rise and popularity of vampire- and zombie-based books and films has spurred numbers of them, such as the *Twilight* series, *World War Z*, the *Resident Evil* series, and *Pride and Prejudice and Zombies*. Public taste is notoriously fickle and astute filmmakers will keep a close eye on audience tastes and trends. Since the development process can last a year or two or more, an idea that is time-sensitive, like a political or current-events story, may be out of date by the time the film is released. Also, similar movies that get the jump on a film may reduce an audience's appetite for a certain type of film. An example is *The Giver*, based on Lois Lowry's fantasy novel. In the time it took to develop and produce the movie, other young adult dystopian movies like *The Hunger Games* and *Maze Runner* cast a shadow on the movie, making it look like another copycat.

The franchise model has become a staple in Hollywood, due to its pre-awareness, which means that distributors do not have to create awareness from nothing. There are 11 *Star Wars* movies, and additional *Star Wars Lego* movie spin-offs. The entire *Star Wars* franchise has earned box office of $7.5 billion worldwide and revenue from merchandise and licensing of upwards of $24 billion. Of paramount importance in the franchise model are comic book properties and their substantial "universe" of characters, settings, and plotlines. A cinematic universe, with substantial intellectual property of villains, heroes, alliances, locations, props, and long-running battles over multiple comic book titles written over decades with a built-in audience, is very attractive to studios. So too is the ability to cross-promote and combine them in various ways, through movies, games, TV shows, apps, and merchandise. Fox is exploiting the *X-Men*, *Fantastic Four*, and *Deadpool*, Disney owns the profitable Marvel Universe of comic properties, while Universal owns and exploits DC Comics, and the recent Netflix acquisition of comic book publisher Millarworld indicates there will be a steady stream of comics-based franchise films and related content. The mere development of a comic book property into a movie does not guarantee success, and typically comes at a high price, due to the substantial investment, illustrated by expensive failures such as *The Mummy*, one of Universal's Dark Universe of monster-themed movies to feature classic monsters such as Frankenstein, the Wolf Man, the Creature from the Black Lagoon, the Hunchback of Notre Dame, and the Invisible Man. These films tend to do well internationally, where movie-star appeal is critical and bigger-scale movies are impactful.

A franchise film creates opportunities to leverage a movie into other media and forms of entertainment, such as video games, toys, clothing, music products, and amusement park rides, and successful franchise movies can generate

multiple sequels. Recent franchise installments, like *Spider-Man*, *Harry Potter*, and *Pirates of the Caribbean*, targeting children and teen audiences, also lend themselves to lucrative co-marketing efforts that strengthen advertising for the film, such as deals with companies like McDonald's and Coca-Cola.

Inside the studio, development executives spearhead the development process, seeking development material for the studio. With an in-depth understanding of talent, audience tastes, international film markets, and great contacts, these high-pressure positions often have high turnover, and are decreasing in number as the studios release fewer films over time. These positions are the result of the long climb inside agencies and studios from internship, to assistant junior executive and, working up the ladder, development executives are ultimately the few who decide what movies end up on the big screen.

As the DVD market shrinks, and digital alternatives steal consumers' attention away from traditional media like movies, studios must rein in spending and reduce overhead; typically by cutting staff and making fewer movies, resulting in fewer executives making increasingly high-risk decisions.

Building a Package

The ultimate purpose of development, of course, is to attract financing and to get the film produced. Financing will depend in part on a producer's experience in the industry, but a critical component is the strength of the producer's package, an assemblage of most or all of the elements necessary to "green-light" or approve the project and the financing to begin production.

To create a complete development package, a producer or studio development executive must acquire a script or a story idea or the legal rights to a literary or other property; hire a writer to transform it (the book, idea, and so on) into a script; prepare a budget for the film based on the script; and attach a director, and one or two main actors to the project.

A Script Is the Foundation of a Film. A producer may develop a completed script she has optioned or acquired from a writer (called a **spec** script, written on speculation), or hire a writer to create a script based on an idea or property owned by the producer.

An idea for a film may first be presented in the form of an outline, then a **treatment**, which is a narrative prose version of the film story, from 3 to 30 pages long, before taking shape as a completed screenplay.

Once a producer has evaluated and chosen the literary property or screenplay he or she wants to make into a film, development begins in earnest, and the theatrical motion-picture rights for the property or script must be legally secured.

Controlling the Script or Property

Negotiations for a screenplay or the rights to a literary property take place between a producer and the writer or owner of the property, or his or her agent,

resulting in a contract often called a Literary Property Agreement, specifying the terms of the transfer of rights from one party to the other. There are two ways a producer can acquire a script. She may purchase or option a completed script or hire a screenwriter to write a script based on an idea or concept or another literary or dramatic work.

The ease or difficulty, and cost, of buying a completed script depends on the status of the screenwriter. A script from an established writer with many credits, hits, and awards, will attract the attention of the studios and go for a high price. A successful writer is also likely to be represented by a major talent agency, which will take the script directly to the studios. A script from a less established writer will be more accessible to an independent producer and will be available at a lower price. Acquisition prices for a completed script can range anywhere from a few thousand to several millions of dollars.

From a legal standpoint, when a writer pens an original script, it is protected by copyright laws as a work created by the author. The copyright is owned by the writer.

When a writer is hired and paid to create a script based on an idea or property owned by the producer, that is called a "work for hire" and the producer owns the copyright. It is common in such deals for the writer to draft a treatment or outline. If the producer is satisfied with the treatment, the writer will then go on to complete the script.

When acquiring a completed script or the rights to another work, a producer should seek to obtain maximum exploitation rights in the property, such as sequel, prequel, and remake rights, theatrical stage production rights (both dramatic and musical), television movies and series rights, and video game rights. Examples of the value of such rights include the development of the Oscar™-winning movie *Fargo* into an Emmy award-winning television show of the same name, in its third season; *The Producers*, made as a film in 1968, adapted into a hugely successful Broadway musical in 2001, and then made as a movie again in 2005; the 2003 movie *School of Rock* which became a successful musical on Broadway in 2015; and *Justice League*—a video game based on the popular Warner Bros. movie franchise.

In addition to format rights, the studio or producer will seek to acquire the widest possible distribution rights, including the right to exploit the film in as many territories around the world as possible, and in all media, including all forms of television, home delivery systems, internet delivery and IPTV systems, and any methods or formats developed in the future. The producer should also negotiate for the maximum period of exploitation, up to perpetuity.

The Decision to Option or Purchase a Script or Other Work. Studios almost always purchase, rather than option, scripts or other works. Competitive, auction-type bidding on hot scripts has raised studio script prices over the years, with some spec prices in the millions, such as the historical thriller spec *Section 6*, by Aaron Berg, sold to Universal in 2013 for $1.2 million,[15] and the sale of Lisa Joy's *Reminiscence* by Legendary Pictures in 2013 for $1.75 million.[16]

Not every expensive script makes a hit movie, as illustrated by the acclaimed screenwriter Ron Bass's script *Mozart and the Whale*, a love story about a man with Asperger's syndrome, which was sold for $2.75 million, while the film only grossed $88,000.[17]

An independent producer may not be able to afford to outright purchase a script or the rights to another work outright, or may choose not to invest the capital required. An alternative is to option the script or the rights.

An option is a cost-effective means for a producer to develop a property. Under a typical option agreement, a producer will pay an option price, usually no more than 5 percent of the agreed purchase price for the property, to obtain the exclusive right for a period of time to develop and produce a film from the script or other work. The term of the option will generally run one to two years. At the end of the option term, the producer must either exercise the option, purchasing the script or property outright, or extend the option term for an additional period. The advantage of an option is that a producer pays less upfront for the exclusive right to develop the work for a period of time, enabling underfunded independent producers to compete in acquiring scripts and properties.

For instance, if a movie was budgeted at $5 million, the script purchase price would be approximately 3 percent of that, equaling $150,000. An option price is calculated at 5 percent of the total purchase price, so 5 percent of the purchase price of $150,000 would equal $7,500 to be paid upfront. Prior to the end of the option term, say two years, the remaining balance must be paid.

However, if the script or property is not developed and financed within the option term, and the rights revert to the owner, then any investment by the producer in the option, or in development, such as the cost of having a script written, will be lost. Also, if the producer loses the rights to the underlying work she may not produce a film from a script written during the option period that becomes, in the parlance of the business, a "dead" script.

When a studio drops a project, but still retains the underlying rights, the project enters a state of limbo known as turnaround. The producer is usually given the opportunity to take her project to another studio, but must compensate the original studio for any development costs if a film is produced.

Script Format. A typical script has three acts, and is 90–120 pages long, with one page equaling one minute of screen time. The writing is formatted to highlight characters, their dialogue, and important visual and audio material, using shorthand terms such as EXT. for exterior, and INT. for interior, centering dialogue, and capitalizing key terms to make them stand out.

The writing phase of a development project may start with an outline, then progress to a "treatment," and then to a first draft of a script, followed by a second draft, and final draft. Most movie scripts go through several rewrites before a final shooting script is ready.

An outline consists of the main plot points in outline format. A treatment is a written narrative of a film's story, written in a prose style like a book that is easier to read than the stylized format of a script. While a treatment is not always

2.

```
INT. MESSY APARTMENT - KITCHEN - NIGHT

Krissy eats a sandwich in one hand, pouring coffee in a
travel mug with the other.

A cell phone resting on the counter RINGS.

                    KRISSY
          Hello?
               (beat)
          Hi mom! Today was so busy, I'm
          sorry I didn't call you back.
               (listening)
          An infection? You're kidding.
               (beat)
          Of course I'd love to hear all
          about it.

Krissy finishes her sandwich.

                    KRISSY (CONTD)
          No. From the gall bladder into the
          spleen?
               (chewing)
          I thought that's where the kidneys
          lived.
               (beat)
          Sorry mom, but I'm late.
               (beat)
          For the second job. I know, I know.
          Love you too!

EXT. OFFICE BUILDING - NIGHT

Rundown office complex in creaky Edgewater, New Jersey,
KRISSY, drives into the lot, narrowly avoiding an oncoming
car.

She pulls car into one of many parking spaces.

INT. OLD CAR - OFFICE BUILDING - NIGHT

Upset by the near miss, Krissy turns off the car. She
retrieves a backpack, gathering a cup of coffee.

                    KRISSY
          Jerk nearly killed me!

From the depths of the car, her cell phone RINGS.

                    KRISSY (CONT'D) (CONTD)
          I'm already late!
```

Figure 3.2 Script Page Format.

necessary, it can serve as a tool for defining story and character issues, and also to attract initial interest in the project from talent and potential financial backers.

The Writers Guild. The Writers Guild of America (WGA) is a craft guild for film and television writers. The guild sets work and credits rules, establishes pay scales, lobbies on behalf of its members, and arbitrates disputes over credits. Guild agreements with producers and the studios, which are renegotiated every few years, set minimum pay scales for the work of its members, and require contributions by a producer or studio for pension and health benefits for the writer. WGA rates correspond to the film's projected budget, and the scope of work and type of project. For example, the WGA theatrical minimum for the period 5/2/16–5/1/17[18] for the sale or purchase of an original screenplay range from $47,862 minimum for a low-budget movie (under $5 million) and begin at $97,978 for a high budget film. Rates for a treatment and original screenplay are as follows:

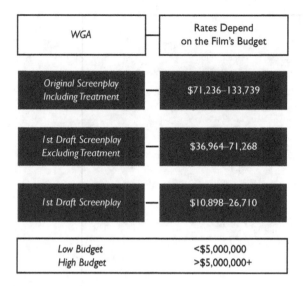

Figure 3.3 Sample WGA Rates.

Protecting a Movie Before it is Made

While a mere idea cannot be copyrighted, the expression of an idea—a screenplay outline, or treatment, and a screenplay itself—can be protected against plagiarism, or outright theft, by establishing the existence of the expression of the idea, in whatever form, at an earlier date than any infringing document or work. An easy way to do that is to register a property online with the Copyright office (copyright.gov). Another way to do that is for a writer or producer to register each iteration and version of the project—outline, treatment, script—with the Writers Guild of America (as of this writing, the registration cost is $20 for non-members and $10 for members) to document ownership and existence as of a certain date.

In the United States, copyright is secured automatically as soon as a work is created,[19] and while the use of a copyright notice is not required, it is customary to indicate copyright on the screenplay title page, in the following format: "TITLE OF WORK © 2018 AUTHOR NAME." Copyright protection for a film made from a script lasts for the duration of the author's life plus an additional 70 years, for works created after January 1, 1978. For works-for-hire or corporate authorship (when a studio or production company hires a writer), the duration of copyright is 95 years from publication or 120 years from creation, whichever is shorter. In general, copyright registration is a legal formality intended to create a public record for legal protection in case of a breach in copyright.[20] Once the copyright expires, a work falls into the public domain and may be used for any

purpose. It is important to note that copyright laws vary from one country to another. The US Copyright Office FORM PA is used to protect a screenplay and the registration fees are $35 per application.[21]

To avoid a legal dispute, a producer may do a copyright search or WGA search to clarify ownership. If the property was never registered with the Copyright Office or the WGA, he or she may also obtain Errors and Omissions Insurance, to protect the producer from claims of copyright infringement.

A movie title itself cannot be copyrighted, but it may be protected under trademark and unfair competition laws. To protect a title, a producer should retain a law firm that specializes in title reports to research similar titles. A film title can be protected by having it registered with the MPAA's Title Registration Bureau.[22]

Attaching Key Players/Name Value

A critical step in creating a development package is attaching a director, and a star or name actor to the project. Since almost all directors and actors have agents, managers, and lawyers, getting material through these intermediaries to the talent can be difficult. If possible, it is preferable to get a script directly to a director or actor before running the gauntlet of her or his representatives. Top directors and actors are in high demand, but the bigger the star or director attached to a project, the better the chances for securing financing and distribution.

The types of deals made with talent or a director during development vary, and are complicated by the "ticking clock." If a producer succeeds in attaching an actor to a project before it is financed, the actor's commitment will usually be for a limited period of time, and if financing is not raised within that time, then the actor will go on to another project. The same is true with a director.

The importance of name recognition in the film industry cannot be overstated, whether it is in Hollywood circles, where the bigger names add cachet to a project, or in the independent sector, where potential investors or distributors will want to know "who's in your movie." Attaching an established director to a project can be a good first step, since a well-known director will help attract experienced, and possibly bankable, actors.

Once a producer has attracted the interest of a director or actor to a development project, she must at least attach the talent to the project in a way that will allow her to represent to investors or distributors that the director or actor is involved. The least complicated and most inexpensive way to do that is to obtain a "letter of intent," which indicates that the director or actor is willing to do the film if he or she is available when production starts. A stronger form of attachment is an agreement such as a "letter of commitment" that commits the actor or director to do the film if production starts by a certain date. This arrangement will, however, usually require payment of a "holding fee" to the actor or director, which can range from a few thousand dollars to a five- or six-figure

payment, depending on the prominence or star power of the talent. The holding period will usually be short; no more than a month or two. This sort of deal is very risky for a producer.

It is even riskier for an independent producer to sign a performance contract with an actor or director before the producer has locked in her financing for the film. Such contracts, which fully commit the talent to deliver his or her services, usually will include a "pay or play" clause, requiring payment of the talent's full fee even if the film is never produced or if production doesn't start by a certain date. Unless the financing is in place, an independent producer almost always will, and should, avoid signing such a deal.

The studios, of course, have no such problem and simply sign talent to a project once it has been green-lighted.

Credits are often used as a bargaining tool in Hollywood, and can be a powerful incentive for talent to commit to a development project. For movie professionals, credits are a statement of the role and status of a creative artist or producer both within the industry and among the public. Actors, in particular, are often eager to spread their wings and move into a producing role. There are no limits to the number of producer credits that can be awarded on a movie, and a producer may offer a producer credit to an actor, director, or writer to induce him or her to work on the project, or to take a fee lower than his or her usual "ask." Many independent films employ this strategy to attract talent and keep budgets down. Deferred pay and a percentage of the profits of a film are other inducements a producer may use to attract actors or directors and to negotiate a lower fee. Dealing with agents can be difficult for a relatively unknown independent producer. An agent will usually insist on verifying the financing for a project, so as not to waste their client's time. Certain actors will not even read a script unless money is deposited in a bank account, as proof that the producer has the money to move forward on the film. If the project has caught the interest of the talent, usually for artistic reasons, then he or she might agree to go forward without the usual guarantees and protection sought by agents and managers, although this is the exception.

In the development and packaging process, as in business generally, leverage in the form of the relative power of the parties to a deal makes all the difference. An unknown producer approaching well-known talent is at a disadvantage. An unknown screenwriter approaching a well-known producer must be willing to make concessions to get his or her project produced, while a producer, even if not well known or established, with a hot script that everyone wants to buy, has the leverage. The studios undeniably have leverage over most talent and producers, except in the case of megastars like Michael Bay, Jerry Bruckheimer, Steven Spielberg, Clint Eastwood, Tom Hanks, and the like. Whatever they want, they will usually get.

Creating a Budget

Creation of a budget is a crucial step in the development process. A budget consists of two sections: the "above-the-line," which includes creative costs, story acquisition and script costs, and the salaries of the producer, director, and principal actors; and the "below-the-line," which is the physical cost of making the film, such as location costs, sets, equipment, costumes, crew, insurance, and so forth.

Although the above-the-line portion of the budget cannot be determined until the director and talent are hired, a line producer or production manager can estimate the below-the-line costs once there is a completed script. As a rule of thumb, the below-the-line portion of the budget should represent roughly 60–70 percent of the total cost of the movie. This rough rule serves as a benchmark to indicate whether a budget is within normal parameters.

If an expensive star is attached to a film, that will affect the budget, and tip the balance between above- and below-the-line closer to 50–50. Stars increase the above-the-line budget directly, but they will also increase the below-the-line due to the additional personnel and equipment usually demanded by them or their agents: an entourage, a chef, a personal trainer, and more lavish accommodations. Also, an expensive star at the top of the budget will tend to pull up the demands of other cast members and key crew; a "rising tide that lifts all costs" phenomenon. Theoretically, it is worth the money to attach the star since he or she carries the film's profitability on his or her shoulders; however, costs can easily spiral out of control.

Film budgets are comprised of a top sheet summarizing the major categories of expenses.

A complete detailed budget documents the hundreds of line items organized by the various units.

Budgets are complex and time consuming to create. There is specialty software for film budgeting (Movie Magic Budgeting is the most popular), and it requires a detailed knowledge of union rules and contracts, insurance rates, and employment and industry details from craft services to postproduction. A producer may create her own budget, but will rely on a line producer to insure its accuracy, someone who keeps abreast of insurance rates, payroll fees, and changes in guild and union wage rates.

Studio Versus Indie

The difference in the development process between the studios, and online players like Netflix and Amazon as opposed to independent producers, is one of scale, resources, and access to material and projects. Since the theatrical market drives the profitability of a movie for all the other windows of distribution (DVD, TV, internet, foreign, and ancillary markets), studios must release a certain number of films into the theaters each year. This requires the studios to

FILM TITLE		Date
Producer		Format
Director		Length
Line Producer		Locations

Acct No.	Category Description	Page	Total
1100	Screenplay	1	$25
1200	Producers	1	0
1300	Directors	1	100
1400	Cast	1	175
	TOTAL ABOVE THE LINE		**300**
2100	Production Staff	2	125
2200	Extras	2	25
2300	Sets	2	350
2400	Props	3	50
2500	Costumes	3	175
2600	Makeup & Hair	3	200
2700	Electrical	4	1,500
2800	Camera	4	350
2900	Sound	4	350
3000	Film/Video Stock	5	100
3100	Locations/Catering/Transport	5	400
	TOTAL BTL PRODUCTION		**3,625**
4000	Editing	6	2,500
4100	Sound & Music	6	150
4200	Lab & Duplication	6	3,500
	TOTAL BTL POST		**6,150**
5000	Insurance	7	2,500
5200	Legal	7	175
5300	Publicity	7	2,500
5400	General & Administative	7	350
	TOTAL BTL OTHER		**5,525**
	Total Above the Line		$300
	Production		3,625
	+ Post		6,150
	+ Other		5,525
	= Total Below the Line		15,300
	Above the Line + Below the Line =		15,600
	+ Contingency (10% of ATL + BTL) =		1,560
	= GRAND TOTAL		**$17,160**

Figure 3.4 Budget Top Sheet.

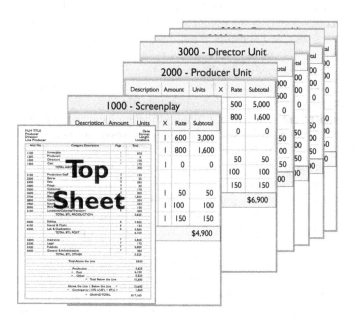

Figure 3.5 Budget Layers.

maintain constant and intense development activity both internally and externally through independent production companies, and ensures that the studios will be the first stop for agents, writers, directors, and other sources of film projects and ideas. Independent producers travel in the wake of the studios, with fewer resources and less access to the best ideas and projects.

Nevertheless, independent producers and production companies continually seek product for development, often relying on submissions from writers and agents, and they are always on the lookout for material that has escaped the eye of the studios or that is offbeat or different from the product that usually attracts the studios. Certain independent production companies, as well as established actors, writers, directors, and producers, maintain established relationships between their company with studios (known as first-look, housekeeping, or development deals) that give them an edge in attracting projects and getting their films made. The advantage of a first-look agreement for a studio is the opportunity to develop or finance projects of those successful companies or talent before anyone else. These deals are generally only possible for established and experienced producers or talent with successful track records, for example like Amazon with producer Christine Vachon, Margot Robbie with Warner Bros., Amy Pascal with Sony, Universal with Elizabeth Banks, Tina Fey with Universal.[23] If a studio passes on a project pitched inside a first-look deal, the production company is free to take it to another studio. The studio supplies some combination of an office, support staff, and funding to acquire scripts and

properties, as an advance against future profits, in exchange for the right of first refusal to any project developed by the producer. Due to funding, shifting management, box-office success, and audience taste, these deals change frequently, tracked in *Variety* magazine's column "Facts on Pacts."

Development deals are expensive for the studios to maintain, and are often scaled back during economic downturns. In return for funding the development of a film under such an arrangement, the studio owns the film.

As noted, independent producers with a studio affiliation have an edge over other independents. A producer with such a deal may, however, develop many projects without any being green-lighted for production. Waiting for the financial commitment or "green-light," while enduring shifts in ownership and management and changes in the script demanded by studio executives, can create a frustrating situation for independent producers. A film project in this sort of "development hell" for an extended period may ultimately be put into "turnaround," essentially abandoned by the studio at which point the producer can take it elsewhere.

The studios, by virtue of their substantial resources and relationships with talent and literary agents, have the best material submitted to them first, although well-financed independents like Annapurna Pictures or A21 also attract good material. Independent companies without a studio relationship often receive development material that has already been rejected by the studios (such as *Twilight*, which was rejected by MTV, then Paramount, ultimately released in 2008 by Summit Entertainment[24]). Another difficulty for independent producers is holding together all of the elements in a development package for the time needed to raise financing. Agreements with actors and directors almost always have outside dates by which production must start, or the talent is released from his or her obligation.

A producer working on a studio-developed film will earn a sizable producer's fee, and some of the profits, if any, but the studio that funded the movie's development and production will own the film. A producer who can self-finance development without funding from a studio has a good chance to retain an ownership interest in the film.

A downside to studio film development is that decisions pertaining to a movie's development and financing are often made by committee, which is antithetical to the creative process of filmmaking. This practice has been reinforced by the risk-averse corporate mentality of the studio environment today, and contributes to a plethora of movies criticized as formulaic, bland, safe, and vehicles primarily for advertising.

The relationship between studios and independent producers is one of interdependence. The studios rely on independent producers to round out their slate of films, and provide them with films at a lower cost than movies the studios themselves can produce. Independent producers need the studios to distribute their films and to provide some or all of the financing.

DIY Filmmaking

With the prevalence and availability of affordable digital film equipment, filmmakers of all kinds are taking matters into their own hands and making their own do-it-yourself movies, promoting the idea that anyone is capable of making a film. The development process for a DIY project bypasses the traditional movie professionals, encouraging filmmakers to martial their own resources, eschew agents, managers, star actors, entertainment unions generally, and take the process into their own hands.

DIY doesn't preclude the use of skilled technicians in production, but rather embodies the spirit of a can-do attitude applied to all aspects of filmmaking. The do-it-yourself process of film development may utilize anything from working with friends and family, to finding resources via posts on social media, Craigslist, and elsewhere. The movement is empowering and keeps filmmakers working on projects in spite of commercial pressure, lack of distributor or funding, in order to produce and create movies against all odds. These are typically microbudget films, self-financed, or utilizing crowdfunding.

There are several platforms where independent producers can find scripts of every genre, such as Simply Scripts, The Blacklist, or InkTip. The producer can deal directly with the writer to make the deal for the project. Filmmakers can find filmmaking deal memos and contracts online, then cast their star, not from Hollywood necessarily, but from social media fame. DIY filmmakers cast celebrity video bloggers from Vine, YouTube, Instagram, or Facebook, for a character who will bring their own following and can help sell a movie. Some of the top online stars have millions of followers and views. Successes in the DIY space who have gone on to inspire movie makers from humble first features made through sheer resourcefulness, include Robert Rodriguez (*El Mariachi*), Richard Linklater (*Slackers*), Kevin Smith (*Clerks*), Sean Baker (*Tangerine*), and Oren Peli (*Paranormal Activity*).

Notes

1. Dodd, Christopher J. *Theatrical Market Statistics 2016*, Motion Picture Association of America, Inc. p. 4. Retrieved February 22, 2018 from www.mpaa.org/wp-content/uploads/2017/03/MPAA-Theatrical-Market-Statistics-2016_Final.pdf.
2. Pisano, Gary P. and Allison Berkley Wagonfeld. (2004) *Pacific Coast Studios*. Boston, MA: Harvard Business School Publishing, p. 8.
3. The Numbers. (n.d.) Nash Information Services, LLC. Retrieved July 2, 2017 from www.The-Numbers.com and www.the-numbers.com/movie/Snow-White-and-the-Huntsman#tab=summary; www.the-numbers.com/movie/Mirror-Mirror#tab=more.
4. Boone, John. (2014, June 6) "Movies that Came out at the Same Time and Are Basically the Same Movie," *E News*. Retrieved on June, 13, 2017 from www.eonline.com/uk/news/551562/26-movies-that-came-out-at-the-same-time-and-are-basically-the-same-movie.
5. Murray, Rebecca. (2006, August 22) "Exclusive Interview with *Half Nelson* Writer/Director Ryan Fleck: Ryan Fleck Discusses His Critically Acclaimed Film, *Half*

Nelson," *About.com* online. Retrieved July 24, 2008 from http://movies.about.com/od/halfnelson/a/halfnelson82206.htm.

6. Kaufman, Debra. (2009, September 9) "Director Shane Acker on *9,*" *Studio Daily.* Retrieved July 2, 2017 from www.studiodaily.com/2009/09/director-shane-acker-on-9/.

7. Balio, Tino. (n.d.) "Diller, Barry: U.S. Media Executive." Retrieved July 16, 2007 from www.museum.tv/archives/etv/D/htmlD/dillerbarry/dillerbarry.htm.

8. IMDb. (n.d.) IMDb.com, Inc. Retrieved July 21, 2017 from www.imdb.com/title/tt1132623/combined.

9. Del Ray, Jason and Rani Molla. (2017, July 9) "Amazon Prime Is on Pace to Become More Popular than Cable TV," *Recode.* Retrieved August 13, 2017 from www.recode.net/2017/7/9/15938658/amazon-prime-numbers-members-us-households-cable-tv.

10. Wasko, Janet. (2003) *How Hollywood Works.* Thousand Oaks, CA: Sage Publications, p. 15.

11. Rottenberg, Josh. (2016, February 21) "Ryan Reynolds on Putting Blood, Sweat and 10 Years of his Life into 'Deadpool'," *LA Times.* Retrieved June 15, 2017 from www.latimes.com/entertainment/herocomplex/la-et-hc-ryan-reynolds-deadpool-20160209-story.html.

12. Kit, Borys and Tatiana Siegel. (2016, April 14) "Will Ferrell Pitch Lands at Universal in 7-Figure Deal," *Hollywood Reporter.* Retrieved August 1, 2017 from www.hollywoodreporter.com/news/will-ferrell-pitch-lands-at-884148.

13. Acuna, Kirsten. (2014, February 6) "13 Movies that Bombed in the US but Were Huge Hits Overseas in 2013," *Business Insider.* Retrieved June 14, 2017 from www.businessinsider.com/movies-with-most-overseas-revenue-share-2014-2.

14. IMDb (n.d.) IMDb.com, Inc. Retrieved July 11, 2017 from ttp://www.boxofficemojo.com/alltime/world/?pagenum=1&sort=year&order=DESC&p=.htm.

15. Sneider, Jeff. (2013, October 12) "Universal Wins Heated $1.2 Million Bidding War for Spy Spec Script 'Section 6'," *The Wrap.* Retrieved July 3, 2016 from www.thewrap.com/universal-wins-heated-bidding-war-spy-spec-script-section-6/.

16. Graser, Marc. (2013, October 14) "Legendary Buys Lisa Joy Spec Script 'Reminiscence' in Bidding War," *Variety.* Retrieved July 24, 2017 from http://variety.com/2013/film/news/legendary-buys-lisa-joy-spec-script-reminiscence-in-bidding-war-exclusive-1200724859/.

17. We Screenplay. (2017, May 17) "The Most Expensive Spec Scripts of All Time." Retrieved July 6, 2017 from www.wescreenplay.com/blog/post/the-most-expensive-screenplays-ever-sold.

18. WGA. (2014) Writers Guild Of America. "WGA 2014 Theatrical and Television Basic Agreement—Theatrical Compensation," SCHEDULE OF MINIMUMS. REVISED AS OF MAY 2, 2016, WGA. p. 1.

19. US Copyright Office. (2006, July) Copyright Office Basics. Retrieved August 3, 2007 from www.copyright.gov/circs/circ1.html#hsc.

20. Ibid. A work that was created (fixed in tangible form for the first time) on or after January 1, 1978, is automatically protected from the moment of its creation and is ordinarily given a term enduring for the author's life plus an additional 70 years after the author's death. For works made for hire, and for anonymous and pseudonymous works (unless the author's identity is revealed in Copyright Office records), the duration of copyright will be 95 years from publication or 120 years from creation, whichever is shorter. Works originally created before January 1, 1978, but not published or registered by that date are automatically brought under the statute and given federal copyright protection. The duration of copyright in these works is generally computed in the same way as for works created on or after January 1, 1978: the

life-plus-70 or 95/120-year terms apply to them as well. The law provides that in no case would the term of copyright for works in this category expire before December 31, 2002, and for works published on or before December 31, 2002, the term of copyright will not expire before December 31, 2047. Works originally created and published or registered before January 1, 1978: Under the law in effect before 1978, copyright was secured either on the date a work was published with a copyright notice or on the date of registration if the work was registered in unpublished form. In either case, the copyright endured for a first term of 28 years from the date it was secured. During the last (28th) year of the first term, the copyright was eligible for renewal. The Copyright Act of 1976 extended the renewal term from 28 to 47 years for copyrights that were subsisting on January 1, 1978, or for pre-1978 copyrights restored under the Uruguay Round Agreements Act (URAA), making these works eligible for a total term of protection of 75 years. Public Law 105–298, enacted on October 27, 1998, further extended the renewal term of copyrights still subsisting on that date by an additional 20 years, providing for a renewal term of 67 years and a total term of protection of 95 years.

21. US Copyright Office. (2006, July) Copyright Office Basics. Retrieved August 3, 2007 from www.copyright.gov/circs/circ1.html#hsc.
22. Litwak, Mark. (2003) "Entertainment Law Resources. Frequently Asked Questions: Titles." Retrieved October 15, 2007 from www.marklitwak.com/faq/titles.html.
23. Conradt, Stacy. (2016, April 30) "8 Hit Movies that Were Originally Rejected by Studios," *Mental Floss*. Retrieved September 1, 2017 from http://mentalfloss.com/article/79197/8-hit-movies-were-originally-rejected-studios.
24. McNary, Dave. (2016, April 30) "Facts on Pacts," *Variety*. Retrieved June 23, 2017 from http://variety.com/2016/film/news/studio-producers-deals-1201736686/.

Chapter 4

Movie Financing

Film is an expensive art form and the development, production, and distribution of commercial motion pictures requires significant amounts of capital. The major studios and large independent production companies, such as Lionsgate and MGM, can raise capital at the corporate level, through the public or private equity and debt markets, or by offering investors economic interests in a slate of films. Independent producers must essentially finance films one at a time, primarily from private equity investors or lenders, or by licensing distribution rights in advance of production and borrowing against these licenses. As noted in Chapter 2, a number of new companies formed by extremely wealthy individuals have emerged in the past decade, and these companies finance their films from the personal wealth of the owners.

In this chapter we will explore the various financing techniques and strategies employed by the studios and independents, and consider how changes in the distribution structure of the business, driven and shaped by new technologies, has affected, and will have an impact on, the financial architecture that has prevailed in the industry in recent decades.

Film financing is inherently risky and, necessarily, financing a single film is riskier than financing a slate or group of films. This reality makes it easier for the studios or large independent production companies to finance films than independents. Also, all of the studios are now divisions of large media companies, so an investment in the larger corporate enterprise further reduces the risk of depending on the success of a particular film or group of films. Plus, the studios all have significant film and television libraries constituting a large asset base and cash-flow generator, which supports balance-sheet debt financing. Funding for short movies must primarily be financed by grants and private money since there is no market or studio interest involved.

As a product, a film cannot be realistically "market tested" before it is made, and while attempts may be made to reduce risk—producing sequels of hit films, casting big stars—there are no sure bets. A film faces risk at every juncture. During development the odds are against a film getting financed at all. Once financed, films face completion risks[1] and problems during production can drive up the budget and cause delays, thus jeopardizing distribution plans. Once

released into the marketplace, films face performance risks—the quality of the completed film, the effectiveness of its marketing campaign, receptivity from audiences—which may result in far less revenue than originally forecast. Even for a commercially successful film there is no guarantee that investors will fully recoup or see a profit.

Corporate Financing

The major studios, as divisions of large conglomerates, utilize funding provided by their parent companies. Also, the studios have a wide variety of external financing options available to them, due to their size, asset base in the form of large film libraries, and large-scale distribution operations that spread risk across many films. Larger independent production and distribution companies, such as Lionsgate and Summit, that share some of these attributes, may also raise capital from similar sources.

Film companies raise capital in the form of debt or equity in the corporate enterprise, licensing distribution rights, securitizing economic interests in films, and accessing governmental subsidies ("soft money"). All film financing is a variation on one or more of these financing techniques.

Balance-Sheet Financing: Equity and Debt

Equity Financing. Film companies may raise capital through the sale of equity in the public or private markets. The major studios, as noted, are now divisions of larger publicly traded parent companies, and funding for movie production and distribution is either internally generated from the film division's cash flow or funded by the parent company, which itself may raise additional equity through the sale of shares. Capital can also be raised in the private equity markets, sometimes in significant amounts.

Few film production/distribution companies are publicly traded. The movie business is perceived as risky, and historically has generated a relatively low return on invested capital. There have been periods, however, when the movie business has caught the public's fancy and companies have been able to ride that interest to raise money in the public markets. These periods are usually marked by a new technology that holds the promise of substantially increasing revenues from film distribution. The last such period was in the early to mid-1980s, when annual revenues from home video were growing at double-digit rates. It was also a time when the stock markets generally were "hot." That combination led to a spate of film company public offerings: De Laurentiis Entertainment Group, Nelson Entertainment, Vestron, and Weintraub Entertainment. For different reasons, almost all of these companies failed, wiping out shareholder equity and, in some cases, debt. When similar technology-driven revenue growth occurred in the late 1990s and early 2000s with the advent of DVDs, the ill will on Wall Street from the debacle of the 1980s may have been a factor in the lack of a

similar surge of public offerings in the movie industry. More recent technological developments, such as internet-based distribution platforms, have been perceived as disruptive to the standard film business model, and, if anything, have put that model at risk.

Debt Financing. The major studios and larger independents, particularly those with film and TV libraries, can also borrow money at the corporate level, so-called "balance sheet" borrowing, for movie production. Under these arrangements the lender—a bank, insurance company, pension fund, or individual lenders who purchase corporate notes or bonds—is lending to the company, not against individual films or even a slate of films. The source of repayment of the loan is the company itself, backed by its asset base and revenue streams, independent of the performance of the films produced with the borrowers' funds. The structure of this type of borrowing is often a line of credit that can be drawn down by the company when needed.

Entertainment Banks

All of the major domestic and international banks are lenders to the major studios or their parent companies. There are a number of other banks that have carved out a niche in the entertainment sector and will lend to smaller companies or to finance individual films or groups of films. These include Comerica, First Republic Bank, Union Bank of California, FilmBankers International, Société Générale, and Israel Discount Bank.

The terms of any loan are, of course, a function of the risk to the lender. The majors or their parent companies, with strong balance sheets, will pay relatively low rates of interest, probably in the range of 100–200 "basis points" (1–2 percent) over the prevailing prime or LIBOR rates, while smaller borrowers and independent producers will pay much higher rates, and additional placement fees and costs.

Coproduction Deals

The term "coproduction financing" covers a wide range of film financing arrangements that involve a sharing of the production cost of a movie between two or more companies. Examples include two major studios splitting the cost of a film, as with *Titanic*, or cost-sharing between a US distributor and one or more foreign distributors, as with *The Da Vinci Code*. The coproduction strategy is a tool for managing risk and is usually employed with big-budget films, with a distributor willing to reduce some of its downside risk in exchange for a share of the upside if the film is successful. Most coproduction deals involve a split of the distribution rights between the funding partners, either along territorial lines or by media.

There has been a rise of Hollywood and Chinese slate deals in the past three years, partnerships between Hollywood players for multiple films. Examples

include a deal between Universal and Perfect World to co-finance 50 films for $250 million, and $1 billion deals, between production distribution company STX Entertainment and Chinese Huayi Brothers Media Corp, and Paramount's $1 billion deal proposed between itself and Shanghai Film Group and Huahua Media.

"Slate" Deals; Off-Balance Sheet Financing; Limited Partnerships

While the studios are able to finance film production without great difficulty and generally on favorable terms they will often utilize other strategies to raise production funding; strategies that shift risk and/or carry a lower cost of capital, or that allow the distributor to enjoy the benefits of ownership while not burdening the company's balance sheet with the cost of ownership. We will look at several of these strategies.

Slate Deals. Out of every ten films released, one or two may be profitable to investors, and it is assumed that investing in a slate of films is less risky than investing in a single film. A transaction to invest in, or lend for the production of, a group of films is characterized as a "slate" deal.

Slate debt financing from a bank or other lender, such as a private equity or hedge fund, pension fund, or insurance company, may be obtained by a major studio, or a large, established, independent distributor, subject to certain conditions, including budget limits, and a minimum level of territorial presales if the distributor/borrower is not handling all worldwide distribution. In the case of an independent distributor, the conditions for drawdown may include certain casting requirements, performance criteria on already released films, a certain level of presales, and a strong sales agent attached to each film, as well as business plans with realistic presale estimates and revenue projections. A recent example is the $1 billion slate-financing deal between Paramount and Chinese company Huahua Media in 2016.[2]

The fees that a bank or other lender will charge to finance a slate of films will depend on the creditworthiness of the borrower, the amount of financing, and the perceived risk. Interest is generally 1–3 percent above prime rate, plus fees for arranging the financing, approximately 1–3 percent of the total loan, and an additional fee for funds committed by the lender but not yet drawn down (a "stand-by" fee).

Slate debt deals may also be structured to provide so-called "mezzanine" financing. A mezzanine loan is a loan that covers a portion of the film's budget and that ranks in priority for repayment behind more "senior" debt. Mezzanine lenders tend to be private equity funds or investment banks, rather than commercial banks, and the interest rate on a mezzanine loan will be substantially higher than on the senior debt to reflect the greater risk to the lender. Interest on mezzanine debt can range from 3 to 8 percent above prime rate. Also, to further compensate for the risk, a mezzanine lender may ask for equity points or some

other participation in any profits from the film. Mezzanine debt will not cover the full budget above senior debt; there must be some equity and/or soft money below the mezzanine loan.

Slate debt financing is an alternative to a corporate "balance sheet" loan, which is repayable out of all the revenue and assets of the borrower. Since it is riskier it will, as indicated, be more expensive.

Another type of slate deal includes both equity and debt financing. This type of deal became popular in the early 2000s, and from 2002 to 2007 about $10–12 billion in financing was raised by the studios and others in the form of equity/debt slate deals. The debt portion usually comprises most of the financing in these deals. The major lenders were hedge funds and private equity funds; pools of capital raised from wealthy individuals, pension funds, family wealth managers, and the like. The slate deals were large in terms of funds raised; from $250 million to $1 billion. Examples were Legendary Pictures, Relativity Media, and Dune Capital. Many of these deals were organized and backed by large commercial banks and investment firms, which offered the deals to their major clients. Recent examples include the $250 million Universal Pictures and Chinese multimedia company Perfect World Pictures, as well as the Sony $200 million deal with Lone Star Capital and Citibank.

Given the large amounts invested, the funders were able to extract favorable terms from the studios; lower than standard distribution fees (12.5 percent versus as high as 30 percent); "corridors" of revenue where the fund would recoup a percentage of revenue greater than its profit-sharing percentage, and a right to sell back its interest in the films to the studios at some point in the future based on an independently determined value of the slate of films. Another favorable feature of such deals was that the studios treated all video and DVD revenues as income and then took a distribution fee, as opposed to including only a royalty on such sales as income to the pictures. While these deals promised returns of over 20 percent a year on the equity portion of the investments, by 2007 a number of the funds were in trouble, having financed flops like *Evan Almighty* and *Poseidon* with indications that some of the funds had seen their equity wiped out. By 2008, the pace of these equity/debt slate deals had slowed to a trickle.

For the studios, the equity/debt slate financing proved to be a multibillion-dollar bonanza, continuing the historical pattern in the industry of rich "outsider" investors getting caught up in the excitement and speculation of movies, throwing large sums of money into film production, then losing most of their investment, and leaving the film industry behind, prompting veteran producer George Lucas to call the hedge fund investors "the suckers of the moment."[3] It remains to be seen what will follow, however this model continues to be popular, seen in several of the recent deals between Hollywood and China.

Off-Balance-Sheet Financing. The films financed by equity/debt slate deals are owned by a corporate or partnership entity separate from the studios, and as such, are examples of a financing strategy called "off-balance-sheet" financing. Typically the various means by which a film company obtains financing, whether

loan or equity investment, appears on that company's balance sheet, the principal tool used by investors and banks to evaluate the creditworthiness, profitability, and strength of a corporation.

Another example of off-balance-sheet financing was a formation of a Australian subsidiary by DeLaurentiis Entertainment Group of an Australian company and the subsequent sale of 51 percent of the shares of that company to the public. This enabled the parent company (DEG) to borrow money through the Australian subsidiary to make films that the parent company would distribute worldwide while keeping the debt incurred in making these films off the balance sheet of the parent.

In an off-balance-sheet financing transaction, equity and debt capital are raised through a separate corporate or partnership vehicle in which investors other than the film company own a majority interest. The debt portion of the financing, which typically represents most of the funding, does not appear on the balance sheet of the film company, since it owns a minority interest in the newly formed entity (often called a "special purpose vehicle" or SPV), and the equity investment does not dilute the shares of the film company. The key to the value of the SPV is that while the debt and equity are "off-balance sheet," the film company controls the use of the funds and realizes the lion's share of the economic benefits derived from the funds through the structure of the distribution deal between the SPV and the company.

Using off-balance-sheet financing, then, allows a company to enjoy the economic benefits of equity and debt while maintaining a lower "debt to equity ratio," the relation between the debt of a company and its equity capital, than would be the case if the funding went directly to the company. Thus, while this strategy can be a useful tool to manage risk (transferring assets and liabilities to an SPV's balance sheet shifts the risks and tax burden associated with those assets to the SPV, and the new stand-alone entity maintains its own credit lines and financing), the SPV has also been used as a way to conceal liabilities and debts for which a company does bear risk. A film company, for example, may carry a movie produced and owned by an SPV on the film company's balance sheet as an asset for a value based on the film company's share of future revenue, which may be substantial, reflecting the company's distribution fees and recoupment rights, while none of the debt associated with the film appears on the balance sheet. Historical examples of the abuse of off-balance-sheet financing include Enron and the losses incurred by commercial and investment banks as a result of the write-down of subprime mortgages that had been off-loaded to SPVs.

Limited Partnerships. A limited partnership is a form of legal entity often used to finance a single film but also sometimes used for multiple picture financing. Investors in a limited partnership have limited liability, which means that they have no responsibility for losses of the partnership in excess of their investment, similar to shareholders in a corporation. The limited partners also have the right to their share of profits and losses of the partnership. The losses may, under

certain conditions, be used to offset a limited partner's other taxable income, creating a tax benefit for the investor, and this is a primary advantage of the limited partnership form. The creative and management control of the limited partnership is vested in the general partner who is liable for all of the debts of the partnership. At the studio level, limited partnerships are typically created for multiple films. Limited partnership financing allows the studios to extend their own cash resources while simultaneously releasing more films.

Film companies and studios used limited partnerships frequently in the 1970s and 1980s, but their popularity declined due primarily to changes in the tax law that severely limited the use of partnership losses by individual investors. Independent filmmakers still use limited partnerships to finance a single film.

Examples of limited partnership funding were the Disney Silver Screen Partnerships in the 1980s, which raised almost $1 billion. A studio can sell complete or partial ownership in the films and the structure may grant a perpetual equity ownership stake in the film to the partnership or ownership for a limited time, with a buyout by the studio at some future date, which was the structure of the Silver Screen deals, guaranteeing the investors a minimum return of their investment back after a period of years, without interest.

Film companies received production funding, while investors offset income with passive losses, attractive to those in high tax brackets. Historically the returns on these limited partnerships have not been very high,[4] and while popular in the 1980s, the shift in tax laws reduced their attractiveness to investors and entertainment companies, and limited partnerships are much less in use at the studio level. It is unlikely that the form will regain popularity for multiple-picture financing.

Picture Financing

The studios and the larger independent production companies finance single pictures out of their general corporate funds or through financing raised at the corporate level using the techniques and strategies discussed above. Independent producers generally finance films one at a time, through funding from a distributor, bank loans, equity investors, subsidy funding, or, most likely, some combination of these sources.

The major studios produce most of their films in-house, but frequently fill out their slates with films developed by independent producers, acquiring the rights to the films before, during, or after production. If a film project or idea seems promising to a studio it may "step" finance the development of the project, advancing funds to complete a script, attach a director, and start preproduction.

Independent producers, well-known actors, writers, and directors, as well as agents and managers and entertainment lawyers submit projects to the studios constantly, so there is heated competition to gain access to studio (as well as established production and distribution company) financing. New opportunities have been created by the voracious spending of cash-rich Amazon, Netflix, and

Google, and will continue with Apple's entry into the production space as they seek to produce original content, although the financial terms of the deals offered by these companies have much less upside than a traditional studio deal.

Production/Financing/Distribution Deals

For an independent producer with a single film project that she has developed or acquired, the most certain, and in many ways least complicated, way to finance her film, is to secure a development and production deal with a studio or a large independent distributor or one of the streaming companies, such as Netflix or Amazon. In exchange for development funding and full production financing if the project is green-lighted, the distributor will acquire the producer's rights to the project, copyright ownership of the film, and worldwide distribution rights. The producer will receive a development fee, a producing fee, and some continuing financial interest in the revenue or profits from the exploitation of the film.

The form of agreement used in such a deal is a "production-financing-distribution" contract, or so-called PFD or PD in the trade. The distributor will advance development funds to acquire any underlying rights, such as the film rights to a book, hire a screenwriter, attach a director and major cast, prepare budgets, and so forth. The distributor does not commit to complete the project; at any point along the line it may pull the plug and decide not to proceed. The distributor will continue to own the project; however, the producer may negotiate for "turnaround" rights (see Chapter 3).

If the film is green-lighted under a PFD, the distributor funds the full production cost. The producer will receive a pre-agreed fee and credit, and usually has a right to receive a percentage of the "net profits" from the exploitation of the film. Whether there are "net profits" will be determined based on a distribution agreement establishing the contractual rights between the distributor and producer that is part of the original PFD agreement.

As noted, a PFD with a studio distributor is the simplest and most certain way for an independent producer to get a film made. What the producer gives up in exchange is ownership of the film and the chance to make any really big money out of a successful movie, but at least the film gets made and distributed, a much less certain outcome using other financing techniques.

Negative Pickup Deals

A variation on the PFD deal is a so-called "negative pickup" deal. The difference between the two is that the producer herself finances the development of the project, including the acquisition of rights and script, and perhaps the attachment of major cast and/or director, before the distributor gets involved. If the distributor likes the project, then they will agree to acquire, or "pick up" the film, when completed to agreed specifications for an amount equal to the budgeted negative cost of the film.

The producer then will be able to arrange financing, probably through a bank loan secured by the negative pickup agreement, to produce and deliver the film. Since a "completion risk" will still exist (for example, the film goes over budget, or is not completed in accordance with the delivery requirements in the pickup agreement) the producer will likely have to arrange for a completion bond.

The advantage of a negative pickup deal to a distributor is that it does not bear any of the risks of development but still acquires worldwide distribution rights, usually in perpetuity or for a very long term. For the producer, in exchange for taking the development risk, she will likely receive a higher producing fee than under a PFD, and a larger share of profits from the film. Also if the distributor's rights are for a term less than perpetuity, at some point the rights will revert to the producer or her heirs.

Development Deals

Another form of studio-distributor financing on a picture-by-picture basis are development deals, also known as housekeeping deals; agreements between a studio and a producer or production company. They are often headed up by a prominent producer, a hot actor or director, where, in exchange for an office on the studio lot, readers and development staff, option payments, and script costs paid by the studio, any project developed by that producer or company will be owned by the studio. These types of deals are generally available only to well-established producers, actors, or directors and are often cut or eliminated during leaner economic times. Also, most of the projects developed under housekeeping deals never get produced but are trapped in development hell.

Loan Financing

While it is possible to finance the production of a movie with a loan from a bank or other lender if the producer has substantial assets he or she is willing to put up as collateral security for such a loan, or if she is willing to give a personal guarantee, such financing is highly unusual and improbable. No lender will make a loan solely on the security of an independent movie project.

What is possible is to use the assets created by the film itself—the distribution rights—to secure distribution commitments from a studio or independent distributors, and to use these commitments as collateral for a loan to make the movie.

Presales and Distribution Deals

An independent producer may develop a project and "prelicense" the distribution rights to create collateral for a loan to fund production. A prelicense or presale is a license entered into before completion of a film. In effect, this strategy entails entering into a series of negative pickup deals, each for a specific territory and/or media for a minimum guarantee or advance equal to a portion of

the film's budget. These contracts can then be aggregated and offered to a lender as collateral. Typically, a lender will not loan the full amount of the contracts but will limit the loans to about 75 percent of the face value of the contracts.

As indicated, rights may be prelicensed territory by territory, by media, that is, home video/DVD, cable, network TV, and so on. Presales are obviously riskier to the licensee/distributor than licensing a completed film and, therefore, generally carry higher distribution fees and often include an equity participation in the film to the licensee above its fees and expenses.

Financing a film through presales is difficult, particularly for first-time or unknown filmmakers. If the filmmaker has attached one or more star actors, an established writer, and a strong director, that may tip the scales in her favor. An additional challenge arises in the form of a "ticking clock"—a producer must try to find sufficient presales, or other collateral for a bank loan, or additional funding, in a timely manner to keep her cast, director, and writer committed to the project.

It is difficult to fully finance a movie with prelicense deals alone and a producer may have to find additional financing to fund the balance of the budget. Those sources include gap financing, equity, and soft money.

Gap Financing. Some banks or other lenders may loan up to 40 percent of a film's budget against the value of unsold territorial and/or media rights. This is known as gap financing since it covers a portion of the gap between prelicense deals and the estimated full value of all rights (measured by prevailing minimum guarantees or advances for such rights based on the film's budget, cost, etc.). The lender will require sales estimates on the unsold rights from a reputable sales agent that show a value of the rights equal to approximately 200 percent of the proposed gap loan. Due to the higher risk associated with gap loans than a loan against presales, the interest will be higher and the loan may also carry other fees, and in some cases, an equity "kicker."

Equity Investments—Limited Partnership and Limited Liability Company

An independent producer, like a studio or large distributor or production company, may look for equity investors in his or her film project. The major obstacle to single-picture equity financing is the lack of diversification of risk offered to the prospective investor; all of her or his eggs are in a single basket. If the movie fails to recoup its cost after all expenses, as is the case with many, if not most, independent films, there are no other possibilities for the investor to recoup or make a profit. Nevertheless, by taking advantage of the "glamour" factor that lures many investors to films, a name actor or actors, liberal use of executive producer or even producer credits, and a generous deal in terms of profit share to the equity investors, an independent producer can, in some cases, attract investors to a project. Producers must verify that equity investors are "accredited or qualified investors" according to the SEC Securities Act defined

in Regulation D, meeting annual income requirements of at least $200,000, or a minimum net worth of $1 million.

Outside of a very small budget film it is likely that the equity investment would represent only a portion of the film's budget, probably no more than 35 percent, with the balance coming from other sources such as presales, gap financing, and soft money. Having the base of equity funds will make it easier for the producer to access these other sources for the balance.

The traditional profit split in the movie industry between producers and investors has been a 50/50 arrangement, known in the trade as 50 percent to the money and 50 percent to the creative, which includes the producers. In more recent years, this has tended more to a 60/40 split in favor of the equity and, as indicated, it may take an even more generous split to attract investors. Also, equity deals in independent films usually provide that the investor gets his money back before the producer gets any of the profits. The amount of net profits to be split, if any, is usually determined on the basis of a standard industry formula for calculating net profits, with any other profit participations coming off-the-top, that is shared pro rata, between the producer and the investors.

The preferred vehicle for an equity film investment is the limited partnership (LP) or limited liability company (LLC) form previously discussed, shielding the equity investors from any potential losses beyond their investment and allowing a flow-through of losses for income tax purposes, which may be utilizable by the investor against his or her other income under certain, very limited, circumstances.

Limited-partnership interests are considered securities, and there are strict federal and state (blue sky) laws regarding fraud and complete disclosure to protect the investors.

To raise money with an LP or LLC, producers must create an offering which consists of a private placement memorandum, the LP or LLC agreement, and a questionnaire to determine that the investor is known in some way to the producer (has a preexisting relationship), and possesses the sophistication, and necessary liquidity, to withstand the risk of the investment.

Crowdfunding, Production Incentives, Soft Money

There are several influences on financing that have been growing in importance and popularity. Crowdfunding has emerged as a popular way to raise film funding, primarily for indies but also by celebrities. Soft money and production incentives increasingly influence where movies are shot and edited.

Crowdfunding

The Internet has been heralded as a means of democratizing the film industry. Filmmakers can self-distribute their films via the Internet (whether people will watch or pay to watch is another issue), and there has been an experiment with

financing films via the Internet since the early 2000s. On sites like indiemaverick. com, movieshares.com, and cinemashares.com, a producer can sell shares in independent movies. The filmmakers provide their script, budget, and poster, and investors can search for projects they like and buy a share in that film for as low as 25 dollars. An advantage of crowdfunding is that filmmakers retain creative control and equity, offering perks varying from t-shirts to producer credits in exchange for specific amounts.

Celebrities now routinely use crowdfunding campaigns to fund their films outside the studios, including Zach Braff (*Wish I Was Here*, raising $2 million), Don Cheadle (*Miles Ahead*, raising over $300,000). Part of the success of the campaign is related not only to the design and execution of the campaign, but also to how well-known the person is raising the funds and the size of their social media following. Popular platforms include Kickstarter, Indiegogo, Seed & Spark, Slated—a matchmaking site for financiers and filmmakers—Ulele, Juntobox, Pozible, and Patreon, with new ones arising all the time, like Indieboogie. Each platform takes a percentage of funds raised, and has various rules about raising the funding. Crowdfunding is often used for small and medium productions as gap financing, for example the first part of *Iron Sky* raised $1 million of its $10 million budget.

As there are more sites with competing services, some sites are expanding into online distribution, so that once the film is funded and complete, donors can then consume the movie in that platform.

An early success story was the microbudgeted movie under $100,000, limited theatrical and home-video-released documentary film, *Iraq for Sale* (2006). The filmmaker Robert Greenwald raised $200,000 to make the film, but it is important to note that he had a track record directing *Wal-Mart: The High Cost of Low Price*, which may have contributed to his ability to raise funds, through the Internet or otherwise.[5]

Crowdfunding campaigns consist of a trailer, the synopsis and logline, various perks, and updates throughout. With more crowdfunding platforms than ever, this has become a vital and competitive landscape for independents. Service-providers related to crowdfunding are numerous; filmmakers can hire PR firms and agencies that specialize in creating, marketing, and running the campaigns. With the rise in popularity of this type of fundraising the SEC has updated its rules to allow for crowdfunding not only in exchange for perks, but also as an investment, a means of selling securities—or shares in the film to the general public. The limits on how much one can invest are based on income. Up to 10 percent of a person's annual income or net worth (whichever is lesser) may be invested up to $107,000, according to the SEC website.

Production Incentives, Soft Money. The term "soft money" refers to any source of financing that does not have to be repaid, or is available in exchange for rights in the film of much lesser value than the amount of the financing. Typically soft money refers to production incentives, subsidies, rebates, or tax-advantaged investments that are made directly by, or enabled through tax laws

of, countries or governmental subdivisions, such as states in the United States, provinces in Canada, or European countries. It has been estimated that there are hundreds of different "soft money" sources for film financing available worldwide, and, while available to both studios and independents, soft money has become a crucial source of funding for the latter. Prior to 1985, tax-advantaged investment financing was available to producers and distributors in the United States, based on prevailing tax law. However, changes in the law in the early to mid-1980s closed that window. In 2004, Congress implemented a federal program (the American Jobs Creation Act) that created a new type of tax-advantaged investment in movies. Because of its complexity and limiting conditions it never became widely used, and ended in 2016.

However, while federal programs were eliminated or curtailed, beginning in the 1990s, many states began to implement subsidy or rebate programs as a way of attracting film productions. These programs, which now exist in almost all 50 states, have become a major source of financing for both studios and independents, and the programs have worked to lure productions. The rationale for these programs is that film production within a state or other locale will generate jobs, economic activity, and tax revenues that will exceed the rebate or subsidy in value.

Outside of the United States, countries and particular regions within certain countries have similar programs to bring film production to that region and to support the local film industry. A US producer would have to partner with a local producer and production company, to coproduce a film, in order to take advantage of these programs, and in most cases, the US producer could have only a minority interest and role in the production. Even China now offers 10 percent soft money incentive if a film is shot in the country.

Each state or region has very specific rules and regulations to access such funding, which can save productions up to 40 percent of their film budget in a best-case scenario. Tax credits, rebates, elimination of sales tax, permit fees, and other incentives can significantly reduce a film's production budget.

Independent producers in particular have come to count on soft money, and its availability has a great deal of influence on the location that a producer chooses to make a movie. Producers can benefit from researching the territory through the local film commission (the Association of Film Commissioners International is a good resource), who will guide the producer through the process. Knowledgeable accounting firms like JFA Production Accounting and KPMG, which have expertise in film, are also a valuable source of information.

Historically, soft money programs have tended to flourish in the years after they are introduced and then are gradually curtailed or eliminated by the government because of perceived or real abuses, or a perception that the program has served its purpose and is no longer politically justifiable. Thus, the watchword for producers would be to take advantage of these programs while they can.

Other Sources

Beside the traditional financing sources, there are other techniques that resourceful producers and production companies, including studios, can and do use to help finance films.

Product Placement. Companies will pay to have products placed in movies. It is an effective form of advertising and publicity for a range of products, such as cars, food brands, clothing lines, and so forth. Some companies may be willing to donate a product, like an automobile for use in the production, which will save the cost of buying one.

Viewers are accustomed to seeing brands in movies, and certain franchises are notorious for the amount of product placement contained in the film. The Bond movie *Spectre* is believed to have more product placements than any of the 007 series' previous movies, with 17+ brands plying their wares on screen, including a $38.6 million dollar Heineken shot.[6] It is not a stretch to say that entire films are product placement, such as *Angry Birds*, *The LEGO Batman Movie*, and *Transformers*.

Music Recording Rights Advances. If a film includes a strong original music score, it is possible to negotiate with a record company for an advance in exchange for the rights to the score.

Services Deals. Some production funding can be raised "in kind" in the form of services that are received in exchange for a deferral or contingent payment and/or an equity interest in the movie. This technique is often employed with lower-budget independent films. A typical services deal might involve a postproduction house that agrees to provide editing space and other post services for an interest in the film. Film laboratory services may also be handled in this way, as well as sound recording and editing services. Some of the cast and crew on a low-budget movie might be prepared to defer a portion of their normal wages for an interest in the film, or for later payment out of revenues to ensure that the movie does get made.

Credit for Dollars. An actor may be prepared to accept a lower fee than her "ask" price to work on a particular film that she believes will be good for her career, in exchange for a profit interest and producer or executive producer credit. Many actors aspire to become producers, and getting producer credits helps them advance that ambition. So, a "credit for fee" swap can enable a producer to get an actor he otherwise couldn't afford and to get the film made. Along similar lines, but riskier, is to entice an actor to work for a reduced fee by offering to let him direct the movie. Many actors also aspire to be directors, so this can work, but it is risky if the actor has never directed before.

The Future

Financing for films comes from multiple sources but a significant part of that funding is based on the current structure, or architecture, of film distribution, particularly the concept of exclusive exploitation windows and territorial rights.

As will be discussed in Chapter 6 on distribution, new technologies have altered and undermined the distribution architecture. The Internet and OTT technologies give filmmakers the ability to sell their films directly to the consumer, bypassing the traditional gatekeepers; film studios, distributors, television broadcasters, and home video and DVD distributors. But it is precisely in exchange for the exploitation exclusivity that accompanies this gatekeeper function that distributors are willing to advance production funding in one form or another. Also, it is reliance on the established economic and business models based on the prevailing architecture that enables distributors to project baseline revenue, particularly from downstream sources like television and home video and DVD, that investors are willing to invest in, and lenders are willing to lend to finance film productions.

We can also assume that the major studios will still retain their gatekeeper role for the vast majority of commercial theatrical films because of the filmmakers' need for substantial funding to make their films and to market them. Also, the studios are establishing their own OTT platforms (HBO GO, Hulu, Showtime Anytime) to distribute new and library films or acquire existing platforms, following the historical industry pattern of letting others do the pioneering R and D work and then taking over the technologies. Since the studios will still control all of the distribution windows, including the new windows, the fact that revenue may be shifted from one window to another, as from television or DVD to OTT, should not affect the studios' ability to finance their product line.

The more fundamental problem for independent producers who must rely on the presale model of financing with a significant portion of such presales coming from television broadcasters and other media distributors, is that, taken to its likely ultimate outcome, the internet revolution will eliminate viewing of movies on television and video or DVD, thus eliminating these licensees as sources of presales or sales estimates that can be banked. The video and DVD market has significantly shrunk since the advent of internet streaming platforms. But it has been replaced to some extent by licensing of films to those platforms.

The challenge for the independent sector then will be to replace these obsolete platforms as presale sources. At this point it would seem there are only two possibilities: increase presales for theatrical rights, and presales of OTT and internet rights. The former option might prove difficult to achieve since theatrical performance of independent films is not historically that strong or predictable. However, it does seem likely that some form of presale market will evolve for internet platforms, with film websites replacing television broadcasters and DVD distributors as buyers. There are, however, significant hurdles that will have to be overcome, the principal ones being the current lack of territorial exclusivity on the Internet and the fact that no producer will be willing to give exclusivity to any one film website over all the others available to consumers, since the only way to maximize a film's sales will be to make it available on as many film websites as possible. These challenges indicate the possible

emergence of a new type of "middleman" that will buy internet rights from producers, perhaps for an advance or guarantee, and then license to the websites.

As with past technologies, the challenge posed by the new internet technologies are also opportunities for entrepreneurs who can develop and implement business models to overcome the hurdles and to exploit the new opportunities created by a powerful new technology that enables films to be distributed instantly worldwide to vastly larger audiences than currently possible, and in ways much less costly and cumbersome.

Notes

1. Desai, Mihir A., Gabriel J. Loeb, and Mark F. Veblen. (2002, November 14) "The Strategy and Sources of Motion Picture Finance," Harvard Business School Note, 9-203-007, p. 2.
2. Lang, Brent. (2017, August 3) "Viacom Executives Flying to China as Huahua Film Slate Deal Looks Shaky," *Variety*. Retrieved June 23, 2017 from http://variety.com/2017/film/news/viacom-executives-flying-china-huahua-film-slate-deal-shaky-1202514750/.
3. Clark, Lucas. (2007, March 30) "Hedge Funds Are Suckers," *The Wall Street Journal*. Updates from *The Wall Street Journal*'s "D: All Things Digital Conference." Retrieved January 27, 2008 from blogs.wsj.com/dnotebook/2007/05/30/lucas-hedge-funds-are-suckers.
4. Vogel, Harold. (2007) *Entertainment Industry Economics: A Guide for Financial Analysis* (6th ed.). Cambridge, England: Cambridge University Press, p. 87.
5. Kirsner, Scott. (2007, March 30) "Filmmakers Hope for Online Funds: Entrepreneurs Using Internet to Find Donors," *Variety*. Retrieved 30 September, 2006 from www.variety.com/articleVR1117962289.html?categoryid=1019&cs=1.
6. Creighton, Sam. (2015, October 22) "Making a Killing! 17 Different Brands Linger on Screen in New Bond Film," *The Daily Mail*. Retrieved June 13, 2017 from www.dailymail.co.uk/tvshowbiz/article-3285408/Making-killing-17-different-brands-linger-screen-new-Bond-film-Spectre-007-profits-endorsement.html.

Chapter 5

Movie Production

Production is the manufacturing process, when a movie is actually made. It is divided into stages of sequential time periods: preproduction, production, and postproduction. During preproduction all of the planning takes place for the shoot, production is the period of principal photography, while editing completes the movie during postproduction.

Once financing for a film is in place, the process of production begins in earnest. Producers should never fully go into production until all the money is in the bank. Preproduction is the preparation leading up to the start of principal photography; production, generally the most expensive and resource-intensive period, is also known as principle photography when shooting is started and completed. Postproduction is the period when a film is finished, editing all of the footage together into a cohesive story, adding music, sound, and special effects.

The production of a film is a complex process, a maze of details and logistics. A core team supports the producer, identifying, securing, and organizing the resources necessary to complete the film. A production schedule and budget are

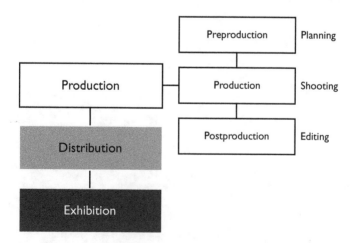

Figure 5.1 Sequence of Movie Production.

essential to guarantee that critical tasks are accomplished in order to complete the film on time and on budget.

With advances in technology, filmmakers have a variety of choices pertaining to format. Mainstream American audiences expect a film at least 90 minutes long, with stereo sound, and in color, although occasionally films are shot in black and white, for historical or artistic reasons, like *The Artist* (2011), *Ida* (2013), and *Sin City* (2014). The vast majority of films released in the United States are in English, with exceptions like *Passion of the Christ* (2004), *Apocalypto* (2006), and *Babel* (2006), as well as imported foreign films like *Toni Erdman* (2016) and *A Man Called Ove* (2017). While 35-millimeter film stock is occasionally used to shoot a film, digital technology is the norm as movies are shot on high-definition video and edited digitally. In 2015, 90 percent of US theatrically released movies were shot digitally—and most played on digital projectors in movie theaters.

In order to satisfy domestic audiences and foreign film buyers, distribution agreements specify the format of a film, a minimum length, color, language, and technical specifications, which must be agreed upon in advance of production. These specifications must be met in every respect for the distributor to be bound to the contract.

Before 1950, in the era of the fully integrated studio system, most movies were produced on studio lots and soundstages, with some location shooting in and around the Los Angeles area or, in the case of westerns, in the Arizona or Utah desert. Directors and production and set designers were wizards at reproducing times and places far removed from mid-twentieth-century Hollywood on the lots and in the studios, as witnessed in *The Wizard of Oz, Casablanca, Frankenstein*, and *Samson and Delilah*. Except for second unit "establishing" shooting, it was rare for a production to go to an actual location. Also, during this era, almost all the personnel needed to create and produce a film were employees of the studios: producers, writers, directors, actors, cinematographers, and editors. When a production was green-lighted the necessary personnel were assigned to work on the picture. That scenario has changed dramatically and in every aspect: today movies are shot on actual locations, all over the world. Decisions as to where to shoot are driven primarily by access to production incentive programs, which offer financial enticement and infrastructure to support shooting. Studio lots and soundstages are used mostly as office space and for television production and commercials. Producers, directors, writers, and all other personnel needed for production are independent contractors, hired to work on a single film at contractually determined fees (subject to union and guild rules and minimums). Another significant change in production that took place over the last few decades was the development of computer-generated imaging (CGI) enabling more spectacular special effects, exemplified by films such as *Avatar, Batman v Superman, Star Wars: The Force Awakens, The Jungle Book*.

The consequences of these changes have been dramatic. Production costs skyrocketed as the logistical complexity of physically producing a picture on

multiple locations increased, and the price for talent and qualified professionals soared as fixed salary arrangements were replaced by negotiated per-picture fees, increasing the bargaining power of sought-after talent. Widespread and growing use of CGI, an expensive technology, changed the kinds of movies that were made while also driving up budgets. While production technology has changed radically, the process has not, although there are more tools to manage that process.

Preproduction—Planning

The preproduction phase is when the planning for principal photography takes place and all the legal, administrative, and logistical details required for shooting are organized and carried out.

Organizing Preproduction Time

The preproduction phase is organized into weekly segments, to ensure that key tasks are accomplished on a timely basis. By the time preproduction begins, a "start date" for principal photography will have been set, and the preproduction process must be completed by that date. On a studio film, preproduction can span four to nine months. As a rule, it is better to spend more time on preproduction if necessary to ensure that all the pieces are in place before shooting begins. Once principal photography is under way, the daily costs of production will soar, and fixing problems that could have been resolved during preproduction will be much more costly.

For an independent film, the length of preproduction can vary widely, depending on the size of the budget, whether some or all of the financing has been raised, and the availability of personnel. Indie films that have partial financing in place, and by necessity are being produced on nights and weekends when the principals are free, may have preproduction time that, condensed, is two to three months, but takes place over a year's time, such as *Boyhood* (2014) and the largely self-financed horror movie which took six years to make, *The Evil Within* (2012).

Formats

Digital technology has changed the way films are made, and the industry has transitioned from shooting and editing on film to completing the process digitally. The following chart illustrates the progression of format shift in the top 100 films from IMDb over the past 15 years, on the film and education data blog, stephenfollows.com.

In 1909, Edison's organization, the Motion Picture Patents Trust, set 35-millimeter film as the standard for movie making. That continued until digital technology cameras became widespread in the 1990s. George Lucas' movie *Star*

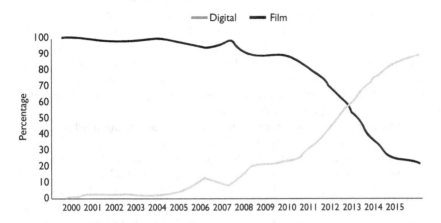

Figure 5.2 Shift in Movie Formats.

Wars: Episode II—Attack of the Clones (2002) was the first major movie to be shot entirely on digital video.[1] Most movies today are shot and edited digitally. Production is linked to distribution and exhibition; as 98 percent of the world's theaters project digitally, the digital print is delivered by internet, satellite link, or as a hard drive or optical disc such as Blu-ray. Digital movies are projected using a digital video projector instead of a film projector.[2] In the early 2000s, digital cameras started to be used for studio movies. That has progressed to the point that now 90 percent of theatrically released films are shot digitally.[3] However, high-profile filmmakers such as JJ Abrams (*Star Wars: The Force Awakens*), Quentin Tarantino (*Pulp Fiction*), and Christopher Nolan (*The Dark Knight Rises*) still prefer 35-millimeter film. In 2014 Paramount announced that they would no longer release 35-mm films, referring to the recent digital conversion of movie theaters; 98 percent of them project digitally and no longer have the capacity to project the traditional film format.

As with all technological changes, there are positive and negative implications. On the production side, digital is less expensive than film, it is faster to watch playbacks and is less fragile than film. Negative attributes of shooting digitally are that formats are constantly changing, as well as that hard drives can be unreliable and become corrupted. On aspect of digital filmmaking that is both negative and positive is that with digital shooting, a filmmaker can shoot many takes (provided one has the crew, actors, and locations) in comparison to film. An argument exists that for a director to shoot as much as she likes without limits breeds indiscipline on the set.[4]

Digital formats may be less expensive to shoot, but they have a different, somewhat flatter, look than film, while high-definition video captures very sharp detail. There is resurgence in three-dimensional (3D) film format, which began in the mid-2000s, utilizing improved 3D technology, in films such as *The Emoji*

Movie, The Lego Batman Movie, Alien Covenant, and *Logan.* There is a growing trend to release films that appeal to a large target audience simultaneously in traditional theaters (on 2D) and 3D or IMAX (*Wonder Woman, The Fate of the Furious*). Advances in technology that are swelling in popularity include 4D movie experiences that combine a 3D movie in a special theater with sensor-equipped motion seats, wind, strobe, fog, rain, and scents in sync with the story. While the shooting format is 3D, the overall sensory experience is planned during the production period for the various effects.

Formats that are currently popular in short films and rising quickly include virtual reality, augmented reality, and 360-degree movies. 360-degree films give the viewer a film that is happening in 360 degrees around them, and can be viewed on a computer, tablet, VR headset, or smartphone attached to a viewer such as Google Cardboard. Virtual reality is made up of environments (filmed live or digitally created) where viewers can move around inside, and interact with digital creations, depending on the filmmaker's design. Computer processing power is required, so the VR headgear (and accessories such as gloves) can be used and is typically connected to a computer or game console. Creators are combining 360 with VR to get the best of both experiences. Augmented reality is the creation of objects inside or on top of the current environment. If you have used Snapchat filters, or been run over by someone playing *Pokemon Go* so that the player could collect the Pokemon creature appearing inside their phone, that is a good example of augmented reality—the player was looking through a screen at the real world, and a digital creature appeared over it. These technologies are fairly new and developing, so the finer points are being worked out to improve the viewer's experience. Large companies have invested heavily in these technologies as well: Facebook and Google, Sony, Samsung, and many other electronics manufacturers.

Key Personnel

The production process involves hundreds of people performing specific tasks that must be integrated to the common end of producing a film. The number of employees working on a film is directly related to its scope and budget, and on independent productions with limited budgets, crew and cast often perform multiple roles.

The producer is ultimately responsible for the successful completion and delivery of the film. She must delegate responsibilities and will generally rely on two main professionals, the director and a line producer, to carry out the producer's vision and production plan.

Line Producer and Director. A director will usually be attached to a film early in the development phase, and a line producer, chosen by the producer and director, in the early stages of the production phase. Together, the line producer and the director carry out the producer's plan for the film's production.

These two positions "report" to the producer; however, the balance of power between the line producer and director often is determined by the status,

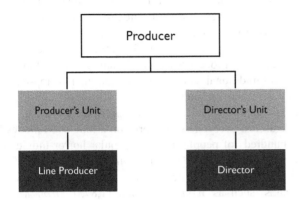

Figure 5.3 Primary Units in Film Crew.

experience, and clout of the director. In cases where the director is a major figure, the balance may well be in her or his favor.

Producer's Unit. The producer's unit implements and executes the business, organizational, and administrative aspects of a film's production. The line producer, who oversees the physical production of the film, is assisted by personnel in the producer's unit such as the unit production manager, who tracks expenditures, keeps the books, and pays the bills, and a production coordinator and production accountant.

Director's Unit. During preproduction, the director will approve the hiring of his or her team, including an assistant director and second unit directors.

According to Directors Guild of America (DGA) rules, a member director must be consulted before the producer hires a line producer, but the producer will have the final word on the selection. The director's closest working partner will be the first assistant director (AD), and the director will almost always choose her or his own first AD.

A successful production requires close teamwork between the line producer and the first AD. The line producer will determine the budget based on the script and organize the physical process of production in the most cost-efficient way. The first AD is responsible for ensuring that the day-to-day shooting follows the production plan and stays within budget.

Cast and Crew. The production of a film is a complex logistical exercise involving hundreds of individuals: technicians, crew, cast members, caterers, drivers, and personal assistants.

Personnel hired to work on a movie commit themselves for the period of production, and cannot accept other work during that time. Each works as a freelance or contract employee, employed for the duration of time they are needed.

In live action movies, crew is needed to scout locations, build sets, design costumes, attend to makeup and hair, and the many other tasks that contribute to

the filmmaking process. Animated movies have different crew roles compared to live action movies, as the process is very different. The timeline to create an animated movie can be extensive, for example an average Pixar movie takes four to five years to make.[5] The process begins with a script, utilizing a director and actors for the voices; however, the process is largely digital and created in computers, although there is still traditional hand-drawn animation, and stop-motion animation made with clay models or cut-outs.

As attested by the credits that run at the end of a film, which in recent years have expanded to include almost everyone who works on a film, even modestly budgeted films employ hundreds of people, like the popular horror movie *Get Out* (283 workers)[6] and Sundance winner *I Don't Feel At Home Anymore* (206).[7] Elaborate, big-budget films with extensive special effects and stunts may require personnel in the thousands, such as *Wonder Woman* (1,875),[8] *Iron Man 3* (3,310).[9] On average the top films of the past two decades have each had 3.5 writers, 7 producers, 55 people in the art department, 32 in sound, 55 in camera/electrical, and 156 in visual effects.[10]

Primary Tasks

Production of a movie is, in some respects, planned when all or a portion of financing is available or guaranteed. On a studio level, or for movies with guaranteed distribution, production is planned backwards from a final date by which the film must be completed, or talent stop dates, when the star or director is no longer available. These deadlines will dictate certain business decisions, such as the schedule, and the order of scenes to be shot. A producer and her staff must also plan for contingencies such as: weather, illnesses among cast or crew, or complicated filming that may take longer than expected, such as stunts or action shots.

Infrastructure. The production of a film may be thought of as a single-purpose enterprise, created and organized solely to produce that one movie. Like any business enterprise, a film production requires a legal and physical infrastructure, capital, a physical location, staff, equipment, insurance, bank account, books and records, and so forth.

Legal Form. Every film production is carried out through a legal entity organized for the sole purpose of producing the film. A corporate or quasi-corporate form, such as a limited liability partnership, is almost always used to limit the personal liability of investors, financiers, distributors, and producers.

Shooting Script/Breakdown/Schedule. A critical early step in the production process is the finalization of a shooting script, the version of the script that incorporates input from the director, the producer, the distributors, and possibly the actors. Although further script adjustments may be made during shooting, they generally will be minor in nature. The shooting script is used to finalize and fine-tune the budget and shooting schedules.

Once decisions about the shooting schedule are made, a script breakdown is generated by the line producer with the assistance of the assistant director to

coordinate production times and resources for maximum efficiency, in time and cost.

During the preproduction phase the producer and line producer, together with the director, will interview and hire crew and service providers, rent equipment, cast talent, and begin scouting locations and designing the look of the production.

An editor is selected by the director and producer. This is a key decision, as editors have an enormous impact on the final look of the film. Many directors are themselves former editors, and have certain editors they prefer to work with. Woody Allen, for example, almost always uses the same editor; Steven Spielberg with Michael Khan; Martin Scorsese and Thelma Schoonmaker (both 40+ year-long relationships); Richard Linklater and Sandra Adair (20+ years); Sofia Coppola with Sarah Flack are just a few examples. Postproduction service providers are often consulted during this period, based on the nature and quantity of visual and special effects to be used in the film. Certain types of films, like action movies, or special-effects-heavy movies, like horror films, require careful planning to guarantee that the correct shots are taken during production, for use in postproduction.

Once the script, budget, and schedule are finalized, and cast, crew, and locations are secured, appropriate insurance is obtained, and all of the necessary contracts are executed.

On a union production, employment contracts will be based on the various union rules. There are several filmmaking unions or guilds: Directors Guild of America (DGA), the Writers Guild of America (WGA), the Screen Actors Guild—American Federation of Television and Radio Artists (SAG-AFTRA), IATSE (International Alliance of Theatrical and Stage Employees), the AFM (American Federation of Musicians), and the Teamsters transportation crew. Together these unions cover almost every position involved in the filmmaking process.

Working with the script breakdown the line producer and first assistant director identify all of the needed personnel, locations, equipment, and props to be organized into the most cost-efficient groupings so as to combine like elements, cast, extras, and locations. To make the most of shooting days, coordinating every detail—from production paperwork to batteries, data capacity and the number of hard drives to script copies, walkie talkies, directions to the set, electricity, and power supplies—is as important as the selection of cast and crew.

In organizing the shooting schedule, it is common to start production with less demanding scenes, so that the crew and cast can become familiar with one another and comfortable working together. Action scenes, which take the longest to shoot, although they may be on screen the shortest amount of time, are impressive to show to financiers or studio heads, so a line producer and assistant director may schedule some of these scenes to be shot relatively early in production, in order to generate and maintain enthusiasm and support for the film.

Planning

Creativity during film production may be the result of good chemistry on a set with certain individuals, but it rarely happens by accident. Planning and back-up contingencies for every possible event during production will most likely guarantee that creativity can flourish.

The script and the budget drive all of preproduction. Whether a film is a "period piece," or takes place in the present day, will determine how elaborate the production design will be, including the budget for costumes, and props. The genre of a film will influence whether a film is heavily dependent on special effects, stunts, or extensive computer-generated imagery. Explosions, which are often expensive to create, require trained professionals. Securing necessary locations, the rental of needed equipment, the construction and decoration of sets, and the acquisition or rental of props, is the result of careful planning. Allocating within a budget to ensure the highest production values on screen requires weighing and comparing costs with an eye to which elements are essential to the film, and which are not.

Asking "what if?" contributes to the planning process, and productions prepare for the possibility of inclement weather, cast or crew illness or injury, personality conflicts, and all imaginable occurrences that could possibly impede production.

Timeline/Scheduling. Working from the shooting script, the line producer will generate a detailed shooting schedule. Movies are rarely shot in sequential order because it would be too expensive. The first priority is to work within the availability dates of the stars, with strict attention to their "stop dates." Scenes in the same locations (particularly if they are very expensive, or require travel) will be grouped together; other locations will be prioritized, by time of day, and by interior or exterior.

Once the sequences of the script are organized in the most time- and cost-efficient order, the line producer can identify which locations, sets, technicians, cast, and crew are needed at a particular time during the shooting. When the script breakdown is complete, the locations are scouted and selected, the secondary and minor actors are assigned, the crew is selected, and the sets are designed and built.

Special circumstances, such as working with animals or children, or working in hazardous conditions require clearances, animal rights representatives, and additional insurance.

Shooting days are precious and cannot be recaptured. Precise coordination is necessary to make the most of them—anything forgotten or overlooked, even something as small as a battery or light, film stock, or power source, can mean a costly delay.

Documentation. Every film generates large quantities of paperwork, from the contracts for employment to the legal due diligence required to prove that a film has not infringed on someone else's copyright, to the multitude of production

forms (call sheets, breakdown sheets, production reports) that track the progress of the production.

Chain of Title. The value of a film is not in the completed film, but in the right to license and exhibit it, and proof of ownership of the distribution rights must be meticulously documented for the benefit of exhibitors, distributors, licensees, investors, and lenders. When a completed film is delivered to an exhibitor or other licensee, the ownership of the rights to exhibit and exploit the film must be documented through chain of title, the legal documentation supporting the acquisition of all the underlying rights, including derivative rights, to the film.

Unions. An important decision in the development process, and dictated in part by studio involvement in a film, is whether the film will be a union or non-union production. All of the studios and prominent independent production companies have agreements with the various unions in Hollywood, and producers developing a studio film must follow the appropriate union guidelines, requiring the producer to be a signatory with the film industry unions and guilds, obliged to adhere to their contracts and rules regarding pay scales, and fringes and benefits. Union strikes and wage increases can have an impact on the budget for a film, or possibly delay production. All aspects of the development and production of a union film are more expensive than a non-union film, due to benefits and minimum payments set by the guilds, but a producer will have the benefit of hiring from a pool of individuals with the experience and training required for union membership.

The film industry relies on trained individuals from different unions, such as the DGA, the WGA, SAG-AFTRA, IATSE, the Teamsters, and the AFM. Each guild or union sets standard guidelines for minimum pay scales, payment during production, fringes and benefits, screen credits, and procedures for arbitration. An independent producer who is not a signatory with the guilds may decide to produce a non-union film, which is less expensive to make, but the film may lack the marketable elements necessary to succeed. Not all members work regularly or often. Membership numbers in the entertainment guilds and unions are listed below.

- DGA: over 16.000 members;[11]
- SAG-AFTRA: 160,000 actors, announcers, broadcasters, journalists, dancers, DJs, news writers, news editors, program hosts, puppeteers, recording artists, singers, stunt performers, voiceover artists;[12]
- WGA Total: 26,000; WGA East: 3,841[13] + WGA West: 22,159;[14]
- IATSE 130,000.[15]

Union and guild agreements in the film industry are negotiated between the individual union or guild and the AMPTP (Alliance of Motion Picture & TV Producers), which represents the major studios. The resulting agreements are binding on the studios and any company that employs or contracts with a union

or guild member. Union and guild members are not permitted to work on non-union productions. Over the years, there have been several major conflicts between the AMPTP and the various unions over benefits and participation in profits from various distribution streams and new technologies.

Lengthy strikes include the 1998 (22 weeks) and 2007–2008 (three months) Writers Guild strikes, and the SAG strikes in 1980 (three months) and in 2000 (six months). Film projects in development and production were delayed, causing budget increases, and studio release schedules had to be adjusted to make up for incomplete projects, due to the delay caused by the strike.

SAG and the DGA, founded in the 1930s, and the WGA, founded in the 1950s, were formed to fight for minimum pay rates and benefits, safety and work conditions, credits, and to combat unfair studio policies. At that time, writers, directors, and actors were employees of the studios, with little bargaining power, and employment agreements favored the studios. The subsequent growth and increased power of the guilds has resulted in greater equity for guild members and significant gains in benefits and protection for those working in the industry. Eligibility for membership in the guilds is determined by working on productions at guild rates, for signatory companies. Members pay yearly dues and must carefully follow guild rules to maintain their membership, such as not working for any non-guild or non-union productions. Fewer than 5 percent of the members make their living solely from acting.[16]

Founded 20 years later than the other guilds, the Producers Guild of America (PGA) is more a trade group than a guild or union. The PGA supports producers and other members of the producers unit, in film, television, and new media.

The International Alliance of Theatrical Stage Employees, known as IA, or IATSE, is an important union that serves as an umbrella for many local unions (locals) or sub-unions, which represent most employees or contractors working as below-the-line crew, such as grips, costume designers, makeup and hair artists, script supervisors, electrical technicians, craftspeople, film technicians, production office coordinators, accountants, crafts services staff, and first-aid employees.

On location shooting, trucks and other transport are needed, and the Teamsters union represents most people providing the transport services.

Unions and guild agreements cover salary, hours, health benefits, pensions, overtime rates, and include arbitration provisions. The guild agreements also cover minimum credit requirements, and the guilds will determine credit disputes between members. The guilds and unions have strict rules preventing members from working on non-union productions, although they do allow members to declare themselves financial core employees, a hybrid status where the member can work on non-union productions, but give up the right to run for union office or vote in union elections.

The film industry is largely a referral business, and directors, line producers, and crew members will want to work with people they have worked with in the past. There is even a superstition in Hollywood that if a crew or cast member has worked on a hit, he or she will bring some of that magic to the current

production. As production incentives continue to dictate where production goes, that will drive work for entertainment professionals, and many crew are moving from Los Angeles to newly established production centers in the US, including New York, Atlanta, Georgia, and New Orleans, Louisiana, as well as outside of the US to Vancouver and Toronto in Canada.

The Director's Contract. The director's contract will spell out the basic terms of his or her employment: fee, "pay or play," start and stop dates, profit share, if any, contingent compensation, approval rights, credit, including a possessory ("film by") credit, and any special accommodations (housing, special transportation, per diem expenses, and so on). The director may also negotiate for final cut—the right to make and deliver the final version of the film, which may not be changed by the producer or distributor. Major directors will usually get final cut, but more typically it remains with the producer or distributor.

The Star's Contract. The star's contract will also detail the basic terms: fee, start and stop dates, profit share, contingent compensation, approval rights, accommodations, and credit. Major stars will demand a "pay or play" contract and, in the case of non-studio films, may also ask that his or her acting fee be deposited in a bank account before the contract is signed.

Major stars also will demand, and often get, approvals over changes to the script, and the selection of a director, and various fringes and amenities during a production, such as their own hair and makeup personnel, private jets, a chef, a personal trainer, and other assistants. Billing and credits are of major importance. The fine points of billing (for example, size of type, position, above or below title) will be spelled out in detail in the star's contract. The contract will also specify any post-filming obligations, such as publicity tours and television appearances.

Casting. The producer and director will work closely with a casting director to find the right actors for each role. An experienced casting director will have information about working actors, their experience, asking fees, and abilities. The casting director will usually interview and screen potential actors for the speaking roles, and will assist in negotiating contracts with actors selected. A good casting director can serve as an intermediary with talent agencies for an inexperienced producer, often getting a better response from the agency than would the producer. Aggressive casting directors may try to bypass agents, which may be helpful for an indie picture.

The more recognizable name talent that a producer can add to his or her project, the better. Name recognition can make all the difference in financing and marketing a film. Independent producers, working on lower budgets, often cast name actors in smaller or "cameo" roles, seeking the advantages of having a name to sell but keeping the cost of the name down. An actor with a large social media following can influence decisions about casting, as they bring along a built-in audience for a movie.

Where to Shoot/Production Incentives. A critical decision impacting shooting today is which state or region to shoot in, largely influenced by film

production incentives—financial perks offered by the government to lure shooting to their region. Locations on a movie overall are determined by the script and the budget. While it might be ideal to shoot on the actual locations described in the script, location shooting is expensive, with multiple location shooting even more so. Here, too, as in so many aspects of filmmaking, there is a divide between studio films and independents.

Of primary importance in planning a shoot is the length of time required, and where it will be made. Following the example of European and Canadian film production incentive programs drawing productions with financial inducements, most states in the US followed suit. As of this writing, all but 16 states in America, and some major cities, offer tax credits or tax rebates that essentially function to return a portion of the budget spent in that area back to the producer. In essence, a production may receive real discounts of anywhere from 10 percent to 30 percent off of the budget compared to comparable shooting in another place. Many professionals have relocated to rising centers of movie production like New Orleans and Atlanta for increased employment opportunities. Each state with a production incentive program is facilitated by a film commission, which is a quasi-governmental organization to help attract production and offer required information and support to production on the best use of the incentive.

Following is a list of state film commission websites, where film production incentive-related details may be found, as well as a website for the Association of Film Commissioners International, a clearing house for incentive information.

The majority of studio films today are shot on location rather than on a soundstage or on a studio lot. Independent movies may also be filmed on location but are more likely to be confined to one or two locations, which may serve to represent multiple locations in the script. Or, less expensive locations may substitute for the more expensive location depicted in the film. Toronto, for example, has often been the location of choice for films set in New York.

When a production shoots on location, the location will be determined by matching the place with the story—an urban or rural setting, a well-known or historic setting, a story that takes place in a particular physical setting (the sea, mountains, etc.). Examples of films shot on location include *Prometheus* (shot near Helka, an active volcano in Iceland)[17] and *March of the Penguins*, whose location in the Antarctic made shooting very dangerous.

Soundstages/Developed Film Industry Centers/On Location. Films are either shot on a soundstage, or on location. Animated films are created digitally on a computer, or sometimes with animators creating drawings or manipulating clay or puppets. Most of the studios own production facilities, where sets and environments can be built on soundstages. If a locale can be reproduced effectively, the production can avoid the expense and time necessary for traveling to a location.

Soundstages provide very controlled environments, with all of the necessary equipment and security for a film shoot, and sets can remain in place overnight, saving time on the next day's shooting. Examples of a film shot on soundstages

Table 5.1

Association of Film Commissioners Int'l www.afci.org

Interactive map of film commissions http://variety411.com/production-incentives

Alabama www.alabamafilm.org

Alaska www.alaskafilmgroup.org

Arizona www.azcommerce.com/film

Arkansas www.arkansasproduction.com

California www.film.ca.gov

Colorado www.coloradofilm.org

Connecticut www.ctfilm.com

Delaware www.filmdelaware.com

District of Columbia www.film.dc.gov

Florida www.filminflorida.com

Georgia www.georgia.org/industries/entertainment/

Hawaii www.filmoffice.hawaii.gov/

Idaho www.filmidaho.com

Illinois www.film.illinois.gov

Indiana www.in.gov/film

Iowa www.produceiowa.com

Kansas www.filmkansas.com

Kentucky www.filmoffice.ky.gov

Louisiana www.louisianaentertainment.gov

Maine www.filminmaine.com

Maryland www.marylandfilm.org

Massachusetts www.mafilm.org

Michigan www.michiganfilmoffice.org

Minnesota www.mnfilmandtv.org

Mississippi www.filmmississippi.org

Missouri www.mofilm.org

Montana www.montanafilm.com

Nebraska www.neded.org/nebraska-film-office-home

Nevada www.nevadafilm.com

New Hampshire www.nh.gov/film

New Jersey www.nj.gov/state/njfg134ilm/

New Mexico www.nmfilm.com

New York www.nylovesfilm.com

North Carolina www.filmnc.com

North Dakota www.ndtourism.com/information/north-dakota-film-production

Ohio www.ohiofilmoffice.com

Oklahoma www.oklahomafilm.org

Oregon www.oregonfilm.org

Pennsylvania www.filminpa.com

Puerto Rico www.puertoricofilm.org

Rhode Island www.film.ri.gov

South Carolina www.FilmSC.com

South Dakota www.filmsd.com

Tennessee www.tnentertainment.com

Texas www.texasfilmcommission.com

Utah www.film.utah.gov

Vermont http://accd.vermont.gov/business/innovation/creative_economy/film_media

Virginia www.film.virginia.org

Washington www.washingtonfilmworks.org

West Virginia www.wvfilm.com

Wisconsin www.filmwisconsin.net

Wyoming www.filmwyoming.com

include *Captain America: Civil War*; the elaborate airport scene was filmed at the soundstage in Pinewood Studios in Atlanta. One benefit of shooting on a soundstage is the controlled environment. No unauthorized persons can access or interrupt a shoot, and noises and disturbances can be eliminated. These conveniences can be expensive for the producer, as the studio will charge the film for all of the costs, personnel, equipment, insurance, security, and overhead associated with the use of the soundstage.

The six major studios have soundstage facilities in Southern California and some in Florida. In addition, there are other soundstages around the country: Steiner Studios (*Trainwreck*, *The Wolf of Wall Street*, *Men In Black*); Kaufman Astoria (*Money Monster*, *Birdman*), and Silvercup Studios (*Sex & the City I & II*, *Julie and Julia*, *Tower Heist*) in New York City; the EUE Screen Gems Studio in Wilmington, North Carolina (*Iron Man 3*, *The Conjuring*, *We're The Millers*); Greenwich Studios in Miami, Florida (*Bad Boys II*, *Analyze This*, and *Stuck On You*); and Pinewood Studios in Atlanta, Georgia (*Guardians of the Galaxy Vol. 2*, *Captain America: Civil War*, *Black Panther*).[18]

Studio film production is expensive, and to cut production costs, studios seek to shoot films in regions which offer robust production incentives and attractive currency rates. Canada has been a popular country to shoot in, where lower costs, savings from the currency exchange (prior to the decline in the value of the US dollar in 2007–2008), and the use of locations like Toronto doubling for New York City resulted in significant savings. Another source of cost savings is shooting in a right-to-work state such as North Carolina, Texas, or Louisiana: (28 states are right-to-work states as of this writing), where non-union employees may be engaged for both studio and independent productions.[19]

Film Commissions/Production Incentives. Motion picture and television production can be lucrative for a community, through the creation of jobs, tourism, and peripheral spending. Significant dollars pour into the local economy. Governments and film commissions around the world actively promote their area to film producers in an attempt to attract movie production. Many countries and regions, including states in the United States, offer various incentives such as tax rebates, budget subsidies, and below-the-line services and facilities, to draw filmmakers. For example, New York State markets itself as a state, but due to its popularity, also highlights New York City as well. The Association of Film Commissioners International is a clearinghouse that helps producers to find locations that are appropriate for the visuals that they seek; in addition to the crews, services, and access to any available financial or tax incentives. During preproduction, the location scout, line producer, producer, director, production designer, and assistant director will participate in a decision to shoot on location. It cannot be overstated how important these incentives are to the industry and they absolutely drive where productions are shooting, and savvy investors will often inquire as to the size and stability of the program. Factors that must be considered in deciding on the selection of a location include currency exchange rates, travel and housing expense, political instability, or other

such risks, access to local crew and equipment and infrastructure to support the production (hotels, restaurants, facilities). Commissions also provide filmmakers with information about local resources, incentives, available locations, obtaining shooting permits, security personnel if needed, and other useful information.

From 1992 to 1998, foreign productions shot in Canada quadrupled, the majority of them originating in the United States.[20] Other locations around the world, such as Malta, Romania, and the Isle of Man benefit from film production originating from the United States. Public officials in major film centers like Southern California and New York, as well as professionals who work in the film business, grew increasingly alarmed as the trend grew. In response, many states and localities, beginning in the late 1990s and early 2000s, enacted incentive programs to keep production "stateside." These programs have proven to be a great success, and at their peak 44 states offered them.

There are attractive production incentives in US states like CA, PA, CT, NY, and LA, and cities like Atlanta, Georgia; Austin, Texas. Louisiana, Florida, and New Mexico have evolved into vibrant, active film centers, with everything a film production could need—locally trained crews and technicians, facilities, and equipment. Shooting on location in an area that has a developed film industry means that the producer can hire crew and talent local to the area, avoiding the cost for travel for everyone working on her production.

As of this writing, 37 states offer some sort of financial and/or tax incentives or subsidies to attract film production and there is stiff competition among them. Some states are carefully reviewing these programs to determine whether they provide sufficient return on investment.[21] These incentives range from no sales tax in Massachusetts, to the availability of select no-fee locations in many states, such as California, to a 35 percent rebate in Oklahoma, a 30 percent refundable credit available in New York, and a 20 percent rebate in Colorado. The rebates and credits are calculated on the amount of money spent in the state. There is no doubt that incentives work: in a recent study, the Louisiana Economic Development agency concluded that the state received 22 cents for every dollar it spent luring the entertainment industry, generating $1.8 billion in new household earnings for Louisiana, and an average of 14,171 jobs over a two-year period. Similarly in New York, credits created 70,812 jobs in 2015 and 2016, with earnings of more than $4.2 billion.[22] In Cleveland, over 1,700 full-time jobs were created, with the program deemed a success after the shooting of *Fast 8*.[23] A recent resounding success is Georgia, whose film industry was virtually non-existent ten years ago, but hosted more feature film productions in 2016 than any other market.[24]

Where the incentive is in the form of a state tax credit, rather than a rebate or direct subsidy, the credit can be "sold" to an individual or corporation with state tax liability, usually for about 80 percent of the amount of the credit. Other forms of state or local sponsored incentives include loans, loan guarantees, rebates on certain services, waivers of state sales taxes, and low or no-fee locations.

Each state has its own rules and guidelines with conditions that must be met to qualify for incentives. Such conditions usually include a minimum amount that must be spent on the production. Most states also have a cap on the amount of a rebate, credit, or subsidy on any single film and also an overall maximum amount that may be awarded under the incentive plans in any year. As more states offer these benefits, specialists have emerged to assist producers in navigating this type of financing, although most of the necessary information and assistance is available from the state film commissioner offices.

As noted, the phenomenon of American states and regions offering subsidies and incentives is fairly recent, emulating programs that European countries have offered for many years. These incentives in the United States have proven to be so successful for some states that many other states have followed their example and are drawing a significant amount of film production to their regions. Even European and foreign film productions are coming to the United States to benefit from these incentive programs.

Shooting Abroad/Foreign Coproductions. Location shooting overseas, although expensive, is sometimes necessary or desirable for an authentic look in a film. While most countries have film commissions or film offices to assist producers, it is almost always prudent to have a local line producer and production manager and, for cost reasons, local crews, if available. Even with good local help, however, producing a film in a foreign country (foreign to the producer, that is) presents challenges related to language issues, customs and work practices, local laws, and cultural differences.

Many countries outside the United States have subsidy and incentive programs as well as international coproduction treaties with one another. These programs are almost always limited to spending within the country, or another treaty country, and except for direct-spend subsidy programs like in Malta or the Isle of Man, may be available only to productions owned or controlled by local or regional (for example, European) production companies. Countries now seek film production by offering aggressive incentives such as the 30 percent cash rebate from Malaysia, and the Irish 32 percent tax credit which includes above-the-line costs in the incentive, typically excluded from most programs.

China, which has moved aggressively into movie production in recent years, has developed a competitive incentive, in spite of political backlash about overspending in the entertainment center. The incentive offers a 40 percent rebate for projects that shoot at the Wanda-owned soundstage (which is not yet completed) to receive a 40 percent rebate, bankrolled by the regional government and Wanda from a development fund worth $750 million to be spread over five years.[25] As the Chinese government issues rules to restrain investment in international entertainment and other sectors, the future and risk inherent in these schemes remains to be seen.

European incentives offer national and also programs at the state level, such as Bavaria and Berlin, which have different amounts of capital and also different rules. Navigating all of these funds can be a complex and time-consuming

proposition for the filmmaker, particularly when two or more countries and regions are included.

Insurance and Completion Bonds. Filmmaking is a risky business on many levels. Productions must carry adequate insurance in the form of liability coverage, accident insurance, automobile insurance, as well as insurance for the cast, props, negative, camera and equipment, property damage, and workers compensation. The amount and cost of insurance for a particular film will be based on the type of film, budget, and the risks, if any, posed by the nature of the shooting. An action movie, with lots of stunts, may require higher insured limits and more costly coverage than a straight dramatic film. Premiums are based on the budget on a cost per thousand dollars, and may run anywhere from 2 to 6 percent of the budget of the film. Producers also will usually insure the life and health of the lead actor. In cases where the actor has medical problems or a history of drug or alcohol abuse, insurance may not be obtainable and the actor will have to be replaced.

Depending on how a film is financed, most independent producers will have to obtain a completion guaranty in order to secure production financing. Completion guaranties, which are a form of insurance, ensure a film's financiers or lenders that the film will be completed and delivered on time and in accordance with the delivery requirements set forth in any distribution agreements, protecting against the risk that the producer will go over budget and run out of money, or that some unforeseen events will occur that will significantly delay the timely completion of the film. Studios will occasionally purchase a completion guaranty, particularly when they are cash flowing a production with an inexperienced producer or director.

A completion guaranty agreement will give the guarantor the right, under certain conditions, to take over the production of a film, replacing the producer. A guarantor may also remove and replace the director if the movie is running over budget or behind schedule. Very few productions are taken over by completion guarantors; it serves the interest of the producers, director, and the guarantor to resolve any budget or timing problems and avoid a takeover.

The completion guarantor will exhaustively review a film's budget, shooting script, financing arrangements, distribution agreements, and delivery requirements before issuing a guaranty. The guarantor will also look at the track record and experience of the director, producer, and line producer and, in some cases, may insist on a change in the line producer and the designation of a production manager satisfactory to the guarantor. During shooting, and postproduction, the guarantor will monitor the production, alert for any signs of budget or scheduling problems. It may also monitor the drawdown and use of production funds to ensure that no funds are misapplied.

The standard premium, or fee, for a completion guaranty is 6 percent of the film's budget. If the guaranty is not used the guarantor will usually rebate half of the fee.

Completion guaranties may be thought of as a "necessary evil"; however, the fact that very few guaranties are ever triggered and productions taken over is a

testament to the effectiveness of the system. Also, producers and directors, who know they are under the eye of a guarantor will likely proceed with somewhat more care and caution and will be more apt to quickly resolve developing budget or scheduling problems than those who have no one watching the store.

Production

The production phase is the actual shooting phase of the film, beginning on the first day of principal photography. The maxim "time is money" applies to production. During this time, most equipment, crew, cast, location, props, and resources are being utilized, therefore this is generally the most expensive period in the overall production process. Each day of shooting must result in the footage and scenes specified in the shooting schedule, and when the scheduled scenes are actually shot, it is termed "making the day." Once a film is behind schedule, it is very difficult to catch up without going over budget, and after a certain date, key personnel may be unavailable to work on the production. The production phase is a period of intense, often frenetic, effort by the hundreds of people involved, and requires meticulous preparation and execution. Things can go badly very quickly at great cost. Tempers will flare, nerves will fray, at times boredom will set in, romance may blossom. But all that counts, in the end, is the film. The process may be compared to making sausage—you don't want to see it being made but you want to eat it when it's done.

Length of Production

The period of production for a movie can last between 2 and 12 months, depending on the complexity of the production. If the film is a period piece or contains many children, animals, stunts, and action shots, or requires shots prepped for elaborate cinematic choreography, or extensive special effects, the production period will be lengthened.

A typical studio production schedule will last about 60 days for a 120-page script, shooting an average of two pages a day. The lower the budget, the fewer shooting days are available, and a producer may attempt to eliminate pages and scenes entirely to reduce expenses; however, 90 minutes is generally the minimum screening time required for a theatrical release.

A director and producer must maintain strict discipline on the set to avoid getting behind schedule and going over budget. They usually have incentives to stay on time and budget; some producer and director contracts include financial penalties for cost overruns or late delivery, their reputations are at stake and, in the worst case, they could be taken off the film by the studio or completion guarantor. During the production process, the director is in charge, and will make the final decisions, although most directors will consider comments or "suggestions" made by the producer, the director of photography, the sound person, or the star during shooting. It is imperative that the production "makes the day," acquiring

the scheduled scenes needed for every shoot day; as well as sufficient "coverage" of each scene, shooting a scene several times from multiple angles in order for the editor to have sufficient choices in assembling each scene during post.

A Typical Production Day

At the beginning of the shoot there is a production meeting so the producer and director units can review script scenes that will be shot that day, also termed "sides," to go over details. There is usually a production meeting every day of shooting, to review what needs to be done that day and deal with any problems that may arise. A call sheet will be given out for each production day with locations, directions, weather forecast, cast arrival time, scenes to be shot, and other pertinent information.

A production day typically starts early in the morning. Actors and crew rehearse the blocking for a scene with the director, to determine exactly where the cast and camera need to go. Once the director is satisfied, actors get into makeup and wardrobe, locations are dressed with construction and scenery, and the crew prepares lighting and equipment such as camera cranes and dollies. When the required personnel and sets are ready, everyone takes his or her place, and the director begins shooting.

To help the director and editor keep track of which scenes are being shot while viewing the takes, a slate is used at the very beginning of each take. The scene and take number is written on the slate, and the clapper is snapped shut in front of the camera, providing an auditory and visual cue to sync the sound with the picture.

Scenes are usually shot several times from different angles, until the director is satisfied, with sufficient coverage of the scene. As many scenes as possible will be fit into a day, which typically lasts 12 hours. When the day ends, the director selects certain takes (called "the dailies") to be printed, viewed, and evaluated in case shots have to be redone. Bad sound, shots that go out of focus, flubbed lines, lighting or shadow problems, are just a few reasons for repeating takes until the director feels there is enough coverage of a scene. Although most of his or her work takes place during postproduction, an editor will begin editing scenes during production.

On studio films, there may be several units shooting simultaneously at different locations. The first unit, comprised of the director, and the first AD, with the director of photography and camera and support personnel, may shoot a key scene with the star, while a second unit, with another director, second AD, and smaller camera crew, shoots a scene with a stunt double, or additional coverage that does not require the star's presence, establishing shots, background shots, and cutaway shots, according to the director's instructions and storyboards.

Shooting with additional units allows the schedule to be compressed, which results in a shorter shoot. With modern computer technology and the Internet, additional unit shooting can take place simultaneously in different parts of the

globe. Files of footage shot in another location can be emailed or uploaded onto a server for the director to review.

An additional cost factor in organizing a shooting schedule is the Screen Actors Guild rule regarding consecutive employment pay, which requires that SAG-AFTRA members receive payment for consecutive employment, from their first appearance during a production to the last, as well as the actual days they work. If these appearances are scheduled months apart, the actor must be paid for the entire time in between. This puts pressure on the line producer and AD to group all performances of actors as close together as possible. Union rules require specific "turnaround" times between wrap (the end of that day) and call time the next day, in order that crew and cast have sufficient time for rest. A standard workday is 12 hours on, 12 hours off. If crew or cast are scheduled to break these turnaround times, these "forced calls" may incur overtime charges, and can be dangerous for tired people working on movies.

If there are product placement deals made with advertisers in exchange for services or funding for the production, these shots must also be integrated into the script and shooting. The terms of these agreements may specify shooting the product at a certain angle, or that the product has to be on screen for a specified amount of time.

Special-effects shots, whether for physical effects, visual effects, involving wires, and lighting effects like blue screen or green screen, enabling the filmmaker to create an illusion of actors in a different physical space, require special equipment, sometimes safety personnel, and must be planned carefully.

During a shooting day, if there is no studio representative on set, the line producer may call the studio to report on the day's progress and studio production executives may want to see the dailies on a regular basis.

Throughout production, the line producer and production office continue to plan for upcoming production days, handling any travel details, logistics for location shooting, changes, or other details. Interruptions in production can be caused by weather, illness, or union disputes, personality conflicts, and misbehavior, and must be dealt with quickly, where possible.

At the completion of the production process, the production has a "wrap party" that celebrates the intense work and kinship of the cast and crew. The phrase "that's a wrap" signals the end of the shooting period. The process of wrapping a movie includes paying final bills, selling, archiving, returning, or disposing of sets, props, and wardrobe, or holding them if needed for possible reshoots. The director's contract typically lasts an additional ten weeks allowing time for her to deliver a director's cut of the film.

Key Roles

A confident producer, ultimately responsible for the production, empowers the director to run the set during production, and depends on the production manager to carry out the production and protect the producer's financial interests, by

monitoring the budget and schedule, and making the best deals throughout production. Good producers are not necessarily on the set every moment, looking over the director's shoulder, although established producer–director teams often evolve a manner of working that suits each personality, and there are many long-term partnerships, such as Todd Haynes and Christine Vachon, Woody Allen with Letty Aronson, Bob Evans and Roman Polanski, Brian Grazer and Ron Howard, and the Coen brothers.

The producer's unit supports the producer, headed up by the line producer assisted by the unit production manager. The principal function of the producer's unit is to enable the director by making sure she has the tools she needs to do the job. She is aided by the production coordinator who coordinates logistics, handling and arranging the digital files, arranging transportation and accommodations, and tending to any emergency needs.

The director's unit is led by the first assistant director (who works with the unit production manager to organize the shooting schedule), and second assistant director (manages logistics so all cast and crew arrive at the right place at the right time, assists in directing extras, and distribution paperwork).

Supporting and executing the director's vision is the director of photography (DP), who is in charge of lighting, selecting the proper camera, and supervising the camera and lighting crews. The camera operator operates the camera at all times and maintains the compositions established by the director and DP.

Without power there could be no film production, and the gaffer handles that important job; she is the chief electrician, responsible to the DP for safe and efficient execution of lighting patterns outlined by the DP.

The production designer helps make the director's vision concrete by planning colors, patterns, and the choice and look of important props. Costume designers, wardrobe personnel, set construction, and prop masters all contribute to the carefully planned look of a film. In the case of historical period films, or futuristic films, the challenges are greater, as creating or reproducing a film world may include disguising or hiding the existing world.

Depending on the scope of effects, special effects supervisors are on site during a shoot for green-screen shots or complex effects to make sure they'll be shot in a way that works for the editing process. Effects work, like action scenes, can be painstaking and time consuming.

Maintaining continuity is an important issue during production since a movie is shot out of order, and weeks can separate the shooting of scenes that, on screen, appear sequentially in the completed movie. The script supervisor polices the continuity of a production, often by taking pictures, and making notes on breakdown sheets listing props used, costumes, stunts, vehicles, and sound equipment, and relaying that information to the director, AD, prop master, stunt coordinator, and wardrobe supervisor, ensuring that all the scenes for the movie are shot successfully. The grip assists the gaffer during lighting procedures and maneuvers the camera during moving shots, building platforms, rigging picture vehicles, and laying dolly track. Teamwork and energy are important to a film

Table 5.2

Production Unit

Executive Producer: Brings key financing element that makes the film possible.

Producer: Oversees the filmmaking process, assembles script property, major cast, key crew positions, and finds financing. Responsible for film's completion, schedule, and budget.

Line Producer: Supervises the allocation of the budget of a film.

Directing Unit

Director: Responsible for the visual translation of the script into film, planning shot composition, and directing cast and crew.

First Assistant Director: Executes the director's wishes. Maintains the shooting schedule, and appropriate paperwork in tandem with the Production Manager. Ensures that personnel are at appropriate place at the right time (supported by Second Assistant Directors).

Second Unit Director: Leads secondary camera unit to shoot minor scenes.

Locations

Location Manager: Scouts and negotiates the use of locations, including permits, releases, parking; maintains community relationships associated with locations.

Production Management

Unit Production Manager: Assists in budget preparation and maintenance, creates shooting schedule, similar to and supporting Line Producer.

Production Coordinator: Coordinates production office logistics, shipping, travel, and emergencies.

Production Assistants: Any ad hoc duties as needed, errands, etc.

Cinematography

Director of Cinematography (also known as DP, DOP— director of photography, or cinematographer): Executes the director's visual plan through the selection and use of camera and lights.

Camera Operator: Operates the camera. Assisted by First and Second Camera Assistants, responsible for lenses, pulling focus, and loading hard drives or film into the camera. A Steadicam Operator may be employed to operate a harness worn with a camera to give a smooth gliding appearance. 3D Technicians may be included on the crew when the movie is shot for 3D format.

Still Photographer: Takes pictures on set for publicity and continuity.

continued

Art & Prop Department

Production Designer: Leads the art department—executing the practical aspects of the director's vision—overseeing their team in coordination with the Director and Cinematographer.

Storyboard Artists: During preproduction, draws, or creates in a computer, scenes of the movie with the Director and Production Designer to aid in previsualization of the film.

Set Designer: Draws, designs, and builds sets, props, and models.

Special Visual Effects Crew and Technicians: Build and operate miniatures and models.

Set Decorator: Chooses all set dressing, from furniture to art and household items.

Greensman: Chooses and maintains flowers, plants on the set.

Property Master: Chooses and maintains props and nondecorative items specifically mentioned in the script—books, guns, photos.

Prop Maker: Creates special props to match production design.

Set Construction Foreman: Head carpenter, oversees all set construction, including Carpenters, Painters, Scenic Artists, Paper Hangers (wallpaper, tiles), and Drapery Crew (making/installing drapes and upholstery), Plasterers and Welders under the direction of the production designer.

Electrical and Grip

Gaffer: The chief electrician, executing the DP's lighting plan in the safest, most effective manner; assisted by a Best Boy, who also supervises equipment.

Electricians: Rig and operate electrical equipment and lights.

Generator Operator: Provides generator power.

Key Grip: Responsible to DP for managing grip crew.

Grips: Move the camera, and operate/build equipment to move cameras—dollies, platforms, picture trucks, cranes.

Sound

Production Sound Mixer: On set, the Production Sound Mixer operates the sound equipment to ensure clean sound is recorded.

Boom Operator: Places the microphone, typically on a long boom pole, which must be kept from making any shadow visible to the camera.

Other Assorted Cast

Stunt Coordinator: Plans safe and convincing looking stunts overseeing all Stunt People.

Transportation Captain: Oversees and chooses all vehicles used during production on and off screen, directs the Drivers and the Honeywagon (portable toilet) Driver. Assisted by the Transportation Coordinator.

Table 5.2 Continued

Production Unit

Costumes/Hair/Makeup

Makeup Artist: The Key Makeup Artist supervises makeup artists and hairstylists. Makeup artists apply and touch up makeup to face and body for special effects and prosthetics.

Hairstylist: Responsible for styling, cutting, coloring artist hair or hairpieces.

Costume Designer: Purchases, designs, supervises costumes; overseen by Production Designer.

Wardrobe Supervisor: Supervises entire wardrobe department.

Talent

Cast: Principal actors with speaking lines.

Supporting Cast: Supporting roles.

Stunt Players: Stunt performers for substituting for principal cast.

Day Players: Hired to act on set for a day, may have a few speaking lines.

Extras: Actors without speaking lines, usually appearing in background, also called background or atmosphere.

Production Management

Script Supervisor: Maintains continuity of script, carefully recording camera position, appearance of set and cast.

Animal Trainer: Handles, transports, directs, and trains all domestic animals and wildlife used in a film. An Animal Wrangler handles livestock and insects.

Craft Service: The Craft Service personnel provide meals and snacks throughout production.

First-Aid and medical personnel are often employed on film sets during production. Fire Safety Captain and Police are often present on set for safety.

Teacher: Instructs child actors on set.

Writer: Writes the script that film is based upon, sometimes on set.

Editorial

Composer: Composes musical score for the film.

Editor: Chooses and edits film footage to create final version of the film, with the director, and guidance from the producer, assisted by a First Assistant Editor.

Foley Artist: Creates sound effects.

Composer: Composer who writes original music to score a film.

Orchestrator: Arranges the composer's musical themes for the orchestra playing the musical score.

production, and every member of the cast, crew, specialists, technicians, and supporting personnel working on a film makes an important contribution.

With the advent of digital production there are two important roles added to the camera and electrical department: the DIT (digital imaging technician) and data wrangler. The DIT is the camera department crew member who works in collaboration with the cinematographer on workflow, systemization, camera settings, signal integrity, and image manipulation to achieve the highest image quality on a technical level and creative goals of cinematography in the digital realm.[26] The DIT establishes the technical goals of creating, maintaining, and protecting the digital files as they are captured in the camera. The data wrangler checks and protects that footage in digital form from the camera to the editor. This is the person on set who is responsible for making sure that raw footage from the camera is transferred to the editor without any data loss or corruption. All backups have their data integrity checked and log sheets with checksums and details of the contents of the files will be produced. As footage is passed from the shoot to post the data wrangler should keep a log of who has received what and track all copies of the footage.[27]

Following are brief descriptions of cast, crew, and supporting employees on a film production who all play an important role in creating a film.

Postproduction

Postproduction is the period when the completed scenes are assembled into the final version of the film, and other elements of the finished film are added. In addition to the editing process—choosing effective shots and assembling them into the best order to tell the story—special effects and computer-generated effects are added, sound and dialogue is perfected, music is composed, recorded, and added to the film, and the many technical processes involved in completing a film, such as the addition of opticals, titles, and color correction are carried out.

The cost of postproduction is linked to the type of film being made. Simple dramas without computer-generated imaging and few special effects will be less expensive than effects-laden films. The expense of music varies widely as well; a musical score that relies on licensing famous hit songs, in addition to, or instead of, an original score, can inflate the postproduction budget.

Today it is common to have an original score written for a film. For each piece of licensed music used in a film, permissions, clearances, and synch license must to be obtained.

To maintain the security of the film, prevent piracy, and keep the film from being seen by unauthorized personnel prior to its release, there are very tight controls over who has access to the unfinished film, and lab access letters are required for access to the original prints of the movie and soundtrack.

In addition to completing the film for theatrical release, versions of the film must be edited for release on IPTV, streaming, Blu-ray, television, and in the foreign markets (which may require changes to dialogue, or sexual or violent

content), DVD, trailers, and other marketing uses. The delivery requirements in a standard distribution agreement, for any release format, are detailed and extensive, and all the material and legal and technical requirements must be met during postproduction.

Picture

For a two-hour movie, the editor may have to sort through hundreds of hours of footage to find the best takes to tell the story. If the editor has a thorough understanding of what the director wants, her first rough cut of the film will be ready just a few weeks after production is completed. This preliminary cut by the editor runs long so that the director will have ample footage from which to choose and cut.

With the availability of digital editing, a film negative does not have to be cut until final decisions have been made. The film can be digitized, and edited in the computer, with Avid System, Davinci, Adobe Premiere, or using Final Cut Pro software. The popularity of these computer systems, and non-linear editing—editing different parts of a film in any order, not just in the order of the film's final story—gives today's editors enormous flexibility. This allows the director and the editor to try many different options before committing to one version.

The editor and director work together on the director's cut, a contractual right in the Director's Guild agreement that gives the director the first opportunity to realize her vision. Temp music may be used and the film may be previewed to limited audiences to gauge the film's pacing and effectiveness.

Like many other technicians and professionals working in the film industry, most editors belong to a guild, the Motion Picture Editor's Guild, which is a member of IATSE. The Motion Picture Editor's Guild also represents many of the other professionals who work in postproduction, such as sound, music, assistant editors, animation, technical directors, librarians, and apprentice motion-picture editors.

The creation of computer-generated special effects begins in earnest during postproduction, utilizing footage from the production, and combining these with other images, as well as creating images from scratch within the computer, or painting unwanted material out of shots.

Special effects can be optical (i.e., effects that are created by manipulating the screen image), photographic, such as the arrival of the aliens in *Independence Day* (1996), or by using CGI technology; or mechanical effects, by using puppetry, mechanized props, scenery, or pyrotechnics during live action shooting; or a combination of both.

Special-effects technology is becoming more affordable and adaptive as demand for its use increases. Some postproduction houses specialize in one or more of these effects, employing technicians with expertise, and working with direction from the director and editor.

A producer making a movie containing special effects will hire a special-effects or visual-effects supervisor during preproduction, who will offer guidance for achieving a certain look at the most cost-effective price. The effects supervisor guides the producer and the director throughout the production process on requirements for certain shots in order for them to work with a special effect, such as specific camera instructions, or additional coverage.

As the special-effects industry grows, many companies specialize in a certain type of effect, and the visual-effects supervisor may split the effects work up between two or more companies. Starting with movies like *Jaws* and *Star Wars*, audiences began to look forward to, and expect, realistic-looking special effects.

Conforming color and the overall look of the film for visual consistency takes place as the postproduction editing is completed. Transitions like dissolves and fades (optical effects) and titles on screen are also created in postproduction, the credit sequences are added to the front and the end of the film, sound and picture are combined until the final film file is completed, from which all of the copies are made. For a digital 3D movie, two different images at the same time-code have to proceed through the same workflow, put together in two layers resulting in one file at the end, in the stereoscopic film which adds the third dimension that gives the image its depth.

Sound

Once the picture is locked (picture editing complete) copies are made for the sound editor and composer to work on simultaneously. The time-code appearing on the film helps everyone working on the film to synchronize (sync) sound and music precisely to the picture.

Sound for film includes dialogue, sound effects, and music. During production, sound is recorded on a separate track, and if certain dialogue was not performed cleanly, or was interrupted by another sound, the actors must rerecord their lines, replacing the original lines filmed—a technique known as ADR (automatic dialogue replacement, also called looping). The music and effects tracks (M&E tracks) are required to isolate specific lines of dialogue from other noises, and are also helpful for foreign distribution, when foreign dialogue may replace the original language.

New lines of dialogue can also be added if the angle of the shot conceals the actor's mouth. The director Federico Fellini often employed this technique, scripting a great deal of the film after it was already shot. The dialogue editor constructs the various audio tracks with actor's spoken lines, and room tone to match the sound environment on the shoot.

Sound effects have a strong impact on an audience's emotional response, and the sound-effects editor constructs an aural emotional background on which the dialogue, music, and picture will rest. The sound-effects editor can add traffic sounds, clocks ticking, bells chiming, and background noise, choosing from enormous libraries of sounds or creating their own. Foley artists create sound

effects in the studio for a film, sounds that are more lifelike than the real sounds themselves. Popular Foley substitutions are clapping gloves together to imitate bird wings flapping, and thumping watermelons to imitate the sound of punching in a fight. Foley artists can create aural profiles of a character's footsteps (as in westerns), and other sound profiles that immediately evoke that character.

Music composers create and record a score that matches the style of a film, and serves to highlight or disguise the appropriate scenes. Music may be written as an underscore, visual, or background vocal—when a singer is singing on or off camera, and source music—music that emanates from a source on screen such as a radio or instrument. Composers may write a score for live musicians, or for synthesizers or computers as a means to reduce costs. On elaborate film scores a composer may compose various musical themes and is assisted by an orchestrator, who scores the themes in an emotional style, happy, or scary, or nostalgic, for the various instruments in the orchestra. Each unit of music is referred to as a cue, and they are carefully timed, recorded and matched to the picture. Composers do not have their own union, but most composers will orchestrate and conduct musicians for a film score, in order to qualify for benefits through the AFM (The American Federation of Musicians), the musicians' union.

The music editor, selected by the composer, synchronizes the music with the image. Buying the rights to hit songs by well-known musical artists is very expensive, and music clearances must be negotiated and documented to ascertain that the filmmakers are not held liable for any copyright infringement. A music supervisor searches for, and selects music to best suit the film and capture the attention of the film's target audience.

Synchronization licenses must be obtained from the music publisher to rerecord music for a film, and master use license must be obtained for previously recorded music. If the soundtrack of a film is separately released as a recording, mechanical licenses for the music are required. Relevant licenses and proof of music clearances will be included in the chain of title.

Preparation For Delivery

Materials must be completed during the postproduction period for advertising and publicity for upcoming distribution, such as trailers, commercials, and print materials. Materials required for foreign distribution, such as foreign language tracks or subtitles, must be created and/or edited during postproduction, and all of the necessary paperwork to fulfill distribution contracts and document the chain of title must be completed. Coordination between the production office and all of the postproduction personnel working together enables the film and all of its deliverables to be completed. Following is a list of the specialists in postproduction working together to successfully complete a film.

As in the entire production process, the complexity of postproduction is directly related to the type of film, its budget, and how simple or complicated a project

Table 5.3

Postproduction Executive	Supervising Sound Editor
Postproduction Supervisor	Foley Artists
Postproduction Coordinator	Sound Effects Editor
Composer	Rerecording Mixers
Music Editor	Title Design
Orchestrator	Creator of Title & Opticals
Executive in charge of music	Negative Cutter
Music Supervisor	Color Timer
Musicians	Second and other units
ADR Editors	Effects Vendors
Sound Editors	CGI Artists
ADR Mixer	3D Technicians
ADR Group Coordinator	DIT and Data Technicians

it is. Animated or action films, films with many special effects, and musicals, are films which will require more time and budget allocated to postproduction.

Film production, from preproduction through postproduction, is an elaborate and complex process, and the specialized knowledge and expertise of each participant highlights the collaborative nature of filmmaking. It takes talent, careful planning and budgeting, professional discipline and expertise, and perhaps a bit of luck for a film to be successfully produced.

Impact of Mobile, VR/AR, and IMAX

Consumers display an insatiable appetite for new technology. Virtual reality, augmented reality, and 360-degree films offer a radically new experience. Mobile devices, whether smartphones or tablets (and the increasingly diminutive laptops) offer entertainment on-the-go. While one side of the industry is getting smaller—with headsets that offer isolating experiences and the tiny screen on your phone, the other side of the industry is getting bigger, with the rising popularity of large-format IMAX movies.

Mobile

Younger audiences are interested in streaming content that is accessible on their smartphones or tablets. Due to the small screen and commute times, video consumption on phones tends to favor content that is shorter, like web videos and streaming television, rather than full-length movies. As the mobile phone market continues to grow, filmmakers will adapt. More than half of all video viewing is done on mobile devices, primarily from phones,[28] so this is an area for opportunity. The reasons people avoid watching movies on a phone include battery life, buffering time, connection speed, data costs, screen resolution, and sound quality.

The latest wave of technology is impacting Hollywood; however, the long-range effects remain to be seen. New and alternative formats, as well as new ways of consuming movies are exploding, made possible by smartphones, the availability of high-speed bandwidth, readily accessible high computer processing speeds, competitive pricing in the electronics market, and widespread popularity of all things mobile. Not everyone watches movies on their mobile phones, but numbers are substantial, as illustrated in the chart below (as of 2016).[29]

With the popularity of smartphones and their increasingly high-quality cameras, there is a rise of movies produced on mobile phones. Renowned director Michel Gondry made a high-end short using an iPhone 7 model that debuted in 2017, and a popular film at the 2015 Sundance Film Festival was the feature film completely shot on iPhone 5-model phones with add-on lenses, entitled *Tangerine*. The film was picked up by Magnolia, which went on to distribute it in theaters and ancillary windows, netting over $1,000,000 in total revenue.[30]

360-degree films are immersive spherical videos which can be viewed in a headset, to look around and see all 360 degrees, or viewed on a computer, with the ability to pan around to look wherever one likes. The films use multiple cameras or lenses to obtain all the footage, which is then stitched together digitally. These cameras and editors are available to consumers at very affordable price points, with higher end cameras available for 100,000 dollars. Other than a viewer turning around to see what direction action is happening, the technology is not interactive.

Virtual reality is a technology whereby a movie can be made in live action, or animated. A viewer is both immersed in the film, and there may be interactive components. Entertainment analysts compare the potential of the AR/VR/360 technologies to the beginning of the mobile phone industry due to their rapidly growing popularity. The user typically wears a headset connected to a computer

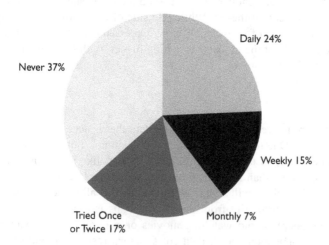

Figure 5.4 Frequency US Consumers Watch Video on Their Smartphone.

and can see in all 360 degrees around them. Depending on how the VR experience is designed, the viewer may be able to cause events to occur (moving through space, causing character actions), by picking something up using a remote control or gloves, or focusing on an object in their field of view. At the moment, shorter content is the norm, although with AMC Entertainment, Westfield Mall, and Hollywood elites like Spielberg investing in VR theaters, with ventures like Dreamscape Immersive, the virtual reality multiplex, long-form content is inevitable.[31] What is billed as the first virtual reality movie—a Jesus Christ biopic—made its debut at the Venice Film Festival in 2016.

Facebook, Google, and the electronics companies are investing heavily in this sector, for online players that allow consumers to watch these formats online and in their computers, as well as related headsets, accessories, cameras, and related software. The experience has a lot in common with gaming, in that multiple branching narratives are possible depending on the design of the creator.

The biggest impact of 360-degree filmmaking seems to be how the movie inspires empathy. Non-profits are having tremendous effects using these films, to raise awareness and funds. Certain genres, like horror, or total immersion in natural environments, are very impactful in these mediums. The negatives of the technology include isolation in the headsets; physical discomfort from looking all around, up and down; availability; and price of the technology. As VR and 360 become more widespread, the technology will improve, and most likely prices will fall.

Augmented reality is a technology which enables digital characters and objects to be viewed superimposed on top of the real world. AR has been spectacularly popular with Snapchat—a mobile phone app where people can add digital masks, glasses, accessories like ears, mustaches, animal decorations over their faces for fun on still images or video. The Pokemon Go game also caused a surge in interest in AR.

Holographic technology, being developed for video cameras, headsets, and phones, offers the possibility to see and create two-dimensional surfaces that show precise, three-dimensional images of real objects created in light. Microsoft and the Red Camera are just two of the companies moving quickly in this space. The technology is moving to where computers respond to programs using commands and gestures to summon and manipulate data and layer it atop physical objects.

As these technologies mature, they will be blended together for more interesting media in what may become a combination of gaming and filmic experiences, creating more interactive movies.

IMAX formats are an integral part of the movie landscape. Exhibitors use them to draw additional revenue from frequent moviegoers who will pay more for premium formats. IMAX is a large format—70 mm—displaying images of far greater size and resolution than conventional film systems. As of June 2017, there were 1,257 IMAX theaters in 75 countries.[32] Screens reach heights of up to 80 feet. More than 500 of the theaters are located in commercial multiplex

theaters, while the rest are in museums and science centers. All are licensed to use the IMAX name; operators pay maintenance and royalty fees to IMAX. The company also produces special-format films, such as *Under the Sea 3D*, which are shown on its projection system. Premium large-formats give big theater chains new ways to grow their bottom line.

From a production perspective IMAX is expensive and difficult to make. The cameras are heavy and loud. The sheer size of the film stock means that the camera can only hold about three minutes at once, and the reloading of the stock is time-consuming. IMAX film runs through the cameras and projectors sideways, with the sprocket holes at the top and bottom instead of the sides. Of the almost 1,257 (as of the time of writing) IMAX theaters in the world, more than 100 of them are in China.[33] Approximately 57 IMAX movies were released in 2016, nature-themed movies in planetariums and museums, as well as tent-pole movies released on the bigger formats too. In 2017, many tent-pole movies were released in multiple formats including IMAX, such as *Blade Runner 2049*, *Transformers: The Last Knight*, and *Guardians of the Galaxy Vol. 2*.

Notes

1. Alexander, Helen and Rhys Blakely. (2014, September 17) "The Triumph of Digital Will Be the Death of Many Movies," *The New Republic.* Retrieved June 14, 2017 from https://newrepublic.com/article/119431/how-digital-cinema-took-over-35mm-film.
2. Digital cinema. Wikipedia. Retrieved August 6, 2017 from https://en.wikipedia.org/wiki/Digital_cinem.
3. Follows, Stephen. (2016, January 11) "Film vs digital." Retrieved August 16, 2017 from https://stephenfollows.com/film-vs-digital/.
4. Alexander, Helen and Rhys Blakely. (2014, September 17) "The Triumph of Digital Will Be the Death of Many Movies," *The New Republic.* Retrieved June 14, 2017 from https://newrepublic.com/article/119431/how-digital-cinema-took-over-35mm-film.
5. Vardanega, Joshua. (2013, July) "Pixar's Animation Process," *Pixar Animation Studios.* Retrieved July 3, 2017 from http://pixar-animation.weebly.com/pixars-animation-process.html.
6. ImDb. (n.d.) "Get Out," IMDb.com, Inc. Retrieved July 21, 2017 from www.imdb.com/title/tt5052448/combined.
7. IMDb. (n.d.) "I Don't Feel at Home in This World Anymore," IMDb.com, Inc. Retrieved July 21, 2017 from www.imdb.com/title/tt5710514/combined.
8. IMDb. (n.d.) "Wonder Woman," IMDb.com, Inc. Retrieved July 21, 2017 from www.imdb.com/title/tt0451279/combined.
9. IMDb. (n.d.) "Iron Man 3," IMDb.com, Inc. Retrieved July 21, 2017 from www.imdb.com/title/tt1300854/fullcredits/.
10. Fellows, Stephen. (2014, February 24) "How Many People Work on a Hollywood Film?" Retrieved September 3, 2017 from http://stephenfollows.com/how-many-people-work-on-a-hollywood-film/.
11. DGA. Retrieved August 23, 2017 from www.dga.org/The-Guild/Members.aspx.
12. SAG-AFTRA. (n.d.) "About Us." Retrieved October 2, 2017 from www.sagaftra.org/content/about-us.
13. Union Facts. (n.d.) "Writers Guild East." Retrieved October 2, 2017 from www.unionfacts.com/union/Writers_Guild_East.

14. Union Facts. (n.d.) "Writers Guild West." Retrieved October 2, 2017 from www.unionfacts.com/union/Writers_Guild_West.
15. IATSE. (n.d.) "About the IATSE." Retrieved October 2, 2017 from www.iatse.net/about-iatse.
16. Bureau of Labor Statistics. (2007). *U.S. Department of Labor, Occupational Outlook Handbook, 2008–09 Edition: Actors, Producers, and Directors*. Retrieved October 3, 2017 from www.bls.gov/oco/ocos093.htm.
17. Moviefone Staff. (n.d.) "The 10 Most Dangerous Film Locations Ever," *Moviefone*. Retrieved July 12, 2011 from www.moviefone.com/2011/07/12/the-10-most-dangerous-film-locations-ever/.
18. Company websites: Retrieved September 23, 2017 from: Steiner Studios (www.steinerstudios.com/), Silvercup Studios (www.silvercupstudios.com/), Kaufman Astoria (www.kaufmanastoria.com/), EUE Screen Gems Studios (http://euescreengems.com/), Greenwich Studios (www.greenwichstudios.com/), Pinewood Studios (www.pinewoodgroup.com/our-studios/usa/pinewood-atlanta-studios).
19. National Right to Work Legal Defense Foundation. (n.d.) "Right to Work States." Retrieved 23 June, 2017 from www.nrtw.org/right-to-work-states.
20. Baltruschat, Doris. (2002, May 10–12) "Globalization and International TV and Film Coproductions," Media in Transition 2: Globalization and Convergence presented at MIT, Cambridge, MA.
21. Silverman, Gerald B. (2017, August 3) "Looking at You, Kid," *Bloomberg BNA*. Daily Tax Report: State. Retrieved August 23, 2017 from www.bna.com/looking-kid-tax-n73014462719/.
22. Loren C. Scott & Associates. (2017, April 2) "The Economic Impact of Louisiana's Entertainment Tax Credit Programs For Film, Live Performance & Sound Recording For Office of Entertainment Industry Development," *Louisiana Department of Economic Development*, www.lorencscottassociates.com, p. 23.
23. Cho, Janet H. (2016, July 1) "Ohio's $40 Million Motion Picture Tax Credit Will Bring Even More Hollywood Jobs and Films to Greater Cleveland," *The Plain Dealer*. Retrieved August 23, 2017 from www.cleveland.com/business/index.ssf/2016/06/ohios_40_million_motion_picture_tax_credit_will_bring_even_more_hollywood_jobs_and_films_to_greater_cleveland.html.
24. Silverman, Gerald B. (2017, August 3) "Looking at You, Kid," *Bloomberg BNA*. Daily Tax Report: State. Retrieved August 23, 2017 from www.bna.com/looking-kid-tax-n73014462719/.
25. Brzeski, Patrick. (2015, April 4) "Wanda's $8B China Studio Offers Unique Hollywood Incentive," *Hollywood Reporter*. Retrieved July 30, 2017 from www.hollywoodreporter.com/news/wandas-8b-china-studio-offers-unique-hollywood-incentive-988942.
26. Pennington, Adrian. (2008, September 3) "4K—Bane or Blessing?" *Digital Studio Me*. Retrieved August 14, 2017 from www.digitalproductionme.com/article-718-4k-bane-or-blessing/1.
27. Chapman, Alister. (2014, September 9) "Don't Confuse a DIT with a Data Wrangler or Runner," *XDCam-User*. Retrieved July 23, 2017 from www.xdcam-user.com/2014/09/dont-confuse-a-dit-with-a-data-wrangler-or-runner/.
28. Roettgers, Janko. (2016, December 6) "More Than Half of All Video Viewing Now on Mobile, Tablet Viewing Flat," *Variety*. Retrieved August 30, 2017 from http://variety.com/2016/digital/news/mobile-video-viewing-stats-1201934907/.
29. eMarketer. (2016, March 29) "How Often US Consumers Are Watching Video on Their Smartphones," *eMarketer Company Blog*. Retrieved August 17, 2017 from www.emarketer.com/Article/How-Often-US-Consumers-Watching-Video-on-Their-smartphones/1013802.

30. Newton, Casey. (2015, January 28) "How One of the Best Films at Sundance Was Shot Using an iPhone 5S," *The Verge*. Retrieved September 21, 2017 from www.theverge.com/2015/1/28/7925023/sundance-film-festival-2015-tangerine-iphone-5s.

31. Barnes, Brooks. (2017, September 26) "Coming Soon to AMC Theaters: Virtual Reality Experiences," *New York Times*. Retrieved October 10, 2017 from www.nytimes.com/2017/09/26/business/media/amc-theaters-virtual-reality.html.

32. IMAX Corporation. (n.d.) Corporate Information. Retrieved October 2, 2017 from www.imax.com/content/corporate-information.

33. Porges, Seth. (2013, July 9) "7 Things You (Probably) Didn't Know About Imax," *Forbes*. Retrieved September 2, 2017 from www.forbes.com/sites/sethporges/2013/07/09/7-things-you-probably-didnt-know-about-imax/#aa85fbe357a9.

Chapter 6

Movie Distribution

The key to the financial success of a film is how it is distributed and marketed. A movie that has been made and is never distributed will not recoup costs or generate profits. No one needs to see a movie, they have to want to see it. The role of the distributor is to position a film in the marketplace, and maximize all of the possibilities to generate revenue by licensing all available and exploitable rights, in as many territories as possible, for the longest amount of time.

Movie distributors plan how best to sell a movie—where, when, in what formats; working with marketers to effectively reach the target audience. A distributor will arrange the distribution plan to match the film's genre, budget, star power, and story. Distribution creates availability of a movie so that consumers have access to buy and watch the film in a variety of markets and formats. But distribution isn't enough, audiences must be aware of the movie.

- Distribution creates availability.
- Marketing creates awareness.

Marketing and distribution should work in concert, or money and effort will be wasted. Distribution and marketing activities for a film are closely related, and planning should begin from the moment a project gets the green-light. Marketing and distribution entails a wide range of activities, directly and indirectly related to the promotion, publicity, and release of a film.

Every commercial motion picture represents a significant investment of money and resources, and is a product that is unique and without a certain or established market. Every film is a gamble; in some real sense, a roll of the dice. Movies lend themselves only in a limited way to market research, or pre-testing of consumer acceptance or interest. A film is released and has only a short window of time to establish itself in a very competitive marketplace, and that initial performance—perhaps its opening weekend in theaters—may well determine its long-run commercial success in the aftermarkets: online internet platforms, video/DVD, cable, television, and in the foreign markets.

A distributor's challenge is to identify the target audience for a particular film, defining that audiences' demographics and psychographics, planning a

release that will most directly appeal to those viewers. Then the distributor must create and maintain awareness of the film among that audience, transforming awareness into a desire to see that film.

Distribution Details

The economic value of a film is in the legal right to exploit the copyright of the film by licensing or selling the rights to view it. For audiences to buy and consume the product, distributors must make sure audiences have access to it; distributors guarantee audiences that access.

Distribution is the critical juncture for monetizing a movie, every activity up until that point—development, production, financing, and marketing—incurs expense. The current movie distribution architecture—separating media windows, staggering timelines of release in different formats and territories—was created by the studios in order to maximize profits. As new distribution technologies emerge, that architecture is disrupted and changed to accommodate them.

It is impossible to overstate the disruption to the movie distribution that has been caused by the ability to stream and download movies on the Internet. This technology has changed how movies are distributed and marketed, and is affecting finance and production as well.

Distribution Structure

A film is licensed or sold for exploitation in a series of media windows. The term "windows" is used to denote the form of media utilized to "view" the film, such as:

1. Movie theater/3D, IMAX, 4D
2. Free (broadcast) television
3. Cable pay stations
4. Basic cable/syndication
5. DVD/Blu-ray/video
6. Pay-per-view
7. Video-on-demand, NVOD, SVOD
8. Internet streaming
9. Internet download.

Distribution is structured to maximize revenue from each media and territory for a movie.

From the 1920s until now, the industry has gone from one way to sell movies to the public (in the theater) to many, as several different technologies have developed. Studios could release a movie in every media at once, in every territory, all at the same time. However, they do not, in order to maximize profits.

In addition to the theatrical release, there are several other retail opportunities for films in the marketplace. With the advent of each new technology, the

distribution landscape shifts, but traditionally, the price paid by the consumer to see a film in any given window is higher than the price in subsequent windows, and the portion of the retail price retained by the studio is greater in earlier windows. For instance, for each movie ticket sold in a movie theater, the distributor will receive $6–7 per person per ticket sold (more for 3D and IMAX) but the distributor will receive much less from retail sales in subsequent formats, generating significantly less for cable, TV, DVD, PPV, and internet formats.

Distributors separate the windows by:

- media
- territory
- term.

Film is a unique product in that it can be licensed or sold over and over. The ability to separate distribution rights to a film, by media window, time, and territory, gives distributors the opportunity to control how, when, and where a film is available, controlling an audience's access to, while maximizing awareness of, that movie. The order that media windows are structured maximizes a film's revenue. Due to extremely high production and marketing costs, distribution companies are under great pressure to make back their investment—in the form of license fees from every possible source—as quickly as possible.

License fees from multi-phased distribution are critical to a movie's financial success. Historically, the licensing of films for viewing in different media formats has followed a standard chronological pattern, with every format—theatrical, television, internet streaming or download, VOD, DVD; or sub-format, such as pay-per-view TV, pay-TV, and free-TV—allocated a licensing "window," which begins at a certain point in time after the start of the first window. That guarantees exclusivity to certain windows for a period of time. The economic logic that drives this structure is that the structure is based on the cost of the window format to the consumer. The greater the cost, the earlier the window will commence and a consumer will not pay to view a movie in one format if he or she can view it in a less expensive one. If a film is available to a viewer on free television at the same time it is running in theaters it is likely that many, if not most, viewers would choose to see it for free, resulting in significantly reduced theatrical revenues. The cost to the consumer is linked to another economic fact that supports the window hierarchy: the studio distributor's share of the price paid by the viewer is smaller both in percentage terms and dollar amount, in each succeeding window. Thus, it is in the distributor's financial interest that as many viewers as possible see a film in the most expensive formats.

As new distribution formats emerged, the sequencing of windows had to be reshuffled. An historical example is the introduction of pay-cable television in the 1970s. Prior to pay-TV the first window after theatrical release was network television, and the networks paid substantial licensing fees for the right to show recently released theatrical films. Driven by the logic of the window sequencing,

pay-TV replaced network TV as the first non-theatrical window, degrading the value of the films to the networks and reducing the licensing fees they were willing to pay (which, however, were replaced by the fees paid by the pay-TV systems). The advent of home video, which replaced pay-TV in the sequencing, pushed network TV back further to the point where by the 1980s, the networks all but discontinued licensing of theatrical films.[1] They had become "used merchandise."

An interesting consequence of the reshuffling of format windows was that the networks began to produce their own films; the "movies of the week" and mini-series, as replacements for theatrical films. As noted at the beginning of this book, this development expanded career and work opportunities for filmmakers and movie professionals, and the TV movies and miniseries were sometimes produced by the studios, generating more revenue for them as well. This pattern has continued—new platforms, from HBO to Netflix—at the beginning of their existence, begin by licensing studio content, learning what their audiences prefer, then start generating their own film and episodic content, relying less on the studios.

The current distribution sequence allows each media a period of exclusivity before phasing to the next.

In addition to separating the windows by time and media, the film industry traditionally staggered the theatrical release of a film throughout the world, typically starting in North America, then moving around the globe, riding the marketing wave created in the United States. However, piracy and online file-sharing provide opportunities for copies of a film to be made in one territory, then illegally sold or given away for nothing, in territories where the film has not yet been released, diluting potential revenue. To protect against lost profits and thwart piracy, the industry is moving toward releasing a film—day and date—simultaneously in all major world markets.

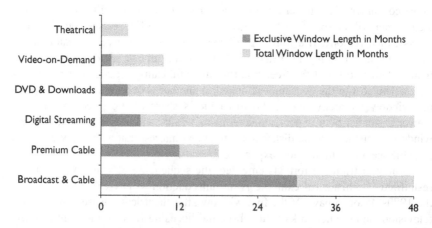

Figure 6.1 Windows of Distribution Sequence.

Since the late 1990s, movie executives have closely observed the music industry, as it evolved from a brick and-mortar marketplace to one which resides primarily on the Internet, and have noted the problems spawned by this transition—piracy, file-sharing, revenue loss. Hollywood, in an attempt to ward off similar problems, has adapted to new technologies and battled piracy by reshuffling the distribution windows, shrinking each window's time period, adding anticopying encryption to DVDs, implementing antipiracy media campaigns, and initiating lawsuits against individuals making illegal downloads and copies. The MPAA is lobbying for support by the US government in negotiations with nations where much of the piracy takes place, like Russia, Ukraine, Malaysia, China, and Canada.[2]

Consumer demand plays a role—consumers want to watch new movies immediately, in the comfort of their own home, for as low a price as possible. Another component is price structure. Movies are priced according to media window, and region where they are sold. A film on DVD has a basic price range, as does a movie theater ticket, but those prices have nothing to do with the cost of making the actual product. Audiences will pay the same price for *Avatar*, produced for $237 million, as they will for horror movie *Get Out*, which cost $5 million to shoot. More expensive films must generate more revenue, just to break even.

The distributor structures the distribution agreement accordingly in an attempt to maximize revenue based on a variety of factors.

The Distribution Agreement

A distribution agreement is a legal document that assigns rights to distribute a film from the copyright owner, usually the filmmaker or producer, to a distributor. The agreement defines the scope of the licensed rights and the allocation of revenue from exploitation of the licensed rights between the parties. In addition, the agreement will specify the materials and film elements that the licensor must deliver to the licensee to enable the licensee to exploit the film.

A distribution agreement that is entered into before the completion of a film is commonly referred to as a "presale" or "pre-license" agreement. Such an agreement often provides that the licensee will pay the licensor a stipulated amount on delivery of all the film materials and elements. If the licensee is creditworthy the producer may be able to borrow against the licensee's promise to pay on delivery, using the loan proceeds to help finance the film. In the case of a studio-financed movie, there are two dominant models: the "negative pickup," where the studio agrees to pay for the film on delivery; and the production/finance/distribution model, where the studio cash flows the budget during production. In either case the studio winds up with all the distribution rights.

A distribution deal memo is a short-form contract that includes the main points of a distribution deal, serving as the basis for a long-form legal contract to be drafted later. Following is a list of items typically addressed in a distribution deal memo.

Table 6.1 Short-Form Distribution Deal Memorandum

1. Date
2. Licensee Name: (Distribution Company) Address Phone/Email/Fax
3. Licensor Name: (Production Company) Address Phone/Email/Fax
4. Film Details: Title/Director/Writer/Key Cast/Required Contractual Elements/Language/Format/Running Time/MPAA Rating/Budget/Deliver Date
5. Rights being granted: (which media rights are licensed) Theatrical/Non-theatrical/Videograms (DVD or other physical media)/Pay-TV/Free TV/ Wireless/Internet/Airlines/Ship/Other/VOD/PPV
6. Holdbacks: time separation between media
7. License Term: length of license being granted, start and end dates
8. Authorized Language(s): dubbing/subtitling
9. Territory
10. Disposition of Gross Receipts: (% of Gross to distributor as distribution fee)
11. Minimum Guarantee (if any)
12. Royalty % (for Videograms, physical media like DVD, Blu-ray)
13. Cross Collateralization: Combining revenue between various media, or territories, to offset Distributor risk.
14. Distribution Expense List
15. Buyout: _____% of the License Fee as a flat buyout of certain Rights, listed specifically.
16. Marketing Commitment by Distributor
17. Governing law and jurisdiction, arbitrating body
18. Parties intend to enter into a more formal long-form agreement, to be negotiated in good faith defining the terms set forth above and such other terms as are customary in agreements of this nature. Until such time as a more formal agreement is entered into, this deal memorandum shall constitute a binding agreement between the parties.

Deal Points

The terms of any deal struck between a copyright holder and the distributor are based, in large part, on the negotiating leverage between the parties. Studio-produced and -financed films will be distributed by the studio. Where a distributor is acquiring rights to a movie, the amount paid for the rights will be based on the revenue that the distributor believes can be generated by the film.

It is common for a distributor to make an upfront payment to the licensor on acquisition of the distribution rights. This payment, usually called a "minimum guarantee," will be recouped by the distributor out of the revenues earned by the film. The minimum guarantee is typically paid on delivery of the film, although under some circumstances it may be paid prior to delivery.

A producer may license all of a film's distribution rights to a single distribution company, or may separate the rights and license different rights to different distributor/licensees. If possible, a producer may pre-license (pre-sell, also known as presales) certain territories or media of a movie for financing, before it is made.

Distribution rights can be divided and licensed or sold separately by:

- media (theatrical, pay cable, TV, DVD, VOD, PPV, internet), and by
- term—limited periods of time (from months to years) or in perpetuity, and by
- territory (either by country or region).

Media. A distribution agreement will specify the media formats licensed under the agreement, including any of the following:

- Theatrical Distribution Rights: The right to exhibit the work in theaters open to the general public on a regularly scheduled basis where admission fees are charged to view films.
- Pay Television: Distribution via pay/cable, over-the-air pay-TV, master antenna, community antenna, closed circuit, multi-point distribution services and similar means where viewers pay for the right to watch the movie including hotel, motel, hospital, excluding free television.
- Free Television: Distribution via television broadcast, such as network and syndication television broadcasts, transmissions by over the-air satellite, and similar methods where the consumer is not charged a recurring access fee.
- Video-on-Demand: (VOD) allowing a viewer to request, for home or other non-theatrical viewing, a movie on a television or other screen that is sent via some signal directly to the consumer and not to the general public to watch at a specific time and place. It is distinguished from pay-per-view (PPV) where the consumer does not request a particular time and place.
- Internet Download—Transactional Video-on-Demand: TVOD allows the consumer to watch the film for a distinct fee at a time and place determined by the consumer and which is distributed by a platform charging the fee.
- Internet Streaming via Subscription—Subscription Video-on-Demand: In SVOD the consumer pays a fee to subscribe to a service that gives the consumer access to a library of works for a period of time for viewing at a time and place selected by the subscriber.
- Internet Download supported by ads—Ad-Sponsored Video-on-Demand: In AVOD a platform gives the consumer access to a movie, the cost of which is paid for by the advertiser. The consumer is not charged a fee. Similar to broadcast television, the advertiser pays for the programming in exchange for access to audience eyeballs.
- Videogram (physical formats such as DVD, Blu-ray, video tape, or other electronic storage devices), available for sale or rental.
- Semi-Theatrical, Non-Theatrical, Non-Traditional Theatrical. Exhibition of a film to audiences by companies who are not primarily engaged in the movie exhibition, such as educational, cultural, religious, and charitable organizations, film societies, film festivals, museums, hospitals, government agencies, and religious institutions.

The deal may also include any future media, known and unknown throughout the universe. A distribution agreement may also grant to the distributor ancillary and derivative rights. Ancillary rights refer to rights related to the content of a film—a novelization of the film, merchandising, or music publishing and sound-track rights. Derivative rights refer to the creation and exploitation of other works based on a film, and include remake, sequels and prequels, television series, and stage plays.

Term. Typical fixed license terms can range from 1 to 15 years or longer. The length of the term depends on the media format, the territory, and other deal terms such as the size of the minimum guarantee. An "all rights" deal with a significant minimum guarantee will tend to run longer, 10 to 15 years or more. Television license deals range from one to five years, and video and DVD, seven to ten years. When the licensing rights expire, the rights will revert back to the copyright holder, who then may relicense the rights.

Outside of studio-financed deals, a producer or filmmaker generally will not grant distribution rights in perpetuity. The agreement will also include provisions for a reversion of rights if a distributor abandons the film or in the event of other defaults by the distributor.

Generally, each media format will have a window of exclusivity during which subsequent format releases are held back from the market.

Territory. For American films, the domestic territory is defined as North America including Canada, and all other territory rights are designated as "foreign." Foreign rights are licensed by country or region. The country territory may include its former colonies and adjacent area where a common language is spoken. For example, French rights often include French-speaking Switzerland.

Each territory must be clearly defined in the distribution agreement. Where distribution deals cover multiple territories, it is common for the producer to request that there be no cross-collateralization, so that the accounting for each territory stands on its own, ensuring that the profit in one territory is not offset by losses in another. Cross-collateralization is the practice of pooling profits and losses from multiple territories or media in accounting, in order to offset revenue gains and loss. A distributor, on the other hand, will push for cross-collateralization between media and/or territories.

Common Elements

Exclusivity. First-cycle distribution agreements almost always convey a license that is exclusive, within the territory and media formats. Without exclusivity, licensors would be able to license competing rights to other distributors and third parties. Distribution agreements may grant the licensee the right to sublicense and assign rights to third parties within the territory and for the licensed media formats, enabling distributor/licensees to assign rights to other parties, such as television rights to a local broadcaster.

Revenue and Profit Definitions. The total money earned by one sale of a film typically does not go directly to the distributor. Instead, the distributor receives a portion of the sale, varying by media technology and geographic market. These are spelled out in the distribution agreement. Some of the terms commonly used in distribution agreements include: box office, the money received by exhibitors from ticket sales in movie theaters; and film rentals which is the amount received by the distributor from box-office revenues after the exhibitor takes its share; gross receipts, the combined revenues received by a distributor from all media exploitation of a film.

From film rentals, the distributor deducts its distribution fee, and then distribution expenses. After all deductions and charges against revenue are taken, any balance remaining constitutes net profits.

Certain parties involved in the making of a film, such as the director, star, or writer, may be entitled to profit participations; contingent payments based on a percentage of gross receipts (only for big players), adjusted gross, or net profits. Gross revenue is revenue prior to any distributor deductions. Adjusted gross is revenue minus certain distribution expenses, specifically spelled out. A diagram of the flow of money, and related terminology can be found in Chapter 9, Table 9.4.

The producer and all profit participants receive monthly or quarterly statements with an accounting of the film's financial performance to the date of the statement. Inevitably there will be judgment calls made in regard to certain accounting issues, such as, for example, the allocation to a film of television revenues from the license of a package of films. For that reason profit participants always ask for and receive, a right to have statements audited. Auditing the distributor's accounting records for a film costs a minimum of $20,000 but often pays for itself.

A distribution agreement will include an extensive and detailed list of required delivery items (see Table 6.2). Depending on the arrangement between the distributor and producer, the producer may be involved with certain aspects of the release strategy and marketing plan for a film. Once the film is in distribution, the producer will receive monthly or quarterly accounting statements, showing revenue earned by the film, fees, expenses, and recoupable amounts chargeable against the revenue, and the proceeds then due the producer, if any. The distribution agreement will typically give the producer the right to audit the distributor's books in order to verify the accuracy of the film's accounting.

Changes in Distribution: OTT, Convergence, Disruptors

New technologies force changes in distribution patterns, with seismic shifts occurring after the rise and popularity of certain technological developments: television; video; DVD; cable; and now streaming and download of movies over

Table 6.2 Film Distribution Delivery Requirements

1. Reel-By-Reel Fully-Filled M&E (6 channel if available) at 24fps with OPT & DIA guides.

2. MASTER FILE: A 2K or High Definition Uncompressed AVI File Sequence manufactured from a Quality Control-passing first generation 1080p HD Video Master or Digital Intermediate, delivered on a Firewire hard drive. The image on screen shall be in the original aspect ratio in which the Show was photographed. The audio tracks shall be fully-mixed and filled in the following configuration: Ch. 1 Stereo Composite English Left, Ch. 2 Stereo Composite English Right. Textless Section Backgrounds (including Main and End Titles and any scenes wherein textual information appears) shall be transferred at the tail, sixty (60) seconds after the end of the feature.

3. PROJECT FILE: Final Cut Pro or AVID file (including all sound files).

4. FILM ITEMS: All elements listed below, must be provided for both the Feature and Release Trailer. REEL-BY-REEL ENGLISH SUBTITLES in timecoded Text (*.txt) format.

VIDEO ITEMS: Masters must be provided for both the Feature and Release Trailer.

1. PAL 25fps and NTSC 29.97fps 4 × 3 Full Frame masters in the aspect ratio of 4 × 3 (1:33:1).
 If the feature was shot in a widescreen format, the 4 × 3 Full Frame masters must be either:
 a. Created via a "pan-and-scan" process; or
 b. Created via a "center extraction" process.

2. PAL 25fps and NTSC 29.97fps 16 × 9 Full Height Anamorphic masters on DBC.

3. 23.98fps and 25fps HIGH DEFINITION (HD) 16 × 9 Full Frame masters on a HD-CAM SR tape with: stereo composite on channels 1 & 2; stereo fully-filled music and effects tracks on channels 3 & 4; 5.1 printmaster on channels 5 through 10; and Dolby E 5.1 on channels 11 & 12.
 If Original Aspect Ratio (OAR) is DIFFERENT from the aspect ratio of the 16 × 9 Full Height Anamorphic master, the following items must also be delivered: (a) PAL 25fps and (b) NTSC 29.97fps Matted Anamorphic masters (preserving the OAR) on DBC; and (c) 23.98fps and (d) 25fps HIGH DEFINITION masters (preserving the OAR).

4. MPEG-2 files in PAL (720 × 576 pixels/min 5000/448 kbps) and NTSC (720 × 480 pixels/min 5000/448 kbps).

5. HI-DEF Quicktime files. 1920 × 1080p 23.98 ProRes HQ Self Contained QuickTime file.

6. BONUS FEATURES on a DVD video disk in both NTSC and PAL.

7. ENGLISH SUBTITLES in timecoded Text (*.txt) format.

A. All DBC and HD items must contain:
1. Composite stereo sound on channels one and two and isolated, fully filled music & effects (M&E) stereo tracks on channels three and four. This requirement extends to all features, trailers, and textless footage.

Table 6.2 Continued

2. Textless backgrounds of all sections of the Show where text is present, for both the feature and trailer.
3. Release Trailer at the end of each master.

B. PAL Digibeta masters must be created from a source of equal (or greater) resolution to native PAL resolution (625/50) and shall be delivered with EBU time-code with matching LTC and VITC on lines 17 and 19.

C. NTSC Digibeta masters shall be in Non-Drop Frame time-code with matching LTC and VITC on lines 12 and 14.

D. Each master element must be clearly and completely labeled on both the cassette/disc itself and its protective casing. Video elements should include exact length of entire program (and each subsection of the program, if applicable), video standard, aspect ratio (including anamorphic, full-frame, and/ or letterbox designation, if applicable), lines of vertical resolution, whether the program is progressive or interlaced, framerate, time-code type, time-code of program's start and end, indications of the location of trailer and textless materials, and audio channel configuration (including MOS designations for unused channels). Audio masters should include exact length of entire program (and each subsection of program, if applicable), framerate, time-code type, time-code of program's start and end, sampling frequency, and audio channel configuration (including MOS designations for unused channels).

E. All video masters should be free of subtitles, except when specified otherwise.

SOUND ITEMS: Continuous audio elements must be provided by Licensor to Distributor per below:
1. Sets of PCM or AIFF digital audio files that are synchronous with the framerate of all delivered video masters, broken down thusly:
 a. composite sound on 2 tracks in stereo
 b. dialogue on 2 tracks in stereo
 c. music on 2 tracks in stereo
 d. unfilled effects on 2 tracks in stereo
2. Sets of PCM or AIFF digital audio files of the 5.1 mix which are synchronous with the framerate of all delivered video masters, broken down thusly:
 a. the discrete 5.1 sound mix w/LT/RT
 b. the Fully-Filled 5.1 M&E mix w/Dialogue Guide and Optional
 c. the 5.1 mix encoded in DOLBY-E audio

ANCILLARY ITEMS: The following items must be provided in English
1. Contractual Credit Block with copyright information and required logos, in Microsoft Word format.
2. In Microsoft Word format: a treatment-length synopsis, a three-paragraph synopsis, a one-paragraph synopsis, and a one-sentence synopsis.
3. Production notes provided in Microsoft Word format.
4. Layered Key Art in Photoshop (PSD) format conforming to the following specifications:
 a. Size: eight-by-twelve inches (8" × 12") – at minimum
 b. Layout: no text should fall within a half-inch margin surrounding the artwork's four edges

continued

Table 6.2 Continued

 c. Orientation: vertical
 d. Resolution: three-hundred dots per inch (300 dpi)—at minimum
 e. Color Mode: CMYK or RGB
 f. Font files for all fonts utilized in delivered artwork

5. High-Definition Frame-grabs adhering to the following specifications:
 a. Cleared for unrestricted use
 b. A minimum of thirty (30) selects
 c. Resolution: same as source
 d. Color Mode: CMYK or RGB
 e. File format to be uncompressed TIFF
 f. A list of actor identifications for each frame-grab

6. Digital production photographs adhering to the following specifications:
 a. Cleared for unrestricted use
 b. A minimum of thirty (30) selects
 c. Size: four-by-six inches (4" × 6")—at minimum
 d. Resolution: three-hundred dots per inch (300 dpi)—at minimum
 e. Color Mode: CMYK or RGB
 f. File format to be Camera Raw, Photoshop (PSD), uncompressed TIFF, or high quality JPEG
 g. A list of actor identifications for each still
 h. A list of photographer credits for all stills

7. Lab Access Letter which shall be irrevocable for the duration of the active term.

8. Quality Control ("QC") Reports with an "approved" grade performed by a verifiably reputable lab as follows:
 a. 100% QC reports for all high definition masters
 b. Spot QC reports for all down-conversion masters derived from 100% QC'd high definition masters
 c. 100% QC reports for every standard definition master not created from a high definition master

9. Errors and Omissions policy maintained by Licensor for the Picture, if any, for three (3) years beginning within 30 days from the date of this Agreement. Copies of the policy and all endorsement must be delivered to Distributor. The Errors and Omissions insurance policy must name: Distributor and its owners, partners, subsidiaries, licensees, successors, distributors, or affiliated companies and each of their officers, directors, shareholders, agents, and employees as an additional insured. Coverage should include, but not be limited to, all EPK and DVD Bonus materials (including interviews, commentaries, out-takes, deleted scenes, "making of," behind-the-scenes and B-Roll footage. Such endorsement shall also include a statement providing Distributor with 60 days prior written notice in the event of a cancellation or material revision of the policy. The policy must provide limits of at least US$1 million per occurrence/US$3 million in aggregate and a deductible of no greater than ten thousand dollars ($10,000). The policy must provide coverage for occurrences during the term of the policy regardless of the date of claim. Licensor agrees to deliver a copy of said policy to Distributor not later than delivery of the Show.

Table 6.2 Continued

10. Complete chain of title Documents comprising the following:
 a. Copies of all agreements transferring rights to the screenplay and the picture, together with proof of payment for writing services, option payments, extensions of option payments and exercising of option payments;
 b. Complete statement of all screen and advertising credit obligations, defining and describing both the form and nature of the required credits and any restrictions as to the use of name and likeness, including licenses for all logos appearing on the billing block;
 c. Statement of any restrictions as to the dubbing of the voice of any player, including dubbing dialogue in a language other than the language in which the Show was recorded;
 d. Copy of the final approved shooting script;
 e. Copies of all licenses, including, but not limited to: fully executed master use and synchronization/performance music licenses; contracts; assignments and/or other written permissions from the proper parties in interest permitting the use of any musical, and other material of whatever nature used in the production of the Show;
 f. Copies of all agreements or other documents relating to the engagement of primary personnel in connection with the Show including those for individual producer(s), and the director;
 g. Clearly legible copy of the copyright registration for the screenplay(s) and the motion picture;
 h. Non-disturbance agreements signed by any person or entity (other than guilds) having a lien or encumbrance on any rights in or to the picture;
 i. Copy of the final credit determination from the Writers Guild of America if the screenplay was written subject to the WGA Basic Agreement.

11. Certificate of Origin should be an original copy notarized by the applicable governmental authority attesting to the country of origin of the Show and setting forth the following additional information: title of Show; Producer; at least two of the principal cast members; Director; year of production; and running time.

12. The dialogue continuity script must be a detailed subtitle spotting list of the completed Feature and Release Trailer conforming in all respects to and with the action and dialogue contained in the completed Show in form and condition suitable for submission to various censorship boards.

13. Music cue sheet (complete and accurate) to industry standards.

14. Clearly legible copies of fully executed agreements for all actors receiving credit in the main titles and/or paid advertising and all key production personnel (e.g., director, producer, writer, composer, department heads such as editor, director of photography, production designer, etc.).

15. A complete cast list indicating addresses for representatives and addresses used to report to the Screen Actor's Guild and indicating if the actor was engaged pursuant to the Screen Actor's Guild Basic Agreement or pursuant to another guild.

continued

Table 6.2 Continued

TRAILERS: The following trailers must be provided by Licensor to Distributor:
1. Release Trailer – approximately 90–180 seconds – to be included in all the delivery materials described above. The goal of this "Release Trailer" is to drive audiences to the Show. It is imperative that both the Sales Trailer and EPK be delivered to Distributor as soon as possible. If the Show has yet to be completed, Licensor shall use best efforts to deliver the Sales Trailer and EPK no less than 6 and 3 months, respectively, prior to the completion of the Show.

the Internet, also known as "Over-the-Top" content (OTT). Over-the-top content is a term used in broadcasting and technology to refer to film, TV shows, audio, and other media transmitted over the Internet without an operator of multiple cable or direct-broadcast satellite television systems.[3] OTT bypasses traditional distribution systems and "cuts the cord" from cable services or traditional TV broadcasting.

OTT

As mentioned in Chapter 1, OTT (content delivered via Internet without cable or satellite service) is a disrupter in cinema, and is the result of convergence in technologies and access to capital. As the newest technology, and wildly popular with consumers, the question now is where and how to insert OTT into the film distribution architecture without reducing revenue from the other modalities. OTT is affecting media on a large scale, not just the movie industry, but traditional television broadcasting and cable as well.

When there was only one way to see a movie, films could only be licensed to theaters. As new technologies emerged, movies were licensed or sold over and over again. The ability to separate distribution rights, by media window, time, and territory, gives distributors an opportunity to control how, where, and when a film is available around the world, phasing in audience access to, and maximizing awareness of, a film. When, and in what sequence, media windows are ordered affects and determines the ultimate revenue from a film. In light of high production and marketing costs, distribution companies are under great pressure to make back their investment as quickly as possible, encouraging experimentation with the traditional ordering and separation of windows.

A single distribution company, such as a Hollywood studio, may control all of the rights to a film, or different distribution companies may control select rights, such as foreign or domestic, television, or DVD.

The producer's challenge, in addition to finding financing and successfully completing the film production, is to license film rights to a distributor or distributors who will successfully release the film into the marketplace, maximizing the possibility of commercial success. Distribution deals for a film may be made before, during, or after the film's completion, and are often linked to a film's

financing, since many films are financed by licensing distribution rights prior to production.

Film distributors may own the copyright and exploitation rights to a film directly, as is the case with most major studio films, or may license these rights from the copyright owner, who may be the producer or financier of the film.

The principal business of the studios today is distribution. Studios finance movies in order to acquire and control the distribution rights, and generally directly distribute (license and sell) these rights worldwide, without the use of intermediate distributors or sales agents, to users such as movie-theater companies (like AMC Theaters and Regal), internet streaming and download platforms (Amazon, Netflix, iTunes, YouTube, Vimeo), DVD rental companies (Netflix, Redbox, Family Video), DVD retailers (Wal-Mart, Target, Best Buy), television broadcasters (HBO, Showtime, TNT, independent stations), and their counterparts outside the United States.

Non-studio distributors—companies like Lionsgate, Magnolia Pictures, A24, Oscilloscope, Zeitgeist Films, Strand Releasing, and Koch Lorber Film—will generally acquire the exploitation rights from the copyright owners (producers) for specific media and/or territories, and then sublicense these rights to the "end users" (theaters, TV broadcasters, video and DVD distributors and retailers, and so on). Distribution companies make their money by charging fees to the licensors and, if they have partially or fully financed the film, from their share of the profits. In cases where the distributor acquires rights for a cash payment (a "minimum guarantee") the distributor's fees may include a share of the profits from the media and/or territories licensed by the distributor.

Distributing movies has become more complicated, due to the larger number of possible outlets. This market fragmentation increases dependence on distributors. The big distributors have an advantage due to their global reach and only large distributors have established relationships and efficient access to hundreds of movie theaters, cable channels, and foreign markets.

As with much of the film industry, distribution is dominated by the Hollywood studios. Of the 718 movies released theatrically and otherwise in 2016, 133 were released by the studios, generating 58 percent[4] of the $38.6 billion of global box office. A total of 585 were released by non-studio distributors. The studios accounted for 87 percent of revenue from 2016 domestic film distribution,[5] while independent non-studio film distribution generated approximately $4 billion in revenue.

Beginning in the 1990s, the studios started specialty divisions to handle films other than mainstream big-budget movies, as a way of "branding" aimed at niche audiences. For example, Universal Pictures distributes mainstream films, and its division Focus Features handles smaller-budget pictures for more of a niche audience.

The Major Distribution Companies

There are two levels of movie distribution companies, the six large Hollywood studios, and the much smaller distributors, with a few firms in between. The studios, with access to capital, a global marketing network, and relationships with theater chains that depend on the studios for a steady stream of product, have a distinct advantage in reaching the broadest consumer base. Anyone can produce a film if they can finance it, but it is the distribution arms of the studios that largely determine whether a film will reach a wide audience. After the Paramount Consent Decree of 1948 forced most studios out of the theater business (see Chapter 2), and the advent and growth of television in the 1950s, studios gradually shifted from the vertically integrated model that had prevailed since the early days of the industry, to a model relying more on independent producers and production companies providing films to the studios. The studios' role became more like that of banks, providing the financing for films, whether they originated at a studio level or from an independent production company, in exchange for distribution rights.

Functioning parallel to, and in the shadow of, the majors are numbers of independent distribution companies. Lionsgate, STX Entertainment, Open Road Films, and A24 are among the bigger players in the indie distribution business, releasing a significant number of films, some with large budgets. Many smaller companies, like Cohen Group, Cinema Libre, Zeitgeist Films, First Run Pictures, Palm Pictures, and Strand Releasing operate in this space, releasing fewer films, aimed at niche markets, such as audiences interested in documentaries or foreign films. Independent distributors may brand their companies by distributing a certain type, or quality of film, or by marketing to a target audience. By necessity, independent distributors release fewer films than studios, generally with smaller budgets, and are discerning in which films they choose to distribute, since the capital invested in any one film represents a greater financial risk to an indie than does a single film to a studio.

Independent distributors provide film audiences with richness and variety, taking risks with stories and themes that the studios avoid (such as films like *Searching for Sugarman, Nymphomaniac, Human Centipede, Tangerine, The Neon Demon, Spotlight, Where To Invade Next*). Independents often help launch talented filmmakers who go on to illustrious careers, such as directors Spike Jonze, Cameron Crowe, Daron Aronofsky, and the many noted filmmakers—Matt Stone, Trey Parker, James Gunn, who were helped along by Lloyd Kaufmann's Troma Studios, and Francis Ford Coppola, Ron Howard, and James Cameron—who worked on films distributed by New World Pictures, run by the well-known B-film filmmaker Roger Corman. The studios have sought to replicate the success of some of the largest independents, by establishing independent distribution divisions—like Paramount Vantage, Fox Searchlight, Sony Pictures Classics, Focus owned by NBCUniversal—or by acquisition, with Disney buying Miramax and Universal buying Good Machine.

Each of the six studios is part of a corporate conglomerate, with a global reach and vertically and horizontally integrated holdings spanning film, television, magazines, cable, internet portals, newspaper, book publishing, and radio outlets, providing cross-marketing opportunities for their films. Of the $11.4 billion generated in domestic box office in 2016 reported by the MPAA, Disney led in market share (see Figure 6.2). Together, the studios, with Lionsgate, generated 90 percent of industry revenue.

As discussed earlier in the text, the Hollywood studios have dominated the film industry since its early days. In addition to servicing the theatrical and ancillary film markets, all the major distributors have divisions engaged in licensing and merchandising, music, international distribution, and television and home entertainment production and distribution. The studios' domestic trade organization, the MPAA (Motion Picture Association of America) has an international counterpart, the MPA (Motion Picture Association), and both represent the collective interests of the studios.

Each major distributor also has ongoing relationships with independent production companies that supply the studios with product, and long-term relationships with the major theater chains.

Warner Bros./New Line. Warner Bros. Pictures is owned by Time Warner, which is in negotiations to merge with multinational telecommunications conglomerate AT&T at the time of this writing. Warner Bros. Entertainment distributes films through Warner Bros. Pictures, New Line, Warner Bros. Home Entertainment Group, Warner Bros. Digital Distribution and Warner Home Video, New Line Cinema; and owns movie studio Castle Rock Entertainment and comic book company DC Entertainment, and video games through Warner Bros. Interactive, as well as movie theaters Warner Bros. International Cinemas.

Anticipating the opening of the Chinese market the company opened an office in Beijing, Warner Bros. China, and formed a joint venture, Flagship Entertainment, with a local company to produce Chinese language films.

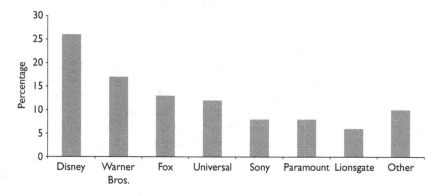

Figure 6.2 2016 Studio Market Share.

Warner Bros.' library consists of 79,000 hours of programming, including nearly 7,400 feature films including the successful *Harry Potter* series, as well as *Inception, The Hangover, The LEGO Batman Movie, Kong: Skull Island, Wonder Woman, Dunkirk, The LEGO NINJAGO Movie, Justice League,* the *Annabelle* franchise, and *It,* according to the company website.

Paramount is a subsidiary of Viacom, which is owned by theater chain National Amusements. Paramount produces and distributes films through Paramount Pictures, Paramount Animation, Paramount Classics, Insurge Pictures, MTV Films, Nickelodeon Movies, and Paramount Vantage; distributing movies on video and DVD through Paramount Home Entertainment.

The company maintains the Paramount Pictures library of some 3,300 films, including classic hits from the *Star Trek, Godfather,* and *Indiana Jones* series, as well as several franchises: *Transformers, Mission Impossible, Teenage Mutant Ninja Turtles, Paranormal Activity,* and *Captain America.*

Paramount Pictures International is responsible for marketing and distributing Paramount movies to audiences around the world. The company secured a $1-billion deal with Huahua and Shanghai Film Group to co-finance movies over a three-year period; however, it hit a snag when Chinese companies missed a payment in 2017, possibly caused by flops (*Baywatch, Ghost in the Shell*) that the companies collaborated on.[6] Paramount's parent company Viacom is aggressively pursuing expansion into European markets with a SVOD platform (subscription video-on-demand) combining movie and television properties in the Paramount library, according to the company website.

Walt Disney Studios. The Walt Disney Studios is the motion picture arm of Walt Disney Company, which also owns the American commercial broadcast television network ABC, broadcast, radio, cable properties, and theme parks. Walt Disney Studios produces and distributes live action films through imprints Walt Disney Pictures, Buena Vista (*Pirates of the Caribbean* franchise, *Chicago*), Hollywood Pictures, children's and animated films brand Pixar (*Toy Story, Cars*), Marvel titles (*Iron Man* and all of the Marvel comic properties), LucasFilm (*Star Wars* franchise films such as *Rogue One: A Star Wars Story*), Touchstone Pictures (*Armageddon, The Prestige*), and independent artistic profile films under the Miramax label (*Shakespeare in Love, Cold Mountain*). Disney also distributes scores of classic animated family films such as *Snow White, Pinocchio,* and *Fantasia,* and non-animated films like *Signs, Santa Clause 2, Scream,* and *Spy Kids.* Disney's acquisitions of Pixar (cost $7.4 billion) and LucasFilm ($4 billion) extended their properties with extensive merchandising, theme parks, and video games, according to the company website.

The company's film and television library consists of 30,000 hours of content. Disney has expanded internationally, with theme parks in Europe, Japan, and Shanghai; acquiring 50 percent of UTV, India's leading entertainment company, in order to access the large Indian audience. Disney entered into coproduction partnerships with Chinese companies Jiaxing Media and Wudi Pictures to co-develop films targeting the massive Chinese movie market.[7]

Sony. Sony Pictures Entertainment is the movie production and distribution unit of the electronics company Sony. Sony Pictures operates Columbia TriStar Motion Picture Group, which includes Columbia Pictures (big-budget films); Screen Gems (midsized budget); Sony Pictures Classics (small budget); and marketing and acquisitions unit TriStar Pictures. Its film library contains more than 3,500 titles, including classics such as *Bridge on the River Kwai* and *Lawrence of Arabia*, as well as DVDs (Sony Pictures Home Entertainment), digital production (Sony Digital Production), and online video (Crackle).

Sony's franchises include *Smurfs*, *Spider-Man*, *The Da Vinci Code*, and *Men In Black*. Sony was a force behind the Blu-ray high-definition DVD format, and part of an investor consortium that owns Metro-Goldwyn-Mayer (MGM) with a large library of movies and franchises including *James Bond, Pink Panther*, and *Rocky*. Sony is moving into the Chinese market partnering with Wanda Company in exchange for film financing, according to the company website.

Universal. Universal Pictures is the filmed entertainment arm of media conglomerate NBCUniversal owned by cable giant Comcast. Universal Pictures is a film studio responsible for *Harry Potter, The Fate of the Furious, The Bourne Identity, The Secret Life of Pets*, and *Jurassic World*. Recent releases include *Bridesmaids, Girls Trip*, and *Despicable Me 3*. Through its Focus Features imprint, the company also produces lower-budget specialty films including *Darkest Hour, Phantom Thread*, and *Coraline*. Universal Pictures is part of Universal Studios, which also operates theme parks under the Universal banner through Universal Parks & Resorts.

Universal has a substantial library of 4,000 titles, and the NBC Universal On Demand business, which makes NBC Universal films available for viewing via video-on-demand and pay-per-view. Universal has taken a minority interest in Stephen Spielberg's company, Amblin Partners. Expanding internationally, Universal has opened an office in China and is launching a Chinese theme park in Beijing. Universal Pictures is disengaging from Oriental DreamWorks, the animation group, following disagreements with Chinese partners, according to the company website.

Fox. 20th Century Fox Film Corporation is owned by 21st Century Fox. 20th Century Fox Film produces, acquires and distributes motion pictures throughout the world through 20th Century Fox, Fox 2000 Pictures, Fox Searchlight Pictures, Fox International Productions, and 20th Century Fox Animation. Fox movies include *Avatar, X-Men, Planet of the Apes, Deadpool, Alien, The Simpsons*, and *The Kingsman*. 21st Century Fox was spun off from News Corporation, and retains film and television properties, separated from the publishing divisions. In addition to several television subsidiaries, Fox holds 30 percent of the online platform Hulu and has a 39.1 percent ownership interest in Sky, Europe's leading entertainment company.

Lionsgate produces and distributes films and television shows, with a library of more than 16,000 movies and television titles. The company owns 43 percent of production studio Roadside Attractions, and all of Summit Entertainment—which

created the lucrative franchise *Twilight*. Lionsgate gained prominence by creating highly profitable content for niche audiences, then going on to cash in on the popular *Twilight*, *The Hunger Games*, and *Saw* franchises. Lionsgate has not yet reached the scale and scope of the major studios, but is well on its way, performing in the top market share in box office in the past five years. The company is both horizontally and vertically integrated and, in addition to movies, offers a variety of content on several platforms spanning VOD, broadcast, cable, interactive, digital, DVD, music, publishing, and video games. Among many others, subsidiaries include Starz and a variety of global holdings such as Celestial Tiger (according to the company website).

Evolution of Film Distribution

The dominance and profitability of the film studios from the 1920s to the 1950s were based on several factors: vertical integration with control over production, distribution, and exhibition; the economic advantages of the studio system, retaining directors, writers, and stars as salaried employees; and, not least, the fact that movies had no competition for the "eyeballs" of the public. With the advent of sound in the 1920s, many smaller independent chains or single theaters closed, consolidating the power of the studios. The decade of the 1930s was the heyday of the theatrical business as measured by yearly admissions. Weekly cinema attendance in the United States in 1930 was 80 million, 65 percent of the US population. By 2016, weekly attendance had declined to 25 million, approximately 8 percent of the population, reflecting the vast growth of television and computer technologies as alternatives to movies for the interest and attention of the consumer. The following chart illustrates movie admissions from 2007 to 2016 (see Figure 6.3).[8]

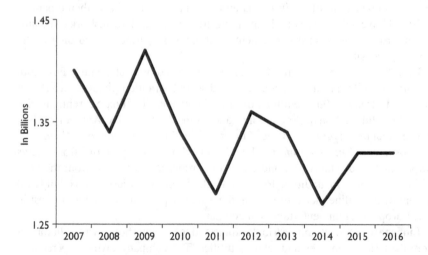

Figure 6.3 US/Canada Admissions, in Billions, MPAA.

During the boom period of the 1930s, the studios released a steady stream of films, with each studio releasing a new film every one or two weeks. By 2016, the average output of a studio had dropped to 20–25 films a year.

With the beginnings of television in the 1950s, and the first threat to the studios for the "eyeballs" of consumers, an industry behavior pattern emerged. Certain the new technology would undermine their business, the studios first attempted to destroy or circumvent it. When these attempts failed, the industry then figured out how to turn the technology to its own advantage, and then ultimately took it over. This pattern, repeated with cable TV, and video and DVD, is currently playing out over OTT and other new platforms that directly link the viewer to the filmmaker.

Today, the means available for exploitation of a film include: theatrical and enhanced theatrical versions such as 3D, 4D, and IMAX; non-theatrical and ancillary, including airlines, ships, military bases, universities, film clubs; pay-per-view, including in-hotel systems and video-on-demand systems; DVD, Blu-ray; public video theaters; pay television, network television; free television, including basic cable; and internet streaming and download sales online.

Movie theaters remain the preferred and exclusive first window for release, to generate awareness and buzz that cascades over all other windows of distribution. However, consumer demand, the pressures of competing entertainment, and piracy are pushing all of the windows up and closer together. A variety of companies are experimenting with simultaneous release in video-on-demand and theaters.

Theatrical Distribution

Theatrical exhibition has traditionally been the engine that drives all of the other distribution windows. A successful theatrical release can maximize revenue in the aftermarkets, and even a modest theatrical run generates awareness for a film that will increase overall revenues.

In planning a theatrical release the distributor has three key decisions to make: the pattern and size of the initial release; the timing of the release; and the advertising spend to support the release.

Theatrical Release Patterns

There are four types of theatrical release patterns for a movie. Which pattern to use depends on a variety of factors, including competition from other films, the target audience, film genre and rating, time of year, available budget for prints and advertising, and the film's budget, stars, and marketable elements. The release patterns are wide—nationally on 600 or more screens; limited—several hundred screens with the intention to widen the release within a few weeks if the film performs well; platform—opening the film slowly in a few key cities on a handful of screens (for example, New York, Los Angeles, Paris, London), then

gradually expanding the number of cities and screens; and four-wall—renting a theater to exhibit a film without a distributor. An exclusive opening, to introduce a platform or limited release, is the release of a film on ten or fewer screens, particularly suitable for foreign and independent films with a small niche audience.

A wide release is the pattern of choice for large-budget films that have broad, national appeal based on genre and talent elements. Examples of wide releases include *Rogue One: A Star Wars Story* (2016; 4,157 screens), *The Secret Life of Pets* (2016; 4,381 screens), and *The Fate of the Furious* (2017; 4,329 screens), according to Box Office Mojo. As a further refinement of the term "wide release," the trade publication *Variety* characterizes a release into 600–1,999 screens as "wide," and on 2,000-plus screens as a "saturation" pattern. For select films that will receive the widest releases, distributors may also plan 3D or IMAX screenings as well, enabling them to charge a higher price point for essentially the same product.

The major studios seek to make spectacular events out of the saturation openings of these tent-pole movies. Saturation openings generate substantial box-office revenue quickly by virtue of the size of the opening and the advertising campaign that supports it, ensuring some minimum revenue even if the film receives poor reviews and weak word-of-mouth support. The advertising and publicity campaign also helps create some momentum that will keep even a poorly received movie in the theaters for at least a few weeks. The wide-release pattern is also used when a studio believes it has or can create a successful franchise: a film brand that can generate sequels and attract a loyal audience, and that can be cross-marketed on a wide variety of platforms, such as product merchandising, video games, theme-park rides, music soundtracks and songs downloads, stage plays or musicals, television shows, and the like. Recent examples include the *Harry Potter* series with Time Warner's announcement of a Harry Potter theme park,[9] the *Pirates of the Caribbean* franchise, as well as the *Spider-Man* and *Shrek* movies. A wide release can also be used to quickly bury a bad movie, like *Battlefield Earth*, selling as many tickets as possible before the audience realizes the film is not very good.

The best times of the year to release big-budget, event films are the end-of-year holiday period (Thanksgiving through Christmas), and the summer (May through August). In recent years, this has resulted in the studios releasing more tent-pole films closer together during these periods, with each film having to earn big box-office grosses before it faces competition and its grosses begin to drop off, placing more pressure on a film's opening weekend performance. "Opening weekend" box-office figures are now routinely published in most major news publications and on television news programs, with the power to influence audience choice and subsequent box-office revenue, positively if the figures are good, negatively if the figures are bad. The opening weekend figures can even impact the share price of the studio's parent company.

Summer is a critical period for the movie industry, generating 40–50 percent of annual box office. In 2017, virtually every studio released one or two tent-pole

films, in wide release during the summer season, with many of the films' opening weekends hot on each other's heels. More than two-thirds of the films were sequels, remakes, part of a franchise, or based on popular books, toys, or games. The following graphic shows movies released wide throughout Summer 2017 (see Figure 6.4).

In spite of big-budget franchise films meant to reduce risk, the Summer 2017 box office was the worst in ten years, failing to top $4 billion for the first time since 2006.[10]

A limited release might entail an exclusive one- or two-city opening week, to give the film a special-event feel and hopefully generate some good critical reviews, then jump to several hundred screens within a few weeks, and then,

May Weekends

1	Guardians of the Galaxy Vol. 2
2	King Arthur: Legend of the Sword, Lowriders, Snatched
3	Alien: Covenant, Diary of a Wimpy Kid, Everything, Everything
4	Baywatch, Pirates of the Caribbean: Dead Men Tell No Tales

June Weekends

1	Wonder Woman, Captain Underpants
2	The Mummy, It Comes at Night, Megan Leavey
3	Pixar's Cars 3, 47 Meters Down, All Eyez on Me, Rough Night
4	Transformers: The Last Knight
5	Baby Driver, Despicable Me 3, The House

July Weekends

1	Spider-Man: Homecoming
2	War for the Planet of the Apes, Wish Upon
3	Dunkirk, Girls Trip, Valerian
4	Atomic Blonde, The Emoji Movie

August Weekends

1	The Dark Tower, Detroit, Kidnap
2	Annabelle: Creation, The Glass Castle, The Nut Job 2
3	The Hitman's Bodyguard, Logan Lucky
4	Birth of the Dragon, Leap! Terminator 2

Figure 6.4 Wide Movie Releases Summer 2017.

if successful, to a thousand or more screens. If an "exclusive opening" strategy is not followed, then the film will open simultaneously nationwide in a few theaters in each of a limited number of major urban markets, with a similar further rollout, if successful. This release pattern is suitable for genre films (action-adventure, thriller, comedy) that have some marketable talent elements, but are not high profile enough to support a truly wide release, and it allows the distributor to limit its print and advertising spend until the film has proved itself in the marketplace. Examples of successful films that received a limited release are *Spotlight* (2015), *Lion* (2016), *Manchester by the Sea* (2016), and *The Zoo-keeper's Wife* (2017).

The Imitation Game, which went on to win an Academy award for Best Adapted screenplay, opened in four theaters on its opening weekend in 2014, ultimately rolling out to 2,402 screens and grossing $228 million in revenues worldwide.[11]

A platform release or exclusive run will start off with one or two "exclusive" openings in a major city like New York or Los Angeles, in the hopes that it will attract favorable reviews, media buzz, and generate word-of-mouth support. The release then may be widened, to perhaps 150–200 screens over a several-week period and, if successful, additional screens will then be added. Platform releases are generally used for a specialized film that needs an extended run to build audience interest and support. Examples of successful platform releases include *The Color Purple, Driving Miss Daisy*, and *The Piano*.

One of the most carefully calculated platform releases, *Tinker, Tailor, Soldier, Spy*, opened strongly on four screens in New York and Los Angeles in December 2011. Additional theaters were added later in January, to 57 screens, then jumping to 886 screens, reaching an outstanding $6,772 per screen average. The film went on to win a BAFTA award for Best British film, and was nominated for an Academy Award for Best Actor, going on to ultimately gross $80 million worldwide, being in theaters for a long run.[12] A platform release conserves marketing expenses while establishing its performance.

A four-wall release is the practice of a producer renting a theater or two in order to have some kind of theatrical release, whether to qualify for awards or to experience their movie on the big screen.

Timing the Theatrical Release

The timing of a film's theatrical release is a critical strategic decision. There are several key factors that come into play: the target audience; the time of year; competition from other films; key film awards; and film festivals.

The summer and the end-of-the year holiday season are the strongest periods for movie-going in the United States and generally throughout the world. These are the times when most big-budget "event" or "tent-pole" films, and films aimed at school-age children, will be released. These are also the most competitive periods in terms of the number and size of releases. While these peak periods

can be difficult competitively for smaller-budget independent films with smaller marketing budgets, there are also opportunities to "counterprogram" by releasing a film that might appeal to a different audience than that attracted to big-event films. Examples include the May 2007 weekend, when the PG-13-rated *Pirates of the Caribbean: At World's End* opened, and Lionsgate positioned an R-rated horror picture, *Bugged*, as a gory, buggy alternative to the Disney favorite, as well as the 2008 summer film *Mamma Mia!* opening opposite the latest Batman film, *The Dark Knight*.

The periods of the year from January to March and from September to October are not considered optimal release times for big-event movies, but smaller, more narrowly targeted films may open well during these months. Studios often use these periods to release films with uncertain prospects, for which they want to spend less on advertising.

Positioning the release of a film around a major award event or a film festival, such as Cannes or Sundance, can also be a good strategy, particularly for an independent film, such as *The Blair Witch Project*, which debuted at Sundance in 1999, and *The Piano*, successfully released after it won major awards at the Cannes Film Festival in 1993. Michael Moore's film, *Sicko*, was screened at the Cannes Film Festival before its summer 2007 release in the United States, earning early buzz worldwide.

When a film has received an Academy Award, or even a nomination, it may be rereleased into the theaters, such as *The Departed* (2006 rerelease), *Crash* (2006 rerelease),[13] and *Chicago* (2003 rerelease).[14] According to a 2001 study, a Best Picture nomination can garner an average of $11 million in ticket sales for a film between the day the nominations are announced and the Oscar™ telecast.[15]

Competition from Other Films. Distributors are fully aware of their competitor's release schedules, and, if possible, try to avoid head-to-head competition for the same audiences. It is not uncommon for a distributor to change the scheduled opening date of a film to avoid direct competition with a bigger, more heavily supported film, although release dates are generally set months in advance and cannot be changed easily. Also, delaying the release date creates negative "buzz" around a movie.

Distribution Budget/Prints and Advertising

Releasing a film is a very expensive proposition. Depending on the type of film and the theatrical release pattern, the cost of a movie opening wide can easily run into many millions of dollars. The average studio film expenditure on prints and advertising (P&A) in 2017 was about $48 million.[16] Most independent non-studio distributors simply do not have the resources to match the studios' P&A budgets. Access to large amounts of capital from a parent company, and an annual output of approximately 20 films, enables the studios to ride out flops, until the next hit comes along. Small distribution companies, releasing fewer

films, take a bigger gamble with each film, usually without backup financial resources.

The two major expenses in opening a film theatrically are advertising—wide-release films with large budgets require big advertising campaigns to create awareness and even smaller releases can require millions in advertising spend—and virtual print fees, payment in lieu of the cost of actual film prints. Virtual print fees go toward covering the cost of converting the theaters to digital format.

Opening Weekend

A film's opening weekend has always been a strong predictor of ultimate success or failure, and is the focus of a large share of a distributor's advertising spend and public-relations efforts. In the weeks leading up to an opening weekend, media data companies, like Box Office Media, Nielsen, OTX, comScore, and MarketCast provide the distributor with data on public awareness of all the movies to be released, using phonecall surveys to track and gather information. Once the film opens, Exhibitor Relations, Nielsen, Screen Engine, CARMA, and Rentrak gather and submit data to the studios, and within hours, a distributor has a fairly accurate picture of what the film's opening weekend numbers will be. The public tracks opening box-office figures through newspapers and television news shows, and may use the figures as a barometer to decide whether they should go see a particular movie.

Given the importance of the opening weekend box-office numbers, and the momentum that a successful theatrical release can give to the aftermarkets, most of a movie's marketing budget, generally about 80 percent, is spent on opening the film in theaters. Typically, films open on a Friday, and by Monday morning, distributors have detailed financial information about the film's performance, and must decide whether to continue to support the film with additional advertising, or to cut their losses and begin to scale back the ad campaign. It is relevant to note that distributors do not receive all of the box office, that money is divided, split roughly in half between distributors and theaters. The details of these contracts are more clearly spelled out in Chapters 8 and 9.

Weekend box-office figures are reported in most newspapers and magazines, news programs, and on numerous websites. Publicity around movie earnings has reached global proportions, with websites devoted entirely to movie information, such as www.imdb.com, www.boxofficemojo.com, and www.the-numbers.com, frequented by film industry professionals and the public alike. While opening weekend numbers may appear to yield impressive numbers, these figures can be misleading. The best measure of a film's opening weekend performance is not the total box-office gross, but rather the per-screen average: the average box-office take for each screen on which the film appears over the opening weekend.

For example, two films that opened on the same weekend—11/24/2017—reported similar box-office results. *Daddy's Home 2* earned $13,217,419 and

Table 6.3 Comparison of Per-Screen Average

Films	Box Office	Theaters	Per-Screen Average
Daddy's Home 2	$13,217,419	3,518	$3,757
Murder on the Orient Express (2017)	$13,170,932	3,152	$4,179

Murder on the Orient Express, $13,170,932, according to Box Office Mojo. At first glance, *Daddy's Home 2* appears to have performed slightly better. However, comparing the per-screen average reveals that *Murder on the Orient Express* was actually more successful.

The opening weekend per-screen average is key to a distributor's decision whether to continue supporting the film with more advertising, or to begin to cut back. As a rough rule of thumb for a wide release, an opening per-screen average of under $4,000 is a sign that the film is not working. An average of over $8,000 is a strong opening and indicates that the film is working with audiences and should be supported with a continuing advertising campaign. An opening average between $4,000 and $8,000 requires a more fine-grained analysis of the opening weekend: What markets did the film perform well in, and what audiences did it attract? Based on such an analysis, the distributor can continue to support the film, but better target its advertising to the markets and audiences who responded to the movie on the opening weekend.

Another key indicator of a movie's performance and prospects is the drop-off in box office between the opening weekend and the second weekend. A drop of up to 30 percent in box-office revenues from the first to second weekend is not uncommon for big tent-pole films. A drop of over 50 percent is a signal that the film is likely to have a short life in the theaters, and the marketing spend should be adjusted accordingly. Again, as with the per-screen average, a drop of between 30 percent and 50 percent requires a more intense analysis by the distributor of the strengths and weaknesses of the movie before deciding on the ongoing level of advertising support.

There is some relationship between the marketing budgets and production budgets, with marketing budgets calculated at approximately half of the production budget. Higher budgets demand higher marketing expense. Big-event movies with budgets of $500 million and up commonly have global marketing budgets of $150 million and can double that.[17]

The size of the marketing budget also corresponds to the size of the theatrical release—a film that opens on 1,000 or more screens will require at least 1,000 files of the movie to be sent to the theater, and will entail extensive and expensive national advertising support in the form of network television commercials.

The convergence of marketing on social media platforms has created more innovative and cheaper possibilities for marketing movies, and has also given consumers more direct ways to share their "word of mouth," influencing their friends quickly as to whether to go see a film in theaters. With more choices,

consumers often skip the theater release. The studios are pushing for a new "window" which would let you see a new movie at home, for an extra fee, before the standard 90-day waiting period after it opens in theaters. To add more pressure, Netflix is building a straight-to-streaming library of movies, which could theoretically compete with ones that are in the theaters, and is projecting making 40–50 new movies per year.[18]

Costs of Distribution

Currently, marketing costs for studio films average $45 million. These costs are borne by the distributor but are recoupable from film revenues. The producer may negotiate for a minimum marketing and advertising commitment—a floor to ensure that the distributor spends enough to give the film a chance to succeed, but distributors are reluctant to agree to a minimum spend, and rarely do so.

Since the distributor's cost of doing business is substantial, a producer may seek to impose a cap on distribution expenses—a ceiling, since these expenses will eventually be paid from the revenues of his or her film. A producer will often seek to limit marketing expenses to the first year of release, and capped per market. Promotional expenses should be limited to direct out-of-pocket costs spent on promotion of the picture, and should exclude distributor overhead and staff, since these expenses are covered in the distribution fees.

Each distribution deal is unique to an extent, customized for a specific film, and shaped by the needs of the parties involved, the leverage each party can bring to bear on the deal (usually in favor of the studio), and the marketplace conditions. The facts of life are that in dealings with the studios, most producers have very limited leverage and have to accept the "standard" terms offered to other producers. Exceptions would be in cases of a powerful producer, like Steven Spielberg, or Jerry Bruckheimer, or a potentially "hot" film being chased by more than one studio.

Convergence

There has been a tremendous amount of convergence—that is to say merging—in the film industry in the past decade, in every phase; production, financing, distribution, and exhibition—due to digital technology, the prevalence of personal computers, smartphones and tablets, an increase in broadband speed, expansion and accessibility of the Internet.

Convergence is traditionally defined as moving toward a union, or coming together, but can be further understood to be a flow of content across multiple media platforms, cooperation between multiple media industries, and the migratory behavior of media audiences. The meaning of the word is growing to include technological, industrial, cultural, and social changes; not merely technological, and may also include active audience behavior. Therefore, convergence is a combination of distinct media technologies, functions, and media forms resulting.

Convergence in production has happened thanks to digital technology, embraced by the prominent companies and electronics leaders in the 1990s, such as Apple, Avid Technology, Kodak, Sony, Canon, Nikon, Arri, and Panasonic. These companies flooded the market with means of production, shooting, and editing, in digital formats. Once digital production and editing became the norm, millions of consumers were making their own videos and films. At the studio level, production has shifted primarily to digital away from film.

Distribution on the Internet gives creators a way to share their work, and the creation of YouTube in 2005 offered an easy way for creators to upload their movies. While the majority of commercial movies are not shot on phones and tablets, with *Tangerine* (2015) being one exception, the capability is there and the trend is going in that way. Movie production is furthered by the rise in popularity and affordability of mobile phones, personal computers, and tablets, putting production in the hands of (almost) everyone. The majority of tablets and smartphones now have video cameras so that anyone with one of these devices can make a film. There are an increasing amount of apps to edit, color, enhance sound, to improve the films, as well as peripheral equipment such as additional lenses and tripods.

Convergence in film financing includes crowdfunding where filmmakers can build fan-bases directly and appeal to them to finance, then help market, their movies. Crowdfunding platforms merged with high-speed internet to show video trailers online, and the financial technology to securely pay online, and the ability to cross-promote through social media. Crowdfunding has increased as a viable funding method for movies. Successful films including *Super Troopers 2* ($4.6 million raised on Kickstarter), *Iron Sky* ($656,371 on Indigogo), and *Ordinary Women* ($200,000 on Seed & Spark) are all crowdfunded films. Some have gone on to win an Oscar™ (*Inocente*, best documentary short, 2013) and get shortlisted for an Oscar™ (*The Fencer*, nominated for best foreign-language film, 2015).

Distribution online is the convergence of the digital revolution, high-speed internet, and companies investing heavily in the infrastructure to show and sell video content via streaming and downloading. Once theaters were converted to digital projection, distributors benefited from that in several ways. Distributors no longer have to pay for and ship 35-millimeter prints of a film, they can send a DCP (digital cinema package), saving money except for the virtual print fees. Distribution technology has also advanced rapidly in recent years, with more flexibility in booking and programming entertainment, while also offering the ability to screen higher-priced 3D films. Distribution works in tandem with exhibition. Theaters have replaced film projectors with digital systems, eliminating movie prints altogether; theaters store movies on digital hard drives and may also install satellite systems to receive movies digitally. The transformation to digital cinema projection in theaters, led by the 1999 release of *Star Wars: Episode I—The Phantom Menace*, led to efforts toward a standard for digital projection worldwide.

Movie marketing is flourishing from a combination of the Internet and social media, creating new ways to promote and market films, as well as the added bonus that it is easily shared among fans. Mobile technology ties into that as well, so more immediate decisions are made to see movies, and platforms to watch trailers and read ratings have flourished. Marketing has further benefited from the widespread popularity of smartphones, as audiences use apps to buy movie tickets, watch trailers, rate movies, and interact on social media, and increasingly, to watch movies.

Where convergence is changing distribution and exhibition the most is with the combined proliferation of smart televisions and widespread computer use, and availability of high-speed internet, which makes it easy to watch movies at home via over-the-top transmission. Distributors are following the examples of Amazon, Netflix, YouTube, and iTunes, creating their own online platforms such as Hulu, HBO Go, HBO Now, Showtime Anytime. Satellite providers and gaming platforms are getting into this space as well with DirecTV Now, Sling, and Playstation Vue. All of this convergence disrupts the movie industry in many different ways, especially the movie exhibition sector.

Disruptors

Disruptors to distribution include new ways of watching movies, on mobile platforms, and the inevitable shift to streaming. With almost 1.8 billion users, Facebook is a likely destination for films and could stream ad-supported films or offer a subscription service.

On the production side, augmented reality, virtual reality, and 360 movies provide potential for a combined gaming and movie experience. This would influence distribution in that these movies may have to be consumed on game consoles or require VR headsets. As production advances, audiences could even be included as actors in a movie.

Filmmakers now selling their movies straight to audiences online is an obvious disruption to distributors, but not one that is significantly threatening, yet. It may prove to be if enough prominent filmmakers decide to forgo traditional distributors in favor of self-releasing, which is happening in the music industry.

The new media disruptors—primarily Netflix and to a lesser extent Amazon, with Apple on the horizon—are disrupting the distribution model in a way that has occurred several times in the history of the movie business. That pattern consists of new companies developing and putting into use a new technology; then licensing Hollywood product for release of films utilizing the new technology and building a customer base and interest in the new technology, with the next step being production of their own films.

Netflix in particular has emerged as a competitor to Hollywood, offering lower fees to the studios for the product they do license, and lower fees to the producers who are making original Netflix content. Netflix is aggressively

shunning the theater window in favor of offering new movies to consumers on home and mobile platforms. All of this is disrupting the distributors' standard business practices.

The rising impact of China, with its vast audiences, emerging movie industry, and large investments in production is also disruptive. In pursuit of Chinese audiences and investment capital, the Hollywood studios have demonstrated a willingness to alter story lines, change the ethnicity of characters, and cooperate with Chinese government censors in avoiding or deleting material unacceptable to the censors or Chinese moviegoers. Movie makers are making concessions like cutting scenes in which a Chinese character is killed, or deleting Chinese villains (the James Bond film *Skyfall*, *Pirates of the Caribbean: At World's End*), changing the origin of the zombie virus from China to Russia (*World War Z*), adding Chinese products for product placement (*Captain America: Civil War*, *Independence Day, Resurgence*), and adding Chinese actors (*Rogue One: A Star Wars Story*).[19] One can be cynical about these capitulations by Hollywood to a government which brooks no opposition and rejects any notion of artistic freedom, all in pursuit of elusive profits. A chilling precedent was Hollywood's willingness to continue to court the German film market after the rise of Hitler in the 1930s, to the point of allowing German censors to force deletions of any content that the censors deemed anti-German. The studios did not cover themselves with glory then, and time will tell whether that ignominy is repeated in the China experiment.

Impact of the Internet and Mobile Technology

Digital media is defined as audiovisual media contents and applications that are distributed directly over the Internet, including digital video content, digital music, as well as digital games for different devices and electronically published written content.[20]

Within digital media, video-on-demand (VOD) is the fastest-growing market. Two economic models prevail—advertiser based, featuring ads during the movie or show, and subscription. Growth primarily has been in the subscription-based services. The pay-per-view and the video download market are stagnating in nearly every region. Internet subscription VOD services, led by Netflix, Amazon Prime Video, and Hulu, are projected to grow rapidly in the future, rising from $8 billion in 2016.[21]

The global VOD market size was about $16.3 billion in 2016 and accounts for 16 percent of the digital media market. With this share, VOD is significantly bigger than digital music,[22] with 86 percent of the global VOD market generated in the United States, China, and Europe. The cumulative market size of all three regions is $14 billion, dominated by the United States. Within that, video streaming is the biggest segment, followed by video downloads and pay-per-view.[23]

Mobile. Smartphones are on track to become the fastest adopted technology in history.[24] In 2016, an estimated 63 percent of the population worldwide

already owned a mobile phone. Statistics indicate that mobile phone usage is growing and will reach 5 billion people by 2019, and that 43 percent of 18–35 year-olds watch movies and TV shows multiple times per week.[25] The rapid adoption, and ability to stream video for viewing, as well as shoot and upload video, has influenced movie distribution from a consumer and studio perspective.

Mobile technology on smartphones and tablets combined with fast internet speeds and a variety of websites offering videos has changed the way audiences watch movies and TV; wherever and wherever. As mobile continues to grow, this may encourage shorter movies, which are easier to watch on the smaller screens; and impact the visual style of films to view them more easily on smaller screens. Movies are increasingly being shot (and sometimes edited) on cell phones and tablets, with audiences accustomed to the visual language and style; and then distributed online via YouTube, Netflix, and other platforms. According to *Time* magazine, 50 percent of Netflix, Hulu, and YouTube content is watched on mobile phones.

Mobile viewing, which is included in the online platforms, has eclipsed DVD. As the DVD window has diminished in importance and revenue, the Internet holds the promise to restore those profits, but as of yet, has not.

Related to the Internet and mobile is the use of computer processing to track and measure audiences with minute detail. Internet technology that has become widespread in tandem with internet video is recommendation engines. These computer algorithms analyze audience viewing or buying patterns, then recommend similar movies. The Netflix CineMatch algorithm is very popular, encouraging viewers to find lesser-known titles.

The CineMatch algorithm works by taking into account a number of factors which include:

- The movies themselves arranged into groups of closely related movies.
- The audience ratings of the movies. If a movie is rated high by a customer who also watched the movie you are watching now, it is likely to show up in the recommendations.
- The combined ratings of a movie by all users. The movies with highest overall ratings are likely to be enjoyed by almost everyone.

Beyond computer algorithms, future machine artificial intelligence will analyze viewer's choices, learn them, and is predicted to actually create movies in the future, with similar genre and actors that a person prefers.

New formats like virtual reality and augmented reality and 360 videos are growing quickly, a direct result of digital technology. 360-degree and virtual reality films can be viewed on a desktop computer, over the Internet with specific VR players, on VR headsets designed specifically for these formats, and also on your smartphone, using a holder to wear the phone on your head like glasses. An example of these would be Google Cardboard.

Augmented reality is used primarily by smartphone users, adding digital filters or objects on top of what a user sees, illustrated by Pokemon Go, where a viewer would see digital creatures superimposed on reality, or Snapchat, and an advantage is that it does not require a headset.

Oculus VR, acquired by Facebook in 2014, released its first high-end virtual reality headset. Other established manufacturers like HTC followed with similar headsets. The Google Cardboard, a low-priced VR solution using a smartphone as a display, was shipped more than 88 million times in 2016. VR is one quickly growing sector in entertainment, projected to increase from $421 million in 2016 to $5.0 billion in 2021. 360-degree films, virtual reality, and augmented reality will drive the development of new formats, possibly merging games with movies.

Direct and Hybrid Models

Models of distribution can vary, depending on the size and scope of the movie. Where large distributors utilize every media format and territory, smaller-budgeted indies may not be able to, instead creating direct and hybrid models of distribution in order to reach audiences as efficiently and effectively as possible.

Filmmakers typically have three options for distribution: traditional, using proven distributors, the large studios or smaller companies; DIY—the do-it-yourself model; or a hybrid of both. Traditional distribution for indie filmmakers consists of working with a distributor before the film is made, and then the distributor distributes the film in as many media and markets as possible. Another traditional method is when a producer funds and makes a film independently of any distributor, then attempts to sell or license distribution rights of the film to a distributor at film festivals or film markets.

Filmmakers who want to release a movie in theaters have a few options: four-wall release, essentially renting a theater; or a special event where the movie is screened for a group. For additional media windows, a filmmaker can sell their film online through one of several platforms like Amazon, YouTube, iTunes, or Vimeo, a crowdfunding platform that offers distribution; or work with an aggregator like Quiver, Distribber, IndieFlix, or The Film Collective.

To maximize a direct-to-fan or hybrid model, the filmmaker must coordinate the release with extensive marketing, holding events, selling merchandise, and vigorous social media activity.

Global Influences on Distribution

Over time, Hollywood has been very successful in finding and mining new financing sources, whether from Wall Street, tax and real estate deals to production incentives, to industry tycoons and their offspring, in the US and abroad. Both film production and distribution are expensive and the studios and other movie distribution companies must continually seek new funding.

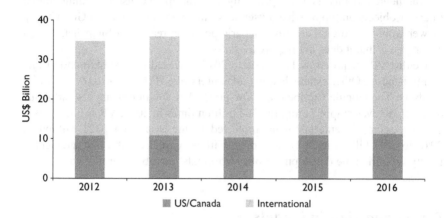

Figure 6.5 Total Box Office, MPAA (US$ Billion).

The potential of global influences is a question of math. With 7.8 billion people on the planet, only 5 percent live in the United States, so the potential for a new and growing customer base is outside of America. Also, North America is a mature market for movies, saturated with cinemas, so the bigger opportunities are in the emerging markets, particularly China. Between 2009 and 2013, cinema admissions in China rose by 239 percent, whereas in the US they shrunk by 5 percent over the same period.[26]

Hollywood is increasingly creating movies with the global market in mind, and the international share of box office is growing, illustrated in Figure 6.5 above, which shows, in US$ billions, the proportion of North American box office compared to that from international sources.

The logistical complexity of the release and cost of marketing is layered on top of making the film as well in the case of wide releases worldwide, as Hollywood must now create movies for the global stage.

Notes

1. Gomery, Douglas. (n.d.) "Movies on Television." Retrieved November 9, 2007 from the Museum of Broadcast communications website www.museum.tv/archives/etv/M/htmlM/moviesontel/moviesontel.htm.
2. Gruenwedel, Erik. (2014, October 27) "MPAA Reveals 'World's Most Notorious' DVD Piracy Markets," *Home Media Magazine*. Retrieved September 2, 2017 from www.homemediamagazine.com/piracy/mpaa-reveals-worlds-most-notorious-dvd-piracy-markets-34466.
3. Wikipedia. (n.d.) "Over the Top Content." Retrieved September 1, 2017 from https://en.wikipedia.org/wiki/Over-the-top_content.
4. Tartaglione, Nancy. (2017, January 5) "2016 Intl Box Office Sees Projected 3.7% Drop Amid Currency Shifts & China Dips—Studio Chart," *Deadline*. Retrieved August 15, 2017 from http://deadline.com/2017/01/highest-grossing-movie-studios-of-2016-international-box-office-1201878861.

5. Box Office Mojo. (n.d.) "Yearly Studio January 1–December 31, 2016." Retrieved September 1, 2017 from www.boxofficemojo.com/studio/?view=company&view2= yearly&yr=2016&p=.htm.

6. James, Meg and Ryan Faughnder. (2017, August 3) "Paramount's China Film Deal Hits a Snag as Viacom Discloses Missed Payment," *LA Times*. Retrieved on July 13, 2017 from www.latimes.com/business/hollywood/la-fi-ct-viacom-paramount-earnings-20170803-story.html.

7. Fergus, Ryan. (2017, May 12) "Disney Teams up with China's Jiaxing Media to Develop Live-Action Movies," *China Film Insider*. Retrieved June 28, 2017 from http://chinafilminsider.com/disney-teams-chinas-jiaxing-media-develop-live-action-movies/.

8. Pautz, Michelle. (2002) "The Decline in Average Weekly Cinema Attendance: 1930–2000," *Issues in Political Economy* 11, Elon University, NC; White, Michael. (2007, December 28) "Hollywood Studios Set Sales Record on Ticket Prices (Update 2)." Retrieved December 29, 2007 from www.bloomberg.com/apps/news?pid=news archive&sid=aZuNecJypP.A; and Finler, Joel W. (1988) *The Hollywood Story*. London, England: Crown Publishers, Inc., 1988, p. 19.

9. Crave Online Film and TV Channel. (2007, May 31) "Universal to Open Harry Potter Theme Park!" Retrieved July 26, 2007 from www.comingsoon.net/news/movienews. php?id=20731.

10. Brevet, Brad. (2017, September 20) "Disappointing August 2017 Closed Out the Worst Summer Movie Season in Over 10 Years," *Box Office Mojo*. Retrieved October 23, 2017 from www.boxofficemojo.com/news/?id=4326.

11. The Numbers (n.d.) "The Imitation Game," Nash Information Services, LLC. Retrieved August 27, 2017 from www.the-numbers.com/movie/Imitation-Game-The#tab=summary.

12. Orden, Erica. (2012, January 11) "How le Carré Flick Devised Its Plan— Studio Behind 'Tinker, Tailor, Soldier, Spy' Watched and Waited to Before Expanding Distribution," *Wall Street Journal, Eastern edition*. Retrieved October 15, 2017 from www.wsj.com/articles/SB100014240529702034369045771490310 20170576.

13. O'Neil, Tom. (2006, March 7) " 'Crash' Makes U-turn Back to Theaters." Retrieved August 9, 2007 from www.goldderby.latimes.com/awards_goldderby/2006/03/index. html.

14. Ibid.

15. La Monica, Paul R. (2006, January 27) "And the Cash Goes to ... 'Brokeback Mountain' and 'Walk the Line' Could Get a Nice Box Office Bump if they Score Oscar Nominations." Retrieved July 17, 2007 from www.money.cnn.com/2006/01/27/ news/companies/oscars/index.htm.

16. Vogel, Harold. (2015) *Entertainment Industry Economics: A Guide for Financial Analysis* (9th ed.). Cambridge, England: Cambridge University Press, p. 136.

17. Rainey, James. (2016, March 8) "The Perils of Promotion: Pricey TV Campaigns, Fear of Change Shackles Movie Spending," *Variety*. Retrieved October 1, 2017 from http://variety.com/2016/film/features/movie-marketing-advertising-tv-campaigns-1201724468/.

18. Kafka, Peter. (2017, June 12) "The Internet Is Finally Going to Change the Movie Business, and it Could Cost Theaters Billions," *Recode*. Retrieved September 12 from www.recode.net/2017/6/12/15783110/netflix-hollywood-movies-windows-home-streaming-regal-cinemark-moffettnathanson.

19. Jenkins, Harry. (2006, June 19) "Welcome to Convergence Culture," *Confessions of an ACA-Fan*. Retrieved August 12, 2017 from http://henryjenkins.org/blog/2006/06/ welcome_to_convergence_culture.html.

20. Kickstarter. "Super Troopers 2." Retrieved July 24, 2017 from www.indiegogo.com/projects/super-troopers-2-film; Indigogo. "Iron Sky" Retrieved July 24, 2017 from www.indiegogo.com/projects/iron-sky-the-coming-race-film#/; Seed and Spark. "Ordinary Women." Retrieved July 24, 2017 from www.seedandspark.com/fund/ordinary-women#updates; Crowdfund Insider. "Innocente." Retrieved July 24, 2017 from www.crowdfundinsider.com/2013/02/10698-crowdfunded-film-inocente-wins-oscar-for-best-documentary-short/; Indigogo. "The Fencer." Retrieved July 24, 2017 from www.indiegogo.com/projects/road-to-the-oscars-for-klaus-haro-s-the-fencer-film.
21. Hoovers. (2016, December 12) "Industry Custom Report: Film Production Industry Film & Video Last Updated," p. 3.
22. Bilton, Nick. (n.d.) "Why Hollywood as We Know It Is Already Over," *Vanity Fair.* Retrieved August 14, 2017 from www.vanityfair.com/news/2017/01/why-hollywood-as-we-know-it-is-already-over.
23. Lubin, Gus. (2016, October 14) "18 Hollywood Movies that Pandered to China's Giant Box Office," *Business Insider.* Retrieved July 28, 2017 from www.businessinsider.com/hollywood-movies-in-china-2016-10?op=0#/#independence-day-resurgence-featured-chinese-star-angelababy-and-a-bunch-of-chinese-products-16.
24. Buss, Sebastian. (April 2017) "Digital Media Market Report," *Statista*, p. 24.
25. PricewaterhouseCoopers. (2017) *Global Entertainment and Media Outlook 2017–2021*, p. 25. Retrieved February 22, 2018 from www.pwc.com/us/outlook.
26. Follows, Stephen. (2017, May 5) "How Important Is International Box Office to Hollywood?" Retrieved August 29, 2017 from https://stephenfollows.com/important-international-box-office-hollywood/.

Chapter 7

Movie Marketing

The marketing of a movie encompasses all of the advertising, promotion, and publicity activities that create audience awareness for a film. Together with the distribution team, a film's marketing professionals define the target market for a movie, and create and sustain awareness of the film to motivate viewers to see it.

Marketing: Creating Awareness for a Film

Marketing and distribution executives work together to create a strategic plan to market and distribute a film. There are no second chances to release a film into the marketplace, and the theatrical launch of a movie will have an impact on the success or failure of the film over its economic lifetime. Effective distribution and marketing are just as important to success as the casting, financing, and production of a film.

Marketing activities include creating trailers, television ads, a website, and planning and executing social media campaigns over multiple platforms, designing a film's poster, outdoor billboards and signage, apps or video games if applicable, conducting test screenings and analyzing the results, adjusting if necessary, and creating merchandising tie-ins, such as toys in fast-food chains. Over the past two decades, digital marketing has changed the marketing campaigns and dynamic of movie promotions. Studios continue to shift portions of their advertising budgets to digital in order to reach consumers on their favored digital platforms. As the digital portion of a film's marketing has risen in prominence and importance, it has simultaneously become more complex, consisting of any combination of a website, ads placed on websites, online magazines, newspapers, and blogs; as well as campaigns on multiple social media platforms, apps, video games, VR and AR strategies, as well as tactics specifically for mobile. There's a tongue-in-cheek saying that when a film is a hit, it's the result of a brilliant production team, and when it's a flop, it was caused by poor marketing.

A Marketing Plan

A marketing plan must be developed for every film, and address the following issues: the positioning of the film in the marketplace (defining the genre and story for the audience); identifying the marketable elements (actors, director, earlier versions in the case of a remake or sequel); defining the target audience; determining the optimal release time and release pattern; determining the P&A budget (prints and advertising, now reflecting costs for advertising and virtual print fees), as well as the best allocation of all advertising expenditures. Most of a film's advertising budget will be spent in the few weeks prior to, and just following, the opening weekend, with expenditures correlating to the budget. The average studio marketing budget is $40–50 million,[1] but can escalate to $100 million for tent-pole films, of which 80 percent goes to television advertising. The major categories and items of marketing expenses include delivery materials; advertising, publicity, promotion; and sales and licensing.

Film File, VPF, DCP, and Delivery Expenses. Delivery materials expenses include the cost of preparing the final film files, trailer prints, and copies of the film as a DCP (digital cinema package) file on hard drives to be shipped for playback in theaters. With the digital conversion of theaters, DCPs have replaced film prints, which was a significant expense in the overall marketing budget, also known as P&A. In place of the price the distributor paid for actual 35-mm film copies ($1,500–2,000) to be played in theaters, there are now VPFs, also known as virtual print fees ($800), which are fees paid to theaters per copy of the film. Virtual print fees are paid by distributors to theaters as financing for the digital conversion. Recutting costs and video masters, as well as subtitling and dubbing expenses for TV and foreign versions are also included in this category.

Advertising, Publicity, and Promotional Expenses. Of the total P&A budget, advertising expenses are a critical component, including the design and creation of all advertising, including key art, the image used on posters and other advertising; poster printing, trailer production, social media campaign including a website, and online advertising campaign: print advertising in newspapers and magazines; TV, radio, and outdoor advertising, as well as in-theater and video-release ads.

Publicity expenses include: photo stills from the set; transparencies; design and production of press kits for radio and TV; one-sheets (posters); press screenings, previews, and preview screenings; star tours and interviews; and promotional videos and television programs.

Expenses for promotion include merchandising tie-ins such as retail giveaways, talker screenings, and film-festival expenses, covering attendance at the festival, travel, and entertainment costs.

Sales and Licensing Expenses include travel and entertainment expenses required for attendance at the major film markets, such as Cannes and AFM.

Determining the Overall Marketing Budget

The determination by a distributor of how much to spend on marketing is a subjective judgment based on the distributor's confidence in the film, and the historical performance of films in the same genre, and with similar talent elements. A rule of thumb in the industry has been that the marketing budget is at least half of the production budget. While each film is different, average studio film-marketing budgets run at $40–50 million,[2] varying upward or downward based on the scope of the release.

The size of the marketing budget is also determined by the selected theatrical release pattern. A wide release will require a substantial pre-opening and opening advertising expenditure, and related publicity and promotion costs. Also, a wide release entails the use of expensive national media outlets, such as network television advertising. Limited releases (several hundred screens) or platform releases (opening in a few cities and expanding if possible) require much smaller advertising budgets.

The initial costs of opening a film in theaters account for approximately 80 percent of a film's total marketing budget. Expenditures after the opening will be driven by the early performance of the film; basically the first two weekends for films in wide release, or the first several weeks for films in limited or platform release. If a film has a commercially successful opening, and/or receives good critical reaction and word of mouth, the distributor should and will support the film by continuing to spend significant amounts on advertising. Hopefully, this additional advertising expenditure will keep the film going strong in the marketplace for several weeks. Conversely, if a film performs poorly on opening, the distributor should probably quickly curtail advertising and cut its losses.

The size of the initial marketing "spend" is crucial. In the highly competitive theatrical market, particularly in the United States, a film has a very short window of time, basically its first week of release (encompassing two weekends), to establish itself in the marketplace. Therefore there is real pressure on distributors to budget and spend more, rather than less, on marketing to support the opening of a film. Underspending can sink the prospects of an otherwise viable film. This pressure has increased since distributors began to ramp up the number of screens on which films open in wide release. Through the 1980s, a film rarely, if ever, opened on more than about 1,500 screens; by the mid-1990s big films were opening on as many as 3,000 screens. In the summer of 2015, *Jurassic World* was released in 66 countries on 19,612 screens, and *Pirates of the Caribbean: At World's End* opened on over 29,000 screens worldwide in 2007, according to Box Office Mojo. The MPAA has reported marketing costs that have climbed steadily since the 1980s (see Figure 7.1).

Studios have access to, and rely heavily on, data that companies like Screen Engine, Nielsen NRG, OTX, and MarketCast gather, tracking audience awareness of a film prior to, and during its opening weeks. Based on that data, and data the distributors generate on their own, distribution and marketing executives

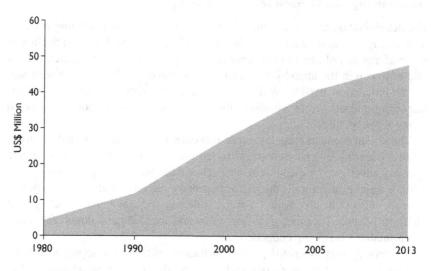

Figure 7.1 Average Movie P&A Costs, MPAA (US$ Million).

may accelerate marketing expenditures if they feel their film is lagging in aware-
ness, in comparison to other films.

This pressure to spend bears on independent distributors as well. If an inde-
pendent is releasing a film wide, it must try to match the marketing muscle of the
major studios that are out with competing films at the same time. Also, there is
greater pressure to spend more on initial marketing, if for no other reason than to
establish consumer awareness that will support greater interest and audiences in
the ancillary markets. The overall result is that marketing expenditures for films
have been steadily increasing since the 1980s, both in absolute terms and as a
percentage of a film's budget.

In the United States, advertising costs are high due to the large number of
screens and the necessary reliance on high-cost television advertising. The
average negative cost of a studio film released in theaters in 2016 is $61 million;[3]
however, over one-third of Hollywood films released in 2016 were budgeted
from $100 million to $250 million, averaging $120 million. Average marketing
costs range from $40 million to $50 million, but marketing is correlated with the
budget. Therefore, a movie with a negative cost of $250 million is likely to have
a marketing budget up to and above $100 million. Even low-budget studio
movies have budgets of $15 million in order to have the minimum production
values and look needed to compete commercially.

There is also some correlation between a film's budget and marketing costs.
Up to a point, the greater the budget, the greater the amount spent on marketing.
Also, since lower-budget films are more likely to be given a platform or limited
release, the marketing costs on low-budget films tend to be lower. While there is
no absolute minimum that can be spent marketing a film, depending on the

release pattern there are certain practical minimums. Even a very limited release, say in ten major market cities, will entail relatively significant marketing expenditures. To properly open a film in one large city, like New York or Los Angeles, on one or a few screens, requires a minimum advertising spend of $100,000. Including print costs and publicity and promotion expenses (which tend to be relatively higher on lower-budget, narrow-release films where there is a greater need to use publicity and promotion to create consumer awareness) a ten-city opening can cost a distributor upwards of $1,000,000. Since any film that is intended for theatrical release (as opposed to an initial release on television or home video) must eventually play in at least several locations, this indicates a practical minimum marketing cost level of at least $500,000 for any theatrical film.

Similarly, while there is no absolute maximum that can be spent on marketing, there are practical limits. Even with a film that has a highly successful theatrical release, while the distributor will continue to spend on marketing to support the film, these costs will begin to decrease fairly quickly the longer the film plays. For example, very costly national television advertising will usually be discontinued after the first few weeks of release, and the distributor will rely more on local print and TV advertising and word of mouth to sustain the picture.

Marketing expenses are incurred well before the film is completed. In many cases, marketing begins before the film is in production. Similarly, marketing efforts can continue long after a film has completed its first theatrical run, as subsequent windows of exploitation also require some marketing support, although much less in absolute dollars than the theatrical window.

On major studio films, the marketing and publicity departments will usually get involved immediately after a film is green-lighted for production. The marketing executives will begin to shape the marketing campaign, with title research and selection, poster and print ad designs, publicity tour planning, and market research. During production, marketing efforts will intensify, including the planning of the advertising campaign and on-set publicity activities.

In the case of independently financed and distributed films, sales and licensing activity, including attendance at major international film markets, will often begin before a film goes into production. In addition to the direct costs of attending the markets, related costs such as poster design and production and sales kits will be incurred at this early stage. These sales and licensing activities will continue until the film has been licensed worldwide, a process often not completed until well after the film's initial release.

Substantial marketing costs can be expended on film projects that are never produced, or on films that are produced but never released. These costs, which can easily exceed $50,000 per project, are nevertheless properly treated as marketing expenses for financial and accounting purposes.

A studio or independent distributor should begin to plan the marketing campaign as soon as it has acquired the distribution rights to a film, which could be as early as the development or preproduction stage.

Consumer Product Sponsorship. Studios view their large-scale, high-profile event movies as brands, to be leveraged by licensing the use of the name and likeness of the film, and characters in the film, to consumer products companies.

Product merchandising opportunities relating to film characters and concepts have increased in recent years, and the marketing techniques have become highly sophisticated.

Global retail sales of licensed merchandise rose 4.4 percent to $262.9 billion in 2016 fueled by films like *Star Wars, Trolls, Batman v Superman: Dawn of Justice, Finding Dory, Paw Patrol,* and *Pokemon.*[4]

Disney's animated films, such as *Frozen,* which grossed $1.3 billion at the box office, earned nearly that from merchandising. The licensing segment of entertainment and characters from movies and stars grosses over $10 billion per year.[5] A product license to a major toy-manufacturing company can generate 6–7 percent of wholesale merchandising revenues to the studio. And if the match between movie and toy is just right, according to the *Hollywood Reporter,* a top-selling franchise can net a movie studio an easy $100 million a year. The *Star Wars* films demonstrated the power of movies to power-sell. By 2017, George Lucas's six-part series had earned $32 billion in toys and merchandising, beyond the $6 billion in box office and $6 billion DVD sales.[6] Both Transformers and Legos toys have created robust movie franchises based on the toys.

The release of the *Pirates of the Caribbean: At World's End* had product tie-ins, offered by Disney Consumer Products, and other companies. In addition to the usual books, toys, and games, Disney aimed for a more mature audience as well, selling tie-ins of sunscreen, home decor, pet apparel, an electric guitar, and series of electronics, like the skull-and-crossbones-topped TV. Planning all product releases, due to design and manufacturing lead times, starts more than a year before the release of the film.

Many toy manufacturers have long-standing relationships with studios—but the majority of merchandising deals for feature films are done on a picture-by-picture basis. Under these licensing deals, upfront advances are paid to the studio, with royalties that might range from 2–3 percent for foodstuffs, to 8–10 percent for apparel.

Fast-food companies can generate from $30 million to $40 million worth of media awareness, as well as premiums, and in-store point-of-purchase advertising, paid for by the consumer products company—representing free advertising.

In addition to product placement within a film, companies use the lure of movies and filmmaking to draw attention to their brands, like BMW's short film competition, copied by Lexus and Chrysler. Since producers are continually hunting for fresh sources of financing, there is no end in sight to the combination of films and sponsorships, although the campaigns, competitions, and product placements vary in success.

Important Elements of the Marketing Campaign

There are several important supporting elements to a marketing campaign, including attributes of the film itself, such as its rating and title, and physical components, like trailers and posters. Coordination and planning between production personnel, marketing and distribution executives, and outside vendors is vital in ensuring that all marketing materials are approved and completed in time for a film's theatrical release.

Film ratings have an impact on marketing, as they influence who can or will see a film. Once the target audience for a film is identified and defined, the film's rating must be compatible with drawing an audience from that group. A film intended for young children must have a G, PG, or PG-13 rating. If a film is in danger of not receiving a PG or PG-13, the producer and distributor may need to recut the edited version of the picture to receive the appropriate rating from the MPAA. According to box-office data site The Numbers, PG-13 has the highest market share over the past two decades.

Under the umbrella of the MPAA (the Motion Picture Association of America) is the organization that rates movies—CARA (the Classification and Ratings Administration). In rating a film the agency considers not just the film itself, but also all marketing campaign elements, such as trailers and posters. Brief explanations are given for why a film receives a certain rating (brief nudity, adult language, etc.)

Most distribution contracts require delivery of a film with a specific MPAA rating, and failure to deliver that rating can nullify the contract. An NR—not rated—designation may mean that certain theaters will not exhibit the film and some newspapers will refuse ads for it. Also, some of the biggest retail outfits

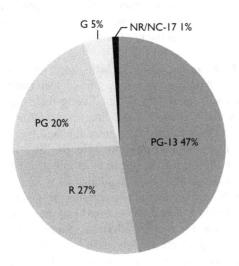

Figure 7.2 MPAA Rating Market Share, 1995–2017.

for video and DVD, particularly Wal-Mart, refuse to carry an NR-rated film. The distributors bear the cost of the rating system, paying a fee of $2,000–15,000, based on the film's budget.

The industry rates itself to fend off governmental or other non-studio rating groups. However, there have always been complaints about the system and how it works. A documentary about the system, *This Film Is Not Yet Rated*, discussed the secrecy and vague qualifications of the raters, and the mixed feelings that many producers and distributors have toward the system.

There is a clear correlation between the rating that a film receives and its box-office potential. A G, PG, or PG-13 rating is an effective marketing tool; an R or NC-17 rating presents a marketing challenge.

The one-sheet is an important marketing tool. It should present a compelling image that signals a film's story, main characters, tone, and genre and announces the title, credits for principal cast and crew, and sometimes a tagline. Often created during development, the one-sheet is used as the standard, color poster for display in theaters, and contains the basic elements needed to create a newspaper ad—key art. The graphic and custom title treatment of the one-sheet typically becomes the logo for the film, and costs for an agency to design a one-sheet typically start at $5,000.

A tagline or lead line sets the tone of the film, for example, a tagline for the dinosaur-themed *The Lost World: Jurassic Park* was "They're walking our streets," and for the comedy *Office Christmas Party* "Party like your job depends on it," or reveals information about the main character such as the movie based on the comic book with the sarcastic protagonist—*Deadpool*—"Wait 'til you get a load of me." Often, the studios do not create their one-sheets in-house, rather they consult with, and hire outside ad companies, and choose the best from among those offered. Stars and directors, the cinematographer, and producers have their names on the one-sheet, and the union contracts and employment contracts of these professionals dictate the size of the print of their name in relation to other names.

Trailers and TV commercials are an important marketing tool, and one of the most effective. Shown in theaters before a movie opens, trailers are rated for an appropriate audience—all audiences, or restricted, simplifying their use for distributors and theater owners. A trailer contains highlights from the film and ideally should clearly convey the essence of the film's story line and best features. Trailers usually advertise films of a genre similar to the film being screened in the theater. In-theater trailers run from one to three minutes. Teaser trailers run short, 45–120 seconds, featuring visual highlights or a logo, like *Minions*, *Star Wars*, or *Batman*, with exciting music. Teaser trailers should pique audience interest, highlighting climactic scenes or effects, and may be screened as much as 1½ years prior to a release. Footage for advertising, trailers, or for online marketing use is shot during production. Television commercials are shorter than trailers, usually 30 seconds, either appealing to the broadest possible audience, or edited to appeal to a niche audience on cable. If the primary

audience for a film is adult male, for example, a commercial that plays up the love interest and the lead female in the cast may be shown on the cable channels, Lifetime or Oxygen, which are watched mostly by women, to appeal to a wider audience.

The broadcast audience, which was once easily reached on any of the three major networks, is now diluted, and the fragmentation of media into niche audiences has complicated marketing for mainstream movies, having an impact on the effectiveness and affordability of reaching a broad audience. TV commercials, which are very expensive (over $5 million for a spot during the Super Bowl), may still be an effective part of an advertising campaign, but are one part of a complicated puzzle. Social media and internet advertising has gained importance in recent years, particularly among younger audiences, evidenced by agencies devoted solely to digital campaigns, such as Ruckus, Blue Fountain Media, and Lounge Lizard. Internet advertising dollars have soared, surpassing TV advertising in 2016.[7] However, movie advertisers are hedging their bets, with TV representing 82 percent of US advertising spending.[8]

The proliferation of small screens has opened up new ways to reach audiences, with promotions via cell phone—movie-themed ring tones and wallpaper (*Wonder Woman*, *Spider-Man 3*)—and offering free film-based games and trailers for a variety of popular devices: Xboxes, iPods, iPhones, and PlayStation Portables.

Title. An exciting title that conveys the story and genre in a few words can be a significant aid in selling a movie. To avoid confusion and copyright infringement, titles are registered by studios and independents with the MPAA's title registry. Titles that get good buzz do not always translate into big box office, like *Snakes on a Plane* ($62 million box office, versus a $33 million budget), or *Battlefield Earth* ($30 million box office, versus a $73 million budget, as per Box Office Mojo) but may stack the deck in its favor.

Logline. A logline is a brief description of a movie's story, outlining the protagonist, their goal, and the obstacle in their way. The logline is used in most marketing materials. For example, the logline on IMDb for *Black Panther* is, "T'Challa, the King of Wakanda, rises to the throne in the isolated, technologically advanced African nation, but his claim is challenged by a vengeful outsider who was a childhood victim of T'Challa's father's mistake."

High-concept films capitalize on a clearly marketable idea, of which the title is an important component. *Jurassic Park*, *Twister*, and *Jaws* are titles that vividly and clearly express what the audience can expect.

Press Book. A press book is compiled from the time a film gets the greenlight, through production. It contains all print materials for a film: newspaper ads, interviews with stars and filmmakers, newsworthy insights into the making of the film, a synopsis, running time, complete list of cast and crew, any awards, and critical review quotes. The press book gives exhibitors a feeling for what the film is about, and provides information for reporters and critics to use in articles, reviews, and publicity tours.

An electronic version, the electronic press book (EPK), would include the same, and all other media—promotional spots and ads, taped interviews, and newsworthy material for use on radio and TV.

Internet Website or Online Presence. Most films have a website built and posted online, even before and during production, to build buzz for the film, posting stills, and comments by cast and crew members. A website specifically for a film can cost from $5,000 to $100,000 (up to $500,000 for big-budget, sci-fi, or horror films) and offers a forum for potential audience members to communicate with the filmmakers. In addition, or instead of a website, a posting for a film may be created on IMDb.com—the Internet Movie Database, or boxofficemojo.com, yahoomovies.com, or similar websites. A blog or a video blog may be created to build awareness among the online community. The site or sites may offer contests, prizes, cuts of the film to view, email offers, or games and activities, while collecting user data about website visitors for future marketing campaigns for other films.

Distributors often hire publicity agencies that specialize in internet campaigns, which can cost from $10,000 to $100,000. *The Blair Witch Project* in 1999 is the best example of the first successful film fueled primarily by savvy use of the Internet. Artisan spent $1.5 million on web promotion for *The Blair Witch Project*, a significant figure at that time. Artisan, with the filmmakers, created a web campaign that blurred promotion with "evidence," playing up the film's no-budget documentary style with reality. Fan sites, a mailing list, a web ring, a Usenet group, online protest sites (supposedly created by residents of the town of Burkittsville, Maryland), and video parodies of the film created a wave of awareness that drove the film's tremendous box-office success ($248 million).[9]

Awards draw attention to a film and often produce free coverage on television, in magazines, newspapers, and on websites. The Academy Awards are the most prestigious and valuable awards, and can boost box office for a film that is still in theaters, or is rereleased into theaters after the nominations are announced or the Oscars™ are awarded. Awards from film festivals, and other award shows, can also raise visibility for a film. The Golden Globes, Screen Actors Guild, Directors Guild, and Writers Guild, as well as the Independent Feature Project's Spirit Awards and the British Academy of Film and Television Arts Awards (BAFTAs) all add to a film's marketing campaign.

The pursuit of awards, particularly an Academy Award, is a deadly serious undertaking in Hollywood. There is an entry fee for each film submitted for an award, and the studios and independent distributors will lobby industry personnel with paid advertising campaigns on billboards and in trade magazines, with budgets that can run into the millions, to influence voting.

Not only does a film benefit from awards, in the form of millions more at the box office and in ancillary sales, but the cast and crew of an award-winning film receive a boost to their careers.

Defining the Audience

Film distributors define and classify an audience by borrowing definitions commonly used in the advertising industry, and used by media research companies, like Nielsen, MarketCast, and OTX Research.

Audiences are commonly divided by age: under or over 25, and more specifically, Kids 5–11; or Youth 12–17; or by a subset of the category of Adults 18–24, 18–34, 25–34, 25–44, 25–54, 45+, and 55+; as well as by gender, lifestyle, geographic area, education level, marital and family status (with or without children), and by affluence or economic level.

Historically, frequent moviegoers have been single males, in the 12–17 age group. Young people are the biggest consumers of motion pictures in all media, including video and premium cable television. Viewer loyalty and interest among the youth demographic has been waning in recent years, which is a huge problem for Hollywood. According to the MPAA, 10 percent of monthly filmgoers buy half of all movie tickets, but 18–24 year-olds are abandoning movies faster than any other group. Teens consume media on an array of devices, often simultaneously, without strong preference for one over another. However, despite the media industry packaging film and entertainment content for a variety of new devices, young people are unpredictable in their taste with a fluid and flexible media appetite, preferring to media-multitask with several media sources simultaneously.

The lure of superheroes and extravagant special effects have been used to draw large audiences into a theater, but movies like *The Big Sick*, *Boyhood*, and *Bridesmaids* did not rely on that formula, and were extremely successful with a wide variety of audiences. The lure of relying on sequels to reduce risk in Hollywood is endemic: in 2015 and 2016, six of the top ten movies were sequels. In the end, as industry veteran Peter Guber observed in the PBS/Frontline documentary *The Monster That Ate Hollywood*, it is all about telling a good story and telling it well. If you do, you will find the audience.

Marketers use data from past releases to predict how films with similar elements, such as story, star, director, and budget might do. They also purchase data from research companies that conduct focus groups, test screenings, and track movie awareness and advertising effectiveness. A movie can only be released once into the theatrical marketplace, and the distribution and marketing team has to get it just right, because there is no going back or doing it over.

Film-Viewing Habits

Film marketers focus on two questions about audience choice: Why does a person choose to go to see a film among many entertainment options? and Why does a viewer choose one film over another? These questions can be approached from the point of communication theory, using social and psychological theories to explain an individual's motives for seeing a particular film, or from an

economic and business viewpoint, studying the behavior of those who see movies to discern the factors that influence consumers when they decide which film to attend.

The creative and promotional variables that have been shown to motivate ticket sales include story type, a film's stars and director, MPAA rating, critical reviews and theater previews, media and word of mouth, advertising, awards and nominations, star appearances on TV talk shows, and whether a film is a sequel or derived from a previously known story.

Regarding MPAA ratings, G-, PG-, and PG-13-rated films have an advantage, since they are the most inclusive. Sequels and films based on a previously known story have a marketing edge in capitalizing on existing awareness.

Word of mouth has proven to be an elusive but powerful variable, and most marketing campaigns are aimed at building word of mouth, through a media blitz, or with some gimmick that gets people talking about a film. Age is an important factor in movie attendance. Younger people have more free time, sufficient disposable income, and a desire to be among the first to see a movie, which supports an opening weekend mentality.

The social context of movie-going is another factor in film attendance. Going to a film is a traditional, and popular American date, and a common experience to share with friends. Research shows that some of the reasons consumers do not go to the theaters include rising ticket prices, crowds, and the logistics of finding a babysitter, parking the car, and having to go out.

Social Media

Movies are widely promoted using social media. It is a lower-cost alternative to television advertising, and able to target audiences based on precise demographics. Social media campaigns include ads on the various platforms, interacting directly with fans on the platforms, to cast and crew activity during production, all in the hopes of attracting followers and increasing buzz for the film.

Social media campaigns are planned in advance with hundreds of text comments, images and video clips to share, from the shoot itself or created after the shoot. Content may include comments from a character, or something designed to spur audience participation, like a contest or game. The goal is always audience awareness, and fans sharing news about the movie. Activities which encourage potential fans to create their own information about a movie, and spread it, is always the goal, so that the posts will go viral, being shared widely. This is the true promise of the Internet, the rapid sharing of information. For relatively modest costs, these campaigns can be created, but it takes ongoing maintenance for the time they are run for upkeep so that someone is responding to comments, tweets, shares, and so forth.

Examples of successful social media movie marketing include *Minions* by using Snapchat, Twitter combined with giant minion character appearances.

People took photos with giant minions at theaters and McDonald's restaurants (where the Minions toys were available), sharing those photos online. With the increasing number of platforms, movies must pick and choose which to use and how to employ them. The *Emoji* movie combined a marketing campaign using a combination of Twitter, Facebook, Candy Crush Saga, Dropbox, Instagram, Just Dance®, Spotify, and YouTube. *Twilight* was the first film to get over one million followers on Twitter, using hashtags that represent the film, playing up the sexy side of vampires with posts to connect with teen girls. *The Hunger Games* sent game invitations to teens on Facebook and Twitter that invited consumers to register for a "district" (a plot element in the story) and then compete with players in other districts. The game created a way for consumers to relate to other fans, and interact with the story. *Deadpool* had a widespread social media campaign, creating satirical materials such as multiple trailers, and posters leading up to the film's release, the "12 Days of Deadpool" with a daily series of marketing leading up to the reveal of the second theatrical trailer on Christmas Day.[10]

One challenge of marketing in the social media landscape is the appearance of new platforms, illustrated in the following chart by The Infinite Dial (Edison Research and Triton Digita) (see Figure 7.3). The wide range of platform choices requires movie marketers to pinpoint their target audience on a specific site, and attract their attention among thousands of other campaigns, data, and attractions within that site. New companies have emerged, like Fizziology and Moviepilot, that collect and analyze social media data specifically for studios and brands.

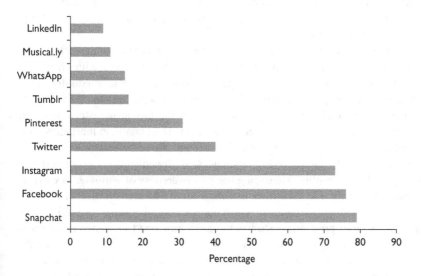

Figure 7.3 2017 US Social Media Reach: Ages 12–24.

Trends in Promotion and Marketing

Trends in promoting and marketing movies include: robust creative social media and digital campaigns; unique merchandising; and the use of detailed audience research.

As mentioned in the previous section, utilizing social media is a requirement for films now. Additional digital components include creating a website, advertising online, and sometimes an associated app or video game. As with all other marketing components, any digital tools must relate to the target market. One example includes the interactive website for *Jurassic World* (2016) which had the biggest opening weekend in movie history. The interactive website brought the fictional theme park to life, with wait times, weather, park capacity, maps and more—all touted as the real-life status of the *Jurassic World* park.[11]

The use of virtual reality and augmented reality to market films will likely increase. For example, VR trailers created for the *Saw* franchise where the user attempted to escape the room featured in the movie, were very popular with consumers.

Merchandising has become a significant revenue stream for movies, particularly big-budget, studio films. Toys and clothes have been very popular merchandise to market films, and generally pointed toward younger audiences. Studios are extending film-related products toward adult audiences. A few examples include high-end merchandise to promote *Kingsman: The Golden Circle*, with products like Scotch priced at $1,000 per bottle, branded shaving sets, and designer clothing;[12] popcorn buckets shaped like Thor's helmet and Hulk's fist for the movie *Thor: Ragnarok*; and for *Fifty Shades of Grey*, makeup, cologne, nail polish, and jewelry.

Kids movies continue to be a gold mine for merchandising, such as the *Minions* franchise deal with Amazon, branding delivery boxes with characters and the movie's release date. The campaign extended to social media too, with customers uploading pictures of their boxes and promoting the movie for free.[13]

Audience research and testing is not new to the movie industry; however, digital tools give marketers more detail than ever. Data can help marketers shift their campaigns to optimize results. In addition to test screenings and exit surveys, showing the movie to live audiences, studios also do concept and title testing as early as possible. Measuring the pre-awareness of a movie, as early as possible, is a priority. Detailed information about pre-awareness offers the studio time to ramp up the campaign to court its viewers. Tools in measuring pre-awareness includes positioning studies to gauge how one film is perceived compared to others coming out at the same time, tracking surveys one to two months prior to a movie's release, and testing audience response to advertising materials. Also, tracking trailer views online is an important component of awareness and enthusiasm of a movie with its fan base.

Publicity stunts and interactive games are fun ways to involve audiences with a movie's release. Geocaching is a real-world, outdoor treasure hunt using

GPS-enabled devices—typically smartphones to navigate through GPS coordinates to find the hidden props. The movie *The Revenant* used a geocache treasure hunt to promote the film, with props that related to the movie; such as a prop skeleton for each of the many people in this film who die lonely, frigid deaths in the woods. Fox hid 20 props packages around the US, Mexico, Europe, and Australia. For *The Smurfs 3D* movie, residents of Júzcar in Spain had their town painted bright blue to promote the movie, winning over the 300 other Spanish villages who were in competition for the privilege.[14]

Film Festivals and Markets

Film festivals have become very important to the movie ecosystem. For studio movies, film festivals are largely used to gain exposure and press. At the major festivals, of which there are a dozen, studios will plan screenings out of competition, with celebrity appearances, in the hopes of building buzz and connecting the movie to its target audience. The profiles of these films tend to be "indie-type" fare geared for an older and more sophisticated audience; the films tend toward more complex narratives than the average tent-pole, comic book films.

The FIAPF (International Federation of Film Producers Association, www.fiapf.org) has members from producers' organizations from 23 countries, and represents the economic, legal, and regulatory interests which film and TV production industries have in common. FIAPF regulates international film festivals, including some of the most significant, referred to as "A" film festivals, listed below.

Studios also go to film festivals seeking to acquire low-cost indie movies that are in competition. For non-studio films, the best shot at getting a distribution

Table 7.1 "A"-Level Film Festivals

Festival, Location	Month
Berlin, Germany	February
Cannes, France	May
Shanghai, China	June
Moscow, Russia	June
Karlovy Vary, Czech Republic	June
Locarno, Switzerland	August
Montreal, Canada	August
Venice, Italy	August
San Sebastian, Spain	September
Warsaw, Poland	October
Tokyo, Japan	October
Tallinn, Estonia	November
Mar Del Plata, Argentina	November
Cairo, Egypt	November
India (Goa)	November

deal is appearing in a popular festival, and the related exposure, press, and social media activity helps the overall buzz for the film in all windows.

There are number of prominent festivals beyond the A-list festivals, which can significantly market a new film and filmmaker: Sundance, Tribeca, South by South West (SxSW) and the New York Film Festival, Telluride, The Hamptons, Palm Springs, San Francisco, Edinburgh, among others. In addition to bigger festivals, there are thousands of smaller festivals, organized by type of film, regional focus, or other theme. Smaller festivals serve an important focus for burgeoning filmmakers in terms of sharing their work on a big screen with an audience, feedback, networking, and marketing, although not necessarily on a large scale.

Film markets are essentially tradeshows for buyers to find films. Financing, development, distribution deals, and intense marketing take place at these, some of which occur at the same time as film festivals. Major film markets include Berlin, Cannes, Toronto, and the American Film Market in Santa Monica, each with a different profile. A number of markets occur alongside of film festivals, such as Berlin and Cannes; however, there is not a great deal of crossover. Most of the market attendees who seek to buy and sell films are not necessarily attending red-carpet premieres, or concerned with the film festival.

At the markets, producers and distributors release pre-planned "announcements" about development and production of movies to receive free publicity. Market attendees who are selling product meet with buyers, advertise their films in development, and screen completed films in order to license them. These are costly events for the participants, but are important in terms of licensing and marketing films, particularly for independent producers and smaller distributors.

Notes

1. Beltrone, Gabriel. (2014, February 24) "A by-the-Numbers Look at Hollywood's Marketing Machine Media Spend and Agencies of the Biggest studios," *AdWeek.* Retrieved October 1, 2017 from www.adweek.com/brand-marketing/numbers-look-hollywood-s-marketing-machine-155895/.
2. Ibid.
3. The Numbers. (n.d.) Nash Information Services, LLC. Retrieved September 2, 2017 from www.the-numbers.com/movie/budgets/all.
4. Szalai, Georg. (2017, May 22) "Licensed Merchandise Sales Hit $262.9B in 2016, Boosted by 'Star Wars'," *Hollywood Reporter.* Retrieved September 2, 2017 from www.hollywoodreporter.com/news/licensed-merchandise-sales-hit-2629b-2016-boosted-by-star-wars-1005108.
5. Robehmed, Natalia. (2015, July 28) "The 'Frozen' Effect," *Forbes.* Retrieved September 23, 2017 from www.forbes.com/sites/natalierobehmed/2015/07/28/the-frozen-effect-when-disneys-movie-merchandising-is-too-much/#17f60cbf22ca.
6. Telegraph Reporters. (2016, May 4) "Look at the Size of That Thing," *Telegraph.* Retrieved July 2, 2017 from www.telegraph.co.uk/films/2016/05/04/look-at-the-size-of-that-thing-how-star-wars-makes-its-billions/.
7. Katz, Brandon. (2016, September 14) "Digital Ad Spending Will Surpass TV Spending For the First Time in U.S. History," *Forbes.* Retrieved June 4, 2017 from www.

forbes.com/sites/brandonkatz/2016/09/14/digital-ad-spending-will-surpass-tv-spending-for-the-first-time-in-u-s-history/#7c6e668f4207.

8. Kehrer, Daniel. (2015, July 1) "8 Insights on How Marketing Drives Movie Box Office Sales," *Forbes*. Retrieved October 1, 2017 from www.forbes.com/sites/forbesinsights/2015/07/01/8-insights-on-how-marketing-drives-movie-box-office-sales/#3936c7908ce3.

9. Film Encyclopedia. (n.d.) "The Blair Witch Project Paradigm and Online Fan Discourse." Retrieved July 24, 2008 from www.filmreference.com/encyclopedia/Independent-Film-Road-Movies/Internet-THE-BLAIR-WITCH-PROJECT-PARADIGM-AND-ONLINE-FAN-DISCOURSE.html.

10. McClintock, Pamela, Bryn Elise Sandberg, and Kate Stanhope. (2016, October 20) "Ryan Reynolds on a Bear Rug, Milo Ventimiglia's Butt and Hollywood's 10 Best Marketing Campaigns of 2016," *Hollywood Reporter*. Retrieved July 12, 2017 from www.hollywoodreporter.com/lists/10-best-marketing-campaigns-movies-939307.

11. *Adweek* staff. (2016, August 7) "6 Unique Trends in Summer Movie Marketing," *Adweek*. Retrieved June 13, 2017 from www.adweek.com/digital/6-unique-trends-in-summer-movie-marketing/.

12. Booth, Kaitlyn. (2017, September 21) "*Kingsman: The Golden Circle*, Beyond the Merchandise," *Bleeding Pool*. Retrieved September 21, 2017 from www.bleedingcool.com/2017/09/21/kingsman-golden-circle-merchandise/.

13. Perez, Sarah. (2015, June 2) "Amazon Turns its Boxes into Ads with First-of-its-Kind Marketing Deal For "Minions" Movie," *Techcrunch*. Retrieved September 21, 2017 from https://techcrunch.com/2015/06/02/amazon-turns-its-boxes-into-ads-with-first-of-its-kind-marketing-deal-for-minions-movie/.

14. Robinson, Tasha. (2016, January 7) "The Revenant Is Trying Out a Geocaching Promotion, but Can America Be Trusted?" *The Verge*. Retrieved September 13, 2017 from www.theverge.com/2016/1/7/10733542/the-revenant-geocache-promotion-find-props-hitchbot.

Film Exhibition, Retail, and Consumption

Exhibition is the point of purchase for a movie, when consumers will pay for and view a film. Certain windows require direct transactions, such as a visit to a movie theater, PPV and internet downloads, whereas other consumption is part of a subscription like HBO, or an OTT service like Netflix; some are ad-supported, like free television.

The role of the distributor is to generate availability for a movie to consumers in as many media formats (windows), and territories for as long as possible. Once available, the product may be exploited in each window; exhibited in movie theaters, for sale in retail environments—both online and brick and mortar—and ready to be consumed. Every window has a different price point, accessibility, revenue splits with the distributor, and a period of exclusivity with the goal of generating the maximum amount of revenue overall for the film. As new technologies emerge, the sequence of release and availability must be adjusted.

Exploitation: Creating Availability of a Film

Historically, the sequence of the release windows (the media technology to view a film) has been based on the price of that window to the consumer, starting with the theatrical window, the most expensive to the consumer, and then moving sequentially to the windows that are less costly. Each window has a period of exclusivity as against less expensive windows. This model is in flux, disrupted by a combination of video-on-demand and internet-based streaming platforms like Netflix, consumer pressure, and the desire of the studios and producers to recoup their costs as quickly as possible.

The theatrical window generates the most visibility for a film, and even if it is a "loss leader," theatrical exhibition contributes to generating revenue in all of the other ways.

Theatrical

Theatrical exhibition is the preferred first distribution window for new films and the theatrical success of a motion picture is often the most important factor in establishing a film's value throughout its economic life.

Companies that own and operate movie theaters exhibit films at indoor movie theaters, film festivals, and drive-in theaters. Major US companies include AMC Entertainment, Cinemark, and Regal Entertainment; leading companies based outside the US include Cineplex (Canada), Odeon & UCI (the UK), and Wanda Cinema (China).

A series of global hits and growth in China helped push worldwide box-office revenue to $39.92 billion in 2017, even as theater attendance in the United States and Canada shrank to a new low, which experts blame on competition from streaming services and weak films during the critical Summer season, according to *Variety*. The world is home to more than 151,000 cinema screens, according to the Motion Picture Association of America (MPAA). The United States and Canada were the largest markets with about 43,000 screens, recently surpassed by China with 50,000 screens, followed by Japan, and France. The US movie theater industry includes about 4,700 establishments (single-location companies and units of multi-location companies) that operate about 5,300 indoor theaters and 390 drive-ins with combined annual revenue of about $15 billion.[1]

The movie theater industry in the United States is represented by the National Association of Theatre Owners (NATO). NATO was formed through the 1966 merger of the Theatre Owners of America, which was founded in 1920, and the Allied States Association of Motion Picture Exhibitors, which was created in 1939. The organization compiles and publishes statistical and historical information on the economics of theater and concession operations, film producers and distributors, theater equipment, box-office sales, and attendance. Throughout the history of the theater industry, theater owners have had to make high upfront investments to build or lease and outfit and equip a theater. Total theater receipts are derived from three sources: admissions, concessions, and screen advertising. Asia Pacific leads the world as the largest source of box-office revenue, as illustrated in Figure 8.1 below.[2]

Theatrical exhibition has demonstrated long-term revenue growth over the past three decades.[3] US and Canadian box-office revenues have increased from $9.6 billion in 2007 to $11.12 billion in 2017, driven by increases in attendance and ticket prices. Year-to-year box-office revenues are dependent on the quality and popularity of the films released by distributors.[4]

From 1995 to 2016, the industry's indoor screen count grew from 27,000 to 40,394 screens. However, attendance per screen declined.[5] The increase in the number of screens from the 1970s through the 1990s was driven by the development of the multiplex—additional screens added to one theater site, rather than new single-screen, or drive-in, theaters. According to NATO and the MPAA, the number of screens per theater has increased, indicative of the

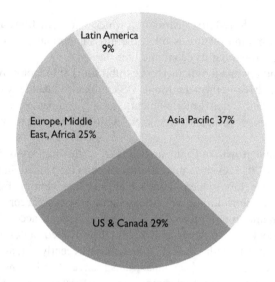

Figure 8.1

industry's development of megaplex theaters, with select theater sites featuring as many as 30 screens, as detailed in Table 8.1 below.

Multiplexes emerged with the rise of the suburbs in the 1960s, when the public changed its social center from urban downtown areas, to shopping malls in the suburbs, where ample space allowed for multi-screen theater sites. The majority of theater chains license first-run films (new films without a prior theatrical release), the success of which in large part depends on the marketing efforts of the major studios. Disruptions in the production, distribution, and marketing of films, from cost cutting by the studios, or strikes for example, are a blow to exhibitors, as are the erosion of audiences from competitive media such as video games, TV shows, or internet programming. In the US, there are 25,914 digital non-3D screens, followed by 16,745 digital 3D screens and 872 analog screens.[6]

The differences between the exhibition business in the US and other countries are notable: laws in the US prevent studios from owning movie theaters, a business model which benefits companies in other countries, creating economies of scale, cost savings, and offering the advantages of vertical integration to the

Table 8.1 Comparison of Top Theater Chains

	2012	2013	2014	2015	2016
1–4 Screen Venues	6,386	6,487	6,133	6,076	6,076
5+ Screen Venues	33,276	33,537	33,824	34,098	34,316
Total	39,662	40,024	39,957	40,174	40,392

distributors. In South Korea, for example, the two biggest distributors, Lotte Entertainment and CJ Entertainment, control almost 80 percent of that country's screens, according to the *LA Times*. In China a big movie such as *Justice League* opened on five times as many screens for its opening weekend than it did in the US, which goes back ultimately to how the industries differ in one country to another.

Important Historical Events in the Theatrical Business

The first movie theaters were nickelodeons, charging five cents for the silent, short films of the time, and they caught on quickly. By 1907, thousands of nickelodeon theaters were showing films, and by 1914, an estimated 27 percent of Americans went to the movies weekly.[7] As noted previously, some of the early theater owners started to produce movies to show in their theaters, and then began to rent their pictures to other theater owners. By the 1920s, grand theaters were built, like the Mark Strand Theater at 47th Street and Broadway in New York City, and Sid Grauman's Chinese Theater in Los Angeles. More movie palaces opened around the country, and audiences flocked to them.

The introduction of sound in the 1920s meant that theater owners who wanted to survive would have to convert their theaters to sound. As the expensive transition got under way, many smaller theater companies failed, and the studios' dominance, bolstered by Wall Street financing, strengthened.

In the 1920s and 1930s, the big theater chains—Loews, Paramount, Fox, RKO, and Warner—were owned by the studios, as part of the complete vertical integration of the industry leaders. Small, individual theater owners were subject to unfair competitive practices, such as blind bidding—having to bid for films without viewing them; and block booking—being forced to license groups of pictures, taking low-quality films with high-quality films. In the late 1930s, the smaller owners filed an antitrust complaint against the studios, which led to the decision in US v. Paramount Pictures in 1948, forcing the studios to divest their theaters.

Following the Paramount decision, the studios, without the pressure to fill their own theaters, reduced their output, forcing some theaters out of business, and leading to the consolidation of others into large chains that would go on to dominate the exhibition industry. As the studios were faced with the threat of television, and then an increasing number of other viewing formats, from cable television, to videocassette recorders (VCRs), they and the theater owners experimented with various gimmicks and new technologies to lure audiences into the theaters, some of which were very short-lived: three-dimensional (3D) film technology, using special 3D glasses (*Bwana Devil*, in 1952, showed natives hurling spears in three dimensions at the audience); drive-in movie theaters; Smell-O-Vision (*The Scent of Mystery*, 1960), which used tubes to disperse different scents inside theaters; SenSurround technology (*Earthquake*, 1974). The major innovations and improvements implemented by theater owners to

maintain and bolster attendance in the television and internet era include: multiple screens (multiplexing); large-format screens like IMAX; modernized theaters with high-end, surround-sound systems; stadium seating; reclining chairs and reserved seating and a transformation to digital projection—bringing back new and improved 3D again. Distributors are using large and enhanced formats like 3D and IMAX to sell movies at a higher price point to avid moviegoers.

The First Distribution Window

Traditionally, the theatrical distribution window is exclusive, without competition from other media. The substantial marketing expenditures and publicity efforts that accompany a theatrical release influence all the subsequent media windows. As the exclusivity of other distribution windows continues to narrow, the theatrical window has become the subject of experimentation for distributors with varying day and date release (releasing on several media and/or territories simultaneously), that threatens to encroach on the exclusivity of the theatrical window.

Leaders in the Theatrical Industry

At present, the top five exhibition companies by number of screens[8] are Regal, AMC, Cinemark, Carmike, and National Amusements, with the top three companies in close competition by total revenue per screen, strongly related to the location of more of their theaters in the top demographic markets.

In addition to the largest companies, there are a number of midsized chains (Kerasotes, Marcus, Hollywood), smaller chains (Landmark, Mann), and independent theater operators (like the historic Pickwick Theatre in Illinois, and the Senator Theatre in Maryland).

The theater exhibitors' trade organization is NATO (National Association of Theatre Owners), representing more than 29,000 movie screens in 50 states,[9] and additional cinemas worldwide, with members from the largest chains to independently owned theaters. NATO lobbies on behalf of theaters—fighting to protect the exclusive theatrical window, and weighing in on other pertinent issues, such as digital theater conversion, piracy, and ticket prices.

Table 8.2 Comparison of Top Theater Chains

	Cinemark	Regal	AMC
North America Screen Count	4,518	7,361	5,261
2015 Revenue	$2.85 billion	$3.13 billion	$2.95 billion
Revenue Per Screen	$631,000	$425,000	$561,000
2016 Revenue	$2.87 billion	$3.12 billion	$3.18 billion

The majority of theaters do not own real estate, with some exceptions, like the National Amusements theater chain. Exhibitors generally rent the space they occupy, with lease terms from 10 to 50 years. Lease obligations represent a major expense item in the theater business and leases can be discharged in a bankruptcy. During the 1990s, when the industry suffered from an over-abundance of screens, a number of chains declared bankruptcy, primarily to get out of unprofitable long-term leases.

Setting Ticket Prices

Ticket pricing is a potential point of conflict between distributors and theater owners. It is in the interest of distributors to have the highest possible ticket prices, since they do not share in any other revenue sources, while the exhibitors might prefer lower ticket prices to boost theater traffic, increasing the vital revenue from concessions, all of which the theaters keep along with revenues from on-screen advertising, and ads and games in the lobby.

The movie-going experience offers an attractive value for consumers, with an average ticket price of $8.65 in 2016.[10] It is convenient and affordable, relative to other forms of out-of-home entertainment, such as concerts, sporting events, and the theater. It remains the great American "date." Historically, theater ticket prices have been inelastic, which means that demand for a ticket is not affected by an increase in price. Price changes have historically been gradual, and it is possible that a single big jump in ticket prices might cause demand to plummet.

A theater ticket price in 2017 of $15.75 (in New York City) may seem expensive; however, in relation to movie production and marketing costs, in some cases above $200 million or even $300 million, $15.75 is a bargain. There is some industry support to tie the ticket price to the budget of a movie, but the concept has not taken hold—although Hollywood, during the studio era, once operated in this way. A theatrical licensing agreement usually provides for a minimum ticket price set by the licensor/distributor, but no maximums.

Table 8.3 Annual Average US Ticket Price

Year	Price
2016	$8.65
2010	$7.89
2000	$5.39
1990	$4.22
1980	$2.69
1971	$1.65
1963	$0.86
1958	$0.68
1954	$0.49
1948	$0.36

Movie Grades and Differential Pricing. From the late 1920s until the introduction of television in the 1950s, movies were assigned a grade that related to the budget, the content, and, to a large extent, the theaters that a film would play in. The grade indicated gore, sexual and violent content, and the quality and star power of a film.

"A-grade" films represented high-production budgets, production values, and popular stars. "B-grade" were genre films, like westerns, science-fiction, and horror. The grading of lower-quality films ranged from C down to Z. Exhibitors paid less for a lower-grade film than for an A-list film.

A-grade films played at a few prestigious theaters in big cities for premium ticket prices, but the smallest theaters could not afford A-grade pictures, and correspondingly played lower-grade films, charging lower ticket prices. Midsized theaters were able to play an "A" film after its initial release, in combination with a lower-grade film and a short or cartoon, but still could not charge the prices paid for the same film shown a few weeks earlier in more prestigious theaters.[11] There is some industry support, although not among exhibitors, for a revival of this type of pricing, tied to the production values, or budget, of a film.

Methods by which ticket price points might be increased are varied and could include: charging higher prices for weekend showings, or prime-time evening showings (somewhat in practice now—matinee tickets are generally priced lower than evening shows), and raising ticket prices during peak film seasons; setting higher prices for the first two weekends that a film opens when demand is highest, then decreasing its price the longer a film is in the theater; or assigning higher prices to better theater seats. In Europe, for example, it is not uncommon for theaters to charge different prices for seating in different sections.

Some differential pricing schemes are already in use, setting a price based on an audience demographic—seniors, students, children; and in certain parts of Europe, charging lower ticket prices to films for children (both for children's and parents' tickets), to appease the grown-ups who must buy tickets to accompany them; or setting the price point in accordance with the quality of the movie theater.

Some theaters have implemented a discounted-ticket multiple-movie pass, bought for a set price, allowing the consumer to see as many movies as she or he wants for a certain period of time. Some consumers will use the passes to see more movies than they actually paid for, and others will use them less, but the passes succeed in driving more traffic through the theater to buy concessions. As of this writing, a new service, Movie Pass, started by a Netflix executive, is an app that offers a subscription where consumers pay $10 per month for access to one movie theater screening per day. The company Movie Pass pays the theater full price for the ticket, taking the loss and collecting data about its users to sell.

To remain competitive in the current environment, it is likely that the theatrical film industry will explore more differential pricing arrangements to entice customers to select the movie theater from multiple entertainment options.

Theatrical Expense and Revenue Sources

The cost of operating a theater includes film rentals, advertising, concession supplies, salaries and wages, rent, utilities and insurance, maintenance of and upgrades to equipment, and general and administrative expenses.

Revenue sources include ticket sales that are split with the distributor, and income from concession sales, advertising revenue for trailers (paid per viewer after they are shown in the theaters), ads shown on-screen prior to a film (profits typically split between an ad agency and the theater), in-lobby attractions like arcade games, in-lobby advertising, and advertising on popcorn bags, tickets, and cups.

Reports from the Cinema Advertising Council indicate that income from in-theater advertising revenues (in-theater onscreen advertisement) is rising, to a record $706.8 million in 2016.[12]

Who Is Going to the Movie Theater?

The MPAA carefully monitors the demographics of movie audiences for its members, the studios. Tracking by age, sex, ethnicity, income level, and marital status, the MPAA compiles data for the studios to inform their business strategy, and identify consumer trends.

Conclusions from the MPAA 2016 Theatrical Market Statistics indicate that, of the 1.32 billion movie tickets sold in 2016, females comprise just over half of the audience. The study also found ages 25–39 and 60+ were each 21 percent of the audience, with every other audience age group trailing, ranging from 8 to 14 percent. Regarding ethnicity of audiences, the Asian/Other category was the highest, seeing a movie 6.1 times per year, Caucasians the least at 3.2 times per year, and African American and Hispanic audiences around 4 times per year.

Rethinking the Theatrical Experience

Exhibitors are investing in the future. In order to appeal to audiences theaters have converted to digital projection, and at the higher ends have created luxury experiences beyond the movie, including deluxe padded, fully reclining chairs, reserved seating, dining in, alcohol, valet parking, leather seats, pillows and blankets, waitresses, gourmet food, doubles seats, babysitting, as well as playgrounds, kids foods with bean bag chairs. Muvico Theaters, Rave Motion Pictures, Emagine Entertainment, and National Amusements are some of the chains that are packaging these services into the movie-going experience, and charging ticket prices almost double the standard price for those viewers who want to avail themselves of the amenities. Embracing a combination of indie fare, select blockbusters, and classic movies, the small theater chain Alamo Drafthouse Cinemas offers a hipster vibe, mixing gourmet food and cocktails in an upscale setting. These types of theaters are growing in popularity. Also on the high end

of the movie-going experience, 4D cinema theaters are emerging, a mix of movie and theme park ride; including throwback technologies of 3D and a type of smellovision.

With the conversion of theaters to digital, 3D and 4D are on the rise. 4D combines a 3D movie with physical effects, like a moving seat synchronized to the action, along with a mix of strobe lighting effects, air jets, water sprays, leg and back ticklers, rain, lightning, temperature changes, air bubbles and scents to accentuate plot points and action onscreen.

For instance, the 4D release of 2017 franchise film, *Kingsman: The Golden Circle*, featured effects consisting of seats that dig you in the ribs as punches are landed, wind jets blowing into your face to create sensations of speed or fast movements, blowing air when a bullet rushes by. Companies in this space include Samsung Electronics, CJ Group (29 theaters), D-Box Technologies (of Canada), MoviePower, and Cineopolis with a dozen 4D theaters in Mexico, opening several more in Mexico, Brazil, and Peru.

Exhibitors are currently fighting to protect their position as the first exclusive window of distribution not only by upgrading their theaters, but also experimenting with new types of entertainment in the form of satellite-delivered concerts, circuses and other performing arts, sports, opera, live theater, classic film programming, and religious services, through companies such as Fathom Events and mainstream theaters, all in an attempt to keep regular patrons coming back, and to court infrequent consumers. Ultimately, consumers will decide the outcome.

Competitive factors in regard to theatrical film licensing include the number of seats and screens available for a particular movie, box-office splits between the distributor and exhibitor, and the location and condition of an exhibitor's theaters. The theatrical exhibition industry faces external competition from other entertainment venues such as concerts, amusement parks, and sporting events, as well as from other distribution channels for filmed entertainment, such as pay-per-view, cable television, internet streaming services and home video and mobile entertainment systems like game consoles.

Personal income and leisure time drive demand. The profitability of individual movie theater companies depends on securing access to the most popular movies and vigorous sales of high-margin food and beverages. The bigger chains benefit from advantages of scale in negotiating with movie distributors, and vendors, while smaller companies can compete by specializing in a specific type of audience, or by providing better service and amenities. The US industry is highly concentrated: the top five companies account for more than 80 percent of revenue.

Film distributors are required by law in most states to offer and license films to exhibitors on a film-by-film and theater-by-theater basis, due to the Paramount Consent Decree in 1948. Exhibitors do not have long-term output deals with studios, and must maintain good relations with them to get the best films and favorable licensing terms in order to remain competitive.

Theaters compete in the geographic areas in which they operate. The level of competition is based on population density and the number of theaters. Competition exists on a national level, in regional circuits, or between smaller independent exhibitors, and the competitive edge usually goes to those theaters in the largest demographic market areas with the most advantageous sites.

Competition for patrons depends on the availability and quality of films, the number and location of theaters and screens, and the comfort and quality of the theaters. In the 1980s and 1990s, the development of new theaters too close to existing theaters resulted in excess capacity and increased competition, and led to the bankruptcy of several theater chains.

Barriers to entry in the theatrical business are low, similar to other retail businesses. There is nothing to prevent a competing exhibitor from opening a new theater near an existing theater, and taking their customers.

The industry-wide strategy of building megaplexes with increasingly higher screen counts generated significant competition and rendered obsolete many older theaters, resulting in the acquisition of failing chains by larger chains, with a few top players in the industry controlling more screens. Growth in the number of screens will continue to negatively affect smaller theater chains and independent exhibitors. Success in the exhibition industry also depends on economic conditions encouraging, or discouraging, consumers to go out and spend money at movie theaters. Economic downturns can be harmful to the theatrical business, although history shows that movie attendance has been countercyclical to recessions, and consumers, needing an escape, turn to movies until almost the very end of a recession. Adverse political conditions, such as terrorist threats, may cause consumers to avoid public places. Increases in gang violence or other unsafe conditions also discourage consumers from going to theaters. To remain relevant and competitive, theaters must continue to invest in a combination of technology, comfort, in-theater amenities, and security measures.

The Transformation to Digital

The high-resolution image theaters project currently are a result of the recent digital conversion of their screens and projectors, spanning from approximately 2005 to 2015.[13] The theater industry has recently completed an expensive conversion from film-based to digital-based delivery, substantially reducing the actual cost of delivering movie prints to theaters; however, distributors must still pay VPF (virtual print fees) to theaters for each film as a means of contributing to the cost of the conversion. More than 90 percent of the world's cinema screens are now digital, according to the MPAA.

In the place of film prints (name for rolls of film) theaters typically receive a DCP (digital cinema package), a hard drive with the digital files of the film, delivered via express courier to the exhibition site. Other, less common methods deliver the film by means of a dedicated satellite link or high-speed internet

connection. The digital delivery systems provide flexibility in programming, booking, and scheduling based on audience demand. This also allows programming of higher-priced 3D versions of digital films.

Content providers and distributors are bearing some of the costs of this change. Theaters without access to adequate capital to finance the conversion costs closed, or were acquired, as happened with the conversion to sound. Examples of this include AMC becoming the biggest movie exhibition chain by buying Nordic Cinema Group in 2017, and Carmike in 2016; and Mexico-based cinema giant Cinépolis buying Bow-Tie Cinema in downtown Manhattan.[14]

The MPAA and NATO created partnerships to successfully complete the conversion and work out the financing. Examples include the Christie/AIX partnership (between Christie Digital, the projector manufacturer and digital-cinema business provider AccessIT), as well as Digital Cinema Initiatives (also known as DCI, representing the studios to ensure technical standards), and National CineMedia (formed by leading exhibition companies AMC, Cinemark, and Regal) that worked together to bring about the conversion to digital cinema on a large scale.

Distributors now pay the theaters a virtual print fee of $800 per digital print (lower than the $1,500–2,000 for per-film print) to the theaters, to subsidize the digital conversion. Overseas, some European companies received government subsidies to convert screens to digital. Besides the direct economic benefits to the distributors, there are several other advantages to digital conversion. Digital film projectors show a consistently sharp image, unlike film prints, which can become damaged over time, degrading the quality of the image. Other benefits include the ready adaptability of theaters to consumer demand, being able to add more screens quickly for breakout hits, or featuring non-movie entertainment such as live concerts during slow movie periods.

China now has the most cinema screens of any country in the world, with 41,000 screens, topping the United States, which had 40,759 as of May 2016, according to NATO, and an average of 5.6 screens per theater site.[15]

Theater chains have steep competition currently thanks to a wide variety of entertainment options available to the consumers, including programming from Netflix and Amazon, as well as home theaters with huge plasma flat-screen televisions, outfitted with high-speed broadband, home-media gateways like Microsoft Xbox, and mobile technology.

Deals Between Distributor and Exhibitor

Distributors prefer to book their films in theater locations best corresponding to the demographic profile of the appropriate target audience, and based on how similar films performed at these theaters in the past. The distributor chooses the theatrical release pattern—wide, saturated, platform, limited, or exclusive—and release dates. Exhibitors either negotiate terms with distributors for a specific film, or distributors may submit bid letters to the desired theaters.

The film booker for a theater chain negotiates the specific deal terms between the exhibitor and the distributor, including: clearances—providing exclusivity by time and territory, for a minimum number of weeks before the film is released in other formats, and guaranteeing that each theater is the only one in the region or neighborhood showing that film; holdovers—stipulating that if the film meets a certain profitability threshold the theater will continue to run it; film rentals—the portion of the box office payable to the distributor; the number of show times, dates, and number of seats; and, occasionally, the payment of an advance by the theater to be deducted from the distributor's share of future box office.

The exhibitor and distributor usually split box-office revenues based on a sliding scale, in an arrangement that favors the distributor upfront, yet rewards a theater with a greater share of revenues over time. Typically in the first week or two of exhibition, two different calculations are made on a weekly basis—the 90/10 split—and the floor payment, with the distributor receiving the greater of the two. The 90/10 split allows the exhibitor to deduct its operating expenses (house nut or house allowance) off the top, then pay 90 percent of the remaining box office to the distributor. Calculation of a minimum floor payment (typically 70 percent or so in week one) is made without regard to the exhibitor's operating expenses. The split between distributor and exhibitor changes every two weeks in a typical deal, although terms vary, depending on the film, the theater, and the time of year.

Over time, the average split between the distributors and theaters approaches 50/50. If a film flops, the distributor and exhibitor will make special arrangements, such as a flat settlement to the theater, or an adjustment to the box-office splits. Terms can be negotiated as firm terms, where the deal remains as initially agreed, or as review terms, where the deal can be adjusted once the box-office results are tallied. Distributors and exhibitors have ongoing business relationships and, therefore, there is a strong incentive to deal fairly with one another, whether a film is a complete flop or a blockbuster hit.

Distributor screenings for exhibitors take place between one and three weeks prior to the release date, and may be scheduled months in advance for big pictures. Once booked in theaters, the distributor and exhibitor plan their shared or "co-op" marketing efforts, for advertising on local television and in newspapers, and arrange for appropriate marketing materials to appear in the theater, such as a one-sheet (poster) and other lobby marketing (banners, video-display teasers, corrugated cardboard stand-up displays).

Due to the seasonally cyclical nature of the film industry, exhibitors and distributors rely heavily on the revenue generated during peak seasons—the summer and end-of-year holidays. Exhibitors may bid on big tent-pole films sight unseen; however, they usually attend screenings of films to decide which films they will bid on.

Competitive bidding for high-demand films raises the price of the film for all of the theaters participating in the bidding, and it benefits exhibitors not to bid too aggressively for a particular movie.

New Business Models

With new technologies come new business models. The media business continues to evolve, which creates new business models that, in turn, will continue to shape how creators inform and entertain us. Business models drive the medium and greatly affect what is created, and for whom. Ad-supported programming developed for large audiences will be very different than programming developed for niche audiences who pay directly.[16] Also, consumers command a great deal of power, in part due to the wide amount of entertainment choices. Audiences are shifting their media time away from traditional modalities such as live TV and frequent theater going, opting instead for services that allow them to watch what they want, when they want, migrating toward original digital video, streaming video-on-demand (SVOD) services, and live streaming on social platforms.

A fairly recent development is that a variety of media businesses are creating original content. From cable companies to the online platforms, Google to Apple, Netflix and Amazon, even Wal-Mart and the telecommunications companies are investing in a content strategy. Approval is pending for AT&T's acquisition of Time Warner, and AT&T is rolling out a service intended to rival Netflix. This is an example of a new media company—like Netflix, AT&T, or Google—investing heavily to insert itself in the space formerly dominated by the traditional media companies, the Hollywood studios. AT&T seems an unlikely candidate in this field; however, its $35.3 billion in revenues in 2015 made it bigger than most Big Media companies including Time Warner, Fox, Viacom, and CBS.[17]

Theaters, faced with flat growth, and a shorter window, must make more money from increased prices, more frequent theater goers, with up-selling enhanced formats, subscription and loyalty cards, and package deals with combinations of drinks and ticket sales.

License fees from multi-phased distribution are important to the financial success of most projects, pushing the distributor to change the pattern to maximize revenue. The changes far squeeze the theater exhibition sector the most. Typically movies first go into theatrical release, then to DVD, internet streaming and online video services, cable and pay-per-view TV channels, and eventually to free TV. The time between a new movie's opening in theaters and its availability on other platforms is shortening. As video-on-demand becomes more popular it becomes a priority to viewers and pressure from those audiences are forcing the distributors to shorten the gap between theatrical release and VOD formats. The VOD players include subscription-based services such as Amazon and Netflix, offering unlimited access to a database of titles for a monthly or annual fee. Rental or purchase services, such as YouTube, iTunes, Hulu, and Vimeo, give consumers the option to pay-per-stream, download to rent, or download to own individual movies, and may also earn revenue from advertising.

The new business model considered for studios is introducing a premium video-on-demand window (PVOD), for new movies, priced from $30 to $50, following a theatrical window of 30–45 days, cutting into the theatrical. Industry analysts are saying that the current exclusive 90-day theatrical window is "a luxury that studios can no longer afford" and that studios could gain from $740 million to $1.8 billion annually by introducing PVOD sooner.[18] The fear of the theater industry is that if PVOD prices drop to $20, consumers will realize that it's cheaper to watch a movie at home than in cinemas, and ultimately theaters will close. Exhibitors could lose hundreds of millions to the PVOD window, and significantly more if Netflix introduces as many as 40 movies on its streaming service, as it has announced.

The small distribution company Magnolia Pictures has released films in the PVOD format prior to the theatrical window, and Radius-TWC and other smaller distributors followed suit. To some extent, the marketability and awareness of the films based on star power, franchise, or awards, will determine whether this is a good bet. Radius-TWC's release of *Snowpiercer* two weeks before the digital VOD release earned $1.1 million from VOD, compared to $635,000 from theaters.[19]

A middle-ground business model might consist of blending the current window structure, with a PVOD release after a certain level box office is reached, as Paramount did with *Scouts Guide to the Zombie Apocalypse* and *Paranormal Activity*.

The primary competition for theatrical dollars is the relentless climb of internet VOD, illustrated in Figure 8.2 below, illustrating the change over time in sources of distribution revenue.[20]

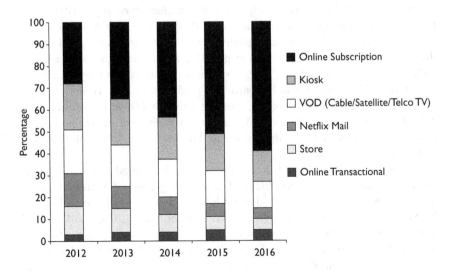

Figure 8.2

Crowdsourcing as a New Business Model. With the advent of the Internet, crowdsourcing—where internet users can vote and participate by rendering their opinions—has become a way to access the "hive mind" online. Since 2010, Amazon Studios has used crowdsourcing to create and curate original content for its online channel. Amazon is crowdsourcing original content—movies such as *Zombies vs Gladiators* and the children's TV series *Magic Monkey Billionaire*—by soliciting writers and filmmakers to upload their work. It has an exclusive, 45-day option to buy movie scripts for $200,000 and TV series for $55,000. It can also pay $10,000 to extend options for 18 months. Rather than accepting completed work, the company develops the scripts it options into trial videos, then posts them online for reviews and feedback from its millions of customers (310 million active customers, 80 million Amazon Prime members). Writers use the feedback to adjust scripts, hoping to boost the chances of creating a hit when Amazon turns a project into a full movie or TV show.[21]

Direct-to-fan video streaming for independent producers is a new business model, relying on the Internet, the ability to self-promote and create buzz, and amass a fan base. Indies are exploiting as many windows and rights as possible, controlling price points that work for them, changing it as necessary, and combining online sales with events, live screenings, film festival screenings, selling merchandise around their movie. This 360-degree model basically means that the creators do everything themselves, and have maximum control. Filmmakers are utilizing their own websites, and online platforms like YouTube and Vimeo and VHX to sell their movies, and build fan bases online in social media.[22]

Franchising a Universe of Content. With the acquisitions of content providers by content exhibitors such as the studios' purchase of comic book publishers, the model of creating universes has been expanded. A content universe such as Marvel combines hundreds of major and minor characters, super villains and heroines, long-running feuds, origin stories that can be combined, intersected, spun off, revised, rebooted, and updated. The studios are well-versed in this, then exploiting the ancillary rights in pay-TV, video games, apps, amusement park rides, and merchandising, but shrewd indie producers like Lloyd Kauffman have imitated this model with his satirical b-grade films in the Troma catalogue (such as *Toxie the Toxic Avenger*), creating musicals (*Toxie the Musical*) and animated shows (*Toxic Crusaders*), and his own channel of Troma-inspired characters. Kauffman offers them through Tromaverse, a subscription service with hundreds of Troma titles.

Create Your Own Model. Recreating the business model by virtue of his power and fame as a director, Steven Soderbergh got fed up with Hollywood, quit the movies, then came back, doing it his way with the stock-car racing 2017 NASCAR-themed heist film *Logan Lucky*. "I want movie studios to keep their grubby paws off my money. And I want complete control over how my films are marketed." Due to his fame and reputation, Soderbergh launched distribution company Fingerprint Releasing, easily sold off overseas distribution rights, raised a $27 million production budget, getting stars (Tatum Channing, Daniel

Craig) to work for scale and profit participation. He then struck a deal with a consultant to raise P&A money to market and distribute the film in theaters, by pre-selling streaming rights to Amazon, as well as other non-theatrical rights. Soderbergh made an atypical distribution deal with a small distributor, Bleecker Street, for a fee under $1 million and profit participation if the film hit box-office targets, and also participation in other revenue streams, including DVD sales—with Mr. Soderbergh approving everything.[23] *Logan Lucky* delayed TV advertising, saving 80 percent of its media buying budget until the last week of the marketing campaign, in contrast to studios that usually begin spending big money months in advance. The film bypassed premieres in Los Angeles and New York, rather focusing on big NASCAR regions with premieres in the south, a charity fundraiser with Regal Entertainment, and sending actor Channing Tatum on a road trip through NASCAR country.[24]

From Video/DVD to VOD/PPV

DVD, once the cash cow of Hollywood, is now in rapid decline, giving way to the promise of video-on-demand, now the fastest-growing segment within digital media which includes e-publishing, video games, and music. Ironically, Netflix, which once made DVDs available and more popular than ever, is destroying the DVD revenue stream as the company accelerates its offering of subscription video-on-demand service. This pattern is a familiar one in the movie industry, a repetition of TV disrupting the movie business, digital disrupting analog, and video giving way to DVDs.

From 2010 to 2016 DVD revenue declined 35 percent, and continues to fall. DVDs are sold to consumers, online, in kiosks and in brick and mortar stores, and they are also available to rent in stores and kiosks. Naturally, sales of DVD players are also falling, tied as they are to the declining DVD marketing. The top selling DVD titles are films that were also hits in the theater. The top sellers in 2016 included *Star Wars: The Force Awakens, Deadpool, Zootopia, Batman v Superman: Dawn of Justice*, and *Finding Dory*.

Hollywood studios may be shortening film release schedules by half, allowing DVD and digital versions to be purchased after 45 days in theaters versus the 90 days that is currently the industry standard. DVDs now are released at the same time as standard transactional VOD (TVOD) in order to maximize awareness and marketing activities. This release pattern reflects the reality that VOD revenues are surpassing the revenues from DVDs. This echoes recurring patterns in movie industry history; format wars when DVD cannibalized VHS; new technology disrupting the movie industry's financial architecture; as well as Hollywood's initial rejection of a new format.

Brief History of Video to DVD. The film industry's first reaction to home video in the 1970s was one of panic. Movie executives feared that if consumers could watch a movie at home they would no longer patronize theaters. Also, home video had the potential of enabling unlawful copying and dissemination of

movies by viewers. The studios launched a legal assault on video manufacturers in an attempt to stop or slow the advent of home viewing. This strategy ultimately came to naught.

Entrepreneurs saw opportunity in the film industry's reluctance to embrace video. New companies such as Vestron, Nelson, Magnetic Video, and HBO Home Video were formed to license video rights to movies from the studios for distribution on videocassettes. This opportunity arose out of the tendency in the industry to avoid taking advantage of a new technology until others have demonstrated its economic viability. Initially, videos were fairly expensive, over $50, and early video players were also expensive, running into the thousands. The first Betamax VCR sold for $2,295. JVC released the VHS-formatted VCR one year later, for a price that was less than half of the Betamax. Competition between competing formats, Beta (by Sony) and VHS (by JVC) stalled the early growth of what would prove to be a hugely popular medium. The lower price of VCRs, in conjunction with longer-running VHS tapes, led to its victory in the format battle. The independent home-video distribution companies that emerged to fill the gap between the Hollywood studios and the video-consuming public may have succeeded too well. By the 1980s, the studios realized that home video would be immensely profitable, and they began to take over the manufacture and distribution process themselves, effectively putting the independent video companies out of business by cutting off their supply of first-run major movies.

After the VHS format became the standard, the price for both video players and videocassettes fell, and another group of entrepreneurs saw an opportunity to purchase videotapes from the studios and then rent the tapes to consumers. Once the initial cost of the tape was recouped, any additional rental fees represented profit. As owners of movie copyrights, the studios sought to block this business model legally, but failed. The irony, is that once the industry was forced to stop fighting and embraced home viewing, that format went on to become the biggest source of revenue and profits for the industry, with theatrical revenue slipping to a distant third. The home-video market expanded rapidly through the 1980s, then declined as DVD took its place.

Rise of DVDs

In addition to reviving, and restarting growth in, the home-viewing market, DVDs were ultimately more profitable to the studios. The technology for digital video discs emerged in 1995, spearheaded by electronics companies Sony, Toshiba, Panasonic, and Philips, and grew rapidly. In 2006, total DVD and video consumer spending reached $23.6 billion, but by 2016, revenue from the sales and rentals of movies and TV shows were 50 percent less, as VOD rapidly surpassed DVD revenue.[25]

The home-viewing market, whether rental or sell-through, has always been dominated by films that have been theatrically released. The advertising and marketing that supports a theatrical release powers the visibility of a movie for

the home-viewing market. In addition to theatrical films for sale or rental on DVD, many movies were produced for a straight-to-video/DVD release, especially movies for children, in the family genre, or made for niche audiences. There were many direct-to-video/DVD movies made for relatively low budgets with nominal releasing costs. Exploitation films, and clearly defined genres; horror, thrillers, sci-fi, were also popular straight-to-video/DVD fare. In the early 2000s, as the popularity of DVDs soared, the videocassette format was phased out by the studios.

One reason for the popularity of DVDs was the technology itself. DVDs were light, durable, and had more memory than CDs, large enough to hold an average movie on one side. To defend against piracy, discs are encrypted. Regional coding allows DVDs purchased in one region to be played in a DVD player purchased from that region, to maintain separation of theatrical releases and DVD releases, from one region to another.

Prior to the invention of cell phones, the DVD player was the fastest-selling electronic consumer product in history, and its rapid penetration of the market fueled significant revenue growth for the film industry from 1999 to 2004 after which DVD revenues flattened.

High-Definition DVD Formats. High-definition DVDs require a player that is equipped for them, with a high-resolution television. Growth in sales of high-resolution 8K and 4K TVs are an encouraging sign for Blu-ray sales. High-definition DVDs entered the marketplace in the early 2000s, with the potential to revitalize the growth of the market. Competing formats, HD-DVD and Blu-ray DVD, slowed the growth of the markets by requiring different DVD players. Studios swung behind Blu-ray and in 2008, Toshiba announced it would withdraw the HD-DVD format. The new format did not replace standard DVDs, as DVDs once replaced videos. In fact, some retailers, such as Sam's Club, are considering with no longer selling DVDs and Blu-rays.[26]

DVD Retailers. The largest DVD sell-through retailers are Wal-Mart, and other chain stores like Target and Best Buy, Kmart, and online retailers like Amazon. These retailers may use films as loss leaders—products with little or no profit to the retailers, but which serve to draw consumers into the store, in the hopes that they will purchase goods with higher profit margins.

DVD Rentals. Videos may be rented through kiosks like Redbox, and the few remaining video rental stores. One of the last of the video rental chains is Family Video, with 759 locations in the US with a concentration in the Midwest and rural America. The big video chains, Blockbuster and Movie Gallery, filed for bankruptcy in 2012, unable to compete in the digital age. At its peak Blockbuster operated more than 9,000 outlets, bringing in $6 billion in annual revenue. In 1989, there were nearly 30,000 video rental locations in the US.[27]

In addition to Family Video, Redbox remains the last stronghold for DVD/video rentals. DVD rental kiosks are stand-alone, completely automated film vending machines, located in supermarkets, malls, and other traffic areas renting DVDs for very low costs, approximately one to two dollars per day. Movie titles

are available on Redbox at some 33,000 locations, including Walgreens, Wal-Mart, Kroger, and 7-Eleven stores, typically 28 days after release on disc and digital sell-through, and before they hit subscription services like Netflix.[28]

An indicator of the shift in power from DVD to VOD was in 2016, when disc sales were eclipsed by subscription VOD streaming numbers for the first time ever.[29]

Netflix, which started as an online DVD rental company, is now a power-house in the streaming business, effectively disrupting the entire movie indus-try's distribution, exploitation, and financing model. Netflix was an immediate hit with consumers for its DVD home delivery rental service via the mail, huge library of 80,000 titles, no late fee policy (which other rental companies then adopted), and the convenience of renting movies online. Initial membership entails a monthly subscription price and access to the Internet to choose movies, mailed to the subscriber with postage-paid, return packaging. In addition to streaming movie services, Netflix still rents DVD and Blu-rays. Netflix has 103 million subscribers, generated revenue of $8.8 billion in 2016, is expanding internationally, projecting that it will produce 40 new titles per year, ahead of any existing Hollywood studio (Netflix website).

Online retailers have played an important role in DVD, offering a huge number and a wide variety of titles, impossible to mass-market stores; reviving titles which would not otherwise be promoted, utilizing computer recommenda-tion algorithms.

A successful DVD ships several million units, typically a hit in the movie theaters. A blockbuster like *Frozen* (2014) sold 11 million units, surpassing *Avatar* and *Twilight* with around 10 million units, according to IMDb. Other DVD top sellers tend to be big box-office hits as well in the theater, like *The Hunger Games* and *Harry Potter and the Deathly Hollows, Part I*, selling over 7 million units. The big video distributors project sales of a minimum of 50,000 units for smaller, low-budget films, and small video distributors can make profits on as few as 10,000 units.[30]

The combined streaming VOD forces of Netflix, Apple's iTunes (then ulti-mately Amazon and YouTube) pushed Blockbuster and Movie Gallery to attempt VOD. Shortly after rival Blockbuster acquired the online video site, Movielink, Movie Gallery acquired an online service, MovieBeam. This ambi-tious growth plan by the second largest video retailer coincided with increased competition from the proliferation of online video services, low-priced in-store rental kiosks, and Blockbuster's aggressive online solicitation of customers. Bur-dened by debt of $1.4 billion, Movie Gallery was forced to close in 2010, an indication of how fiercely competitive an environment the home-viewing rental market had become as a result of technological changes that have opened up numerous alternative delivery platforms. A few years later, Blockbuster closed all but one location.[31]

Netflix, Amazon, and iTunes prevailed. Wal-Mart persists with offshoot VOD service Vudu, in response to retailer Amazon and its video streaming service

Amazon Prime Video which offers commercial-free movies and TV shows, including original programming. Wal-Mart has not yet initiated original programming, and its service Vudu is a streaming transactional VOD service, which also offers Vudu *Movies On Us*, a free, ad-supported streaming video service; as well as InstaWatch, a hybrid of DVD and online, where a customer buys a DVD or Blu-ray and receives a digital copy included.[32] This pattern of a new technology disrupting, then cannibalizing, an existing technology, is exactly what happened when DVD took the place of VHS videos.

With the theatrical window in flux, Hollywood studios may be shortening film release schedules by half, allowing DVD and digital versions to be purchased after 45 days in theaters versus the 90 days that is currently the industry standard. Distribution licenses for the DVD window last 3–7 years. The DVD currently follows the theatrical window (about 90 days long). There is talk of cutting the exclusive time for a movie to be in theater from 90 days to 45, so the DVD would be released at that time. DVD is usually released at the same time as standard transactional VOD in order to maximize marketing efforts and expense.

VOD/PPV

Video-on-demand (VOD) is the fastest-growing segment of digital media. VOD and pay-per-view (PPV) are two windows with similar characteristics: delivery systems that allow viewers to see a film on a television or computer, at home or in a hotel or other venue. Revenue from streaming video-on-demand (SVOD) has been growing.

There are a few differences between PPV and VOD. PPV offers a film for a single viewing on television, at a scheduled start time, for a fixed fee. VOD offers viewers a choice of films for delivery on television or via an internet connection, to either their smart TV or computer, at a time of the viewer's choosing, for a one-time payment. The ability of the consumer to choose the start time of the movie makes VOD a more convenient option than PPV. With its rise in popularity, there are several hybrid versions of VOD as well, including premiere, day and date, subscription, near VOD, advertiser supported, and transactional.

Near VOD (NVOD), is a hybrid between PPV service and VOD, offering a film on several different channels with varying start times.

Technologies for PPV or VOD delivery systems emerged in the 1990s, today they use cable, satellite, or internet technology. Viewing on a traditional television set requires a television with a set-top box, or a smart TV and an internet connection.

VOD film delivery via cable is offered by the large cable operators: Comcast, Time Warner Cable, and Cox, via DSL (digital subscriber line) and by most of the major telecommunications companies. Online VOD movies are offered in several ways: through an advertiser-supported model, via internet downloads that allow ownership of the digital file; or rental—offering limited viewing rights for a

limited period of time with prices from $5 to $20. The success of VOD is due to improved internet speeds, and increased platforms including Netflix, Amazon, YouTube, iTunes, as well as smart TVs. Competitors in the internet VOD space are Netflix, Amazon, DirecTV, Hulu, Sling TV, Sony Playstation Vue, HBO Now, YouTube TV, offering services ranging from $8 to $40 per month.

Video streaming services offer unlimited access to a broad selection of different genres and titles for a subscription fee. Of the global VOD market, 87 percent is covered by the United States, China, and Europe, at total market of $14 billion. Video streaming continues to grow about 5 percent per year. The dominant company in this space is Netflix, with over 83 million members in over 190 countries, including more than 47 million in the United States.

The standard VOD window occurs after the theatrical window, after 45–90 days, and is released at the same time as DVD to maximize marketing. The window is approximately two months to a year long on cable.

PVOD is a premium VOD window for new movies. There is a significant amount of experimentation around this window—primarily because it would cut into movie theater revenue. The window would follow theatrical by 30–45 days. A recent experimentation in PVOD was spearheaded by file-sharing service Napster founder Sean Parker: Screening Room, streaming new movies for $50 while still in theaters. The proposed fee would be split by the distributor, theater chain, and Screening Room.

Transactional VOD (TVOD) refers to a single viewing on cable (e.g., Comcast, Time Warner, Rogers, Cogeco), satellite (DirecTV, Dish Network), or telco services such as AT&T U-Verse or Verizon Fios. The average price point is $9.99 and rental period is 48 hours.[33]

Subscription VOD, also known as SVOD, gives subscribers the opportunity to view titles in the provider's library, at a time of their choosing, for which the viewer pays a monthly fee for access. Examples of SVOD services include Netflix, Amazon Prime, and Hulu Plus.

Advertising-supported video-on-demand (AVOD) allows the viewer to watch films, paid for by advertisers. Ads are typically inserted at the front, back, and at varying intervals within the film. YouTube and free Hulu services offer AVOD.

Pay-per-view rights are licensed to a pay-per-view distributor—such as inDemand—which bills and collects from the customer, splitting fees between distributor, cable operator, and PPV service.

Online and Mobile Platforms

Online and mobile platforms for movies hold the greatest potential for the immediate future of movies as more people consume video on their phones, and people gravitate to OTT content, "cutting the cord" from traditional cable services and traditional TV broadcasting.

OTT content refers to "over-the-top" video content streamed via the Internet, without a set-top box to a viewer's screen. Examples of OTT include any

variation of internet video-on-demand such as SVOD, AVOD, TVOD, or PVOD. The internet provider who provides the service to transmit the content is not responsible for the content, access to it, or any copyright-related issues. OTT services like Netflix, Amazon Prime Video, Hulu, Sling TV, Google Play, iTunes, Plex, YouTube TV are siphoning off viewers from cable and broadcasting, which disrupts the economic structure of the windows of distribution. This is yet another example of new technologies forcing changes in distribution patterns. OTT is disrupting cinema and television distribution patterns worldwide.

The question for the industry currently is where to insert the OTT window into the distribution architecture without reducing revenue from the other sources. As of 2017, 51 million US households watch OTT content through a variety of screens, whether smart TV, computer, game consoles, tablet, or smartphones. There are several contenders in this space, with Netflix as the clear leader, as of 2016, illustrated in Figure 8.3 below.[34]

Netflix is the leader in penetration and total engagement in this space due to its expanding original content portfolio and aggressive move into international markets. Started in 1997 as an online DVD rental service, the company has grown into a force in OTT, delivering subscription video-on-demand programming. In addition to licensing studio product, it moved aggressively into original programming, spending $6 and $7 billion respectively on original content in 2017 and 2018. The relationship between Netflix and the studios has shifted. Netflix is no longer merely an additional window in which to license programming, and therefore a revenue source, but rather direct competition. Studios like Fox are pulling their programming away from the company, and at the Cannes Film Festival in 2017, there was an outcry that the company was destroying

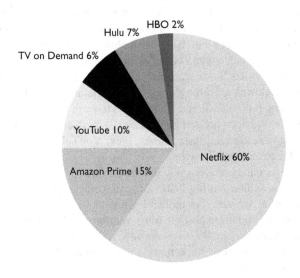

Figure 8.3

movie theaters. When Netflix booked a tiny theatrical release for *Okja*, several theaters in South Korea, CJ CGV, Lotte Cinema, and Megabox, banned the film, a blow to Korean director Bong Joon-ho—as an objection to a day and date release simultaneously on theaters and Netflix.[35] Netflix is expanding through North America, Latin America, Europe, India, and Japan (company sources). Because Netflix rarely releases a movie in theaters, it has no access to the unlimited upside that can happen when a movie hits it big, and the company must keep its production budgets restrained. Netflix is just one of several OTT providers, including Hulu, Amazon, Playstation Vue, Sling, Crackle, HBO Go, Twitch, Showtime Anytime, and Vevo. OTT has risen in importance in the home, but also on mobile platforms such as smartphones and tablets.

Smartphones have become the fastest-selling electronics in history, outstripping the growth of the mobile phones that preceded them. Smartphones outsell personal computers four to one, and half of the adult population owns a smartphone. With improved connectivity, bigger memory, and more efficient streaming technology, smartphones are increasingly used as movie screens on the go.[36] Online and mobile platforms are increasingly a popular place to watch movies, carrying both the promise of expanding the reach of the distributors to larger audiences directly, while threatening the traditional gatekeeper role of the studio distributors.

Mobile phone viewers are gravitating to longer-form content. Of all video viewing on smartphones, 48 percent is now related to clips that are five minutes or longer, while 30 percent of all viewing is videos that last 20 minutes or longer.[37]

Films may be delivered on a mobile phone network using point-to-point technology: sent from a server where the films reside to an individual phone or via point-to-multipoint version of digital video broadcasting for handheld devices. Speed of data delivery, storage, and the speed of broadband influence quality of the viewing experience on phones and tablets. Other mobile devices, like tablets with Wi-Fi access, and portable video game consoles, such as Sony's PSP (PlayStation Portable) and Apple video iPods, can also play films. The Apple platform is enabled for content download through Apple's proprietary store iTunes. There are many applications (apps) designed for mobile viewing; web browsers such as Safari and Chrome and apps created by specifically by Netflix, Amazon Prime Video, Hulu, Sling TV, Google Play, iTunes, Plex, YouTube TV, HBO Now, CBS All Access, DirecTV, and Showtime.

A marketing tool that has emerged alongside online distribution is the ability to track consumer film buying and renting behavior, and to make personalized recommendations to potential viewers. As more film retailers go online, these programs can help consumers find more obscure films, reinforcing the "long tail" theory, coined by Chris Andersen in *Wired* magazine, suggesting that lower-demand films can collectively account for a market share approaching that of best sellers, provided that a retailer can offer a large number of films, as does Netflix.

Film viewing via the Internet and mobile are cannibalizing the DVD window, and the industry needs to find a way for the new windows to replace that declining DVD revenue. More importantly at this juncture the industry must find a way for all of the distribution windows to coexist, profitably, if possible.

Cable/Free-TV/Cutting the Cord

As OTT continues to gather momentum, the forecast is bad news for traditional cable, satellite, telco TV operators, and their programming suppliers. US pay-TV providers dropped by 2 million subscribers in 2016, while OTT TV providers gained 1.5 million over that time. Sling TV, Sony PlayStation Vue, and DirecTV Now offer OTT linear and on-demand services of live television product and films. In response to shrinking revenue and customers, cable providers like Dish and DirecTV started their own OTT services, while the solution for Comcast and others is a "skinny bundle," a lower-priced service. Premium cable channels Showtime, Starz, and HBO launched OTT streaming internet-only versions of their programming.[38]

The theatrical release VOD, DVD, and PPV windows are typically followed by a window for pay-television systems. The introduction of cable television, and the popularity of pay-cable channels, such as HBO and Showtime, which featured movies exclusively in the 1970s, invigorated the film industry in two ways—generating a new distribution window for new films, both from independent and studios sources, and opening a new market for the library films of the studios.

With traditional cable, cable subscribers paid a monthly subscription, receiving access to a number of "basic" stations, and for an additional monthly amount, premium channels such as HBO, Showtime, Cinemax, Epix, the Movie Channel, and Starz. Funding for the premium channels is by subscription fees, and for basic channels through advertising revenue as well.

Cable providers today include Comcast, Spectrum, Cox, Charter; satellite services, like DirecTV, and the Dish Network; and DSL via telecommunications companies like AT&T and Verizon. Access to cable and premium cable channels depends, in part, on the service available in a specific geographic region. All of the studios have licensing deals with premium pay-TV broadcasters, in the United States and abroad. Cable television requires a set-top box to unscramble signals sent via cable, satellite or over the air, and all cable systems carry free over-the-air television channels, and offer basic cable for a base monthly fee and premium pay channels for additional fees. In Table 8.4 below is a list of the biggest providers in order of the number of subscribers, from company sources.

Home Box Office, part of Time Warner, and launched in 1972, was the first pay-cable channel and quickly caught on with subscribers. In its early years HBO and its main competitor Showtime offered only theatrical films licensed from the studios and independent distributors. In the 1970s and 1980s, pay-television license deals, along with video-license deals, were a major source of

Table 8.4 Top 14 Largest Pay-TV Companies by Number of Subscribers (2017)

Rank	Provider	Subscribers
1.	Comcast	22,549,000
2.	DirecTV	21,012,000
3.	Charter	17,147,000
4.	DISH Network	12,173,000
5.	Verizon Fios	4,681,000
6.	Cox	4,275,000
7.	AT&T U-verse	4,048,000
8.	Altice USA	3,500,000
9.	Sling TV	1,355,000
10.	Frontier	1,065,000
11.	Mediacom	832,000
12.	PlayStation Vue	400,000
13.	DirecTV Now	375,000

production financing for non-studio mini-majors, such as DEG, Carolco, Vestron, and Nelson. These sources dried up in the 1990s as growth slowed in the video market and the pay-cable channels began to produce their own programming. Once HBO and Showtime started making their own movies and other original programming, the number of studio films they licensed also declined.

In the United States, the principal premium pay-TV broadcasters are HBO/ Cinemax (39 million subscribers), Showtime/Movie Channel (28 million), the Sundance TV via AMC Networks (60 million), and Starz (23 million), according to company sources. Under long-term output deals with studios, these companies license pay-television broadcast rights to the studio's new theatrical films in exchange for a license fee usually based upon a negotiated percentage of theatrical film rental, with minimums and maximums. The license fees can range from $5 million to $25 million. The local cable operator splits customers' subscription fees with the broadcasters, on a per-subscriber basis.

Pay-TV licenses generally provide for a fixed number of showings of a film over a fixed period, usually one year, after which the film can be licensed to free-television broadcasters. Often the license deal will include a second window, which begins within a year or two after expiration of the first window and runs for another year. The second window usually permits an unlimited number of showings.

As was the case with the advent of free-TV and video, the emergence and growth of the premium cable channels opened up opportunities for independent producers, giving them new markets for their films. Independent films produced for first showing on HBO or Showtime may be released theatrically, if the opportunity arises, as it did with films such as *The Girl* (2012), *Entourage* (2015), and *Kurt Cobain* (2015).

The availability of a film on pay cable begins after the exclusive portion of the PPV/VOD window closes. A film is shown on both the PPV/VOD and pay

cable for four to six weeks, and once the PPV/VOD window closes, the film continues to play on the pay-cable station for the balance of its license period.

Cable broadcasters face increasing pressure from OTT services like Netflix and Amazon to spend more on programming. With Apple getting into the original content business, pledging to spend $10 billion in its first year, and Facebook and Alphabet/Google-owned YouTube poised to spend billions on programming in 2017, the stakes are going up.[39]

Movies are licensed to cable and television through output deals. The television windows are separated by pay television (premium cable stations like HBO, Cinemax, Starz, EPIX, and The Movie Channel), and free television which includes basic cable and broadcast. The television windows vary in licensing details.

The first pay-TV window is for HBO, Showtime, Starz, and the like, where providers offer a license fee to the underlying producer and/or licensor of the film, in order to make it available to their subscribers. The length of window varies based on various deal terms and the license fee varies based on numerous factors, including exclusivity, cast, and length of the deal.

Free-TV/Basic Cable/Syndication

Television is extending beyond the traditional screen and broadening to include programming from new sources accessed in new ways. Fewer people are watching traditional television, and cable subscriptions are down, although people are consuming more content than ever. Half of US TV households now subscribe to some SVOD service and digital video content is on the rise.

TV companies are launching branded apps and sites to appeal to a wider audience; they are distributing on social media platforms to reach a younger audience, forming partnerships with digital media brands to create new content, and partnering with advertisers to create branded programming.[40]

After the pay-TV window, movies are broadcast on either network television or basic cable television and then on syndicated television (groups of independent stations combined like a network by a syndicator), in a sequence based on the distributor's strategy and negotiations with the various providers. The cost for a viewer to watch a film is the lowest on free television, basically free, with advertisers funding the airtime, and on basic cable—with airtime paid for by a combination of overall cable subscription fees and advertising revenue.

Many of the television deals are made at trade shows like NAB (National Association of Broadcasters), NATPE (National Association of Television Program Executives), and Mipcom in Cannes, where film distributors can meet with many broadcasters at one time.

As more distribution technologies developed, new distribution windows moved ahead of the network television window (NBC, CBS, ABC), and the average prime-time network audience for features declined. In response, the US networks have shifted their focus to original programming, and significantly

reduced time slots dedicated to feature films, generally licensing and showing only blockbuster or big-event movies like *Harry Potter and the Sorcerer's Stone* and *Jurassic Park*.

A TV network will pay a fixed license fee to broadcast a film for a specified number of showings over a certain period, usually one year. License fees range from $2 million to $15 million, or higher for a blockbuster. The largest license fees are paid for prime-time network showings of major studio releases. The biggest single TV sale was *The Lost World: Jurassic Park* (1997), which was licensed to Fox for $80 million. For a theatrically released film, non-prime-time license fees can be as low as $250,000. The license will include exclusivity, that is, the film will not be broadcast on any pay or other free-television channels during the license period. Occasionally, feature films have bypassed pay-cable and have been shown on a network broadcast after the video/DVD exclusivity period, such as *Star Wars: Episode I—The Phantom Menace* and *Toy Story*. The broadcast TV window varies widely, from whether the film had a theatrical release, its overall performance, visibility thanks to awards and festivals, and star power. The free-television window spans from one to one-and-a-half years, and may include second or third cycle windows of five or ten years. License fees are contractual, ranging from $2 million to $15 million, tied to the box-office performance of the film. License fees are also based on the size of the TV market, and the number of subscribers for cable licensees.

The television versions of theatrical films are often re-edited to get past network censors and the Federal Communications Commission (FCC), sometimes using "cover" shots to replace nudity, profanity, and gore.

With the decline in the licensing of films by network television, basic cable channels began to license theatrical feature films for first showing after pay-TV. TBS and TNT, FX, Comedy Central, A&E, and Bravo also license an initial free-TV window for selected features. Some cable and TV broadcasters have begun to partner on shared-window deals, splitting the license fees.

Syndicated television licensing involves the sale of films to independent stations for their local markets. A syndicator will amass several individual regional broadcasters, creating a large group which operates like a network and then license films from the studios or other distributors for relicensing to the stations. The stations license films on a barter basis—in exchange for advertising time which is then sold by the syndicator—or on a cash basis. The license period in a syndication deal will typically run for five years. Local stations often bid for packages of films based on the station advertising time rates, paying the syndicator over the license term. Basic cable is proving to be competitive to syndicators in their bids for feature films.

As consumers are faced with a myriad of choices for viewing, they want cheaper prices, great programming, and more options. For years, Comcast, Spectrum, and Time Warner Cable have had exclusive rights to carry premium channels like AMC, History Channel, or A&E. That's no longer the case. Companies like DirecTV Now, fuboTV, Sling TV, and PlayStation Vue offer various

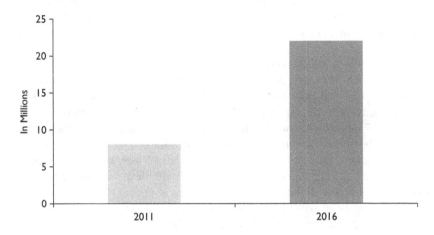

Figure 8.4

"skinny bundles" of cable channels over the Internet for prices as little as $20 per month. The number of viewers who have cut the cord has tripled from 2011 to 2016.

Chief among the reasons given for cord cutting is price, followed by subscription to an OTT service, and preference for binge watching.

Cord cutting is at an all-time high in the US, according to Television Business International.

New Cord-Cutting Alternatives. Companies like Sling Media have developed a system that interfaces with portable players and is designed to network easily with a television, a home computer, and a home-theater system, for flexibility of film-watching on a number of devices. Sling offers a library of content, and also live television content.

Cutting the cord translates to finding an alternative way to watch movie and television programming, including shows broadcast in real time. These offerings combine multiple channels and content as a skinny bundle designed to lure audiences away from broadcast and cable television.

The race to combine the best of movie and cable and television programming will continue, with a range of programming at varying price points. No doubt new hybrid technologies and related tools will be available as well, but ultimately the consumer will decide which platforms are here to stay.

Impact of Global Markets

The US media and entertainment industry (defined as copyright industries) is the largest export industry for the US reaching $703 billion in 2017.[41] American films dominate the world film market and over half of the revenue generated by

the US film industry is from non-North American (US and Canada) markets. According to the MPA (the foreign arm of the MPAA), of the $39 billion in revenue from all media earned by US distributors in 2016, over half came from foreign sources.

American movies are growing increasingly dependent upon foreign markets, influencing which films are produced, and how they are marketed. An example of a film that received poor reviews in the US, but went on to succeed in the foreign markets, was Universal's 2017 release of *The Mummy*, starring Tom Cruise with $75 million in domestic theatrical revenue versus $300 million from international box office, as reported by Box Office Mojo.

Foreign markets are expanding, due to deregulation, increases and improvements in technology, and an increasing number of multiplexes and movie screens abroad, including new digital screens. The United Kingdom, Germany, China, and Japan currently account for the largest portion of foreign revenue to the US film industry. American movies that do particularly well overseas tend to feature a domestic cast and be action-adventure films that are less dependent on dialogue, relying on visual spectacle and special effects.

American films enjoy a competitive advantage in the worldwide marketplace due to several factors. The large domestic market in the United States allows studios and filmmakers to spend more on film budgets, creating films with impressive production values that appeal to audiences worldwide, with a greater assurance of recoupment out of the domestic market even if the foreign markets do not perform as well as expected. Historically, as previously noted in this book, the US film industry was dominated by commercial interests, privileging filmmakers who made commercially successful movies, and developing an industry experienced in making movies that appeal to the largest possible consumer base. Also the dominance of American culture generally throughout the world, in music, television, books, and so forth, strengthens the interest in American films.

The United States remains the theatrical launching pad for most films, and foreign territories ride the wave of marketing buzz to open these films locally. Distributors are, however, experimenting with established release patterns, including the practice of releasing first in the United States. In an unusual release pattern that proved successful, the summer tent-pole movie *The Fast and The Furious 8* was released in 2017 by Universal in the Asian territories first before opening in the United States, earning $225 million domestically and $1 billion abroad.[42]

Marketing campaigns must be adjusted to local sensibilities and cultures, as well as calendar issues—accounting for holidays, theater-attendance patterns influenced by climate or non-air-conditioned movie theaters, and major sporting events like the World Cup.

In recognition of the growing importance of foreign territories and the threat posed by growing indigenous film industries in Europe and parts of Asia, the studios are pursuing and entering into coproduction arrangements to create cultural crossover films, movies based on non-American themes, with a foreign cast, and produced in other languages. For example, a Hollywood/Chinese

coproduction was made by H Collective in China for $30 million. Patriotic action movie *Wolf Warrior II* went on to gross $810 million.[43]

The Hollywood studios have established relationships with foreign distributors and media companies, and are now experimenting with producing locally themed films for the local markets, adding to the large number of films produced in various territories. Coproductions in Mexico and India (Disney and Sony), and central Europe and South America (Universal) reflect the appetite for locally based films. By partnering with local producers and distributors, the studios can create new profit centers and offset any losses in revenue from the increasing popularity of local movies. An additional benefit is the lower cost of producing films in foreign countries, pairing with local companies to access local production funds. An example is the joint venture between Warner Bros. and China to work around China's limited quota on imported films.

The major studios all have their own in-house foreign distribution arms, which directly license the studios' film to theatrical, home-viewing, and television distributors in each major territory around the world. Independent distributors and producers are more likely to license major territories to a single distributor in each major territory and/or to a single company that will handle all foreign sales. Independents generally use a sales agent to license their films.

The economic value of a foreign territory is defined, not only by size and population, but also by the territory's media sophistication, the availability of all major distribution formats, a high percentage of television households among the total population, and the strength of the local economy. Box office is not the only measure of the passion for movies, however; India produces a greater quantity of movies than any other country by number of films produced, illustrated in Figure 8.5.

The major markets for theatrical and video include China, Japan, South Korea, and Australia, in Asia Pacific, and Germany, Italy, the United Kingdom, France, and Spain in Europe. These territories represent between 65 percent and 70 percent of the total foreign theatrical revenues to major studios and between 80 percent and 85 percent of total overseas video revenues.

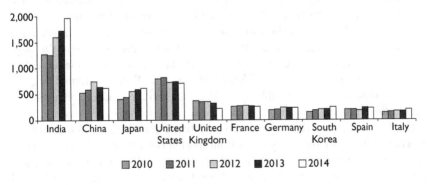

Figure 8.5 Leading Film Markets, by Number of Films Produced.

Licensing Foreign Rights

Many deals for the licensing of American film rights to foreign territories are struck at the major film markets: Berlin, Cannes, Toronto, and the American Film Market in Santa Monica.

In split rights deals, foreign distributors partner with a studio to release a slate of films in which the parties share the financing, and the foreign participants have a limited amount of creative control, with each party keeping the distribution rights for their territory.

Independent producers with films in development may seek presales, licensing rights to foreign territories in exchange for distribution contracts to be used as collateral for production funding from a bank or other lender. Before entering into this type of agreement, most foreign distributors will want to see a US theatrical deal in place. Financing a movie with presales can be complicated.

Producers and distributors count on a certain amount of "soft" money, the catch-all term for financing in the form of tax funds, subsidies, refundable tax credits, sale-leasebacks, rebates, or other production incentives available as a financing source. Many countries have a variety of these incentives available, but there are strict rules to gain access to the funding.

A producer with a completed film may license unsold foreign rights at the markets herself, or contract with a sales agent to make the deals. Sales agents work on a success fee basis, earning a commission of 15–40 percent of sales, and reimbursement of expenses. Both fees and expenses are payable only out of sales. The producer and sales agent will agree on an ask price, which is the starting figure for negotiations, and a take price, the minimum amount the producer will accept.

The relative economic value of different territories is reflected in the size of the prevailing minimum guarantee that a territory distributor/licensee would have to pay a licensor/distributor to acquire all media rights to a film in that territory. A minimum guarantee is an amount paid upfront to license the film. In a typical foreign licensing deal, the licensee or distributor will charge distribution fees on the revenue from exhibition and exploitation within the territory and will recoup the minimum guarantee and any distribution expenses, including marketing costs, from the licensor/distributor's share, which is the balance of revenues after the licensee's fees. The AFMA short-form deal memo is often used as the initial legal agreement to close many of these transactions, prior to the execution of a long-form distribution agreement. The distribution deal memo spells out the basic deal terms, including territory, term, which rights are being licensed, minimum guarantee, overages (royalties payable by the distributor to the producer after recoupment of the minimum guarantee and expenses), and distribution expenses.

Foreign distribution deals are usually negotiated in dollars, and fluctuations in currency values will affect payments from foreign box office. If the US dollar is weak, profits increase in the local currency. The prevailing minimum guarantee in a particular foreign territory will depend on the genre, stars, quality and budget of the film.

Trade Barriers to American Films

Many countries have policies in place to reduce or limit the market dominance of American movies, including tariffs, film quotas limiting imports of American films, limits on prime-time airing of American films on television, as well as subsidy, tax-advantaged investment, and coproduction programs to support local filmmaking talent.

Hollywood studios maintain and operate the largest film distribution systems, not only in the United States, but also in most principal markets abroad. United International Pictures is a joint venture between Universal and Paramount, with distribution facilities in over 20 different countries, while another is 20th Century Fox, which owns 21 foreign distribution facilities worldwide, and has joint ventures and long-term agreements with local distributors where they do not have their own facilities, according to company sources.

Foreign governments have fought Hollywood dominance politically, principally in negotiations around the General Agreement on Tariffs and Trade (GATT). Countries around the world resent the dominance of Hollywood films, perceived (not inaccurately) as taking profits that would otherwise go to local films. There is also a resistance to the cultural values reflected in Hollywood films, particularly as they may influence younger audiences.

At the last major GATT trade negotiations involving Hollywood film exports in the early 1990s, agreement was reached on a "cultural exception," allowing each country to set up trade restrictions for films according to its own cultural preferences, such as limits on viewing times on television.[44] Another effort to reduce American dominance was the implementation of coproduction treaties, designed to foster filmmaking between European nations and other countries, excluding the United States.

Hollywood, responsible for a significant portion of the US copyright industries' net exports, has strong allies in Washington, relationships cultivated for decades. Hollywood depends on the US State and Commerce Departments for help in promoting American movies abroad, and to represent the industry's interests within the World Trade Organization (WTO) and at GATT negotiations. In 2007, Hollywood and the US government enlisted the WTO to investigate China in matters pertaining to film import restrictions, and piracy enforcement, claiming losses of $2.7 billion from piracy of films in China in 2005. A recent trade pact between the US and China in 2017 found China willing to relax its quotient on the number of foreign films that could be imported into China, now 38 films. China has maintained a cap on the number of foreign films that can be shown each year, to ensure that Chinese-qualifying films account for 60 percent of box-office share. China is currently the biggest single export market for US films, but limits to the number of releases in the country have prevented greater growth.[45]

The Chinese market has become increasingly central to Hollywood's financial health over the last several years—according to the Associated Press, as of

December 2016, China has surpassed the US as the country with the greatest number of total movie screens (40,917).

Financially, the biggest box-office market overall is still the US and Canada. Studios are only entitled to 25 percent of box-office earnings in China (as opposed to roughly half of domestic earnings), and that same AP report noted that many movies in China are playing to empty theaters. There has been 144 percent growth in China's box-office revenue since 2012. North American growth was just 6 percent in the same period. The Chinese media and entertainment industry as a whole is worth an estimated $180 billion.

Ratings systems in foreign territories can be a barrier for American films. Violent content that might receive an "R" rating in the United States often has to be cut or modified to avoid an "X" rating abroad. Each territory has a distinct standard as to violent or sexual content, and filmmakers must be aware of and meet these requirements to fulfill contractual obligations to foreign distributors. Foreign distribution companies and executives need to have an understanding of foreign audiences and their preferences, a knowledge about which stars are popular overseas, and an awareness of local consumer film-purchasing habits and the structure of the film industry in a particular territory. China has no rating system. Instead, censors cut out sex, violence, and overly political content for the 38 foreign films allowed to be shown in the country. Risqué movies get a parental advisory. However, movies cannot even get produced or commercially released within the country if they are not approved by the censorship board.

Ancillary Rights

Ancillary rights to a film include the right to remake the film; to produce sequels and prequels; to license stories, characters, and music from the film; to develop television programs; to produce a theatrical stage play or musical; and to develop games—video, arcade, and handheld—based on the film. Ancillary rights also include merchandising rights, publishing rights (novelizations and photo-novels), and music rights (soundtrack and music publishing). The term ancillary rights also generally encompasses non-theatrical exhibition of the film on cruise ships, airlines, and Indian reservations; in hospitals, colleges, schools, churches, and prisons; and to the military.

Soundtrack and music-publishing rights can be quite lucrative, as demonstrated by the success of film soundtracks like *Pitch Perfect*, *LaLa Land*, *Moana*, *Miles Ahead*.

The Role of Film Markets and Film Festivals

Film markets and film festivals play an important role in the distribution process, serving as a forum for producers and distributors to meet, screen films, and do business. Film markets are primarily business gatherings, while film festivals are open to the public and emphasize artistic achievement.

There is now a plethora of film festivals and markets around the world. It is possible to attend a film festival every week of the year, and still miss most of them. The key "must" film markets in the business are: the European Film Market in Berlin held in February; Cannes in May; and the American Film Market, known as the AFM, in Santa Monica in November. The "must" film festivals, which combine art and business, are Sundance in Park City, Utah in January, Cannes in May, and Toronto in September. The markets often take place in conjunction with a film festival, such as the Berlin Film Festival, the Cannes Film Festival, and the AFI Film Festival. The film markets are a gathering place for movie industry people. They offer opportunities to make deals for completed films, as well as films in progress, and, more importantly, to network and "schmooze," making new contacts and renewing old ones. Each market has a different profile. AFM is largely for independent films, Cannes is the biggest market and festival, and has a very international clientele with a large Asian contingent, and Berlin is known for avant-garde and edgy content. Market attendees who are selling product rent space to meet with buyers, advertise their films in development, and screen completed films. There are often industry-related panels and presentations on topical issues. It is expensive for companies and filmmakers to attend the film markets, but it is essential, particularly for independent producers and distributors.

While the studios do not generally participate in the film markets as sellers, key film festivals such as Toronto, Sundance, Tribeca, and Cannes, which highlight some of the most prominent independent films, are important for studio distribution executives, who look to buy completed films to build their slate of releases, and to discover promising talent.

Most of a producer's time is spent searching for financing, and, in addition to film distributors, entertainment bankers and private investors often attend film markets looking for opportunities. Prominent actors, directors, and other possible sources of funding may also participate. The markets provide distributors and producers from all over the world with convenient access to one another, encouraging territorial deal making that would otherwise require extensive travel.

Studio distribution executives utilize the film markets and festivals to acquire completed films, and to discover new projects in the development or production phase. The film industry is very competitive, and studio distribution professionals are under tremendous pressure to find the next hot film, before another studio finds it. Film markets offer a focused environment for studio personnel, independent distributors, financiers, and filmmakers to pitch their projects and find suitable partners for a film.

In addition to the film festivals that take place alongside film markets, there are numerous stand-alone film festivals worldwide. Since the 1990s, when independent films began to garner more attention, and Sundance became a household name, film festivals have sprung up everywhere, as a response to public interest in offbeat or foreign films, or films made by burgeoning filmmakers and as a

draw for tourists. These festivals have played an important role in increasing visibility for indie films, sometimes bringing them to the attention of distributors.

A film festival usually takes place in a centralized location, with venues for screenings and prizes, and may highlight a certain type of film—documentaries, horror (Jackson Hole Wildlife Film Festival, The New York City Horror Film Festival), or category of filmmaker (Queerdoc, San Francisco Women's Film Festival). Festival participants get exposure for their films, media attention and publicity, and sometimes distribution deals.

Festivals date back to the 1930s and 1940s, when Cannes, Venice, and Berlin were launched to promote new films and talent to international audiences and journalists. After World War II festivals like Cannes and Venice were important in helping to rebuild the European film industry.

Notes

1. The Economist. (2013, February 23) "Split Screens," *The Economist*. Retrieved September 2, 2017 from www.economist.com/news/business/21572218-tale-two-tinseltowns-split-screens.
2. Gale Cengage Learning. (2017) "Motion Picture Theaters (except Drive-Ins)," *Business Insights: Essentials. Encyclopedia of American Industries*. Farmington Hills, MI: Gale, p. 2.
3. Dodd, Christopher J. *Theatrical Market Statistics 2016*, Motion Picture Association of America, Inc. p. 16. Retrieved February 22, 2018 from www.mpaa.org/wp-content/uploads/2017/03/MPAA-Theatrical-Market-Statistics-2016_Final.pdf.
4. AMC Entertainment, Inc. (2003, July 2) "Form 10-K Filing" Theatrical Exhibition Industry and Competition Business. Retrieved July 16, 2007 from Edgar online at www.sec.edgar-online.com/2003/07/02/0001047469-03-023268/Section2.asp.
5. Dodd, Christopher J. *Theatrical Market Statistics 2016*, Motion Picture Association of America, Inc. Retrieved February 22, 2018 from www.mpaa.org/wp-content/uploads/2017/03/MPAA-Theatrical-Market-Statistics-2016_Final.pdf.
6. Buss, Sebastian. (April 2017) "Digital Media Market Report," *Statista*. p. 21.
7. Hunter Pellettieri, Jill. (2007, June 26) "Make it a Large for a Quarter More? A Short History of Movie Theater Concession Stands," Slate. Retrieved July 17, 2007 from www.slate.com/id/2169127.
8. Rossolillo, Nicholas. (2016, March 21) "A 2016 Outlook for the Movie Theater Industry," *Motley Fool*. Retrieved September 2, 2017 from www.fool.com/investing/general/2016/03/21/a-2016-outlook-for-the-movie-theater-industry.aspx.
9. National Association of Theatre Owners. (n.d.) "Welcome to NATO." Retrieved May 19, 2007 from www.natoonline.org.
10. Dodd, Christopher J. *Theatrical Market Statistics 2016*, Motion Picture Association of America, Inc. p. 11. Retrieved February 22, 2018 from www.mpaa.org/wp-content/uploads/2017/03/MPAA-Theatrical-Market-Statistics-2016_Final.pdf; Pearlstein, Steven. (2006, November 24) "It Was Better With Bonzo," *Washington Post*. Retrieved July 24, 2007 from www.washingtonpost.com/wp-dyn/content/article/2006/11/23/AR2006112301028.html.
11. B movie. Retrieved August 6, 2017 from https://en.wikipedia.org/wiki/B_movie.
12. Lieberman, David. (2017, March 29) "Movie Theaters Sold $758.3M in Ads Last Year Driven by National/Regional Growth," *Deadline*. Retrieved September 15, 2017 from http://deadline.com/2017/03/movie-theaters-record-ad-sales-2016-national-regional-growth-1202054762/.

13. Barraclough, Leo. (2013, June 23) "Digital Cinema Conversion Nears End Game," *Variety*. Retrieved July 23, 2017 from http://variety.com/2013/film/global/digital-cinema-conversion-nears-end-game-1200500975/.

14. Winfrey, Graham. (2016, July 22) "Why Luxury Theater Chain Cinépolis Is Buying up Movie Houses All Across the U.S.," *Indiewire*. Retrieved October 2, 2017 from www.indiewire.com/2016/07/luxury-theater-chain-cinepolis-expanding-us-cinemas-1201707606/.

15. Schwankert, Steven. (2016, December 21) "China Overtakes US with Almost 41,000 Movie Screens," *China Film Insider*. Retrieved September 28, 2017 from http://china filminsider.com/china-overtakes-us-almost-41000-movie-screens/.

16. Satell, Greg. (2016, January 31) "As The Media Industry Evolves, the Business Model Becomes the Message," *Forbes*. Retrieved October 3, 2017 from www.forbes.com/sites/gregsatell/2016/01/31/as-the-media-industry-evolves-the-business-model-becomes-the-message/#57d0f8f33ccd.

17. BI Intelligence. (2016, October 6) "AT&T Is Doubling Down on Original Content," *Business Insider*. Retrieved October 2, 2017 from www.businessinsider.com/att-is-doubling-down-on-original-content-2016-10.

18. D'Alessandro, Anthony. (2017, March 27) "As Exhibitors Fret Over Studios' Push to Crush Windows, Here's the Sobering Reality About PVOD—CinemaCon," *Deadline*. Retrieved September 13, 2017 from http://deadline.com/2017/06/studios-will-insist-theaters-accept-profit-depressing-pvod-terms-1202111580/.

19. Ravid, Orly and Sheri Candler. (2010, July 15) "Distribution Preparation For Independent Filmmakers—Part 3 Terms, Foreign and Windows," *The Film Collaborative*. Retrieved October 9, 2017 from www.thefilmcollaborative.org/blog/tag/aggregators/.

20. Convergence Consulting Group. (n.d.) Distribution of Movie and TV Rental Market Revenue in the United States from 2012 to 2016, by Source. In *Statista—The Statistics Portal*. Retrieved September 26, 2017, from www.statista.com/statistics/258447/distribution-of-movie-and-tv-rental-market-revenue-in-the-us-by-source/.

21. Barr, Alistair. (2012, October 10) "Crowdsourcing Goes to Hollywood as Amazon Makes Movies," *Reuters*. Retrieved September 4, 2017 from www.reuters.com/article/us-amazon-hollywood-crowd/crowdsourcing-goes-to-hollywood-as-amazon-makes-movies-idUSBRE8990JH20121010.

22. Schiller, Marc. (2013, May 13) "The '360 Equation': The One Business Model Every Filmmaker Needs to Know," *Indiewire*. Retrieved September 2, 2017 from www.indiewire.com/2013/05/the-360-equation-the-one-business-model-every-filmmaker-needs-to-know-38490/.

23. Barnes, Brooks. (2017, July 31) "With 'Logan Lucky,' Soderbergh Hopes to Change Film's Business Model," *New York Times*. Retrieved September 25, 2017 from www.nytimes.com/2017/07/31/business/media/with-logan-lucky-soderbergh-hopes-to-change-films-business-model.html.

24. Faughnder, Ryan. (2017, August 17) "Will Steven Soderbergh's Strategy of Bypassing the Studio System for 'Logan Lucky' Pay Off?" *LA Times*. Retrieved August 29, 2017 from www.latimes.com/business/hollywood/la-fi-ct-movie-projector-logan-lucky-hitman-20170817-htmlstory.html.

25. Convergence Consulting Group. (n.d.) Distribution of Movie and TV Rental Market Revenue in the United States from 2012 to 2016, by Source. In *Statista—The Statistics Portal*. Retrieved September 29, 2017, from www.statista.com/statistics/258447/distribution-of-movie-and-tv-rental-market-revenue-in-the-us-by-source/.

26. Wallenstein, Andrew. (2016, January 6) "Why 2015 Home Entertainment Figures Should Worry Studios," *Variety*. Retrieved August 19 from http://variety.com/2016/digital/news/hdrdvdceshighdynamicrange4k1201670494/.

27. Kirsch, Noah. (2017, February 28) "The Last Video Chain: The Inside Story of Family Video and its $400 Million Owner," *Forbes*. Retrieved August 30, 2017 from www.forbes.com/sites/noahkirsch/2017/02/21/the-last-video-chain-the-inside-story-of-family-video-and-its-400-million-owner/#7bac0322da60.

28. Spangler, Todd. (2016, February 17) "The Slow Death of Redbox: Why the Kiosk Colossus Is the Next Blockbuster," *Variety*. Retrieved July 24, 2017 from http://variety.com/2016/digital/features/redbox-business-model-doomed-1201706612/.

29. Wallenstein, Andrew. (2017, January 6) "Home Entertainment 2016 Figures: Streaming Eclipses Disc Sales for the First Time," *Variety*. Retrieved July 12, 2017 from http://variety.com/2017/digital/news/home-entertainment-2016-figures-streaming-eclipses-disc-sales-for-the-first-time-1201954154/.

30. Adams Media Research/ScreenDigest. "Video-on-Demand: The Future of Media Networks" (June 2005).

31. Taylor, Kate. (2017, June 29) "One of the Few Remaining Blockbusters in the US Is Closing—Take a Look Inside," *Business Insider*. Retrieved September 23, 2017 from www.businessinsider.com/blockbuster-still-exists-but-one-in-alaska-is-closing-2017-6.

32. Perez, Sarah. (2016, October 18) "Walmart Launches a Free Streaming Service, Vudu Movies on Us," *Techcrunch*. Retrieved October 11, 2017 from https://techcrunch.com/2016/10/18/walmart-launches-a-free-streaming-service-vudu-movies-on-us/.

33. Miller, Melanie D. (2015, January 14) "Attention, Filmmakers: Here's Everything You Need to Know About Release Windows," *Indiewire*. Retrieved September 24, 2017 from www.indiewire.com/2015/01/attention-filmmakers-heres-everything-you-need-to-know-about-release-windows-66295/.

34. PayPal. (n.d.) Preferred Over-the-Top (OTT) Services Among Consumers in the United States as of September 2016. In *Statista—The Statistics Portal*. Retrieved October 29, 2017, from www.statista.com/statistics/672629/ott-services-preferred-usa/.

35. Wakeman, Gregory. (2017, July 1) "More Theaters Have Banned Netflix's Okja," *Cinemablend*. Retrieved September 11, 2017 from www.cinemablend.com/news/1667870/more-theaters-have-banned-netflixs-okja.

36. The Economist. (2015, February 28) "Why Smartphones Are the Best-Selling Gadgets in History," *Business Insider*. Retrieved September 2, 2017 from www.businessinsider.com/why-smartphones-are-the-best-selling-gadgets-in-history-2015-2.

37. The Economist. (2015, February 26) "Planet of the Phones," *The Economist*. Retrieved September 2, 2017 from www.economist.com/news/leaders/21645180-smartphone-ubiquitous-addictive-and-transformative-planet-phones.

38. Spangler, Todd. (2017, April 14) "Pay TV's Pain Point Gets Worse: Cord-Cutting Sped Up in 2016," *Variety*. Retrieved October 14, 2017 from www.investors.com/news/technology/youtube-original-content-budget-creeping-up-on-netflix-amazon/.

39. Weiss, Geoff. (2017, September 8) "Facebook To Spend $1 Billion on Original Content For 'Watch' Through 2018," *Tubefilter*. Retrieved October 25, 2017 from www.tubefilter.com/2017/09/08/facebook-1-billion-content-budget-watch/.

40. Business Insider. (2016, October 6) "AT&T Is Doubling Down on Original Content," *Business Insider*. Retrieved August 23, 2017 from www.businessinsider.com/att-is-doubling-down-on-original-content-2016-10.

41. Select USA. (n.d.) "Media and Entertainment Spotlight." Retrieved September 13, 2017 from www.selectusa.gov/media-entertainment-industry-united-states.

42. The Numbers (n.d.) "Fate of the Furious," Nash Information Services, LLC. Retrieved July 23, 2017 from www.the-numbers.com/movie/Fate-of-the-Furious-The#tab=summary.

43. Landreth, Jonathan. (2005, July 28) "Perspectives: China—Taking the Long view," *Hollywood Reporter*. Retrieved July 28, 2005 from www.hollywoodreporter.com/hr/search/article_display.jsp?vnu_content_id=1001014299.

44. Scott, Allen J. (2002, November 29) "Hollywood in the Era of Globalization Opportunities and Predicaments," *Yale Global*. Retrieved November 11, 2007 from www.yaleglobal.yale.edu/display.article?id=479.

45. Mumford, Gwilym. (2017, April 12) "China's Hollywood Film Quota to Expand After Trump Trade Deal," *Guardian*. Retrieved September 21, 2017 from www.theguardian.com/film/2017/apr/12/trump-xi-trade-talks-china-hollywood-film-quota.

Chapter 9

Movie Accounting

This chapter addresses film accounting on a general level, highlighting some of the characteristics that make accounting for movies unique. The public's fascination with every aspect of the movie business extends to disputes over accounting, which occur regularly. "Hollywood accounting" is a code word for creative interpretation of financial data. *Harry Potter and the Order of the Phoenix*, *Return of the Jedi*, *Coming to America*, *Batman*, *Lord of the Rings*, *Forrest Gump*, and *My Big Fat Greek Wedding* all engendered disputes that have brought studio accounting practices under public scrutiny.

Some of the largest general accounting firms working in the film industry are KPMG, PricewaterhouseCoopers, Deloitte Touche Tohmatsu, and Ernst & Young. There are also firms that specialize in film accounting, such as Green-Slate and Marcum LLP.

Film company accounting is complex for several reasons. The average studio film has multiple revenue streams, remitted to the distributor from many different sources, over a long period of time. A distribution company must report profits and losses to a number of different parties with different economic interests.

A recurring debate in the film business arises over the term "net profits." A standard business definition of net profits is "film revenue minus expenses"; however, the debate over net profits illustrates the larger question of semantics in film accounting. There are no standard definitions, and exactly what comprises film revenue or expenses—and who defines the terminology and verifies the information—can make all the difference between whether a film makes, or loses, money.

GAAP Versus Contractual Accounting

There are two types of accounting for films, "corporate" or "book" accounting, also known as GAAP (Generally Accepted Accounting Principles), the standard accounting for all businesses, and contractual accounting, the accounting between parties with a financial interest in a film based on a contract between the parties.

Contractual accounting is used for single films and for accounting to profit participants (those with an economic interest in the film). Major players, such as the director, writer, and star in a film typically receive points—a participation in the profits. Points are used as a bartering tool by a producer, as an incentive to attract talent, or to encourage the talent—whether a writer, a director, or an actor—to accept a lower fee upfront in exchange for payment on the "back end."

GAAP—Corporate Accounting

While the subject of GAAP accounting in general is beyond the scope of this book, it is worth mentioning a few specific areas where historically there have been abuses of GAAP rules and where efforts have been, or are being made, to curb those abuses.

The Securities and Exchange Commission (SEC) regulates and enforces federal securities laws including the promulgation and enforcement of accounting standards. Uniform accounting standards are important, in that the information companies present to the public influences buying and selling decisions in the public markets and stock exchanges. The SEC has designated the Financial Accounting Standards Board (FASB) to establish financial accounting and reporting standards for publicly held companies, and the FASB works with several groups, notably the American Institute of Certified Public Accountants (AICPA), setting guidelines to unify accounting practices in the film industry, and to make the books of film companies more transparent and readily understood.

As new technologies create more revenue streams, film accounting becomes more complicated. Setting standards with regard to these ancillary (non-theatrical) revenues becomes increasingly important. In spite of more consistent accounting standards for films, there are still areas of management flexibility in the presentation of financial data, particularly in the treatment of certain expenses, revenue recognition, and amortization of film costs.

From 1981 to 2002 film company accounting was governed by FASB Statement no. 53 (Financial Reporting by Producers and Distributors of Motion Picture Films), rules established for an industry landscape of film revenue earned primarily from the theaters and free television. As noted, revenue sources from films have changed drastically since 1981, and new forms of media, such as video and DVD, cable television, pay-per-view, and the Internet have been added.[1] New rules were adopted in 2002 by the AICPA (Statement of Position 00–2 [SOP], Accounting by Producers or Distributors of Films) to take into account these new sources of revenue,[2] and rein in areas where film companies had taken liberties in the past.

Changes in the 2002 rules under SOP 00–2 include the proper treatment of items that should be deducted that were formerly capitalized, such as certain distribution and advertising costs, including prints, and projects and scripts that have been abandoned. The income forecast method, which governs the amortization of film costs, historically was abused in some cases by the studios and other

film companies to undervalue or overvalue films as they saw fit. These rules have changed, by, for example, eliminating estimates of future profit from unproven markets or media,[3] and imposing limits on the "useful life" that can be used to calculate annual amortization of costs.

Accounting data can be manipulated to increase or decrease profits. For purposes of paying and reporting taxes, it is sometimes better for a company to reduce profits, by, for example, accelerating film cost deductions.[4]

A public company regularly reports to shareholders, and may be under pressure to maintain its stock price by showing high profits. To raise profits, as previously noted, a company may capitalize certain development or production costs, and interest on production costs, along with certain overhead expenses; or accelerate the date that earnings are reported and license income is received. Television broadcast licenses may pay film license payments over a five-to-ten-year period; however, the licensor can report the entire amount of the income at the beginning of the licenses period, even if only a fraction of it has been received.[5]

Contractual Accounting

The flow of money to a film is comprised of various revenue sources paid to the distributor, which then deducts its fees and distribution costs and the negative cost of the film. The remaining balance, if any, is allocated to the producer and other profit participants as defined in each party's contract and in accordance with the terms of the film's distribution agreement. A sample revenue flow from box office to net profits is illustrated in Table 9.1 below.

It is the essence of contractual accounting that different profit participants in the same film may have different contractual definitions of "net profits."

Table 9.1 Sample Film Revenue Flow

Box Office Paid to a Movie Theater
<u>− Exhibitor portion</u>
= Film Rentals (submitted to distributor)

The Distributor Receives:
 Film Rentals
 <u>+ Distribution revenue from all other sources</u>
 = Gross Receipts

 − Distributor fees
 − Distributor expenses
 − Gross Participations (if applicable)
 − Negative cost + interest + overhead
 <u>− Deferred payments (if applicable)</u> to talent, writer, director
 = Net Profits
 <u>− Net Participations (if applicable)</u>
 = Producer's Share of Net Profits

Table 9.2 Comparison of Profit Participants

Profit Participant A		
Gross Film Rentals	100,000,000	
• Distribution Fee	−30,000,000	
• Virtual Print Fees & Ads	−30,000,000	
Subtotal	**40,000,000**	
• Negative Cost	−35,000,000	
Net Profits	5,000,000	
	X 1%	
I Net Profit Point		
Profit Participant A Share	**50,000**	

Profit Participant B	
Gross Film Rentals	100,000,000
• Distribution Fee	−30,000,000
• Virtual Print Fees & Ads	−30,000,000
• Interest on P&A	−1,000,000
	39,000,000
• Negative Cost	−35,000,000
• Interest on Negative	−2,000,000
	2,000,000
I Net Profit Point	X 1%
Profit Participant B Share	20,000

Contractual accounting is a matter of negotiation between parties, reflective of their leverage. As an example an agreement between Participant A and a distributor may provide that in calculating net profits no deduction will be taken for interest on the negative cost and prints and ads, while an agreement with Participant B on the same film may provide for such interest deductions. The impact will be to put Participant A in a preferred position to Participant B in determining net profits on the same revenue, as demonstrated in the following example.

A-level talent may be entitled to a percentage of a film's gross receipts, although this is rare, while directors and writers typically receive a percentage of net profits. A gross participant will receive a share from gross film receipts prior to any distribution fees or expenses, or from the adjusted gross—gross rentals minus certain expenses, such as prints and advertising.

Accounting Terms and Revenue Sources

It is useful to look at some of the terminology used in film accounting and the way certain items of revenue or expenses are treated for accounting purposes.

Box Office. Box office is the total amount of money paid by ticket holders to the movie theater. On average 50 percent of the box office comes back to the distributor as gross film rentals from theatrical distribution.

Gross Receipts/Gross Film Rental. Gross film rental is the distributor's share of total movie-ticket sales. Gross receipts is gross film rental plus all other amounts received by the distributor from all other forms of distribution, such as TV, cable, pay-per-view and video-on-demand, video/DVD, non-theatrical exhibition, merchandising and publishing rights, and music rights.

Video/DVD. Studios historically have reported film revenue from video and DVD distribution on a royalty basis. This means that for every dollar of gross receipts to the distributor from these sources only a fraction, equal to the royalty rate, is reported as gross receipts to profit participants. Then, the distributor will charge a distribution fee on that amount of receipts. The practice of accounting for only a royalty rate share of revenue was established in the early days of video and DVD, before the studios formed their own video distribution arms. Now that all of the studios manufacture and distribute videos and DVDs themselves, this has proved to be an enormous profit source for the studios and quite unfair to participants since it in no way reflects the economic reality of video or DVD distribution. Profit participants and investors with some clout (recently, hedge funds) can sometimes negotiate a straight distribution deal for video and DVD with all revenues reported as receipts to the film.

Television. Television revenue sources include network television, pay cable (premium channels), and basic cable (free), syndicated, and foreign.

Films are sold to television in packages, usually with a few strong films, or "locomotives" included in a package with weaker performing films. The proper allocation of the total package price to each of the films in the package can be a point of contention between the distributor and producers. Films are sold to

broadcasters in advance of when they are available to be shown, and fees from television sales are generally accounted for in installment payments.

Music, Merchandising, Sequel Rights. In addition to DVD and video arms, studios also have music recording and publishing affiliates, and may license the prequel, sequel, and remake rights associated with a film.

When the distributor releases a film soundtrack, it deducts composer/songwriter royalties, manufacturing and marketing expenses, a 25 percent packaging fee, reporting approximately 50 percent of what remains as part of gross receipts.[6] Film soundtracks serve as a profit center and as a promotional tool, demonstrated by the *Hannah Montana* soundtrack, and *Hairspray*.

As demonstrated by movie franchises like *Star Wars* and *The Lion King*, merchandising rights for certain films can be extremely profitable, and all of the studios have merchandise licensing affiliates. Studios license products, from clothing to stationery to homewares, highlighting characters, props, and designs based on a film. Merchandising requires long lead times in order to create and market items in conjunction with a film, and, consequently, distributor merchandising administration fees are high, approximately 40–50 percent. In some cases, merchandising and music rights may be licensed out to a third party.

Distributors may license the sequel, prequel, and remake rights to a film; however, any revenue derived from these sources is generally not included in gross receipts.[7]

Foreign Revenue. Foreign revenue is revenue from sources outside the domestic market. All distribution deals for films worldwide are made in US dollars; however, they may be deposited in a bank in the country where they are earned, delaying the accounting for these funds to the picture, and payment to profit participants.[8]

Gross Participants. A participant in the "gross" has a more advantageous position than a net profit participant since the gross participant is taking a percentage of revenue prior to any, or minimal, deductions. First dollar gross is a participation calculated on gross receipts, either prior to any distributor deductions whatsoever (very rare), or minimal distributor expenses, such as checking fees, taxes, and trade association dues.[9] Gross after breakeven is a share of the remaining gross receipts after a distributor has subtracted its full fee and expenses, and after negative and P&A costs have been recouped. Adjusted gross is gross after the distributor recoups some, but not all, of its costs and expenses.

Distribution Fees. The distributor charges a distribution fee on all of the gross receipts it receives. The amount of the fee varies by media format or market territory, depending on the complexity of distributing in that media, or market.

Theatrical fees range from 30 to 40 percent (higher for foreign territories), television fees are in the 20–25 percent range, and the video/DVD fees, whether on all revenues or a royalty, are usually around 20 percent. VOD and PPV fees vary from 10 to 20 percent.

Distribution Expenses. Distribution expenses include all of the costs associated with bringing a film to the marketplace and selling it, either directly to

Table 9.3

Advertising—Creative: Music Video, Print, Radio, TV	Marquees Merchandising: Marketing, Promotion
Advertising—Media Time & Space	Music
Advertising—Overhead	Outside Auditing
Advertising—Trades	Posters
Bank Charges	Residuals Offset
Collection Expense	Sales Expenses: Film Festival Fees, Other
Development Costs	Other
Distribution & Licensing Expense	Screenings
Guild Residuals	Shipping
Interest	Tracking/Checking Expenses
Key Art	Trailers & Teasers
Market Research	Virtual Print Fees: DCP, Shipping, Storage, Insurance
Marketing Expense: Other, Television	Storage, Insurance

consumers, or to licensees such as television networks or cable outlets. Here are typical distribution expenses charged against a film:

Participant accounting statements detail distribution expenses during the reporting period and a total to-date. Depending on the size of the theatrical release pattern, and the breadth of its marketing campaign, distribution expenses often run into the millions of dollars.

For purposes of accounting, these expenses should be carefully defined, with both a floor (minimum) and a ceiling (maximum) that may be spent, in order to prevent distributor overspending, which could negatively affect profit participants. Distribution in foreign territories may also include costs for collection, conversion, transfer, foreign versions, release prints, licenses, and export fees.

Negative Cost. The cost of the negative is usually the largest expense to be recouped. A film utilizing studio facilities, soundstages, and the personnel and equipment that goes along with it, pays for the use of such facilities and overhead on top of these costs, ranging from 12 to 15 percent on the actual costs. The overhead, and interest on overhead, is often disputed by a producer, and is commonly examined during audits.

Distributors may insist upon an over-budget add-back penalty, deducting negative cost overruns from the profit participations of the participants (producer, director, star) who significantly influence the budget and schedule of a film.[10] Distributors typically allow for a 10 percent cushion above the negative cost to account for unforeseen circumstances that may arise during production.

Trade Show, Trade Dues, and Festival Expenses. Distributors attend several trade show events annually, film markets such as the Cannes Film Market, and broadcast trade shows, such as NAB, film festivals (Toronto, New York Film Festival), allocating the admission, travel, and related marketing expenses to each film represented at the market or festival. This requires studios to pay trade dues, and checking costs to verify box-office grosses worldwide. These costs are billed to a film based on the amount of its grosses.[11]

Additional Expenses. Distributors pay a variety of additional expenses; re-editing to create additional versions of the film, shipping, taxes, insurance, the cost of converting foreign currencies to US dollars, and if not explicitly spelled out in the distribution agreement, there is a catch-all clause pertaining to "all other costs" customarily incurred by distributors.[12]

Interest. When a studio has funded production, it will charge interest on the unrecouped negative cost, at a rate that generally exceeds the rate the studio pays for loans. One point of contention between profit participants and the distributor is exactly when interest begins to run. Interest may be calculated at the point when funds are available to the production, as opposed to the point when the funds are actually spent, a position favoring the studio or distributor. Interest is charged first against revenues before revenues are applied to reduce the unpaid balance of negative costs, further increasing the interest cost to the film.[13]

Residuals are payable to talent and crew when a film moves beyond its original theatrical release into other windows of distribution. Calculated as a percentage of the gross receipts of the after markets (DVD, television, Internet, cable), residuals are subject to payroll taxes.[14]

Breakeven is the point at which income equals expenses. As this point approaches, a distributor may incur additional expenses pushing back the breakeven point. A clause in the distribution contract stipulating producer approvals for additional expenses may prevent breakeven from being pushed back by the distributor.

A **rolling breakeven** is a breakeven that accounts, and is adjusted, for additional expenses, usually on marketing and advertising.

Cross-collateralization is the practice of accounting for two or more films together so that the profits from the distribution of one or more films may be offset against losses from the distribution of other films. This is a practice favored by distributors and disliked by producers and profit participants.

Net profits are the revenue remaining after all of the distributor's expenses and fees, gross participations, and negative cost and interest have been deducted from gross receipts. Of all terms, net profits is perhaps the most widely misunderstood. There is no standard definition of net profits; only a contractual one. Many films never earn net profits despite significant grosses at the box office. It all comes down to the contractual definition.

Revenue Flow to a Film

The flow of money is different for every film, depending on whether or not a film has a theatrical release, and the chronology and duration of exploitation in the various distribution windows, as well as the extent to which a film includes the release of music soundtracks, a publishing component such as a novelization, and other merchandising. Additionally, the financing source for a film will have an impact on its revenue flow. Films that are studio-financed may be subject to slightly different payment terms than films that are funded by independent sources. What follows is the flow of revenue to an average studio-financed and distributed film.

Table 9.4 Sequence of Revenue to a Studio-Financed Film

	Flow of Money/Terminology	What Is Included
	Box Office −Exhibitor Portion = Film Rentals	Money from Ticket Sales House Nut, Splits with Distributor (Paid to Distributor)
Gross	Film Rentals (The revenue at this juncture is termed the "Gross"—revenue prior to any distributor deductions. Very few, if any, profit participants receive an interest in gross rentals. Only the very elite, most in-demand stars or directors would have contracts that allow for participation at this level.)	
		+ All Other Revenue = Gross Receipts Revenue from: Internet Streaming/Downloads PPV/VOD Pay Cable Free-TV DVD Royalty Percentage Foreign Ancillary/Merchandise/Music/Publishing

Adjusted | **Distributor Subtracts from Film Rentals**
Gross –Distribution Fee

Typically in the range of;
(30% from Theatrical)
(40% from Foreign)
(20% from Streaming, Downloads, Cable, TV, Video, & DVD, PPV, VOD)
(\approx15% from Ancillary)

–Distribution Expenses

Includes Virtual Print Fees & Advertising
Includes expenditures from marketing at film festivals, markets, and NAP
(Includes deductions for taxes, guild payments, trade association dues, conversion, collection costs, foreign versions, subtitling, dubbing, shipping, insurance, and royalty costs.)

–Negative Cost (+ Interest)
–Deferments
= Loss, Breakeven, or Net Profits
–Net Profit Participations

Star, Writer, Director

–Investor Deductions (if applicable)
= Producer's Share

Recognizing Revenue

Film distributors recognize revenue for accounting purposes when the right to receive the income is fixed, there are no further obligations on the part of the distributor to earn the income, and the film is available for exhibition in the exploitation window to which the revenue is attributable. These rules on revenue recognition may result in situations where a distributor has received revenue, but it is not recognized until a later accounting period; a mismatch of accounting revenue and cash income.

Theatrical revenue is recognized when received from the exhibitors.

In the case of television licensing a distributor recognizes revenue when the amount of the license fee is known (or can be reasonably determined), the licensee has accepted the film, and the film is available to show in the licensed window.[15]

As an example, assume a distributor licenses a film to HBO for pay television on December 30, 2018. HBO agrees to pay a license fee of $1,000,000 on delivery of a print of the film. The first showing of the film on HBO cannot be prior to one year after the theatrical release of the film. The film is released theatrically on April 1, 2019 and the distributor delivers a print of the film to HBO on May 1, 2019 and receives the $1,000,0000 license fee on May 15. For accounting purposes the distributor will report the $1,000,000 as revenue in 2020, the year in which HBO can first show the film. In 2019, the distributor will record the license fee as deferred revenue on the liability side of its balance sheet. This liability will be eliminated in 2020, when the item is recorded as income.

Similar recognition rules apply in the case of other revenue from licenses, such as from video and DVD deals, internet streaming and download licenses.

For the licensing of film-related products, such as soundtracks, toys, and other merchandise, a distributor or production company should only recognize revenue from such products after a film has been released even though the revenue may be received prior to release.

Inventory that appears on the balance sheet of a film company as "current" assets (meaning assets likely to be used within the next year) includes: unamortized film costs allocated to the film's primary market, such as theatrical, TV, or DVD; costs on completed but unreleased films, less the portion allocable to secondary markets; and TV films under point of sale. Non-current asset inventory includes unamortized costs allocated to secondary markets more than 12 months from exploitation.

The Value of a Film Over Time

For accounting and tax purposes films are amortized (depreciated) using a method known as "income forecast." The income forecast method attempts to match the amortization of the cost of a film to the periodic revenue earned from the exploitation of the film. Under this method the formula used to determine the amount of amortization in any period, generally one year, is the following:

Table 9.5 Amortization Calculation

$$\text{Amortization in year Y} = \text{Film value} \times \frac{\text{Film gross revenue in year Y}}{\text{Ultimate film revenue}}$$

Projecting the Ultimate Revenue of a Film

The ultimate (ultimate revenue) of a film is an estimate of the total revenue a film will earn over its "useful life." The useful life of a film, for the purposes of calculating ultimate revenue, is ten years from the film's release.[16] For a library film that has been previously released, the ultimate is calculated based on a useful life of 20 years from its acquisition.[17] Film companies are required to calculate the ultimate revenue for each film to which they have distribution rights every year.

Projected revenue from all sources should be included in the calculation of the ultimate, but revenue from emerging territories and technologies (such as the Internet) should not be included in the calculation, unless there is some history of revenue contribution from such sources within the industry generally.

In calculating the ultimate revenue of a film, a distributor can compare how similar films, in terms of genre, stars, budget range, target audience, and theatrical release pattern have performed in the past as a barometer for projected performance.

Film Amortization. As indicated below the cost of a film is amortized using the income forecast method. As an example, if the cost of a film is $50 million, and in Year 1 the film earns $30 million, and in Year 2 the film earns $20 million, and the ultimate is $100 million, annual amortization will be calculated as follows.

Table 9.6 Film Amortization Example

$50 Million Budget	
$30 million	Year 1 film grosses revenue
$20 million	Year 2 film gross revenues
$100 million	Projected ultimate revenue
$30m [income in year 1] ÷ $100m [ultimate revenue] = 30%	Divide film rentals by the film's ultimate revenue [the amount estimated that the film will earn over its life]
30% [amortization] × $50m [the cost of the film] = $15m in amortization Year 1	Multiply the result by the cost of the film = Amortization
$20m ÷ [$100m] × $50m = $10m in amortization Year 2 revenues	2nd year film rentals ÷ Ultimate Year 1 Revenues × Film Cost = Amortization

The preceding calculations assume that the ultimate remains the same from year to year. As the ultimate is, by its nature, a projection, it may be changed in subsequent years. If a film is released and is a greater success than projected in the previous ultimate, the overall value of the film will go up, and the ultimate will need to be increased, as illustrated by the following example.

If the ultimate is lowered, it would have the opposite effect.

Revenue estimates must be reviewed periodically and adjusted to maintain integrity of the income forecast method. Old projects must be written off and changed to overhead after three years.

Audit Rights. It is critical for a profit participant's contract to include audit rights. An audit typically pays for itself, since most audits result in additional amounts due to the participant. However, even with these contractual rights, distributors may attempt to withhold a full and complete reporting of income, as noted in the case of director Peter Jackson, in his attempt to audit New Line for his 5 percent of gross international receipts for *The Lord of the Rings: The Fellowship of the Ring*. New Line produced insufficient documents for the audit, and the case continues in court. The judge has fined the studio, calling for a third-party document retrieval company to find the correct information.[18] As is common with legal battles in Hollywood, the parties often settle, particularly when the stakes are very high.

Table 9.7 Film Ultimate Calculation Example

$50 Million Budget	
$30 million	Year 1 film grosses revenue
$20 million	Year 2 film gross revenues
$100 million	Projected ultimate revenue
$30m [income in Year 1] ÷ $100m [ultimate revenue] = 30%	Divide film rentals by the film's ultimate revenue [the amount estimated that the film will earn over its life]
30% [amortization] × $50m [the cost of the film] = $15m in amortization Year 1	Multiply the result by the cost of the film = Amortization
$50m − $15m = $35m	Adjusted value of film in Year 2
If the film earns $20m in Year 2	Due to current market conditions, the ultimate revenue for the film is raised to $150m
$20m/[$150m (the adjusted ultimate) − $30m] × $35m = $5.8 in Amortization	The higher ultimate [$150m] has resulted in a lower rate of amortization
	2nd year film revenues ÷ New Ultimate − Year 1 revenue × Adjusted value of film in Year 2 = Amortization

Participation statements are typically rendered quarterly for the first few years of release and annually thereafter. Distributors may impose limits regarding auditing—the number of audits that may be performed within a given period, requiring that participants object to a statement within a certain time, or how far back in the books an audit may go. If a discrepancy is found, the distributor's and the participant's accountants meet to agree on a solution. If none can be found, the matter may end up in litigation.[19]

Film Production Accounting requires careful and accurate supervision of the entire film budget over the duration of a film's production. A production accountant is hired early in the filmmaking process after a film is green-lighted, to help fine-tune the budget. Throughout the filmmaking process, the production accountant controls access to production funds as a safeguard to ensure that the funds are spent properly.

On a film production, the accounting department manages and records all production transactions, working together with the producer and line producer. The production accountant is responsible for communicating the status of the film's budget to the relevant parties (usually the producer, studio or distributor, line producer, investors, completion bond company), and generates several financial reports on a daily and weekly basis, including a final settling of the books. Production accountants serve as dealmakers, seeking price quotes from potential vendors, selecting the service providers who provide the best value, and completing the necessary credit applications to establish accounts with these vendors. The accountant also negotiates with film guilds and unions on a union production. If the production is partially financed using tax incentives, government incentives, or other soft money, the accountant will make sure that provisions required to access these funds will be met from an accounting standpoint. Most subsidies or tax incentives require detailed records in order to obtain such financing.

An experienced production accountant has a keen sense of specific cost aspects of film production, and she will often be called upon to estimate how changes—in the script, schedule, or equipment—will affect the overall budget of a film. The initial budget will often change in almost every category, fluctuating for a variety of reasons, throughout a production. Costs sometimes exceed expectations, and the accountant is often called upon to repurpose funds from one line item to another. It is the responsibility of the accountant to stay alert to whether the budget has sufficient room to cover such reallocation or if the adjustments are significant in nature and may have an impact on the shooting schedule, or send the production over budget. If changes are serious, the accountant notifies the producer and financiers.

The accounting department must structure payments and purchases to be met in the required timeline. On a small independent feature, maintaining the budget can be complicated, and on large-budget pictures, particularly those films shot in several locations around the world (requiring the use of foreign crews, paid in foreign currency requiring overseas bank accounts and foreign tax payments), thousands of transactions are generated, each of which must be accurately

tracked, properly allocated in the budget, and verified by the accounting department.

Accounting System. Accounting for film production is a form of project accounting, and requires specialized knowledge of production requirements and certain aspects of accounting. The accountant implements procedures to accurately track, verify, and record transactions, updating all financial records for purposes of analyzing the production budget as it is being spent.

The accounting system for a film is comprised of proprietary film accounting computer software, and specific paperwork and procedures designed to track every dollar of the film's budget. The production accountant is responsible for generating financial reports pertaining to the film on a regular basis, communicating this information to the producer, production manager, studio, investor, or other financing entity.

Guilds and Unions. Studio films are typically union films, employing union and guild talent and crew. However, there are many independent films made that are non-union. Whether a film is union or non-union will affect the cost of the production, and casting. The accountant, often working in conjunction with the film's lawyer or legal department, negotiates with the unions and guilds to set the employment parameters on that particular film.

To cast well-known and recognizable talent, often a producer must hire actors who are members of the Screen Actors Guild (SAG-AFTRA). The unions have cooperative agreements and if a producer wants SAG actors, she or he is usually required to hire other union and guild members for almost all other positions on the film because SAG members are typically not allowed to work on non-union films. The decision about whether a film is a union production under a SAG agreement is critical.

SAG-AFTRA has different tiers of production based on the budget of the film. Films with a budget of $2,500,000 or higher are covered by the SAG Theatrical & Television Basic Agreement, but SAG has several levels of lower-budget agreements to encourage the use of SAG performers in independent and low-budget films; the Ultra-Low Budget Agreement (budgets less than $250,000), Modified Low (budgets ranging from $250,000 to $700,000), and Low-Budget Agreement ($700,000 to $2,500,000). Production under lower-budget agreements allows SAG members to work on reduced pay scales and flexible employment arrangements, excluding the consecutive employment rule and step-up fees. New Media agreements offer indie producers arrangements to work with guild members with deferred rates and very low fees for webisodes and experimental programming with the expectation that when the project generates revenue, their members will be compensated.

Once the SAG production tier has been decided, the accountant negotiates with the representative from SAG and all of the other unions to define hourly rates, meal penalty, the length of the shooting day, and other working parameters on that film. The union representative can set the working terms for the film as long as they fall within the guidelines of that union's overall agreement.

Purchase Orders. The fastest and easiest way for a production entity to do business in the high pressure and time-sensitive environment on a film is for the production company to establish an account with each vendor. The vendor may require the production company to complete paperwork with credit information enabling the vendor to act quickly in response to the needs of the production with the assurance they will be paid.

The accountant signs off on the paperwork; in the form of bids, contracts, invoices approved by appropriate crew, and purchase orders, that help the accountant validate payments to be made. Typically, a production company establishes an account with each vendor, and works with a purchase order system—requiring a written purchase order as a record for each rental, purchase, or service. By strictly adhering to a purchase order system, whereby vendors are only paid through a purchase order issued by approved department heads in the film crew, an accountant has greater control over production monies.

Financial Reports. Reports generated during a film are an important tool for determining how effectively the budget is being utilized. Commonly utilized statements include a cash-flow report, the purchase order ledger, a register of all checks cut, trial balance, cost report, as well as a complete history of all transactions recorded in the production's accounting records—the general ledger bible.

The production accountant must structure payments and purchases to be made in the required timeline. Necessary equipment, props, costumes, sets, locations, and insurance—available at the precise moment they will be needed to keep the film on schedule. Any delay in payment may result in an overall delay of the film's schedule, which almost always has a negative impact on the production.

Film accounting begins with the budget. Once a film gets the green-light, the budget and schedule are fine-tuned. As discussed in Chapter 5, changes in the script affect the budget, and vice versa. The schedule, script, and budget are closely tied together.

To convert the budget to a cash-flow report, a budget is allocated in weekly segments over the duration of the production. As an example, the following illustrations show the conversion of the $1 million budget (see Figure 9.1) in the following example, to be spent over 14 weeks, to a cash-flow report (see Table 9.8).

The total amount budgeted for each line item is also allocated over time, showing the detail to be paid for each crew or cast on a weekly basis. For purposes of categorizing payees on the cash-flow report, cast members are separated into two groups, principal and supporting cast, and they are paid when they are utilized during the production. The principal cast members have more substantial roles and speaking parts, and appear more often in the film.

The cash-flow report includes projected amounts to be spent each week, and the actual amount to be spent may vary from the projected amounts. The funder, whether a studio, independent distribution company, or investors, use the cash-flow report to make funds available—depositing the required amount in the

TITLE
SAG Modified Low-Budget

Account #	Description	Total
10-00	STORY RIGHTS	200
11-00	PRODUCTION	26,500
12-00	DIRECTION	17,000
13-00	CAST	60,376
	Total Above-the-Line	**104,076**
20-00	PRODUCTION STAFF	98,762
30-00	CAMERA CREW	83,327
40-00	PRODUCTION SOUND	24,000
50-00	ART DEPARTMENT	109,450
60-00	MAKEUP & HAIR	14,370
70-00	WARDROBE	28,162
80-00	GRIP / ELECTRIC	89,597
100-00	TRANSPORTATION	50,821
110-00	LOCATION EXPENSES / SET OPERATIONS	148,570
120-00	PRODUCTION MEDIA / STOCK	1,350
125-00	FRINGES / PAYROLL PROCESSING	44,302
130-00	EDITORIAL	28,850
140-00	MUSIC	25,000
150-00	POST SOUND	34,900
160-00	POST LAB	15,045
170-00	DELIVERABLES / STORAGE	10,000
175-00	POST FRINGES	3,705
190-00	LEGAL / ACCOUNTING	13,502
	Total Below-the-Line	**822,713**
	Above-the-Line	104,076
	Below-the-Line	822,713
	Total A/L + B/L	927,789
	Contingency (10%)	92,779
	TOTAL	**$1,020,568**

Figure 9.1

production's bank account each week. It is very unusual for a funder to fund the entire budget upfront.

The purpose of the financial reports is to provide the most current information on the status of the film's budget; what was originally budgeted and what is actually being spent in real time in case changes must be made—to the script or schedule, or to make arrangements for additional funding (or personnel changes) if necessary. An experienced production manager can spot problems before they become insurmountable.

Table 9.8 Cash Flow Example

Preproduction	6 weeks

Post & Wrap

Shoot	5 weeks
Wrap	2 weeks
Postproduction	1 week

Prep

Week #	6	5	4	3	2	1
Funding	**$4,800**	$31,038	$40,156	$124,644	$54,154	$134,030

Shoot

Week #		1	2	3	4	5
Funding		$105,687	$148,896	$107,055	$100,873	$96,247

Post/Wrap

Week #		1	2	Post	Total
Funding		($3,930) Bond/Deposit Refund	($26,400) Bond/Deposit Refund	$119,044	$1,020,568

At the conclusion of the production process, the accounting department prepares a General Ledger Bible, a comprehensive list of every transaction. If an independent audit is required, either by financiers, the distributor, or investors in the film, the accountant assists in preparing the paperwork for examination by the auditor.

Notes

1. American Institute of Certified Public Accountants. (2000) "AICPA Issues New Rules For Film Industry. News Report: Financial Accounting." Retrieved December 5, 2007 from www.aicpa.org/pubs/jofa/aug2000/news3.htm.
2. Showbiz Management Advisors, LLC. "Hollywood Accounting—Case Studies. Hollywood Accounting: AICPA 00–2 AKA SOP 00–2. Page FASB Pronouncements Affecting Hollywood Accounting." Retrieved December 2, 2007 from www.showbiz managementadvisors.com/Hollywood%20Accounting.htm.
3. Moore, Schuyler. M. (2003) *The Biz: The Basic Business, Legal and Financial Aspects of the Film Industry* (2nd ed.). Los Angeles, CA: Silman-James Press, pp. 123–148.
4. Ibid.
5. Ibid.
6. Baumgarten, Paul A., Donald C. Farber, and Mark Fleischer. (1992) *Producing, Financing, and Distributing Film: A Comprehensive and Business Guide* (2nd ed.). New York, NY: Limelight Editions.
7. Ibid.
8. Ibid.
9. Litwak, Mark. (2003) Glossary of Industry Terms. Retrieved November 25, 2007 from www.marklitwak.com/articles/general/glossary_of_terms.html.
10. Baumgarten, Paul A., Donald C. Farber, and Mark Fleischer. (1992) *Producing, Financing, and Distributing Film: A Comprehensive and Business Guide* (2nd ed.). New York, NY: Limelight Editions.
11. Hart, Joseph, F. and Philip J. Hacker. (n.d.) "Less Than Zero. Studio Accounting Practices in Hollywood. The Hollywood Law CyberCenter Studio Accounting." Retrieved November 14, 2007 from www.hollywoodnetwork.com/Law/Hart/columns.
12. Baumgarten, Paul A., Donald C. Farber, and Mark Fleischer. (1992) *Producing, Financing, and Distributing Film: A Comprehensive and Business Guide* (2nd ed.). New York, NY: Limelight Editions.
13. Ibid.
14. Hart, Joseph, F. and Philip J. Hacker. (n.d.) "Less Than Zero. Studio Accounting Practices in Hollywood. The Hollywood Law CyberCenter Studio Accounting." Retrieved November 14, 2007 from www.hollywoodnetwork.com/Law/Hart/columns.
15. Vogel, Harold. (2004) *Entertainment Industry Economics: A Guide for Financial Analysis* (6th ed.). Cambridge, England: Cambridge University Press, p. 134.
16. FASB Statement, *Financial Accounting Standards Board*, p. 139.
17. Levine, Marc H. and Joel G. Siegel. (2007) "Accounting Changes for the Film Industry: Refined Rules for Reporting and Disclosure," *The CPA Journal.* The New York State Society of CPAs.
18. Thompson, Kristin. (2007, September 23) "Jackson vs. New Line: What's the New Ruling All About?" Retrieved November 24, 2007 from www.kristinthompson.net/blog/?p=108.
19. Baumgarten, Paul A., Donald C. Farber, and Mark Fleische. (1992) *Producing, Financing, and Distributing Film: A Comprehensive and Business Guide* (2nd ed.). New York, NY: Limelight Editions, 1992.

Chapter 10

Case Studies

How to Make $250 Million and Lose it, in a Year: The Story of the Film Business—by Stephen Greenwald

In the mid-1980s, I was working as a financier for Dino DeLaurentiis, and we believed that if we could put the infrastructure in place to distribute and produce films, our company would be competitive, and we would make a lot of good movies.

At that time, the company had no assets.

In 1985 DEG acquired the assets of Embassy Pictures, a film company started in the 1950s by Joseph Levine, first with movie theaters, then he began producing and acquiring films. The main asset of the company at the time consisted of 250 films, including hits like *The Producers*, *The Graduate*, *Carnal Knowledge*, *Nevada Smith*, and *Lion In Winter*. In addition to the film library, Embassy had a theatrical distribution system in place in the US with four or five offices. DEG was interested in the distribution system and we wanted to create a company that would produce and distribute films theatrically. Our plan was to acquire Embassy's assets and take the company public. At that time everyone was going public, and the stock market was strong. At that time, Embassy was owned by Columbia Pictures, which was owned by Coke. Columbia did not really want the entire company, it had purchased Embassy for its hit television shows, produced by Norman Lear. We had a hunch that if Columbia could get a safe exit from

DEG

Figure 10.1

Embassy, it would do it, it didn't want to fire some 200 employees of Embassy and get a lot of bad publicity. Columbia wanted Embassy's TV programs, but didn't need its film library; they already had a huge library.

We proposed a deal to Columbia—we would buy the assets of Embassy, including the film library, and in exchange, we would pay no cash, but would assume the liabilities of the company, some $12 million in debts and residuals. Columbia liked the deal—we paid no cash, assumed all of Embassy's debts, and got a 250-film library.

But now we needed cash to run the company.

Dino had a production company—DDLP, with eight films in various stages of development. We transferred all of the distribution rights to those films to DEG.

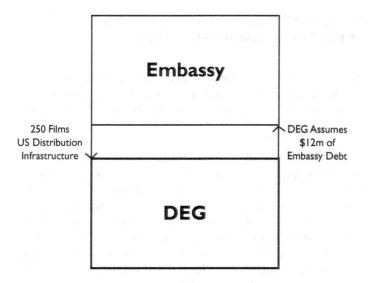

Figure 10.2

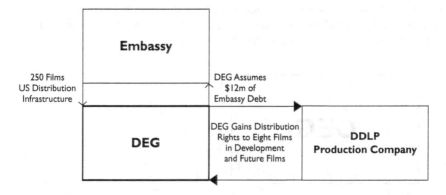

Figure 10.3

To raise the cash required to run the growing company, and meet Embassy's obligations, we licensed the US pay-TV and video rights of the eight films in development/production to Columbia for $1 million per film (PRESALES), netting DEG $8 million.

Also Dino at that time owned a film studio in North Carolina with sound-stages on several acres, so we transferred the entire studio into DEG, in exchange for no cash, but 100 percent of the stock to Dino.

With a distribution system, a 250-film library, distribution rights to eight films in various stages of development and production and a film studio, DEG went public (IPO—CORPORATE FINANCING). PaineWebber valued the company at $75 million, and sold one-third of the company, for $25 million in the IPO (EQUITY FINANCING), and was listed on the American stock exchange. We issued approximately 2 million shares at about $12 per share. At the same time, we sold bonds in the company (DEBT FINANCING)—in the form of unsecured,

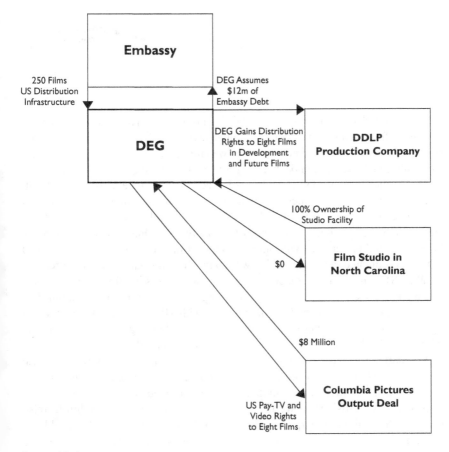

Figure 10.4

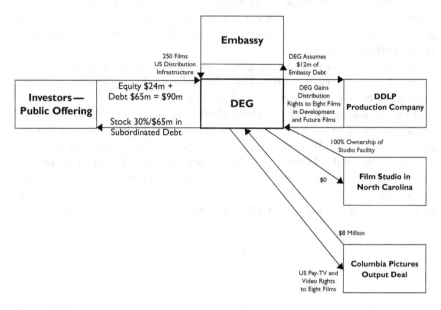

Figure 10.5

subordinated debt, which is essentially a promise to pay, with interest, in exchange for a loan from those individual investors. Generally, the lower the risk, the lower the interest rate, and ours was high, 14 percent. Our shareholders were subordinate to our bonds, which were subordinate to our other debt.

$98 million was a good start, but we needed more money, so we went out, and proceeded to secure lines of credit, for a total amount of $75 million, from four different banks (DEBT FINANCING). We could draw down the line of credit for working capital. The lines of credit function like a loan, you borrow the money and pay it back with interest. The various lines of credit came ahead of the subordinated debt, and, which was somewhat unusual, were unsecured.

With $173 million, we made our big mistake—we started to make movies. But we knew we would need more financing, so, in addition to our output deal with Columbia, we also had an output deal with HBO for pay-TV and video rights. On the basis of these output deals, we were able to get a $50 million line of credit (DEBT FINANCING) from Credit Lyonnais Bank.

We started to produce and release movies, approximately 24 films, like *King Kong Lives*, *Manhunter*, *Weeds*, *Million Dollar Mystery*, and *Dead Zone*, and for every film, in addition to production funding, we needed funds for marketing (Prints and Advertising) so we created a Limited Liability Partnership to raise financing for marketing purposes. The plan for DEG was to form a Limited Partnership and take it public, transferring the US theatrical rights into the Limited Partnership in exchange for the anticipated sum of $75 million (EQUITY

FINANCING) to fund a P&A fund. As they say, timing is everything. Because DEG was a public company, it had obligations to file quarterly and annual reports. When we filed our first 10Q in June of 1985, the big accounting firm, Ernst & Young, which did our accounting, made a mistake, with our help. Ernst & Young told us we could capitalize certain interest we were paying. If DEG capitalized the interest, we would add it to the cost of the film, and then amortize it; the other option was to expense the interest, whereby it would be deducted immediately. Our controller told us to expense it. It is important that a CFO, if not an accountant, has some accounting background or experience, as their job is to oversee the accountants. Our CFO, who was not an accountant himself, told us to capitalize it. We capitalized it. In October of 1985, preparing to take the Limited Partnership public in November, DEG received a call from Ernst & Young, informing us that there was a mistake, we were wrong, they were wrong, and now DEG had to go back to publicly amend the 10Q, which is a public event, raising a red flag to the SEC, who decided it must look into all of the company's past accounting. The SEC mandates that the principals must go to Washington DC, so that it can examine all of our accounting. This delayed the public offering of the Limited Partnership, which we anticipated would raise $75 million, long enough for our movie *King Kong Lives* to be released. The movie opens with a scene in which the ape gets a heart transplant, and goes down from there. That movie set the tone for the Limited Partnership public offering; instead of raising $75 million (EQUITY FINANCING), DEG raised $30 million.

It was time to expand our efforts on a global scale, and in July 1986, I went to Australia, in pursuit of financing for *Total Recall*. Dino owned the rights to *Total Recall*, and Australia had soft money and other subsidy money that we could access, which would cut production costs. Bruce Beresford, an Australian, was attached to direct which fulfilled certain requirements to access soft money (a certain percent of native crew and cast must be hired).

On the long, 14-hour flight back to the United States, I had an idea for a transaction, which for that time was unique, and fairly daring, and Dino had the vision and courage to see the potential and so DEG went for it.

DEG owned worldwide rights to the company's films, and would create a subsidiary in Australia, which would own all of New Zealand and Australian rights to both the DEG library films, as well as any new films. DEG would enter into an agreement with the Australian company that any film made by DEG Australia would be a negative pickup. When the DEG Australian film was completed, DEG US would acquire all rights except for the Australian/New Zealand rights, and DEG US would pay the full production costs. DEG Australia had the guarantee of reimbursement of production costs, and would benefit from all profits from Australian and New Zealand rights.

DEG bundled $3 million cash for DEG Australia to use to make films, all Australian and New Zealand rights to DEG's 250 library films, DEG US present and future films, and the negative pickup deal for new films. The investment

bank we presented the package to valued the entire transaction at about $30 million and did a public offering for DEG Australia.

In order for an company to access the Australian soft money, the company had to be majority owned by Australia, so the public offering sold 51 percent stock to the Australian public, selling for $30 million, 50 percent of the company, which translated into an overall valuation of the company of $60 million. DEG US owned 49 percent of the company, enough to control it, but not a majority interest. If a company owns less than 50 percent of a company, then the debts of that subsidiary do not appear on the parent company's books. We could therefore borrow money from that company if we needed to, but we were not around long enough to do so. The only non-Australians on the board of directors were myself and Dino, which ultimately was our undoing later on.

The DEG strategy was to create this subsidiary structure in other markets, Canada, Europe, etc., accessing their soft money, and splitting out that territory's rights. In Australia, we wanted to build a film studio, and found a 120-acre property. We convinced the government to buy that property, lease it at $1 per year for seven years, then we would buy it back at the cost they paid for it. The Prime Minister of Queensland decided this was a great plan; it would create economic opportunities in the area, and bring jobs and DEG also planned to build a studio

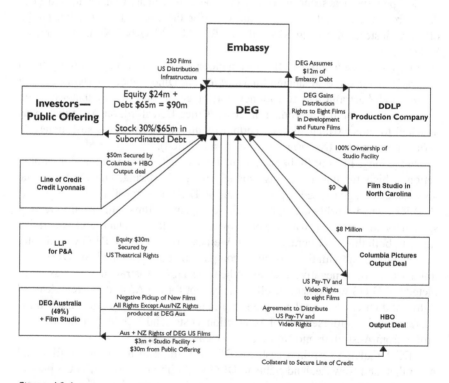

Figure 10.6

theme park, so the government agreed to loan DEG the money to build the studio. At the time it was the largest studio in Australia, built for approximately $10 million, and it still exists today.

All of this was planned and executed within one year. So what happened?

Ultimately, the pictures did not work. And the flaw of the presale arrangements was that the company would have to presell 130 percent of the negative cost before the film was released, which was good, except that we gave away the upside, and whoever buys the rights get their money back. Having presold almost all of the rights to each film only left DEG one market to cover overhead and make a profit, and that was the US theatrical market, which is unreliable.

Ultimately DEG could not match the spending of the studios, and was spending an average of $6–7 million against Warner Brothers opening an Eddie Murphy film supported by P&A spending of $20–25 million.

DEG's film *Million Dollar Mystery*, which tanked in the theaters, and gave one million dollars away as prize money to an audience member, had to be written off, which was a material event, required to be filed with the SEC, causing DEG stock to drop in half. The banks, that had previously required no security whatsoever, came to the company and demanded security on their loans.

We had to start unbundling the company, pulling the plug on *Total Recall*, which was about to start principal photography in Australia for a negative cost of $20 million. DEG Australia's board of directors refused to make the film, as they believed that DEG US would not be able to honor its negative pickup deal. *Total Recall* had a pay or play clause with the director Bruce Beresford, who was paid his $1.6 million, even though we did not make the film. The project was sold to Carolco for $80 million, and completely rewritten, to be made with Arnold Schwarzenegger.

DEG US sold our 40 percent stock in DEG Australia to Village Roadshow for $13 million. DEG went into bankruptcy, Chapter 11, and we paid the banks back, first the $75 million, by selling the film library to L'Oreal, and then another $50 million. The banks were so happy that I managed to save them their money, that when they got into trouble, I was hired to sell other film libraries, and in the 1980s, there were many film companies started and video companies as well (Nelson and Vestron) and they got in trouble borrowing money.

DEG managed to utilize most forms of debt and equity financing, also accessing subsidy and soft money, all of which are used in the film industry today.

Cell Phone Feature Film: *Tangerine*

The movie *Tangerine* (2015) exemplifies the movie industry theme that technology drives the industry. Cell phones now are widely popular, and most have excellent video cameras. A wide variety of filmmaking apps and equipment to augment and support smartphone filmmaking are increasingly available.

Tangerine was a movie shot entirely on cell phones (the iPhone 5), going on to premiere and win awards at the Sundance Film Festival in 2015. It was

purchased by indie distributor Magnolia Pictures, going on to a limited release, in 44 theaters in 2015, also released internationally. *Tangerine* was written by Chris Bergoch, directed by Sean Baer, and produced by Mark and Jay Duplass.[1]

Synopsis: It's Christmas Eve in Tinseltown and Sin-Dee is back on the block. Upon hearing that her pimp boyfriend hasn't been faithful during the 28 days she was locked up, the working girl and her best friend, Alexandra, embark on a mission to get to the bottom of the scandalous rumor. Their rip-roaring odyssey leads them through various subcultures of Los Angeles, including an Armenian family dealing with their own repercussions of infidelity.

> **Genre:** Comedy Drama
> **Budget:** $100,000
> **Box office:** $700,000

The film was executive produced by successful indie filmmakers, the Duplass brothers. Tangerine featured a cameo from Instagram star and style blogger, Francis Lola, playing a taxi driver. The transgender actresses Mya Taylor and Kitana Kiki Rodriguez were not professional actors at the time they were cast in the role. The film was a significant milestone in featuring stories of transgender people, and also in production on cell phones, which the filmmakers kept secret until the premiere.[2]

Previously, director Sean Baker had been nominated for the Spirit Award nominated film, *Take Out*. He is also one of the creators of the long-running comedy television show *Greg the Bunny* (2005) and its spin-off *Warren the Ape* (2010).

The story is gritty in its depiction of sex workers struggling to make a living, but they do not come off as victims. The visual style features frenetic movement, and distorted wide-angle close-ups, using an anamorphic lens adapter for smart-phones and a Steadicam app for phones, and the shoot lasted 22 days. The film was shot on the SAG Ultra-Low agreement, paying the actors $100 per day; it had a total music budget of $1,700 acquired from DJs and musicians via Soundcloud.[3]

With mobile phones currently the fastest adapted technology ever, it is necessary to ask if the future of movies belongs to cell phones, and what that future would look like. From production to distribution, the technology, consumption, and audience demand are present. Will the industry follow suit?

Comic Book Movies Take Over the World: *Wonder Woman*

North American ticket sales during Summer 2017 were one of the worst ever. Summer is typically a strong period for the studios. The model of Hollywood has always been that the winning must pay for the losers, but with more comic book-based movies at higher prices, the risks keep going up. So far, the rewards

do as well, although comic book movies are not fool-proof: for every successful *Wonder Woman*, there's a *Catwoman, Ant-Man*, or *Jonah Hex*, lagging far behind.

2017 depended on the collective box-office successes of *Guardians of the Galaxy Vol. 2, Wonder Woman, Spider-Man: Homecoming, It*, and *Despicable Me 3*. Historically, comic.

The movie *Wonder Woman* (2017) grossed half of its $800 million box office from North America in 4,165 theaters, and the other half from the international market. Comic book movies reduce risk for the studios, benefiting from material with previous awareness, and crossover marketing among sexes; they are naturals for merchandising tie-ins, are inherently visual, and travel well overseas with dialogue and plot subtleties that can withstand translation thanks to splashy special effects, loud makeup, and wild costumes.[4]

Comic book movies have been and continue to be, very popular, but typically the leading characters are male, with a few exceptions in ensemble pieces. Wonder Woman is the most popular female comic book superhero of all time, and aside from Superman and Batman, no other comic book character has lasted as long. The comic started in 1942, and continues to date, with the exception of a brief hiatus in 1986. The film *Wonder Woman* capitalized on the popularity of comic book movies, but was the first to prominently feature a woman as the main character, played by Gal Gadot. The fact that it was a big-budget movie with a female director, Patty Jenkins, was also noteworthy. At the time of this writing, only 7 percent of top grossing films feature female directors.

Typically, superhero film audiences are dominated by male moviegoers; *Wonder Woman* matched female viewers to male ones over the first three weeks of the release. The number of aged 50+ female audience members also went up over the film's first few weeks by more than 20 percent than is typical for this type of film. The film was lauded for its pro-female stance, and due to its success, has a sequel in the making, again starring Gadot, to be directed by Jenkins. The film was not popular with some groups of feminists, commenting on the skimpy and provocative outfits of the character. While not as popular overseas as suspected, Wonder Woman merchandise sold briskly, ranging from costumes, to backpacks, phone cases, jewelry, makeup, posters, toys, candy, novelization, razors, and, bizarrely, diet bars.[5]

At the Forbes Women's Summit in New York, Patty Jenkins said:

> The market is there, and the money is there. As long as you're obsessed with young male audiences and you're writing stories with men and directing them with men, nothing will change. The world is changing, so if Hollywood wants to get rich, pay attention to this: Women are our biggest audience in the world right now. It would be wise to go after them.[6]

Synopsis: Before she was Wonder Woman (Gal Gadot), she was Diana, princess of the Amazons, trained to be an unconquerable warrior. Raised on a

sheltered island paradise, Diana meets an American pilot who tells her about the massive conflict that's raging in the outside world. Convinced that she can stop the threat, Diana leaves her home for the first time. Fighting alongside men in a war to end all wars, she finally discovers her full powers and true destiny.

> **Genre:** Action adventure/fantasy
> **Budget:** $149 million
> **Box office:** $800 million
> **Based on:** Wonder Woman comic book; by William Moulton Marston

Is a constant flow of comic book movies enough to keep Hollywood alive? Perhaps the pressures of the global market increase demand for comic book films to the detriment of other genres and kinds of films from the US, and big-budget, comic book movies will become the staple of Hollywood output, with indies and OTT providers left to the other types and budget sizes of movies.

Relying on Genre: 2017 Horror Movie, Stephen King's *It*

Horror movies have emerged as an extremely popular and profitable genre. They are relatively economical to make compared to other types of movies, don't typically require high-budget stars, because the concept of the film is the star, and they can be effectively marketed to a niche audience. The genre lends itself to sequels, and there are a tremendously high number of them—to date, horror has the highest number of commercially released films by genre on Box Office Mojo, after foreign language and documentaries. Across all genres, horror is the fastest growing. The advances and sophistication in CGI have contributed to the popularity of horror, in part, as quality of visuals has increased. According to an extensive survey of the genre by Stephen Follows on stephenfollows.com, of all the genres, horror is the most immune to bad reviews, with little correlation between what film critics thought of a movie and how financially successful it was.

In a survey of the most profitable movies, comparing box office to film budget, horror is unparalleled, with films like *Paranormal Activity*, *The Blair Witch Project*, *The Devil Inside*, *Annabelle: Creation*, *The Purge*, *Night of the Living Dead*, and *Insidious*. There are a number of hugely profitable horror franchises, including *Friday the 13th*, *Paranormal Activity*, *Saw*, *Halloween*, and *Resident Evil*, and veritable universes of horror/fantasy content by prolific writer Stephen King. King's 40 movies (not counting television shows) range from *The Shining*, *Misery*, *Christine*, *Maximum Overdrive*, *Creepshow*, *Pet Sematary*, *Carrie*, *The Mist*, *Graveyard Shift*, *Riding the Bullet*, with new ones all the time.[7]

The movie *It* (2017), directed by Andy Muschietti, was based on a book by Stephen King. The movie grossed half its revenue from domestic and overseas

audiences, breaking opening weekend box-office records for a horror movie. Budgeted at $35 million, a relatively high budget for a horror movie, *It* went on to gross over $650,000 million globally.[8]

Synopsis: Seven young outcasts in Derry, Maine, are about to face their worst nightmare—an ancient, shape-shifting evil that emerges from the sewer every 27 years to prey on the town's children. Banding together over the course of one horrifying summer, the friends must overcome their own personal fears to battle the murderous, bloodthirsty clown known as Pennywise.

Budget: $35 million
Box office: $651 million

The movie was based on characters and stories from Stephen King's book, *It*, which was adapted as a mini-series in the 1990s before being remade in 2017 as a feature. While not based on a true story, the character has historical roots harking back to a "killer clown" which goes back to serial killer John Wayne Gacy, who murdered 30 young men and boys in the Chicago area in the 1970s, who performed at children's parties as Pogo the Clown. 2017 was a good year for horror, beyond the success of *It*, as well as *Get Out*, budgeted at $4.5 million, grossing $250 million, and *Annabelle: Creation*, budgeted at $15 million, grossing at $102 million.

Like the majority of horror films, *It* is rated R, featuring a scary clown, of which there have been several news incidents in the past few years, some made-up, some mere pranks, others violent. Several sources report that distributor New Line staged clown sightings as viral marketing, which the company denies. The film was marketed aggressively with the clown character Pennywise, played by Bill Skarsgard, and related visuals, like publicity stunts with red balloons, the character's calling card. Author Stephen King shared his own videos, and well-guarded footage was shown at Comic-Cons, building buzz among fans. There was aggressive marketing for the movie online, sharing on social media with hashtag #nevertrustaclown, and video takeovers of fast-food restaurants.[9]

The audience for *It* skewed young and male, which is typical for horror movies. However, the film also appealed to female viewers as well, partly for the nostalgic 1980s feel and innovative marketing campaigns. While horror movies aren't typically marketed like tent-pole films, *It* was marketed aggressively, with IMAX screenings, event-type screenings like the "clowns only" screening at Alamo Drafthouse theaters, and a robust press junket. International territories are eager for horror movies, although territories like Japan, India, and South Korea tend to rely on their own fare. The United Kingdom is a dependable market for US horror movies, and was the second largest grossing territory for *It*.[10]

With the ongoing popularity of horror movies, studios may invest more heavily in horror, with somewhat bigger budgets. However, whether horror can sustain the film industry in the long run remains to be seen.

Netflix in Movie Theaters: *Okja*

OTT and the multiplex—why are Amazon and Netflix releasing movies in
theaters? Released simultaneously in select theaters and online, the Netflix-
produced movie *Okja* (2017) is a dark fable directed by Bong Joon-ho, co-
written by Bong and Jon Ronson starring young Korean actress Ahn Seo-hyun,
and Hollywood actors Tilda Swinton, Paul Dano, and Jake Gyllenhaal. It is
necessary to have a theatrical release for a movie to compete for prizes like
Cannes and the Academy awards, and *Okja* was nominated for a Palme d'Or at
the Cannes Film Festival. In addition to eligibility for awards, the release was a
signal to the industry that Netflix is going head to head in competition against
the studios.[11]

> **Initial release:** May 19, 2017
> **Director:** Bong Joon-ho
> **Budget:** $50 million
> **Box office:** $2 million
> **Nominations:** Palme d'Or, Cannes Best Actress Award

Synopsis: For ten idyllic years, young Mija has been caretaker and constant
companion to Okja—a massive animal and an even bigger friend—at her home
in the mountains of South Korea. But that changes when family-owned, multi-
national conglomerate Mirando Corporation takes Okja for itself and transports
her to New York, where an image-obsessed and self-promoting CEO has big
plans for Mija's dearest friend. With no particular plan but single-minded in
intent, Mija sets out on a rescue mission.

The online streaming company released *Okja* in limited release in movie
theaters and on Netflix at the same time, in the US, UK, and South Korea. The
film debuted in luxury theater chain iPic in the US at premium ticket prices, and
was marketed like an event film. In spite of it being directed by prominent
Korean director Bong Joon-ho, South Korean theaters boycotted the film. At the
Cannes Film Festival screening, audiences booed the Netflix production, as well
as the Amazon-screened debut as well.

Okja is arthouse fare, with dialogue in English and Korean, a message film
about the ethics and state of the meat industry. At first glance the movie appears
to be for kids, featuring a giant CGI pig and young child as main characters, but
due to the subject matter and grisly imagery, distinctly for adults, it was released
as NR (no rating) by the MPAA.

The rise of OTT services like Amazon and Netflix are putting pressure on
studios and the theatrical industry—these companies can skip a theatrical release
because they don't need it. But Netflix is producing more movies, wants more
recognition, and is changing the standard movie release patterns worldwide. Its
announcing of the production of 40 films per year going forward, and Netflix's
statement that it can reinvent the film business, sends a mixed message. Will the

overall net effect of Netflix, and other internet subscription services like Amazon, help the movie industry or hurt it in the long run? Reactions are mixed, and the effect on the standard sequence of distribution is undeniable—theaters are getting squeezed. When Netflix experimented with a simultaneous online and theatrical release with its 2015 film, *Beasts of No Nation*, certain theater chains refused to screen the film. The company plans to continue its dual release strategy for some of its upcoming films, focusing on artistic, auteur-driven projects, including Richard Linklater and Woody Allen.[12]

Analysts speculate that Netflix may attempt to apply its subscription model to its new films available online and in theaters, even offering that service to studio films. Representatives from NATO, the theater's trade organization, remain unconvinced that Netflix will do anything but disrupt the exhibition side of the movies, and hurt theaters. Industry experts muse that Netflix may force the movie experience closer to an on-demand model, in the same way that DVDs have shortened the timespan between a theatrical release date and when movies can be viewed at home.

Amazon is also experimenting with release patterns that offer a theatrical experience for select movies it is producing. Company representatives have stated that they want their audiences to have the full theatrical experience, and the company wants to win Oscars™ as a matter of quality and perception toward its product, and that attitude attracts filmmakers as well. The company's Oscar™-winner movie *Manchester by the Sea*, released in 2016, and premiered at Toronto, signal that it is open to ongoing theatrical screenings with simultaneous online release, like *The Big Sick* in 2017. The company announced it is planning to release 12–14 films at budget levels between $5 million and $35 million. However risky movie making has been historically, Amazon Studios is in a much safer position, because the company is not relying on its revenue from its movie business; it generates movies and television programming in the manner of a loss leader, luring customers into purchasing Amazon Prime service, gathering extensive data about consumers to keep them in the online store longer, and further selling them media and all manner of products.[13]

With the purchase of brick and mortar food chain, Whole Foods, and the company's opening of book stores, it may be that Amazon plans to launch, takeover, or open its own movie theaters. As Apple, Facebook, and YouTube Red delve further into the movie production business, it is possible they may put movie theaters into the mix as an option for their customers as well.

Contrasting Film Industries: Europe and Hollywood—by Michael Kalb

In the following case study, Michael Kalb, German filmmaker and graduate of the University of Television and Film in Munich, presents an overview of the European film market and how it differs from the market in the United States. Considering that approximately 511 million people live in the European Union

(EU) compared to the 326 million in the United States, Europe is a very important and profitable territory for film production and distribution. American producers who want to invest, expand, or coproduce in this market should be aware that there are some significant legal, economic, and ethical differences in how films are produced in most European countries.

European Film Industry: An Overview

This section describes the structure and data about the European film market followed by an overview on financing, coproduction, and distribution. Every European country has its own specific film market, audience tastes and preferences, structure and size of the production companies, sources of film funding, and legal structure. Due to different historical and cultural developments among the many European countries and artistic movements, such as the French *New Wave*, Italian *Neorealism*, or Dutch *Dogma Movement*, there is no unique European style or way of movie storytelling,[14] compared to Hollywood or Bollywood movies. However, the European Union is unifying the laws and practices related to film production, overcoming barriers between the 28 different member states, while encouraging artistic identity and differences.

While Europe is a pioneer in both technological and content innovation in cinema, the EU film landscape is currently characterized by the strong presence of Hollywood productions. Despite US-based companies having produced 622 feature films in 2013, compared to 1,546 European productions in the same

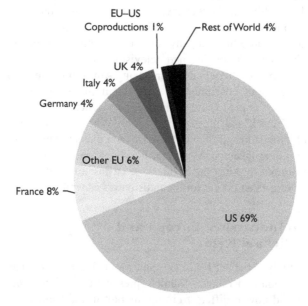

Figure 10.7 European Market Share of the Global Film Industry.

period, Hollywood accounts for almost 70 percent of the EU market, while European companies hold only 26 percent.[15] Since the 1960s, European film industries with their governments have been working to increase the prevalence of European film by establishing public film funding, tax incentives, and other measures for native filmmakers. Collectively the European market share of the global film industry equaled approximately 26 percent in 2013, as illustrated below.

Notwithstanding the ever-encroaching presence of Hollywood, the European film industry is dynamic, with 75,000 companies employing more than 370,000 people. Within the EU, the "Big Five" countries, consisting of France, Germany, the United Kingdom, Italy, and Spain, are responsible for approximately 80 percent of movie releases and professionals working in the industry.[16]

European films generated €7,350 million in revenue in Europe in 2015. France is the strongest film market in Europe, generating 36 percent market share. In terms of domestic market share, it is followed by Italy then Germany. However, the United Kingdom is second to France in theater admissions, as illustrated in the following table.

The film industry in the United Kingdom is commercially driven, compared to other European nations. Continental European countries consider film and other types of art as having high cultural value, therefore it is a duty of the State to support the arts, regardless of any influence by the marketplace. This significant difference in the way of understanding the arts influences not only how European filmmakers think about motion pictures and storytelling itself but also their financing and production.

Film Financing and Coproductions in Europe

The core of the EU film industry consists of nationally based companies, many of which are relatively small and focused on one sector, like production, distribution, marketing, or exhibition, as opposed to the US studios which are both vertically and horizontally integrated, funded by the deep pockets of their parent companies. Therefore, the European film industry finds it difficult to raise the higher production budgets needed to compete on a global scale. The average EU production budget ranges from some €11 million in the UK, €5 million in

Table 10.1 European Admissions, Domestic Market Share, Screen Count

Country	Admissions (in Millions)	Domestic Market Share (%)	Screens
France	213.1	35.80	5,842
UK	168.3	7.42	4,046
Germany	121.1	22.70	4,739
Italy	112.5	28.70	3,752
Spain	102.0	18.50	3,557

Germany and France, to €300,000 in Hungary and Estonia, compared to American studio film budgets averaging $93 million.[17] In general, most European production companies do not have the capital required to finance a film, instead using public film funds. Most European countries have at least one national film fund to support the production of movies. In larger countries like Germany, there are also many regional film funds. The European funding system funds all phases of filmmaking and exploitation, making artists more independent from commercial pressures in addition to supporting the arts ideologically. This boosts the development of new types of arts and storytelling, spurring revolutions in editing, storytelling, composition, and structure originated with European cinema, such as Italian Neorealism, Soviet Montage, French New Wave, and German Expressionism.

Due to their size and demand from the marketplace, most production companies in Europe do not produce several features on a yearly basis. In 2015, roughly two-thirds of German production companies produced one feature film, and only four produced more than four. In most cases a coproduction or pre-licensing deal with a television broadcaster are necessary to finance a movie.

Germany is an example of a typical European country with funds at a national and regional level. Most German feature films are financed with money from one or more public film funds that provide up to 60 percent of the production budget. The DFFF (*Deutscher Film Förder Fonds*) provides filmmakers with a grant of up to 25 percent of the costs of production shot in the country while the FFA (*Filmförderungsanstalt*) is Germany's national film funding institution and

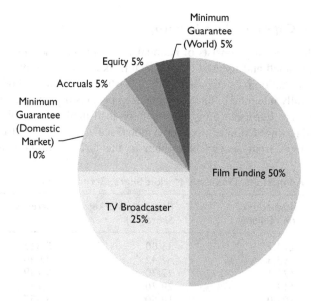

Figure 10.8 Example of Financing for a German Film.

supports selected projects. A jury decides the eligibility of, and the amount of support for, every submitted project. The budget of a particular fund is financed via a film levy raised from cinemas, the video industry, and television. The annual budget for FFA is €76 million and for the DFFF it is €75 million. In addition to national film funds, several regional film funds provide an additional 150 million euro.[18] As media has expanded, so too have the funds, most of which can be used to finance video games, animated movies, and distribution. Following is the typical film financing that comprises a commercially released movie in Germany.

France has a larger and more competitive film market than Germany which makes classical public film funding less important. French TV channels are legally obligated to contribute 5.5 percent of their total revenue to an automatic grant for French film and television productions, known as *compte de soutien*, invested as equity in movies. In 2016, over €672 million in grants were received by the media industry. French television channels devote at least 3.2 percent of their funds each year to fund European film production, with a portion specifically designated to original French language works. On top of the economic support under French law, television services are required to broadcast at least 60 percent of the total annual number of film broadcasts and reruns to European works and 40 percent to original French language works.[19] Following is an example of funding for a typical French film.

Financing films in the UK is similar to the US where most funding is raised from private equity. In 2016, approximately £1.35 billion was spent by "48 major inward investment films."[20] Those films are funded with foreign money,

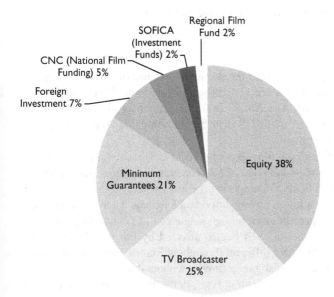

Figure 10.9 Example of Financing for a French Film.

primarily by the US, including *Star Wars: Episode VIII—The Last Jedi, Ready Player One, Alien Covenant,* and *Paddington 2.*

In summary, the challenge of how to finance a film in Europe varies between countries, with a great deal of diversity within the EU. Each of the three largest European film markets, France, the UK, and Germany, have their own methodology within their production and funding system.

For production of movies with non-EU producers, international film funds were established to strengthen the European film market. A coprodution requires a minimum of two member countries to the coproduction treaty. "Creative Europe—MEDIA" is a program that lasts until 2020 with a total budget of €1.46 billion, the "EURIMAGE" is another large European cinema support fund and includes countries outside the EU, such as The Russian Federation, Turkey, and Canada, providing an additional €25 million annually. Every film fund has guidelines, restrictions, and maximum sums of support making it necessary to study each market and possibility of support depending on where a coproduction takes place. Similar to US incentives, filmmakers are required to spend a certain amount of money in the region or country.

Thanks to the efforts of the EU and additional treaties, international coproductions can get national treatment, with foreign productions treated like national productions, benefiting from the various national film funds and support systems. In 2015 almost half of the German feature film releases were international coproductions with companies from France (14), Austria (8), or USA (8). From €61 million of German national public film funds granted to 107 productions, over half funded international coproductions[21] while half of the 283 French feature films were coproductions with 40 different foreign investors.[22]

Distribution in Europe

Distributing a film in Europe follows the same architecture of exploitation as in the US. Most American studios are vertically integrated and directly distribute their feature films in Europe. And American films account for almost 70 percent of the European box office,[23] with US distribution companies representing the majority in this market segment.

The market share of domestic films is 53.4 percent in Turkey, 7.4 percent in the United Kingdom, 35.8 percent in France, 22.7 percent in Germany, 28.7 percent in Italy, and 18.5 percent in Spain.[24] Comparing the low number of the UK with the other countries gives a conclusion on how important language is for the acceptance in a specific market. The perception of foreign language films is that they are automatically perceived as "arthouse" and is also affected by the fact that attitudes toward dubbing and subtitling are different throughout Europe. In Germany, every movie is dubbed, while the Swedish prefer movies without dubbing.

Despite the dominance of American movies, domestic films play a vital role in the EU. There is a board of European distribution companies with knowledge and expertise within EU niche markets, with long-standing partnerships with

European theaters and multiplexes, as well as relationships with American countries, such as German company Pantaleon Films with Warner Bros. Often, US distributors get the EU distribution as well as world-wide distribution of European films if the European company does not have a distribution arm. An example of this relationship was a strategic partnership between a large German production and distribution company, Constantin Film, and the US studio DreamWorks; from 2012 until 2016 Constantin distributed DreamWorks' films in the German-speaking countries (Germany, Austria, and Switzerland).[25] The majority of European films are produced by smaller companies, with a new distributor for each project.

The Nature of Copyright: European Author's Rights Versus American Copyright—by Michael Kalb

Intellectual property and its exploitation varies significantly between the US and most European countries. It is indispensable for American producers and artists who want to work or collaborate with European companies that they understand those differences, and vice versa.

To understand the differences between them it is necessary to look at their historical origin and legal systems. US Copyright Law is based on the Anglo-American Common Law, whereas the Author's Right is based on the Continental European Civil Law. Both legal systems are rooted in their own fundamental ideas and may lead to significant differences.[26]

Continental European Author's Right applies in Germany, France, and most other countries of the European Union, protecting the original copyright owner herself or himself. It is both national and partly stated as a law of the European Union,[27] and may vary between countries. This section focuses on the commonalities of the Author's Right Laws of the European Countries. The origin of the law can be found in the humanistic and individualistic ideals of the French Revolution (1789–1799), formulated during this time period. The so-called "droit d'auteur" (Engl.: Author's Right) states that every work of intellectual and creative expression is inseparably linked to its author. "Droit morale" (Engl.: Moral Right) is often used as a synonym, referring to the notion that a copyrighted work is an expression of the personality and humanity of its author or creator, and includes:

- the right to be identified as the author of a work;
- the right of integrity (that is, the right to forbid alteration, mutilation, or distortion of the work); and
- the right of first divulgation (that is, making public) of the work.[28]

Accordingly, a copyright owner whose place of jurisdiction is in Continental Europe can never hand over all rights to her work. She can only license the right to use the work for specific purposes, such as distribution and exploitation,

advancements, modifications, etc. Furthermore, the Author's Right primarily focuses on the economic and intellectual interests of the author: she should get fair compensation for her work. But the ascribed rights are restricted to certain limits to ensure that the general public can have access to the work for educational and scientific purposes.[29]

In film and television the Author's Right would apply to the scriptwriter, the director, the director of photography, or the music composer, if the leading production company's place of jurisdiction is in the European Union.

Anglo-American Copyright adheres to the underlying copyright laws of the United Kingdom, the Commonwealth States, and the United States, reaching back historically to the English "Statute of Anne" in 1709. This copyright is more commercially aligned for exploitation of copyrighted material. The idea is to support education and spread knowledge by guaranteeing distributors the exclusive and time-limited right to copy a work and bring it to public. The commercial incentive for the distributor will help the public welfare and the exclusiveness will protect the publisher from losses after buying and printing a manuscript, and then a competitor releases the same copy, but at a lower price. As capitalism has always driven the American industry, including the arts, it is no surprise that the Anglo-American and not Continental European system found its way into American Law. Countries in the Anglo-American tradition, including the United Kingdom, the United States, Canada, Australia, and New Zealand, tend to minimize the existence of moral rights in favor of an emphasis on economic rights in copyright.[30] Authors who wish for their work to be distributed widely have to transfer all their rights to a distributor.

International Copyright Agreements. While the Author's Right protects the interests of the author, copyright strengthens the position of the distributor. By considering how copyright is interpreted differently based on location, an attempt to establish a uniform worldwide copyright law is very difficult. There is no such thing as an international copyright; copyrighted works are governed by the laws where they are created.[31]

There are a number of treaties and organizations to protect copyright owners in most parts of the world. The oldest international agreement is the Berne Convention, concluded in 1886 and revised regarding new technologies and distribution formats. Since 1974, the convention has been overseen by the World Intellectual Property Organization (WIPO) a sub-organization of the United Nations. Every member of the World Trade Organization (WTO) agrees to enforce "the protection of works and the rights of their authors[32]" as defined in this convention based on three basic principles:

- Principal of "National Treatment": Works originating in one of the Contracting States (that is, works of an author who is a national of such a State, or works first published in such a State) must be given the same protection in each of the other Contracting States as the latter grants to the works of its own nationals.

- Principle of "Automatic" Protection: Protection must not be conditioned upon compliance with any formality.
- Principle of "Independence" of Protection: Protection is independent of the existence of protection in the country of origin of the work.[33]

All Continental European countries and the US are part of the WTO, and follow the guidelines established in the General Agreement on Tariffs and Trade (GATT) and the Agreement on Trade-Related Aspects of Intellectual Property Rights (TRIPS). Despite all such efforts on an international level there are still some significant differences between copyright systems.

Differences. The major difference between the two systems is the transferability of copyright. Under Anglo-American Copyright Law the author of an intellectual and creative work may transfer the entire copyright to another person or company; including the moral rights and the exclusive exploitation rights, or divide the rights and license them separately. A new right owner is also allowed to pass the copyright on to someone else again. The principle that a company hires an author to do certain work, and the copyright is owned by the company, is called a "work made for hire." The concept of work for hire is vital to the publishing, music, broadcast, and film industry. Although creators are compensated for their creative work, it becomes the property of the employer. Due to the fact that under the Continental European System every work is inseparably linked to the author, it is never possible for an author to transfer his moral rights to another person or company. This is, for example, clearly stated in the German *"Urheberrechtsgesetz"* (Engl.: Author's Right Law) in §29 (1) which states that the Author's Right is not transferable and can only go over to heirs in case of death. However, the owner may concede to another party the exploitation rights (Ger.: *Nutzungsrecht*), either completely, exclusively, or limited in different ways such as time, territory, and with regard to content or ways of exploitation. Same applies in case of an employment or order (work for hire): The employee or contractor of a company will always keep the Author's Right but agrees to concede the exploitation rights of his work by receiving a salary or payment for it. For producers this concession is a very important paragraph in the contract with all crew, ensuring exploitation for a movie.

The German Author's Rights Law dedicates an entire section to copyrights and exploitation rights in the special case of a movie production (§88–95), wherein a producer is a person who bundles all of the rights like a bunch of loose strings in his hand. The Author's Right Law grants the producer automatically all the exploitation rights of the participating crew and artists and the right to edit and make changes in the work itself, allowing proper distribution of the film, necessary for commercial exploitation. This right only applies for currently known forms of exploitation, so producers add a clause regarding future, unknown forms of exploitation, to ensure that the cast or crew cannot block future exploitation in new technology. Because the Author's Right cannot be disconnected from the author creates some obstacles for the producer; affecting

payment issues and the ongoing link between a film work and the original artist.

Compensation Rights. As mentioned previously, under Continental European Copyright, an author has stronger protection than under the Anglo-American System. German law for example dictates that the Author's Rights owner has the right to an "adequate payment" for selling the exploitation rights. There is no further definition of the word "adequate," which leads to another major difference. If a distributor or company pays less than industry standards, the author can demand additional compensation. The same applies for an author-employee of a company.[34] The US has no similar rule and further compensation has to be negotiated individually.

Therefore, when a European producer does business in the US, it is important to consider that there is "no way back" once a deal is closed. For a US producer, for example, if Continental European copyright law applies in a purchase agreement, the author will have the right for an "adequate" amount of money for his work, and also for further compensation, even if not stated in the contract. Of course, this only applies if the author enforces his right.

Usually, a US producer would state that American Law applies in a purchase agreement, but there might be cases, like an international coproduction, or negotiation with a powerful author, where European Copyright Law applies to the contract. European Author's Right Law grants foreign authors the same rights within its (territorial) scope of application if the foreign author's work was published in Europe not later than 30 days after the first publication. This rule can be limited if the author is from a country which is not a member of the Berne Convention.[35] A practical example in this case would be if an US author sells a script to a German producer, she can expect an "adequate" amount of money, regardless of what is stated in the contract, and would retain moral rights as well.

Duration and Public Domain. In most cases and countries today, the general rule is that copyright in literary, dramatic, musical, or artistic works lasts for the life of the author and then until 31 December of the year 70 years after his or her death. In the US, in case of a work for hire, the copyright lasts for a term of 95 years from the year of its first publication, or a term of 120 years from the year of its creation, whichever expires first. For a joint work prepared by two or more authors who did not work for hire, the term lasts for 70 years after the last surviving author's death (for work finished after 1978). With the exception of the work for hire, the same applies in European Law. During the 70-year period the Author's Right of the author who died is automatically transferred to the heirs. This is also the case for the exploitation right if it is not owned by someone else at this time. In a movie or movie-like project the Author's Right expires 70 years after the last surviving person out of the following group: main director, author of the script, author of the dialogues, composer of the music for the film. After the 70-year period the work becomes public domain in both the US and in Europe.

It is interesting that the producer of a movie does not receive any credit as an author in the European law, while in the US a producer's rights can extend to the 70-year rule as well, if she buys the copyright. But for a producer in Europe, he or she must have a credit as one of the authors mentioned above to be part of the joint work, and be subject to the "life plus 70" rule. Regarding the exploitation rights a German producer for example gets some protection from the Author's Right Law: for 50 years after the publication of the movie the producer has the exclusive right to exploit the film. Furthermore he can pass it on to another party.[36] But once the 50-year period is over and the producer wants to renew his exploitation right he needs the agreement of all Author's Right owners (group of persons listed above) to be able to do so. In the US, the exploitation right on the specific work can last until perpetuity even if the idea has already become public domain.

Derivative Work. There are major differences between the two copyright systems for derivative works, a work based on or derived from one or more already existing works. The copyright in a derivative work covers only the additions, changes, or other new material appearing for the first time in the work. As a result, it is not possible to extend the length of protection for a copyrighted work by creating a derivative work. This means that once the underlying work is in the public domain, anyone can use it to create another derivative work, including a remake. Only the new elements of the derivative work get copyrighted. These general rules apply in both European and American Law.

Differences occur when the underlying work is not yet in the public domain and, again, due to the aberration of the understanding of the Anglo-American and Continental European System. In the case of a motion picture derivative work such as a prequel, sequel, spin-off, or other form of media (for example a TV series made out of a movie), where important story elements and characters are adopted, the European copyright owner has to agree.[37] In the US this agreement will usually be part of the copyright buy-out deal, while in Europe it must be explicitly stated as a future form of exploitation within the contract of the exploitation rights. Usually this will include an additional payment to the author. Also in the US a derivative work will often be linked to an additional payment for the author. But it does not have to be so, and might depend on his power, position, and negotiation talent.

In the US the right to do a remake is handled like other derivative rights. A German producer can also obtain the remake rights as a future exploitation right lasting up to 50 years. But, if the author did not grant the producer the Remake Right within exploitation rights the author can transfer it, at the earliest after ten years, to another party. In this case the German Author's Law for once protects the producer a little more. Other European Laws might differ in this case.

Due to the differences between Anglo-American Copyright Law and the Continental European Author's Rights System, there are differences in application and practice in the US and Europe. And within Europe, the law may vary in different countries in large part or specific details. The reasons for differences in

the law may be due to culture and history, national interests, or politics. The good news is that today, thanks to international conventions and agreements, copyright laws of different countries can be understood and compared, and in some cases they are similar, like the American Fair Use Doctrine and the German Quotation Right. Before doing business in another country, it is helpful to consult a lawyer or expert who is familiar with local copyright laws, in order to avoid misunderstandings or missteps.

Notes

1. Jacobs, Matthes. (2015, July 9) " 'Tangerine' May Have Had a Tiny Budget, but the Film's Heart Is Bigger Because of it," *Huffington Post*. Retrieved July 9, 2017 from www.huffingtonpost.com/entry/tangerine-movie-transgender_us_559bc990e4b05d 7587e22881.
2. Vishnevetsky, Ignatiy. (2015, November 11) "Tangerine Is the Frenetic Transgender iPhone Christmas Movie of the Year," *AV Club*. Retrieved September 2, 2017 from https://film.avclub.com/tangerine-is-the-frenetic-transgender-iphone-christmas-1798 184284.
3. Broderick, Peter. (2015, July 10) "How to Be Unstoppable: Sean Baker and the Digital Filmmaking Revolution," *Indiewire*. Retrieved July 3, 2017 from www.indiewire.com/2015/07/how-to-be-unstoppable-sean-baker-and-the-digital-film making-revolution-247890/.
4. Box Office Mojo. (n.d.) "Wonder Woman." Retrieved September 1, 2017 from www. boxofficemojo.com/movies/?id=wonderwoman.htm.
5. Cauterucci, Christina. (2017, June 2) "I Wish Wonder Woman Were as Feminist as it Thinks it is," *Slate*. Retrieved September 4, 2017 from www.slate.com/blogs/xx_factor factor/2017/06/02/i_wish_wonder_woman_were_as_feminist_as_it_thinks_it_is.html.
6. Gerding, Stephen. (2017, June 9) "Wonder Woman: Patty Jenkins Would Not Have Cast Gal Gadot." Retrieved July 15, 2017 from www.cbr.com/wonder-woman-director-not-cast-gal-gadot/.
7. Huddleston Jr., Tom. (2017, September 11) "Warner's 'It' Is the Latest Horror Film to Boost Hollywood's Box Office," *Fortune*. Retrieved September 21, 2017 from http://fortune.com/2017/09/11/it-box-office-record-hollywood-horror/.
8. Box Office Mojo. (n.d.) "Horror Genres." Retrieved October 1, 2017 from www.box officemojo.com/genres/chart/?id=rratedhorror.htm.
9. Gardner, Chris. (2016, September 29) "Stephen King's 'It' Movie Producer Denies Creepy Clown Sightings Are Marketing Stunt," *Hollywood Reporter*. Retrieved July 12, 2017 from www.hollywoodreporter.com/rambling-reporter/stephen-kings-movie-producer-denies-933077.
10. Tucker, Reed. (2017, October 19) "Can Horror Movies Save Hollywood?" Retrieved October 27, 2017 from http://nypost.com/2017/10/19/can-horror-movies-save-hollywood/.
11. Tiffany, Kaitlyn. (2017, June 26) "Okja Is the First Great Netflix Movie—Here's Why That Matters," *The Verge*. Retrieved October 2, 2017 from www.theverge.com/2017/6/26/15747466/netflix-okja-bong-joon-ho-snowpiercer-cannes-hollywood.
12. Wilkinson, Alissa. (2017, May 25) "Why the Cannes Film Festival Matters," *Vox*. Retrieved September 23, 2017 from www.vox.com/culture/2017/5/16/155082 84/cannes-film-festival-how-to-pronounce-high-heels-netflix-jury. http://variety.com/2017/biz/features/amazon-studios-distribution-1202573790/.
13. Shaban, Hamza. (2017, July 18) "Netflix's Next Move Is to Disrupt Hollywood's

Biggest Money Maker," *Washington Post*. Retrieved September 23, 2017 from www. washingtonpost.com/news/the-switch/wp/2017/07/18/after-shaking-up-tv-netflix-is-gunning-for-movie-theaters/?utm_term=.24ffceca316c.

14. Europaeischer Film. (2017, October 5) Retrieved September 23, 2017 from www. arthaus.de/europaeischer_film, 10/05/2017.

15. Katsarova, Ivana. (2014, December) "An Overview of Europe's Film Industry," European Parliamentary Research Service. Retrieved October 19, 2017 from www. europarl.europa.eu/RegData/etudes/BRIE/2014/545705/EPRS_BRI%282014%29545 705_REV1_EN.pdf, 10/07/2017.

16. *European Parliamentary Research Service Blog*. (n.d.) Retrieved October 7, 2017 from https://epthinktank.eu/2014/12/17/an-overview-of-europes-film-industry/.

17. *European Parliament: An Overview of Europe's Film Industry*. (n.d.) Retrieved October 7, 2017 from www.europarl.europa.eu/RegData/etudes/BRIE/2014/545705/ EPRS_BRI%282014%29545705_REV1_EN.pdf, p. 23.

18. Spitzenorganisation der Filmwirtschaft. (2016) "Filmstatistisches Jahrbuch 2016." *Nomos*, p. 74.

19. CNC—Regulation of Film–Television Relations. (n.d.) Retrieved October 7, 2017 from www.cnc.fr/web/en/regulation-of-film-television-relations.

20. BFI. (2017, January 26) "New BFI Statistics Show Robust Year for Film in the UK in 2016." Retrieved October 9, 2017 from www.bfi.org.uk/news-opinion/news-bfi/ announcements/highest-grossing-films-uk-box-office-2016.

21. Spitzenorganisation der Filmwirtschaft. (2016) "Filmstatistisches Jahrbuch 2016," *Nomos*, pp. 14, 17.

22. Spitzenorganisation der Filmwirtschaft. (2016) "Filmstatistisches Jahrbuch 2016," *Nomos*, p. 71.

23. *European Parliament: An Overview of Europe's Film Industry*. (n.d.) Retrieved October 7, 2017 from www.europarl.europa.eu/RegData/etudes/BRIE/2014/545705/ EPRS_BRI%282014%29545705_REV1_EN.pdf, p.21.

24. *European Parliament: An Overview of Europe's Film Industry*. (n.d.) Retrieved October 7, 2017 from www.europarl.europa.eu/RegData/etudes/BRIE/2014/545705/ EPRS_BRI%282014%29545705_REV1_EN.pdf, p. 22.

25. *Constantin Film*. (2012, September 18) "Constantin Film in Strategic Partnership with US Studio DreamWorks." Retrieved October 7, 2017 from www.presseportal. de/pm/12946/2327422.

26. To avoid misunderstandings the word "Copyright" (with a capital "C") is used for the American Copyright. "Author's Right" stands for the German "Urheberrecht" but can also be seen as an equivalent to most of the other Continental European countries' Author's Rights.

27. European Commission. (2016, June 6) "The EU Internal Market: Copyright and Related Rights." Retrieved April 7, 2016 from http://ec.europa.eu/internal_market/ copyright/index_de.htm.

28. International Copyright Basics. *RightsDirect*. (n.d.) Retrieved April 7, 2016 from www.rightsdirect.com/international-copyright-basics/#rights.

29. Deterding, S., P. Otto, and V. Djordjevic. (2013, July 17) "Copyright and Copyright." Retrieved April 7, 2016 from www.bpb.de/gesellschaft/medien/urheberrecht/63355/ urheberrecht-und-copyright.

30. International Copyright Basics. *RightsDirect*. (n.d.) Retrieved April 7, 2016 from www.rightsdirect.com/international-copyright-basics/#rights.

31. Nordemann, W. et al. (1990) *International Copyright and Neighboring Rights Law: Commentary with Special Emphasis on the European Community*. University of Michigan: Wiley, pp. 23, 24.

32. World Intellectual Property Organization. Retrieved April 7, 2016 from www.wipo. int/treaties/en/ip/berne/summary_berne.html.
33. Ibid.
34. Weiglet, Ulf. (2011, July 6) "Wem gehört das Urheberrecht?" *Zeit Online*. Retrieved April 7, 2016 from www.zeit.de/karriere/beruf/2011-06/arbeitsrecht-urheberrecht.
35. Gesetz über Urheberrecht und verwandte Schutzrechte (Urheberrechtsgesetz). Republic of Germany. §121. (n.d.) Retrieved April 7, 2016.
36. Gesetz über Urheberrecht und verwandte Schutzrechte (Urheberrechtsgesetz). Republic of Germany. §8. (n.d.) Retrieved April 7, 2016.
37. Bahr, Kanzlei. (n.d.) *Legal FAQ: Film Law*. Retrieved April 7, 2016 from www.dr-bahr/.

Appendix A

Option and Literary Purchase Agreement[1]

This sets forth the terms of agreement (the **"Agreement"**) dated as of _____, between _____ (**"Owner"**) and _____ (**"Buyer"**),[2] in connection with the published literary work entitled _____ (the **"Property,"** which includes any and all editions, translations, and other versions together with all now existing and hereafter created titles, themes, ideas, stories, contents, dialogue, characters, artwork, visual images, issues, adaptations of said literary work to the extent owned or controlled by Owner) written by Owner.[3] For convenience, the first theatrical motion picture or other production produced based upon the Property is referred to herein as the **"Picture."**

For good and valuable consideration, receipt and sufficiency of which is acknowledged, Owner and Buyer (each sometimes referred to herein as a **"Party"**), have agreed as follows:

1. **OPTION:** Owner hereby grants irrevocably and exclusively to Buyer the right (the **"Option"**) to purchase the "Rights" (defined in Paragraph 5, below). The Option may be exercised by Buyer in Buyer's discretion any time during the **"Option Period,"** which includes the Initial Option Period and the Second Option Period, the duration of which is set forth below:

 a. **Initial Option Period:** The Option Period commences as of the date of this Agreement and runs for the period (the **"Initial Option Period"**) ending _____[4] months thereafter. Purchaser's obligations under this Agreement are subject to the satisfaction of the **"Conditions Precedent,"** which are: (i) Execution and delivery of this Agreement by Owner to Buyer; (ii) Buyer's receipt of the Short-Form Option attached hereto, signed by Owner and notarized, which Short-Form Option may be filed at the US Copyright Office at any time; (iii) Buyer's receipt of the Short-Form Assignment attached hereto, signed by Owner and notarized, which Short-Form Assignment may be filed at the US Copyright at any time after the exercise of the Option and payment of the Purchase Price (and Buyer is hereby authorized to insert therein the date of such exercise of the Option); and (iv) Buyer's receipt of the "Publisher's

Release" substantially in the form attached hereto and agreed to by the Publisher and Buyer (or such other form of publisher's release approved by Buyer), signed by the publisher of the Property.

b. **Extensions:** At any time during the Initial Option Period, Buyer may extend the Option Period for the period (the **"Second Option Period"**) commencing with the expiration of the Initial Option Period and ending ___ months thereafter by paying the Second Option Fee as defined herein prior to expiration of the Initial Option Period. Such extensions shall take effect upon notice thereof to Owner and payment of the applicable "Option Extension Fee" described in Paragraph 2(b), below. Furthermore, the Option Period shall be extendable by Buyer for delays caused by force majeure events (including any guild or union strike) which materially affects development or production of the Picture or in response to claims or litigation in connection with Owner's ownership of any of the Rights or otherwise related to Owner's breach of Owner's representations and warranties, provided extensions resulting from force majeure events shall not exceed 9 months in the aggregate (no more than one extension per force majeure event), and extensions arising in connection with claims or litigation shall not exceed 12 months for each claim unless litigation is commenced. No considera-tion (including any extension fee described below) shall be required to extend the Option Period for force majeure events, claims, and litiga-tion. During the Option Period, Buyer shall have the exclusive right (but not the obligation) to develop the Property. Buyer shall have none of the Rights if the Option is not exercised. In the event the Option Period expires on a Saturday, Sunday, or national holiday, it shall be extended through the end of the next business day.

2. **OPTION PAYMENTS:**

a. **Initial Option Period:** As consideration for the Option, Owner shall be entitled to the sum (the **"Initial Option Fee"**) of _____ US Dollars ($_____),[5] payable within seven business days of execution of this Agreement by Owner.

b. **Second Option Period:** If Buyer elects to extend the Option Period for the Second Option Period, as consideration for such extension Buyer shall pay Owner a sum (the **"Second Option Fee"**) equal to _____ US Dollars ($ _____), payable not later than the expi-ration of the Initial Option Period. The Second Option Fee shall not be applicable against the "Purchase Price" (as defined below).

c. **Set-Up Bonus, Revised Extension Fees:**

i. Set-Up Bonus (Major): If, prior to the exercise of the Option, this Agreement is assigned to a **"Major US Studio"** (e.g., Paramount Pictures, Warner Brothers Pictures, Columbia/Sony Pictures,

Buena Vista/Walt Disney Pictures, Universal Pictures, or 20th Century Fox, New Line, Participant, Amazon, Netflix, Miramax),[6] then Owner shall thereupon be entitled to the sum (the "Set-Up Bonus") of _____ US Dollars ($____). The Set-Up Bonus shall not be applicable against the "Purchase Price" (as defined below).

ii. Set-Up Bonus (Mini Major): If, prior to the exercise of the Option, this Agreement is assigned to a **"Mini-Major Studio"** (e.g., MGM, Lions Gate Entertainment, Fox Searchlight Pictures, Focus Features, Summit Entertainment LLC, Legendary Entertainment, DreamWorks/Amblin, LGE, Legendary, Studio 8, Skydance, New Regency, RatPac, Alcon, low-budget specialty divisions of a major, eOne, CBS Films, or Village Roadshow Limited) then Owner shall thereupon be entitled to a Set-Up Bonus of _____ Thousand US Dollars ($____). The Set-Up Bonus shall not be applicable against the "Purchase Price" (as defined below).

iii. Set-Up Bonus (Major Independent): If, prior to production of the Picture, this Agreement is assigned to a **"Major Independent"** (e.g., IM Global, Broad Green, Bron, A24, First Look, Annapurna, Walden, MRC, Europa, Studio Canal, Constantin, Gaumont, LeVision, CJ Entertainment,) **then** Writers shall thereupon be entitled to a Set-Up Bonus of _____ US Dollars ($____).

3. **EXERCISE:** The purchase price for the rights shall be an amount equal to _____ percent (___%)[7] of the final in-going production budget (less contingencies, financing costs, and bank/bond fees) less the Initial Option Fee (the **"Purchase Price"**); provided, however, that the Purchase Price shall not be less than _____ Thousand US Dollars ($____)[8] nor greater than _____ Thousand US Dollars ($____).[9] Buyer may exercise the Option by sending written notice to that effect and sending the Purchase Price to Owner, whereupon Buyer shall be the sole and exclusive owner of the Rights, provided that the Option shall be deemed exercised if and when Buyer commences principal photography of the Picture, with the understanding that in such instance, the Purchase Price shall be paid within _____ (__) business days after commencement of principal photography. The Initial Option Fee is an advance against and shall be deducted from the Purchase Price.

4. **CREDIT:** Subject to any applicable guild restrictions, if the Picture is produced, Owner will be entitled to credit as follows: (a) "Based on the Novel by _____, published by _____" if the name of the Picture is the same as the Property, otherwise "Based on the Novel _____ by _____, published by _____." All credits shall appear (i) in the main titles, whether such main titles appear before or after the Picture, on a separate card, (ii) in all paid advertising

(subject to customary exclusions), and (iii) in an average size of type not less than one hundred percent (100%) of the average size of type used to accord the screenwriting credit. Such right to a credit shall inure to all subsequent productions including but not limited to all sequels, prequels, remakes, and other productions permitted hereunder. All other aspects of credit shall be in Buyer's discretion. No casual or inadvertent failure to comply with the provisions of this Paragraph shall constitute a breach of the Agreement. Buyer shall notify its third-party distributors and licensees of its obligations to accord credit pursuant to this credit clause and cause them to be contractually bound thereby; provided that no third-party failure nor any casual or inadvertent failure by Buyer to comply with the provisions of this credit clause shall constitute a breach of the Agreement by Buyer. Within a reasonable period following receipt of written notice from Owner specifying the details of any failure by Buyer to comply with this credit clause, Buyer shall take such steps as are reasonably practicable to cure such failure prospectively with respect to positive prints not yet made or paid advertising not yet placed, as applicable, which are issued by or under the control of Buyer.

5. **KEY ART:** Owner will be entitled to receive selected pieces of artwork free of charge which shall form the basis of the Picture's marketing campaign ("Key Art") from Buyer at least _____ (__)[10] days prior to release of the Project, subject to appropriate third-party confidentiality agreements being executed, specifically for use in reprint publication of the Property including and with regards to an edition of the Property published to coincide with the release of the Project. Owner shall have the right to use the title of the Picture if different from the title of the Property on any reprint publication of the Property.

6. **RIGHTS GRANTED:**

 a. **Rights:** If the Option is exercised and the Purchase Price is paid (subject to the Reversion below), Buyer will own, exclusively and forever, the **"Rights,"** meaning all rights, in all languages, throughout the universe, in and to all of the Property other than the "Reserved Rights" retained by Owner as set forth in Paragraph 8, below. Without limitation upon the foregoing, the Rights include the following: all motion picture rights, all television motion picture and series rights (live or recorded); new media rights (including, without limitation, the Internet) all allied and subsidiary rights, including, without limitation, sequel and remake rights, music publishing rights, soundtrack album rights, merchandising rights, promotional and advertising rights (including commercial tie-in rights); and all other rights, whether now known or hereafter discovered, created, or invented, including the sole and exclusive right to tell the stories and utilize the characters contained in the Property in any medium, now known or hereafter devised (except as

expressly reserved by Owner in Section 6, below. The rights herein granted include the right to distribute, transmit, exhibit, broadcast, and otherwise exploit all motion pictures or other productions or properties produced or manufactured hereunder by means of any and all media, means, and devices whether now known or hereafter devised, including, without limitation, theatrical, non-theatrical, internet, computer-assisted, wireless, satellite, cassette, disc, CD-ROM, television (whether free, pay, cable, digital, pay-per-view or otherwise), fiber optic, and/or on-line, and in any and all markets whatsoever, and the exclusive right to use the title or titles by which the Property may be now or hereafter known in connection with any or all of the foregoing. Buyer may in its discretion make any and all changes in, additions to, and deletions from the Property as used in the Picture or any other productions produced hereunder. Any motion picture or other production produced or developed hereunder and all the components thereof shall be registered for copyright in the name of Buyer or its designee as the owner and author thereof. Upon payment of the Purchase Price, Owner shall be deemed to have irrevocably assigned, on Owner's own behalf and on behalf of Owner's heirs, executors, administrators, and assigns, to Buyer in perpetuity all rental and lending rights under national laws (whether implemented pursuant to the EC Rental and Lending Rights Directive or otherwise) to which Owner may now be or hereafter become entitled with respect to the Picture and/or any derivative works derived therefrom. Owner waives in perpetuity all rights Owner may have in law, equity or otherwise under any law relating to the "moral rights of authors." Buyer may use Author's name, approved likeness, and approved biographical material in and in connection with the rights granted hereunder but not as an endorsement of any product, service, or entity. If Author timely provides a professional biography and publicity photos of herself in a form reproducible to customary technical standards, such likeness(es) and biography shall be the materials used by Buyer.

b. **Reversion:** If the Option is exercised but principal photography of the Picture or other production based on the Property does not commence within _____ (__) years thereafter, the Rights shall automatically revert to Owner.

7. **RESERVED RIGHTS:** Owner hereby reserves the following rights in the Property, including all copyrights therein (collectively, the **"Reserved Rights"**).

a. **Publication Rights:** Owner reserves the **"Publication Rights"** to the Property, meaning the right to publish and distribute print editions by any means, modes, methods, now known or hereafter created or conceived, in all languages, including, hard-cover or soft-cover or as an

e-book or other media now known or hereafter devised for the delivery of books (including digital internet), and in magazines or other periodicals, and in any other printed form now known or hereafter devised, in any language, anywhere. Such reserved Publication Rights shall include comic books and graphic novels as well as Owner's right to include photographs and audio-visual interviews (whether written or audio) along with the Property. Notwithstanding Owner's reservation of Publication Rights, Buyer shall have the right to publish in news-papers, magazines, and other periodicals, and in advertising and publicity material, synopses of, and excerpts from, the Property of not more than 7,500 words for advertising and publicity purposes during the Option Period and thereafter if the Option is exercised which may not be serialized and may not be copyrighted in Buyer's name and which are not for sale.

b. **Live Recital Rights:** Owner reserves the **"Live Recital Rights"** to the Property, meaning the right of the Owner or Owner's lawful designee to perform non-dramatic readings of the text of published print editions of the Property (whether abridged or unabridged).

c. **Audio Book Rights:** Owner reserves the **"Audio Book Rights"** to the Property, meaning the right to create and distribute recorded non-dramatic readings of the text of published print editions of the Property (whether abridged or unabridged) in the form of audio-only formats by any audio-only media devices now known or hereafter devised.

d. **Author-Written Sequels of the Property:** Owner reserves the right to create and exploit "Author-Written Sequels." An **"Author-Written Sequel"** is a literary property (story, novel, play, or otherwise) created after the Property, written by Author or by a successor-in-interest of Author or Owner or at the request of Owner or Author, using one or more of the principal and/or material characters appearing in the Prop-erty, participating in different events that extend or continue the events found in the Property (whether prior to, concurrent with, or subsequent to the events contained in the Property.

e. **Radio Rights:** Owner reserves the right to broadcast by radio non-dramatic readings of the text of published print editions of the Property (whether abridged or unabridged). Notwithstanding Owner's reserva-tion of Radio Rights, Buyer shall have the right to broadcast by radio synopses of, and excerpts from, the Property of not more than five (5) minutes for advertising and publicity purposes during the Option Period and thereafter if the Option is exercised.

f. **Stage Rights:** Owner reserves the right to perform the Property or adaptations of it on the spoken stage with actors appearing in person in the immediate presence of the audience, provided no broadcast, tele-cast, recording, photography, or other reproduction of such perform-ance is made. Owner agrees not to exercise, or permit any other person

to exercise, said stage rights earlier than four (4) years[11] after the first general release or telecast, if earlier, of the first Picture produced hereunder, or six (6) years after the date of exercise of the Buyer's option to acquire the Property, whichever is earlier.

g. **Live Television**: The right to broadcast the Property or adaptations thereof by television direct from living actors only on a so-called "one-shot" basis and not as part of a series of television programs, that is, with living actors performing simultaneously with such telecast (as distinguished from the right to televise motion pictures or to televise by the use of tape or other devices). Owner agrees not to exercise, or permit any other person to exercise, said Live Television rights earlier than four (4) years after the first general release or telecast, if earlier, of the first Picture produced hereunder, or six (6) years after the date of exercise of the Buyer's option to acquire the Property, whichever is earlier.

h. **Sale of New Material in Author-Written Sequels:** Owner agrees not to exercise, or to authorize the exercise of, or to sell, license, or otherwise dispose of any of the "Author-Written Sequel Restricted Rights" during the "Restricted Period." The **"Author-Written Sequel Restricted Rights"** are any and all rights of Author in any Author-Written Sequel other than Publication Rights and Audio Book Rights. (By way of example only, if Owner creates a new character that first appears in an Author-Written Sequel, then the motion picture, television, and allied rights to such new character are part of the Author-Written Sequel Restricted Rights and shall not be disposed of during the Restricted Period.) The **"Restricted Period"** means the period commencing as of the date of this Agreement and ending the earlier of (i) three years after the first general release of the Picture to the public in the United States (whether such release is in theaters, the home video market, or via television broadcast, it being understood that test, press, sneak preview, festival, premiere, and similar screenings do not constitute a release to the public), or (ii) five years after the date of the exercise of the Option. After the Restricted Period, Buyer shall have a right of first negotiation with respect to the disposition of any of the Author-Written Sequel Restricted Rights, as follows:

i. **Right of First Negotiation:** If Owner desires to dispose of or exercise any Author-Written Restricted Right or any interest therein (the **"Offered Right"**), whether directly or indirectly, then Owner shall give written notice to Buyer of such desire. Commencing upon Buyer's receipt of such written notice there shall be a 30-day period in which Owner and Buyer may negotiate in good faith for such Offered Right. If by the end of such negotiation period Owner and Buyer do not enter into an agreement based on such negotiations, then Buyer shall have the further right of "last refusal" to acquire such rights, as follows:

If Owner is prepared to accept an offer for such Offered Right, Owner shall submit the material terms of such offer, which submission shall be an offer to Buyer to acquire the Offered Right on such terms (it being further agreed that such offer shall not contain terms that are unique to the offeror and cannot reasonably be matched, furnished, or agreed to generally by other companies in the entertainment industry), whereupon Buyer shall have ten (10) business days to accept or reject such Offer.

j. **Novelizations:** Nothing contained in this Agreement shall be construed as a grant to Buyer of the right to publish a novelization of the Picture (or other production derived from the Property), it being agreed that no such novelization adaptation may be published without the prior written consent of Owner; to be negotiated in good faith.

k. **Certain Rights and Restrictions Re Reserved Rights:** All subsections of Section 8 are subject to this paragraph. The Reserved Rights do not include, and Owner shall not have the right to incorporate, exploit, or utilize in any way (including in any Author-Written Sequel) any new or changed materials, including characters, characterizations, and other elements created, produced, or exploited by Buyer, whether in a production or otherwise created by or for Buyer. Without limiting the foregoing, Owner does not have the right to publish any novelization of the Picture or other production derived from the Property. Any and all publications pursuant to Paragraph 7(a) through 7(c) (including audio recordings) may be registered for copyright in the name of Owner. Owner shall have the right to exploit the Publication Rights and Audio Book Rights in the Property and any Author-Written Sequel(s) at any time. As all rights (other than the Reserved Rights) to the material contained in the Property are, upon exercise of the Option, the exclusive property of Buyer, nothing contained in this Agreement shall be construed as giving to Owner the right to sell, license, or otherwise authorize others to use or exploit any other materials by any means other than the exploitation of the Reserved Rights. Nothing contained herein shall be construed as granting to Buyer the right to any new material found in any Author-Written Sequel. For the avoidance of doubt, if Buyer does not purchase an Author-Written Sequel, Owner may sell such Author-Written Sequel to third parties including any characters contained in the Book and Author-Written Sequel providing such characters were not created by Buyer.

8. **REPRESENTATIONS AND WARRANTIES:** Owner hereby represents and warrants that:

a. **Ownership:** Owner is the sole author of the Property; Owner is the sole and exclusive owner and proprietor throughout the universe (where copyright protection is available) of the Property and any and all rights in and to the Property granted to Buyer herein; and Owner has the full

right, power, and authority to enter into this Agreement and grant Buyer all the rights herein provided for;

b. **No Prior Use:** No motion picture, television, radio, dramatic, or other version or adaptation of the Property has heretofore been authorized or made, produced, performed, copyrighted, or registered for copyright in any country of the world, except as noted herein, and the Property is not in the public domain in any country in the world which provides for a copyright or similar protection; and Owner has not assigned or licensed to any third party or in any manner encumbered or hypothecated any of the rights herein granted to Buyer with respect to the Property, nor has Owner agreed to do so.

c. **Original:** The Property is wholly original (other than incidental material taken from the public domain) or material that is attributed to Owner and no incident therein or part thereof is taken from, based upon, or adapted from any other literary material, dramatic work, or motion picture and the full use of the Property, or any part thereof, as herein granted, will not in any way violate or infringe upon any copyright belonging to any third party and to the best of Owner's knowledge will not constitute a libel or defamation of, or an invasion of the rights of privacy of or otherwise violate or infringe upon any other right or rights whatsoever of any third party.

d. **No Claims:** There is no outstanding claim or litigation brought or to the best of Owner's knowledge, pending with regard to the Property, including against the title or ownership of the Property or any part thereof or in the rights therein, or that the Property constitutes a libel or defamation of, or an invasion of the rights of privacy of or otherwise violate or infringe upon any other right or rights whatsoever of any third party.

e. **Publication:** Owner is party to an agreement with the _____,[12] for the print publication of the Property. None of the terms contained in such agreement are inconsistent with any of the rights herein granted to Buyer with respect to the Property; the Property is registered for copyright in the United States as is customary (under registration number _____; and may be protected elsewhere so far as the laws of other countries provide for such protection for works first published in the United States.

9. **INDEMNIFICATION:** Owner agrees to indemnify, and hold harmless Buyer and its licensees, assignees, employees, members, managers, shareholders, directors, agents, attorneys, and their licenses respective successors and assigns (collectively, "assigns") from and against any and all claims, damages, liability, losses, judgments, costs, and expenses (including reasonable outside attorneys' fees and court costs) (collectively "Claims") sustained or incurred by Buyer or its assigns arising out of, resulting from,

based upon or incurred because of any third party claims arising from a breach of any warranty, undertaking, representation, or agreement made or entered into hereunder by Owner excluding any claims arising from the Prior Agreement. Buyer agrees to indemnify and hold harmless Owner and Owner's agents from and against any and all Claims sustained or incurred by Owner or his or her assigns successors, or heirs arising out of, resulting from, based upon or incurred because of material added to the Property by or on behalf of Buyer that did not originate with Owner and also with respect to the development, production, and distribution of the Picture and/or the exploitation of any of the Rights granted herein, except to the extent any Claims arise from a breach of Owner's representations, warranties, and/or agreements hereunder. Each party shall notify the other of any claim to which the foregoing indemnities relate. Owner shall have the right to participate in the defense of any such claim with its own counsel at its own expense, provided, Owner and Owner's counsel must cooperate with Buyer's counsel and Buyer shall have the sole right to settle any such claim, subject to the following: prior to settlement, Buyer shall consult with Owner with respect to any proposed settlement of any such claim and no settlement shall involve an admission of liability.

10. **CONTINGENT PAYMENTS:** If the Picture is produced as a theatrical motion picture and provided Owner is not in material default:

a. **Net Proceeds:** Owner shall be entitled to the sum equal to _____ percent (____%)[13] of One Hundred Percent of the "Net Proceeds" of the Picture (including all allied rights and exploitation of ancillary markets) of each and every motion picture and/or television motion picture or television program based, in whole or in part, on the Property, and of each and every derivative work produced, performed, licensed, and otherwise exploited, (including by way of illustration, but not limited to merchandising, DVDs, CDs, CD-ROMs) in all media and markets, both domestic and foreign. When defining and accounting for "Net Proceeds," Buyer shall use the same definition and accounting procedures as those which are set forth in the "Net Proceeds Exhibit" of the domestic distributor of the Picture (or "Defined Proceeds Exhibit" or other similar term of art used by such domestic distributor, it being understood that the exhibit being referred to herein is the exhibit used by such domestic distributor when according a typical "__%" contingent participation to authors of Owner's stature) together with the customary "A"-level rider to such exhibit (if any) routinely given by such distributor to authors of Owner's stature. (For convenience, in this Agreement, such exhibit and rider are referred to as the "Net Proceeds Exhibit" notwithstanding the actual nomenclature used by the domestic distributor.) However, if the domestic distributor does not have a "Defined Proceeds Exhibit" or an analogue thereof, then the term

"Net Proceeds Exhibit" shall be deemed to be a customarily defined "__%" contingent participation as is typically accorded to authors in the United States motion picture industry, subject to such changes as Buyer may agree to after good-faith negotiation within customary industry parameters. Notwithstanding anything to the contrary in the Net Proceeds Exhibit (actual or deemed), where Buyer has licensed distribution rights in foreign territories to distributors for minimum guarantees, gross receipts in connection with such territories shall consist of the non-refundable sums remitted by such distributors to Buyer, including such minimum guarantees and any overages, less: A 15 percent foreign sales agency fee charged thereon; foreign sales marketing and delivery costs; and residuals, royalties, import duties, levies, taxes, and other customary "off-the-tops" as provided in the sales agency agreement between Buyer and its foreign sales agent. The audit and accounting rights set forth in the Net Proceeds Exhibit shall be accorded to Owner by Buyer, it being agreed that Owner's audit and accounting rights are limited to the right to receive accountings from and to audit the books of Buyer, it being understood that neither the domestic distributor nor the foreign sales agent shall have any obligation to report to Owner or pay any contingent compensation to Owner or accord audit or other accounting rights to Owner.

b. **Theatrical Sequels/Remakes:** In the event that an English-language theatrical sequel or prequel to the Picture is produced utilizing or based upon characters contained in the Property, or if an English language theatrical remake of the Picture is produced, then upon commencement of principal photography of such sequel or remake, Owner shall, in connection with each such production, be entitled to the following (it being further agreed that if a theatrical sequel or theatrical remake is produced in a language other than English, Owner shall be entitled to 50 percent of the applicable sums set forth below):

i. For Sequels and Prequels: The sum equal to the Purchase Price, paid in connection with the Picture; and five percent (5%)[14] of the Net Proceeds of such sequel or prequel.

ii. For Remakes: The sum equal to the Purchase Price, paid in connection with the Picture; and the sum equal to five percent (5%) of the Net Proceeds of such remake.

iii. Episodic Royalties: If a television program is produced utilizing or based upon characters contained in the Property.

iv. Television Pilot and Series: For each pilot or episode of a TV series, the following royalties upon commencement of principal photography thereof: If initially intended for prime time free television exhibition by ABC, NBC, CBS, Fox, or CW (a "US Broadcast Network") at the rate of 1 episode per week: (A) Up to 30

minutes: $3,000; (B) More than 30 minutes, up to 60 minutes: $4,000; (C) More than 60 minutes: $5,000. If initially intended either for free television exhibition in prime time by a US Broadcast Network at the rate of 2 or more episodes per week or for other cable, pay cable television exhibition in prime time, Netflix, Hulu or Amazon at any other time, 75 percent of the above royalty. Furthermore:

v. <u>Spin-offs</u>: For each TV series which is a generic spin-off 50 percent, or a planted spin-off 25 percent, of the above royalty.

vi. <u>Reruns</u>: 20 percent of the applicable royalty shall be payable for each of the first 5 United States free television exhibitions in the United States or Canada after the first run.

vii. <u>Movies-For-Television or Direct-to-Video movie and Television Mini-Series not governed by 10(c)(i) above</u>: For each movie-for-television or television mini-series primarily intended for initial US television exhibition, the following royalty upon commencement of principal photography thereof, which shall constitute full payment for all runs thereof: (A) $20,000 for the first 2 hours, and (B) $10,000 for each additional hour or portion thereof, but not more than $100,000 in the aggregate, which may be recoupable from any theatrical release payment below. If a program described in this paragraph is initially released theatrically in the United States, Company will pay Owner a one-time sum equal to one hundred percent (100%) of the applicable royalty under paragraph 10(b); if the program described therein is initially released theatrically outside the United States, Company shall pay Owner an additional one-time sum equal to fifty percent (50%) of the applicable royalty under paragraph 10(b) and if the program described therein is released theatrically in the United States after the initial television broadcast, Company shall pay Owner an additional one time sum equal to fifty percent (50%) of the applicable royalty under paragraph 10(b). However, in no event shall Owner be entitled to more than a sum equal to one hundred percent (100%) of the applicable royalty for the theatrical release, if any, of the applicable production.

11. MISCELLANEOUS:

a. **Premieres and Festivals:**[15] If Owner is accorded credit in connection with the Picture, Owner and a guest shall be invited to attend the World "celebrity" premiere of the Picture and any festival to which the Picture is submitted, if any, and, in connection with such premiere, if Owner attends such "celebrity" premiere which is farther than 50 miles from Owner's principal place of residence, then Buyer agrees to cause the domestic distributor to provide Owner and Owner's guest business class travel, accommodations, and expenses.

b. **DVD/Blu-ray:** When such DVDs and/or Blu-rays are commercially available, Buyer shall provide Owner with one (1) DVD copy or Blu-ray copy of the Picture and any subsequent production(s) based on the Property.[16]

c. **Additional Insured:** Owner shall be made an additional insured on the errors and omissions and general liability insurance policies obtained for the Picture, with customary endorsements, in accordance with and subject to the terms and conditions thereof.

d. **Publicity:** Owner shall not participate in, authorize or cause to be released or disseminated any publicity with respect to the Picture, this Agreement or the rights granted to Buyer hereunder without Buyer's prior written consent; provided, however, that Owner shall have the right to mention the Picture incidentally and in a non-derogatory manner in connection with Owner's personal publicity or biography.

12. **CERTAIN LEGAL MATTERS:**

a. **Limitation of Remedies:** Owner acknowledges that in the event of a breach of any of Buyer's obligations under this Agreement, the damage (if any) caused to Owner thereby is not irreparable or otherwise sufficient to give rise to a right to seek or obtain or need for injunctive or other equitable relief; and Owner's rights and remedies in the event of a breach of this Agreement by Buyer shall be limited to the right, if any, to recover money damages in an action at law and Owner shall not be entitled to restrict or interfere with Buyer's right to produce, distribute, exploit, advertise, or promote the Picture or other productions produced pursuant to this Agreement or exercise any of the rights granted to Buyer hereunder.

b. **Assignment:** Buyer shall have the right to assign any or all of its rights and obligations under this Agreement to any third-party person or entity, with permission of Owner, not to be unreasonably withheld or delayed. Buyer shall be secondarily liable unless such assignment is to any parent, subsidiary, or affiliated entity of Buyer or any entity into which Buyer is merged or consolidated or by which Buyer is acquired, or a US major or mini-major film company or similarly financially responsible entity, provided that such assignee assumes Buyer's obligations hereunder in writing. Owner may not assign this agreement or any of Owner's rights or obligations hereunder to any person or entity, except right to receive payment.

c. **Laws and Jurisdiction:** This Agreement shall be governed by, construed, and enforced under the laws of _____ other than said state's conflict of laws, statutes, and principles. Owner and Buyer hereby agree that any action arising out of this Agreement shall be brought in the state or federal courts located in the County of _____,[17] irrevocably submit to the exclusive jurisdiction of any such court, and waive any objection that such party may now or hereafter have to the venue of

any such action or proceeding in any such court or that such action or proceeding was brought in an inconvenient court and agree not to plead or claim the same. The prevailing party shall be entitled to recover reasonable attorneys' fees, costs, and disbursements.

d. **Further Documents:** At Buyer's request, Owner will execute and deliver such further documents consistent herewith and perform such further acts consistent herewith as may be or become reasonably necessary or desirable to effectuate the purposes of this Agreement, including all or any of Buyer's rights under the Agreement. Owner hereby irrevocably appoints Buyer as attorney-in-fact with full power to execute, acknowledge, deliver, and record in the US Copyright Office or elsewhere any and all such documents Owner fails to execute, acknowledge, and deliver within 5 business days after Buyer's written request therefor and furnishing of copies, unless a shorter period of time is reasonably required by Buyer. The appointment shall be a power coupled with an interest. Buyer shall promptly furnish to Owner a copy of any document executed by Buyer under such power.

e. **Payments and Notices:** All payments to Owner hereunder shall be payable to and in the name of _____ [18] at the address provided below, and shall be paid within seven business days after such payment becomes due. Any notice by either party shall be given in writing unless specifically stated otherwise herein. The date _____ (___) business days after the date of mailing or the date of transmission or delivery of any such written notice shall be deemed the date of receipt of service thereof. A written notice to Owner shall be delivered by messenger, national courier (such FedEx or UPS), or first-class mail, or transmitted by facsimile (provided there is confirmation of receipt of such transmission). Email transmission shall be deemed written notice if the recipient has clear authority to accept such notice and has directly (and not by any automatic means) acknowledged receipt. Addresses for payment and notice are:

To Owner:	To Buyer:

f. **This Agreement:** This Agreement sets forth the complete understanding between Owner and Buyer with respect to the subject matter hereof. This Agreement supersedes any prior or contemporaneous agreements and may not be modified, waived, or amended except by a written instrument signed by the Parties except that if there is any conflict between any provision of this Agreement and any present or future statute, law, ordinance, regulation, or collective bargaining agreement the latter shall prevail; provided, that the provision hereof so affected

shall be limited only to the extent necessary and no other provision shall be affected. The term "including" means "including, without limitation" unless specifically indicated otherwise. Owner acknowledges that no representation or promise not expressly contained in this Agreement has been made by Buyer or any of its agents, employees, or representatives. No representation has been made that any production shall generate sufficient proceeds to pay contingent compensation. Nothing contained herein obligates Buyer to develop or produce the Picture or otherwise exploit Rights. This Agreement is not a partnership or joint venture of the Parties and neither Party is an agent of the other. This Agreement shall not be construed so as to create a lien or charge or encumbrance upon any rights, properties, or interests of Buyer, including the Picture. This Agreement is not for the benefit of any third party, whether or not referred to herein. Captions and organization are for convenience only and shall not be used to construe meaning. A waiver of any breach shall not be a waiver of a prior or subsequent breach. All remedies shall be cumulative and the pursuit of any one shall not be a waiver of any other. No failure by either party to perform a duty hereunder shall be deemed a breach of this Agreement unless and until such party fails to cure such failure within 30 calendar days after written notice by the other party of such failure to perform (which period of time shall be reducible to 10 calendar days in the event of Buyer's alleged failure to make payment as required pursuant to this Agreement). All representations and warranties made by Owner and the indemnities furnished by Owner are for the benefit of Buyer and Buyer's licensees, successors, and assigns.

g. **Counterparts, E-Copies:** This Agreement may be executed in counterparts, each copy of which when signed and delivered will be deemed an original and all of which, taken together, shall constitute one and the same document. A facsimile or PDF file of any signature below will be deemed an original signature for all purposes.

Our signatures below shall confirm our agreement to the foregoing.

AGREED AND ACCEPTED:

_____("**Buyer**")

 By: _____

By: _____ [Name]

 [Name] ("**Owner**") Its: Authorized Signatory

Short Form Option

The undersigned, for value received, hereby grants to [Name of Buyer] and its successors and assigns (herein called "Buyer"), the sole and exclusive option to purchase all rights (other than the Reserved rights as defined in the Option Purchase Agreement) in and to the published literary work entitled _____, written by _____ (which together with the title, themes, contents, and characters and other versions thereof, is hereinafter called the "Work"), published by _____ on or about _____ with copyright in the name of the undersigned and registered in the United States Copyright Office, No. _____ as more particularly set forth and upon and subject to the terms and conditions in that certain agreement between the undersigned and said Buyer dated as of _____.

The undersigned hereby agrees to register or cause to be registered United States copyrights and, if applicable, renewals of all United States copyrights in and to said Work, whether or not referred to herein and should the undersigned fail to do any of the foregoing, the undersigned hereby appoints Buyer as attorney-in-fact, with full and power and authority to do all such acts and things, and to execute, acknowledge, deliver, file, register, and record all such documents, in the name and on behalf of the undersigned, as Buyer may reasonably deem necessary or proper in the premises to accomplish the same (which appointment is coupled with an interest and irrevocable).

Buyer is also hereby empowered to bring, prosecute, defend, and appear in suits, actions, and proceedings of any nature under or concerning all copyrights in and to said Work and all renewals thereof, or concerning any infringement thereof, or interference with any of the rights hereby granted under said copyrights or renewals thereof, in its own name or in the name of the copyright proprietor, but at the expense of Buyer, and, at its option and sole expense, Buyer may join such copyright proprietor or the undersigned as a party plaintiff or defendant in any such suit, action, or proceeding.

DATED: _____

[Name of Author]

STATE OF _____)

) ss

COUNTY OF _____)

On _____, ____, before me, _____, Notary Public, personally appeared _____, who proved to me on the basis of satisfactory evidence to be the person(s) whose name(s) is/are subscribed to the within instrument and acknowledged to me that he/she/they executed the same in his/her/their authorized capacity(ies) and that by his/her/their signature on the instrument the person(s), or the entity upon behalf of which the person acted(s), executed the instrument.

I certify under PENALTY OF PERJURY under the laws of the State of New York that the foregoing paragraph is true and correct.

WITNESS my hand and official seal.

SIGNATURE OF NOTARY PUBLIC

Short-Form Assignment

The undersigned, for value received, hereby sells, grants, assigns, and sets over unto [Name of Buyer] and its successors and assigns (herein called "Buyer"), all rights (other than the Reserved rights as defined in the Option Purchase Agreement) in and to the published literary work entitled _____, written by _____ (which together with the title, themes, contents, and characters and other versions thereof, is hereinafter called the "Work"), published by _____, on or about _____ with copyright in the name of the undersigned and registered in the United States Copyright Office, No. _____ as more particularly set forth and upon and subject to the terms and conditions in that certain agreement between the undersigned and said Buyer dated as of _____.

The undersigned hereby agrees to register or cause to be registered United States copyrights and, if applicable, renewals of all United States copyrights in and to said Work, whether or not referred to herein, and hereby assigns said rights under said copyrights and renewal copyrights to Buyer; and should the undersigned fail to do any of the foregoing, the undersigned hereby appoints Buyer as attorney-in-fact, with full and irrevocable power and authority to do all such acts and things, and to execute, acknowledge, deliver, file, register, and record all such documents, in the name and on behalf of the undersigned, as Buyer may reasonably deem necessary or proper in the premises to accomplish the same (which appointment is coupled with an interest and irrevocable).

Buyer is also hereby empowered to bring, prosecute, defend, and appear in suits, actions, and proceedings of any nature under or concerning all copyrights in and to said Work and all renewals thereof, or concerning any infringement thereof, or interference with any of the rights hereby granted under said copyrights or renewals thereof, in its own name or in the name of the copyright proprietor, but at the expense of Buyer, and, at its option and its sole expense, Buyer may join such copyright proprietor or the undersigned as a party plaintiff or defendant in any such suit, action, or proceeding.

DATED: _____

[Name of Author/Owner]

STATE OF _____)
) ss
COUNTY OF _____)

On _____, ___, before me, _____, Notary Public, personally appeared _____, who proved to me on the basis of satisfactory evidence to be the person(s) whose name(s) is/are sub-scribed to the within instrument and acknowledged to me that he/she/they executed the same in his/her/their authorized capacity(ies) and that by his/her/their signature on the instrument the person(s), or the entity upon behalf of which the person acted(s), executed the instrument.

I certify under PENALTY OF PERJURY under the laws of the State of Phil-adelphia that the foregoing paragraph is true and correct.

WITNESS my hand and official seal.

SIGNATURE OF NOTARY PUBLIC

Notes

1. All legal agreements courtesy of Robert Garson, Attorney & Barrister, and Managing Partner of Garson Segal Steinmetz and Fladgate LLC.
2. Usually this will be a producer or development company but it can be an individual too.
3. Ordinarily the Owner is the author, if not this capitalized term would have to be changed to Author.
4. Increments of six months are standard with the initial option period being longer than subsequent renewal periods.
5. Many people ask what is the standard payment in these circumstances and it varies, dependent upon the prominence of the book. Agents usually push at every stage, however from a business perspective, higher option fees usually means that there is less to spend on the development. The way the Owner makes real money is when the movie is made.
6. There are always disagreements of who qualifies as a major or a mini-major; the current streaming studios are included here as they are one of the main outlets at the moment but these are subject to change.
7. Like any other point of compensation, this is negotiable. Usually this ranges from 1.5 percent to 2.5 percent dependent upon the bargaining power of the Owner but also this could be as high as 5 percent.
8. This is known as a "floor."
9. This is known as a "ceiling."

10. Ordinarily 90 days.
11. All figures are subject to negotiation; these figures are customary guidelines.
12. Publisher's name.
13. This figure is subject to negotiation but a 5 percent profit participation would not be unusual.
14. Again, all figures are guidelines and may be negotiated.
15. Very often the Buyer will restrict how many premieres the Owner invitation is extended. Similarly, often Buyers will decline to invite an Owner to a festival as the cost can escalate. This would also be the place to insert any award ceremony invitations.
16. This is a vestige that we expect to end very soon with the rise of streaming but at the moment it remains standard.
17. Most agents and Hollywood lawyers insist that jurisdiction be in California, whereas a great deal of independent producers insist on New York as that is where the funding usually is coming from. Realistically it can be anywhere.
18. If the Owner has a literary agent, all payments will usually be directed to the agency.

Appendix B

Release for Submission of Materials to Studio or Production Company

In consideration of _____'s ("PRODUCTION COMPANY") potential review of my writing sample(s)/proposal: _____ and for other good and valuable consideration, the receipt and sufficiency of which are hereby acknowledged, I am hereby submitting to PRODUCTION COMPANY herewith the following materials (the "Materials") for its evaluation on the terms set forth below:

TITLE OF MATERIALS: _____

FORM OF MATERIALS: (indicate format, e.g., screenplay, pilot, sample episode, sample sketches) _____

Production Company wishes to acquaint all those who have been kind enough to submit materials, including ideas, proposals, marketing or promotional plans, program formats, literary material, videos, and musical compositions, with the problem that faces us in reviewing, investigating, inspecting, and evaluating these materials. Much of the materials that is now being submitted embodies materials, suggestions, or ideas substantially similar or identical to those which have been developed by our staff and employees, consultants or contractors, or which have been submitted by others. Further, we may begin using material similar or identical to yours which we received after the date of your submission. Accordingly, we feel that we can receive and review materials only if it is left up to us to determine whether we have in fact used these ideas and to decide what compensation should be paid in event of use.

Because of this, it is our policy to require the signing of the enclosed release before considering any material, ideas, proposals, marketing or promotional plans, program formats, literary material, videos, and musical compositions. Please read the release carefully and return a signed copy along with the material you wish to submit.

Production Company Submission Release Form[1]

Dear Sir/Madam:

You have indicated that you wish to submit to _____ ("PRO-
DUCTION COMPANY" or "STUDIO") certain ideas, proposals, marketing or
promotional plans, program formats, treatments or other material (the
"Material"). By signing this letter in the space indicated below and returning it
to us, you confirm that you have read the enclosed STUDIO policy concerning
the acceptance of the Material, for review, and you also accept all terms of this
letter and policy.

The following shall constitute our agreement with respect to the Material:

1. You understand that PRODUCTION COMPANY will be evaluating the
 Material as a basis for potential involvement and/or assistance in the develop-
 ment and production of a film/television series production. You further under-
 stand that PRODUCTION COMPANY has adopted the policy of refusing the
 submission of creative materials for evaluation unless the submitter signs an
 agreement defining the conditions of such a submission. You enter into this
 agreement (the "Agreement") with the express understanding that PRODUC-
 TION COMPANY will evaluate the Material solely and completely in reli-
 ance upon this Agreement and my covenants, warranties, and releases herein.
 You specifically acknowledge that PRODUCTION COMPANY would refuse
 to consider evaluating the Materials in the absence of your acceptance of each
 and every provision of this Agreement, and further acknowledge that no con-
 fidential or fiduciary relationship is established by my submission of the
 Materials to you or your acceptance and evaluation of same.
2. You and PRODUCTION COMPANY have not yet reached an agreement
 concerning the use of the Material and you realize that no obligation of any
 kind is assumed by, or may be implied against, PRODUCTION COMPANY
 unless and until a formal written contract has been entered into between you
 and PRODUCTION COMPANY, and then the obligation shall be only as is
 expressed in the formal written contract.
3. You declare that all important features of your Material, and the particular
 items being submitted by you (e.g., script, outline, treatment, drawings,
 photographs, taped materials, electronic files, etc.) are summarized on
 Schedule A annexed to this form, and you have disclosed no other features
 to PRODUCTION COMPANY.
4. You acknowledge that this release covers and governs any and all of the
 Material, whether first submitted to PRODUCTION COMPANY contemp-
 oraneously with, or prior to, or following, the execution of this release, and
 applies also to any submission of the Material made to PRODUCTION
 COMPANY by another source, directly or indirectly, by or through you,
 representatives, and assigns.

5. You warrant and represent that (i) You are the sole author of the Material and all elements thereof, and (ii) no third party has any rights, title, or interest therein or thereto. I agree to indemnify PRODUCTION COMPANY and hold PRODUCTION COMPANY harmless from and against all loss, liability, damage, and expense (including reasonable attorneys' fees) arising from any and all claims, demands, actions, or suits relating to my submission of the Materials to PRODUCTION COMPANY INCLUDING in the nature of unfair competition, breach of contract, breach of implied contract, so-called "moral rights," or on any other legal theory whatsoever including without limitation copyright infringement except for claims of infringement based on unauthorized re-use in the form of identical or virtually identical copying of the Material.

6. You understand and acknowledge that PRODUCTION COMPANY and its associates, representatives, and affiliated organizations ("Associates") have access to and/or may create or have created literary materials, stories, and the like, and that many such submissions received by PRODUCTION COMPANY are similar or identical in theme, idea, plot, or other respects to those developed by PRODUCTION COMPANY and its Associates or are otherwise available to PRODUCTION COMPANY. You agree that you will not be entitled to any compensation because of the use by PRODUCTION COMPANY or its Associates of any such similar or identical materials, or the use of material containing elements similar to or identical with the Materials. You hereby forever and irrevocably waive and release PRODUC-TION COMPANY and its Associates from any and all claims, known or unknown, relating to the Material. You expressly waive any rights under the provisions of California Civil Code Section 1542, or any similar law, which provides as follows: "a general release does not extend to claims which the creditor does not know or suspect to exist in his favor at the time of executing the release, which if known by him must have materially affected his settlement with the debtor."

7. Any controversy arising out of or in connection with this agreement, including without limitation any claim that PRODUCTION COMPANY has used any legally protectable portion of your Material in violation of the terms hereof, shall be governed by the laws of the state of _____,[2] and the parties consent to the jurisdiction of the state, and federal courts of _____ for the resolution of such matters. In the event of such controversy you agree that you shall assert such claims not later than six (6) months after the date on which you first learned (or reasonably should have been aware) of PRODUCTION COMPANY's use or intended use of any portion of the Material. You further agree that your rights and remedies, if any, shall be limited to an action to recover money damages in an action of law, and without limitation of the foregoing, you expressly agree that you shall not seek to enjoin or restrain the production, exhibition, distribution, licensing, advertising, and/or promotion of any of PRODUCTION

COMPANY's programming, promotional, or marketing plans, and/or any of the subsidiary rights in connection therewith.

8. You have retained a copy of the release and your Material, and you release PRODUCTION COMPANY from liability for loss or damage to the Material. You also acknowledge and agree that PRODUCTION COMPANY is not obligated to return your Material to you. PRODUCTION COMPANY's review of your Material constitutes PRODUCTION COMPANY's acceptance of the terms and conditions set forth therein, and PRODUCTION COMPANY shall have relied upon your agreement herein in considering your Material for review. PRODUCTION COMPANY agrees to use reasonable efforts to keep all the Materials confidential.

9. This Submission Release constitutes our entire understanding and agreement, and supersedes any and all prior understandings, whether written, oral, or implied. Any subsequent modification or waiver of this Submission Release must be in writing, signed by both of us. The invalidity of any provision hereof is not to affect the remaining provision.

10. You are executing this release voluntarily, without coercion or undue influence from any source, and do so with complete understanding of all of its terms and effects, and every portion thereof. You acknowledge that you have reviewed this Release with the attorney of your choice (and if you received this Release during a face-to-face meeting, that you can elect to reschedule such meeting for a time after you have had the opportunity to have the Release so reviewed). By signing this Release, you acknowledge that you have either consulted an attorney or have waived your right so to do.

11. If more than one party signs this Agreement as submitter, the reference "you" and "your" shall apply to each such party jointly and severally and binds the undersigned and any and all legal representatives of the undersigned. As used in this release, the terms "PRODUCTION COMPANY" and "we" includes and inures to the benefit of PRODUCTION COMPANY, its partners, their parents, subsidiaries, affiliates, successors, assigns, employees, officers, directors, and licensees.

Very truly yours,

_____ Date: _____

Signature

Print Name

Address

Email Address

ACCEPTED AND AGREED TO:
PRODUCTION COMPANY

By: _____ Date: _____

Its (title): _____

Schedule A

SUBMISSION DESCRIPTION

Title:

Name of Submitter:

Form of Material:

Brief Summary of Content:

Copyright Information (if applicable):

Notes

1. Very often these terms are non-negotiable as a Production Company establishes standard documents and will not devote the time or expense of negotiating each one.
2. Jurisdiction will depend upon the location of the Production Company.

Appendix C

Writer Theatrical Short-Form Agreement—Work for Hire

THIS AGREEMENT, effective as of _____, ____, is made by and between _____ [name of producer] ("Producer") whose address is _____ and _____ [name of writer] ("Writer")[1] whose address is _____ with respect to Writer's services on the feature-length motion picture currently entitled, "_____" (the "Picture").

1. **Services:**

 a. Writer shall render all services customarily rendered by writers in the motion picture industry as and when reasonably required by Producer and at all times promptly comply with Producer's reasonable instructions with respect to writing the screenplay for the Picture ("Screenplay"). Producers judgment shall be final in all matters including, but not limited to, matters of artistic taste and judgment.[2]

 b. **First Draft:** Writer shall write the first draft of the Screenplay ("First Draft") based upon material supplied to Writer by Producer (the "Assigned Material"). The writing services shall commence upon execution of this Agreement and shall deliver the First Draft to Producer within _____ (___) weeks.[3]

 c. **Optional Rewrite:** If a rewrite of the First Draft ("Rewrite") is required, the decision for which is in the Producer's sole and absolute discretion, Producer shall be under no obligation to engage Writer but Producer shall have an irrevocable and exclusive option ("Option"), for a period of _____ (___) weeks after delivery of the First Draft, to engage Writer to write and deliver to Producer a rewrite of the First Draft ("Rewrite"). Writer shall commence Writer's services with respect to the Rewrite upon exercise of the Option, and shall deliver the Rewrite to Producer, incorporating such changes to the First Draft that Producer may reasonably require, no later than _____ (___) weeks after commencement of services.

d. **Optional Polish:** If a Polish of the First Draft or Rewrite, as applicable, is required, the decision for which is in the Producer's sole and absolute discretion, Producer shall be under no obligation to engage Writer but Producer shall have an irrevocable and exclusive option ("Option"), for a period of _____ (___) weeks after delivery of the First Draft or Rewrite, as applicable, to engage Writer to write and deliver to Producer a polish ("Polish") of the First Draft or Rewrite, as applicable. Writer shall commence Writer's services with respect to the Polish upon Producer's written notice so to do, which shall be no later than _____ (___) days after the end of the reading period, and Writer shall deliver the Polish, incorporating such changes to the First Draft or Rewrite, as applicable, that Producer may reasonably require, no later than _____ (___) weeks after commencement of services.

2. **Writer Guaranteed Compensation:** Upon condition that Writer shall fully perform all material services required to be performed by Writer and that Writer is not in default of this Agreement, Producer agrees to pay to Writer, as full consideration for all services to be performed by Writer hereunder, and for all rights herein granted, and all representations and warranties made, the following sums in the following manner:

a. Writer shall be entitled to a writing fee of _____ US Dollars ($_____) for the First Draft payable one half (½) upon execution of this Agreement and one half (½) upon delivery to Producer of the completed First Draft.

b. In the event that the option for a Rewrite is exercised, Producer shall pay to Writer[4] _____ US Dollars ($_____) in connection with the Rewrite, payable one half (½) upon commencement of Writer's services in connection therewith and ½ upon delivery.

c. In the event that the option for a Polish is exercised, Producer shall pay to Writer _____ US Dollars ($_____) in connection with the Polish, payable one half (½) upon commencement of Writer's services in connection therewith and ½ upon delivery.

d. In the event that Writer is entitled to additional compensation according to the terms of WGA 2014 Theatrical and Television Basic Agreement, such payments shall be made to Writer upon such determination.

3. **Writer Contingent Compensation:** Writer acknowledges that the Producer is under no obligation to use or incorporate the Screenplay or to ensure that the Picture is made. If the Screenplay is substantially used in the Picture, and/or Writer receives "Screenplay by" or "Written by" Credit, Writer shall be entitled to:

i. A credit bonus of _____ percent (___%)[5] of the final production budget (less only Writer guaranteed compensation, contingencies, financing costs, and bank fees) provided, however, that the

credit bonus shall not be less than _____ ($_____)[6] nor greater than _____ ($_____)[7] payable upon the later of WGA credit determination and the commencement of principal photography; and

ii. If it is finally determined pursuant to the WGA Agreement, that Writer is entitled to receive a sole "Screenplay By" or "Written By" credit for the Picture ("Sole Credit"), Lender shall be entitled to a sum equal to _____ percent (___%)[8] of One Hundred Percent (100%) of the "Net Proceeds" of the Picture. When defining and accounting for "Net Proceeds," Producer shall use the same definition and accounting procedures as those which are set forth in the "Net Proceeds Exhibit" of the domestic distributor of the Picture, and shall not be calculated differently with regards to Lender than any other Net Proceeds participant, such definition to be supplied upon finalization of the Net Proceeds Exhibit. In the event that Producer engages an independent collection account manager,[9] Lender shall be a specified beneficiary for the purposes of Net Proceeds distribution.

iii. If it is finally determined pursuant to the WGA Agreement, that Writer is entitled to receive a shared "Screenplay By" or "Written By" credit for the Picture ("Shared Credit"), Lender shall be entitled to a sum equal to _____ (___%)[10] of One Hundred Percent (100%) of the "Net Proceeds" of the Picture. When defining and accounting for "Net Proceeds," Producer shall use the same definition and accounting procedures as those which are set forth in the "Net Proceeds Exhibit" of the domestic distributor of the Picture, and shall not be calculated differently with regards to Lender than any other Net Proceeds participant.

4. **Credit:** As determined and required pursuant to the WGA Agreement.[11] If it is finally determined pursuant to the WGA Agreement that Writer is not entitled to receive Sole Credit or Shared Credit for the Picture, no additional consideration shall be payable to Writer hereunder.

5. **Subsequent Productions:**

a. **First Negotiation (Writer):**[12] Provided Producer, its assignee, licensee, or designee produces the Picture, Writer is not in material breach hereof, Writer receives Sole Credit on the Picture, Writer is still actively engaged as a writer in the motion picture, television, or content streaming industries and Writer is available to render writing services as, when, and where reasonably required by Producer, then, if Producer desires to produce a sequel, prequel, or remake for theatrical television (including a pilot episode, mini-series, or made for television movie) direct to video or content streaming platform (collectively, a "Subsequent Production") within _____ (___) years after the release of the Picture, Producer will negotiate in good faith for Writer's services

with respect to the first Subsequent Production on terms to be negoti-
ated in good faith and in accordance with industry standards for com-
parable engagements; provided, however, that in no event shall the
financial terms of Writer's deal be less than those terms contained
herein. If such negotiations result in an agreement for a Subsequent
Production, this right of first negotiation will give rise to a rolling right
for first good faith negotiation for the next Subsequent Production. If
any such negotiations do not result in an agreement within twenty (20)
days from the commencement thereof, Producer shall have no further
obligations to Writer under this subparagraph. The provisions of this
subparagraph apply only to Writer personally and not to any heirs,
executors, administrators, successors, or assigns of Writer.

b. **Passive Payments:**[13] In the event Producer produces the Picture, Writer
is not in material breach hereof, Writer receives Sole Credit on the
Picture upon final determination, and Writer does not render writing
services on the Subsequent Production, then Writer shall be paid the
following amounts, if any:

i. If Producer its assignee, licensee, or designee produces a theatrical
"sequel" or "prequel" (as such terms are customarily understood in
the film industry in New York), Fifty Percent (50%) of the Guaran-
teed Compensation for such sequel (payable promptly upon com-
mencement of principal photography thereof), plus a percentage of
net profits equal to Fifty Percent (50%) of the percentage payable
to Lender on the Picture (for this purpose net profits shall be
defined, computed, and accounted for as for the Picture).

ii. If Producer its assignee, licensee, or designee produces a theatrical
"remake" (as such term is customarily understood in the film industry
in New York), Thirty-Three and a Third (33⅓%) of the Guaranteed
Compensation for such remake (payable promptly following upon
commencement of principal photography thereof), plus a percentage
of net profits equal to Thirty-Three and a Third (33⅓%) of the per-
centage payable to Lender on the Picture (for this purpose net profits
shall be defined, computed, and accounted for as for the Picture).

iii. If a feature-length or mini-series-length television sequel or prequel
to, or remake of the Picture is produced, and if Writer is not
engaged to render writing services in connection therewith, the fol-
lowing sums: (i) if intended for initial broadcast on US primetime
network free television, a sum equal to $3,946 for each full broad-
cast hour thereof, up to a maximum of $30,000, payable within 10
days following the completion of principal photography of each
such television sequel, prequel, or remake; or (ii) if intended for
initial primetime telecast in the US by either HBO, Showtime, or
another national pay television service, a sum equal to 75 percent

of the amount set forth in (i) above; or (iii) if intended for initial telecast on any other type of television, a sum equal to 50 percent of the amount set forth in (i) above. Notwithstanding the foregoing, for purposes of determining the additional sum due Writer pursuant to the previous sentence, the royalty shall be calculated based on the length of the television sequel, prequel, or remake as broadcast. The amounts payable under this subparagraph shall be payable within 10 days following the completion of principal photography of each such sequel, prequel, or remake.

iv. If an episodic television series based on the Picture is produced, and if Writer is not engaged to render writing services in connection therewith, the following royalty for each new program of such series which is produced and broadcast: (i) if intended for initial broadcast on US primetime network free television, for a 30-minute program, $2,077; for a 60-minute program, $3,946 for a program longer than 90 minutes, $5,193; or (ii) if intended for initial primetime telecast in the United States by either HBO, Showtime, or another national pay television service, a sum equal to 75 percent of the applicable royalty set forth in (i) above; or (iii) if intended for initial telecast on any other type of television, a sum equal to 50 percent of the applicable royalty set forth above. For each of the second through sixth US free television runs of the program, Producer shall pay an additional sum equal to 20 percent of the applicable royalty; no further sum shall be payable with respect to the seventh or any subsequent runs of any such program except as may be required pursuant to the Basic Agreement. Initial run royalty payments shall be made within 10 days after completion of principal photography of the program involved or 10 days after Producer's receipt of the full license fee therefor, whichever is earlier; provided that with respect to episodes which are ordered but not completed, if Producer does not receive its full license fee, Producer shall pay Writer a percentage of the applicable royalty equal to the percentage of the license fee actually received by Producer. Rerun payments shall be paid within 90 days after the broadcast triggering the payment. If such episodic television series is broadcast more frequently than one program per week (e.g., a daytime serial), payment for each full week of programs shall be a fraction of the applicable per program royalty specified above, the numerator of which is the actual aggregate license fee paid to Producer on account of all of the programs initially broadcast during a single week, and the denominator of which is the license fee customarily paid by the exhibitor for comparable programs broadcast on a once-a-week basis (but in no event shall such payment be less than the applicable per program royalty provided above).

c. 100/50/50: If Writer is not engaged to render writing services under subparagraphs (iii) or (iv), as applicable, and a program described therein is initially released theatrically in the United States, Producer will pay Writer an additional sum equal to 100 percent of the royalty under the applicable subparagraph; if theatrically released outside the United States, an additional 50 percent of the applicable royalty; and if theatrically released in the United States following its first television broadcast in the United States, an additional 50 percent of the applicable royalty. Notwithstanding the foregoing, for purposes of determining the additional sum due Writer for a program produced under subparagraph (iii), the royalty shall be calculated based on the length of the program as theatrically released.

d. All sums paid to Writer pursuant to this paragraph for subsequent productions shall be credited against any corresponding sums required to be paid by the WGA Agreement in respect of any such rights or services, and any corresponding sums paid to Writer pursuant to such guild provisions shall be deducted from any amounts thereafter payable to Writer pursuant to the provisions hereof.

6. **Results and Proceeds:**

a. **Work for Hire:** Writer does hereby acknowledge and agree that all results and proceeds of every kind of the services heretofore and hereafter to be rendered by Writer in connection with the Picture, including without limitation all ideas, suggestions, themes, plots, stories, characterizations, dialogue, titles and other material, whether in writing or not in writing, at any time heretofore or hereafter created or contributed by Writer which in any way relates to the Picture or to the material on which the Picture will be based (collectively, the **"Material"**), are and shall be deemed to be works made for hire for Producer. Accordingly, Producer is and shall be considered the author and, at all stages of completion, the sole and exclusive owner of the Material and all right, title and interest therein (the **"Rights"**). The Rights shall include without limitation all copyrights, neighboring rights, trademarks and any and all other ownership and exploitation rights in the Material now or hereafter recognized in any and all territories and jurisdictions including, by way of illustration, production, reproduction, distribution, adaptation, performance, fixation, rental and lending rights, exhibition broadcasting and all other rights of communication to the public, and the right to exploit the Material throughout the universe in perpetuity in all media, markets, and languages and in any manner now known or hereafter devised. If under any applicable law the fact that the Material is a work made for hire is not effective to place authorship and ownership of the Material and the Picture and all rights therein in Producer, then to the fullest extent allowable and for the full term of protection otherwise

accorded to Writer under such applicable law, Writer hereby assigns and transfers to Producer the Rights and, in connection therewith, any and all right, title and interest of Writer in the Picture and any other works now or hereafter created containing the Material. Writer hereby grants Producer the right to change, add to, take from, translate, reformat, or reprocess the Material in any manner Producer may in its sole discretion determine. To the fullest extent allowable under any applicable law, Writer hereby irrevocably waives or assigns to Producer their so-called "moral rights" or "droit moral." If under any applicable law the above waiver or assignment of "moral rights" or "droit moral" is not effective, Writer agrees to exercise such rights reasonably and in a way that will not have a material adverse effect upon any other individual.

b. **Further Documents:** Writer will, upon request, execute, acknowledge, and deliver to Producer any documents consistent herewith, after a reasonable opportunity to comment and review, and do any other customary acts as Producer may reasonably deem necessary to evidence and effectuate all or any of Producer's rights hereunder. Writer hereby irrevocably appoints Producer as attorney-in-fact with full power to execute, acknowledge, deliver, and record in the US Copyright Office or elsewhere any and all such documents Writer fails to execute, acknowledge, and deliver within a reasonable time after the written request therefor, which shall be no less than ten (10) business days. It is acknowledged said appointment is a power coupled with an interest. Producer shall provide Writer with copies of any documents so executed (Producer's inadvertent failure so to do shall not be deemed a breach hereof).

c. Writer hereby grants to Producer the right to issue and authorize publicity concerning Writer, and to use Writer's name, voice, approved likeness, and approved biographical data in connection with the distribution, exhibition, advertising, and exploitation of the Picture. Notwithstanding the foregoing, Producer shall not be permitted to use such Writer's name, voice, approved likeness, or biographical data for merchandising, tie-ins, or endorsements, without prior written consent of Lender, which shall not be unreasonably withheld. Writer shall submit a pre-approved photograph and biography for Producer's use in whole or in part, provided that if Writer fails to do so within a reasonable period of time after request therefore, Producer may prepare its own factually accurate version.

d. **Warranties:** Writer represents, warrants, covenants, and agrees that, subject to any limitations thereof as required pursuant to Article 28 of the WGA 2011 Basic Agreement, and subject further to the release from liability provided in Section 6(e), below:

i. Writer is free to grant all rights herein granted and to make all agreements made by Writer herein; Writer has not made, and will not make, any grant or assignment which will conflict with or impair the complete and quiet enjoyment of Producer's rights hereunder; and Writer is not subject to any conflicting obligations or any disability which will prevent or interfere with the performance of Writer's services.

ii. The Material (other than any written material supplied by or on behalf of Producer to Writer or incorporated by or at the request of Producer into any Material written by Writer) is or will be original with Writer (or is in minor part in the public domain, or is based on or otherwise derived from actual persons or events to the extent described in the "Annotation" described in Section 6(e), below); any Material written by Writer has not been copied in whole or in part from, or based on, any other work except that submitted by or on behalf of Producer or Writer as a basis for the Material; the Material has not been exploited in any manner and/or medium; the Material is not and will not be based in whole or in part on the life of any real person except as approved in writing in advance by Producer; and any Material contributed in writing by Writer does not and will not, to the best knowledge of Writer, infringe upon the copyright of any person or entity, and any other Material contributed by Writer, does not and will not infringe upon the copyright of any person or entity.

iii. To the best of Writer's knowledge, the Material contributed by Writer does not and will not constitute a libel or slander of any person or entity or infringe upon or violate the right of privacy or any other right of any person or entity.

e. **Annotation; Release from Liability:** Writer will fully and faithfully complete annotations of each draft of the Material prepared by Writer pursuant to customary annotation requirements, and upon request shall furnish to Producer any research materials prepared or gathered by Writer and discuss the annotation, research, and fact-based nature (if any) of the Material with Producer. Without limiting the annotation requirements referred to above, when turning in a writing step, Writer shall notify Producer (or at the request of Producer, Producer's legal counsel), in writing, of the extent to which characters and/or events depicted in the Material are similar to actual persons or events and the manner in which such persons or events have been fictionalized, it being understood that such obligation of Writer applies to the revisions to the Screenplay that are unique to Writer and do not apply to the pre-existing material in the Screenplay not revised by Writer. To the extent that Writer does so and uses good faith efforts to accurately provide all

information reasonably requested by Producer for the purpose of permitting Producer to evaluate the risks involved in the utilization of material supplied by Writer, then (i) notwithstanding anything to the contrary in this Agreement (including, without limitation, Sections 6(d)(ii) and 6(d)(iii) hereof), in no event shall Writer be required to warrant or indemnify with respect to third party defamation, invasion of privacy claims or other similar claims based in or in part on any actual individual, whether living or dead, or any "real life" incident (and Producer shall defend and indemnify Writer and Lender from and against such claims and liabilities as provided in Section 6(f), below), and (ii) it shall not be Writer's responsibility to obtain any grant, license, consent, release, or other clearance of rights from any such actual person or other third party in connection therewith.

f. **Indemnities:** Writer shall indemnify and hold harmless Producer, the corporations comprising Producer, its and their employees, officers, agents, assigns, and licensees from and against any and all claims, liabilities, damages, and costs (including reasonable outside attorneys' fees and court costs) arising out of or in connection with a breach of the foregoing covenants, warranties, and representations. Producer shall defend, indemnify, and hold Writer and Lender harmless from all claims, liabilities, damages, and costs (including reasonable legal fees and court costs) arising from the use of any material supplied to Writer by or on behalf of Producer or incorporated by or at Producer's direction and/or from any claim arising in connection with the development, production, distribution, and/or exploitation of the Picture or element thereof and/or ancillary thereto, other than with respect to claims caused by or arising out of Writer's bad faith, willful misconduct, or breach of any warranty, representation, or agreement of Writer hereunder or under any other agreement with Producer and/or any Producer affiliate in connection with the Picture. The indemnified party shall cooperate fully with the indemnifying party and shall perform such other acts and deeds consistent herewith as may be reasonably necessary and prudent and requested by the indemnifying party in the performance of the indemnifying party's obligations to defend and/or indemnify hereunder.

7. **Writer's Default:** If Writer fails, is unable or refuses to write, complete, and deliver to Producer any material herein provided for within the respective periods herein specified, or if Writer otherwise fails, is unable or refuses to perform or comply with any of the material terms or conditions hereof other than by reason of Writer's Incapacity ("Writer's Default"), then one of the following will result:

a. **Suspension:** Producer shall have the right to suspend Writer's services hereunder so long as Writer's Default shall continue, but in no event shall any suspension hereunder exceed a duration of thirty (30) days.

b. **Termination:** Producer shall have the right to terminate this Agreement and all of Producer's obligations and liabilities hereunder upon written notice to Writer; except, however, termination shall not terminate Producer's obligations and liabilities hereunder with respect to any drafts of the Screenplay delivered by Writer to Producer prior to Termination pursuant to this Agreement (including, without limitation, any obligations and liabilities that may have accrued relating to the payment of Contingent Compensation and the according of credit hereunder).

c. **Anticipatory Breach:** Any refusal or statement by Writer, directly or by implication, that Writer will refuse to keep or perform Writer's obligations and/or agreements hereunder shall constitute a failure to keep and perform such obligations and/or agreements from the date of such refusal or indication of refusal and shall be a Writer's Default hereunder.

8. **Insurance:** Producer shall add Writer as an additional insured under Producer's Errors and Omissions and General Liability insurance policies in connection with the Picture, but solely with respect to and in connection with Writer's services on the Picture, and subject to the limitations, restrictions, and terms of said policies. The provisions of this subparagraph shall not be construed so as to limit or otherwise affect any obligations, representations, or agreements of Writer hereunder.

9. **Miscellaneous:**

a. **Premieres and Festivals:**[14] If Writer is accorded credit in connection with the Picture, Writer and a guest shall be invited to attend World "celebrity" premiere of the Picture and any festival to which the Picture is submitted, if any, and, in connection with such premiere, if Owner attends such "celebrity" premiere which is farther than 50 miles from Owner's principal place of residence, then Buyer agrees to cause the domestic distributor to provide Owner and Owner's guest business class travel, accommodations, and expenses.

b. **DVD/Blu-ray:** When such DVDs and/or Blu-rays are commercially available, Buyer shall provide Writer with one (1) DVD copy or Blu-ray copy of the Picture and any subsequent production(s) based on the Property.[15]

c. **Travel:**[16] If Producer requires Writer's services in connection with the Picture at a location that is more than fifty (50) miles from Writers' principal residence ("Location"), then Producer shall furnish Writer with (a) one best class available but no less than business class round-trip air transportation (and one such additional ticket for Writer if Writer is required to remain on location for 14 or more days) (if used); (b) first class hotel accommodations consistent with the budgetary parameters of the Picture; (c) exclusive first class ground transportation to

and from airports and hotels; (d) use of a self-drive full size rental car (including gas, parking, tolls, and insurance); (e) exclusive use of an office and/or trailer with reasonable amenities during all periods that Writers are providing services on location hereunder; and (f) a non-accountable per diem of One Hundred Dollars ($100) per day. Without limiting anything contained herein, in no event will the terms of this paragraph be less favorable than the travel requirements set forth in the WGA Agreement. Writers' services under this paragraph shall be subject to Writer's then-professional availability.

d. **WGA:** To the extent and during such periods as it may be lawful for Producer to require Writer to do so hereunder, Writer represents and warrants that Writer is and/or shall be and remain a member in good standing of the WGA or otherwise eligible to perform services pursuant to the WGA Agreement and/or applicable laws. Producer represents and warrants that it is and shall remain a WGA signatory in good standing. The parties agree that if there is any inconsistency between this Agreement and the WGA Agreement, the latter shall prevail, but only to the extent necessary to avoid inconsistency. Producer shall pay directly to the WGA, on Writers' behalves, all contributions required pursuant to the WGA Agreement for pension, health, and welfare plans in connection with Writer's engagement hereunder in addition to all amounts payable in this Agreement. There shall be no crediting of WGA overscale payments to Writer hereunder against residuals or contingent compensation, and vice versa.

10. **Remedies:** Writer acknowledges and agrees that: (i) In the event of any breach hereunder by Producer, money damages shall be sufficient, and Writer will be limited to a remedy for actual damages, if any, and will not have the right to terminate or rescind this Agreement or to enjoin the distribution, advertising, or exploitation of the Picture or any other rights and properties of Producer or its successors, licensees, or assigns; (ii) nothing herein shall obligate Producer to use Writer's services or the results or proceeds thereof in the Picture or to produce, advertise, or distribute the Picture; (iii) this Agreement shall be governed by the laws of the State of _____ [17] applicable to agreements executed and to be performed entirely therein and they are subject to the jurisdiction of the courts situated in _____ County, _____; and (iv) subject to the WGA BA, all disputes, claims, or controversies ("Dispute") in connection with Writer's engagement with respect to the Picture shall be resolved by mediation and, if Producer and Writer are unable to resolve any such Dispute by mediation, by binding and confidential arbitration under the JAMS/Endispute ("JAMS")[18] Comprehensive Arbitration Rules and Procedure in effect as of the date hereof, including the JAMS appeal procedure. The prevailing party will be entitled to recover reasonable attorney fees and costs.

11. **Conditions:** Producer's rights and obligations are conditioned upon (i) Producer's approval of the chain of title of the Picture (approval of which Producer acknowledges); (ii) Producer's receipt, to Producer's satisfaction, of all documents which may be required by any government agency or otherwise for Writer to render services hereunder and to enable Producer to effect payment hereunder; and (iii) Producer's receipt of this Agreement signed by Writer.

12. **Entire Agreement:** This Agreement constitutes the entire understanding between the parties, supersedes all prior understandings whether written or verbal, and may not be modified except by a written instrument duly executed by the parties.

13. **Severability:** In the event any paragraph of this Agreement, or any sentence within any paragraph, is declared by a court of competent jurisdiction to be void or unenforceable, such sentence or paragraph shall be deemed severed from the remainder of this Agreement and the balance of this Agreement shall remain in full force and effect.

14. **Counterparts, E-Copies:** This Agreement may be executed in counterparts, each copy of which when signed and delivered will be deemed an original and all of which, taken together, shall constitute one and the same document. A facsimile or PDF file of any signature below will be deemed an original signature for all purposes.

IN WITNESS WHEREOF the parties hereto have caused this Agreement to be duly executed and delivered as of the day and year first above written.

[Producer]

By: _____ By: _____

[name of Writer] Its: Authorized Signatory

Notes

1. Sometimes there will be a loanout Producer, referred to as a Lender, in which case the agreement will have to include the Lender as a signatory to the agreement.
2. A line may be inserted as to exclusivity of the Writer's Services such as "During all reading periods, Writer's services may be non-exclusive, but on a first priority basis" provided that "services to third parties or on Writer's own behalf shall not materially interfere with Writers services hereunder." The Producer can demand for the Writer's services to be provided on an exclusive basis.
3. There is usually a demand for engagement on a "Pay or Play" basis which means that the Producer it guaranteeing to pay the Writer even if it is later decided that the Writer's services will not be required.

4. If there is a loanout/Lender company, payments will be directed to that company and not Writer.
5. Like any other point of compensation, this is negotiable. Usually this ranges from 1.5 percent to 2.5 percent dependent upon the bargaining power of the Writer but also this could be as high as 5 percent.
6. This is known as a "floor."
7. This is known as a "ceiling."
8. This figure is subject to negotiation but a 5 percent profit participation would not be unusual.
9. Also known as a CAMA—a collection account manager which is a neutral third party that receives the revenues in a film project for distribution to multiple beneficiaries of a given film.
10. This figure will usually be half of the Sole Credit Net Proceeds unless there are more than two Writers, then it may be pro rata.
11. This simple clause can be used if the Writer is a member of the Writer's Guild of America.
12. This is highly negotiable. Some producers refuse to grant any right of first negotiation to a writer and not on a rolling basis which is included in this clause. Importantly, where multiple writers have contributed to a Screenplay as a team, the producer must insist on a "Musketeers' Clause" which only grants the right if all of the team are available to write the subsequent productions—All for One and One for All.
13. Passive payments are hotly negotiated; the figures here are a guideline only.
14. Very often the Producer will restrict how many premieres the Writer's invitation is extended. Similarly, often Buyers will decline to invite the Writer to a festival as the cost can escalate. This would also be the place to insert any award ceremony invitations.
15. This is a vestige that we expect to end very soon with the rise of streaming but at the moment it remains standard.
16. The terms here are a guideline and are negotiable subject to the floor set by the WGA Agreement.
17. Most agents and Hollywood lawyers insist that jurisdiction be in California, whereas a great deal of independent producers insist on New York as that is where the funding usually is coming from. Realistically it can be anywhere.
18. JAMS is simply one of the companies that provide arbitration services such as the American Arbitration Association (AAA) or the Beth Din of America, all of which are privately run and will require each party to contribute toward the process. This clause can be amended so that courts are the sole arbiters of disputes.

Appendix D
Life Story Rights Agreement

THIS AGREEMENT, effective as of _____, ____, is made by and between _____ ("Company") whose address is _____ and _____ ("Owner"), an individual, whose address is _____ concerning the development of a film based on the Owner's life story (the "Film"). This Agreement is intended to outline the understanding and lay out the steps of the Film. It will also delineate the primary responsibilities of the parties for the Film and the obligations and fees associated with the acquisition of rights.

For good and valuable consideration, receipt and sufficiency of which is acknowledged, Owner and Buyer (each sometimes referred to herein as a **"Party"**), have agreed as follows:

1. **DEFINITION OF LIFE STORY:** For purposes of this Agreement, "Life Story" shall mean the irrevocable, exclusive, perpetual, and universal rights to use Owner's name, likeness, sobriquet, voice, and biography; depict, portray, impersonate, or simulate Owner in any way whatsoever, and make use of all the incidents of Owner's life preceding, surrounding, following, and otherwise in any way relating to incidents about the Owner's life that the Company deems in its sole discretion necessary or appropriate to produce one or more motion pictures, whether wholly or partially factual or fictional; and use any and all information and materials in Owner's possession or under Owner's control, which Owner shall, at Company's request, disclose and provide to Company freely, completely, and candidly, in such forms as, without limitation, copies of any newspapers or magazine clippings, photographs, transcripts, journals, notes, recordings, home movies, videotapes, or other physical materials relating to Owner's life story and all Owner's thoughts, observations, recollections, reactions and experiences surrounding, arising out of, or concerning all those events, circumstances, and activities relating to Owner's life story (all the aforementioned rights hereinafter collectively referred to as "Life Story").

2. **GRANT OF OPTION:** In consideration of the mutual promises contained herein, and the payment to Owner of _____ ($___), receipt and sufficiency of which is hereby acknowledged, Owner hereby grants to Company for _____ (___)[1] months from and after the effective date of this Agreement (the "Option Period") the exclusive, irrevocable right and option (the "Option") to acquire the exclusive rights as set forth in paragraph 5 in and to the Life Story, as defined above. The Option Period shall be automatically extended for the duration of any events of *force majeure* (including strikes in the entertainment industry), which events interfere with Company's process to production of the Film provided that no extension for any one event of *force majeure* shall exceed six (6) months.

3. **EXTENSION OF OPTION:** Company shall have the right to extend the Option Period for one (1) period of _____ (___) months by sending notice to Owner prior to the expiration of the previous period, along with an additional payment of _____ ($___). Company may exercise this Option at any time during the Option Period, as it may be extended, by giving written notice of such exercise to Owner. The sums paid under this Agreement, with respect to the initial and extended Option Period, shall be credited against the first sums payable as compensation under the terms of the Compensation provision below. If Company fails to exercise this Option, then the sums paid to Owner hereunder shall be and remain the sole property of Owner.

4. **PENDING EXERCISE OF OPTION:** Company shall have the right to prepare screenplays, budgets, teleplays, treatments or other material, and engage in other customary development and preproduction activities. It is understood that if the Option is not exercised, Company shall have no further right in and to the Life Story, but Company shall own all rights of every kind in and to material Company prepared.

5. **EXERCISE OF OPTION:**

 a. If Company elects to exercise the Option, Company (at any time during the Option Period) shall notify you in writing at the address set forth by US mail (postage prepaid) or by national overnight courier service. The Option may be exercised only in writing; no conduct or oral statement by Company or its agents, representatives, or employees shall constitute an exercise of the Option.

 b. Upon exercise of the Option, the date of exercise shall be inserted in the blank space provided in the short form copyright assignment, attached hereto as Exhibit A. Exhibit A shall be and will become a binding agreement between the parties hereto without any further execution or delivery. In the event Company does not exercise said Option within the time and in the manner set forth herein, Exhibit A shall be of no further force or effect whatsoever.

6. RIGHTS GRANTED:

a. Upon exercise of the Option by Company, Company shall acquire and Owner shall be deemed to have assigned, conveyed, sold, and transferred to Company all motion picture, television, online, allied, subsidiary, and ancillary rights in and to the Life Story for use by Company, and Company's successors and assigns, throughout the world and in perpetuity, including, without limitation, the following rights:

1. To develop one or more screenplays based on whole or in part on the Life Story;

2. To make one or more motion pictures based on the Life Story, in whole or in part, or based on any sequences or characters therein (including, without limitation, theatrical productions, television series, and made-for-television movies, streaming platforms, internet, and direct to video productions);

3. To distribute, exhibit, and otherwise exploit any such motion pictures in any and all media and by any means now known or hereafter devised, including, without limitation, all forms of theatrical and non-theatrical distribution and exhibition (including, without limitation, free broadcast, pay television, streaming platforms, internet distribution, cable, subscription, and pay-per-view);

4. To manufacture, distribute, and otherwise exploit all forms of Blu-ray or DVD and similar devices of any such motion pictures and to combine such motion pictures with other programs on such Blu-ray or DVD;

5. To make changes to the Life Story, to create fictional episodes, characters and/or dialogue for purely dramatic purposes, and to use any part or parts of the Life Story for any purpose of this Agreement;

6. To edit and alter any motion pictures based on the Life Story and to make foreign versions thereof;

7. To publicize, advertise, or otherwise promote any such motion pictures and in connection therewith to prepare and use synopses (not to exceed 7,500 words each) of the Life Story;

8. The soundtrack recording, music publishing, legitimate stage, live television, radio broadcasting, and merchandising rights to the Life Story, to any such motion pictures based thereon and to any of the characters contained therein;

9. To make remakes, prequels, sequels, and spin-offs arising from any such motion pictures;

10. To copyright any such motion pictures, sound recordings, musical compositions, and all other copyrightable works based on or derived from the Life Story and to obtain copyright and trademark protection to all works based on or derived from the Life Story; and

11. To sublicense or authorize others to exercise any of the foregoing rights, subject to Company's obligations hereunder provided.

b. Notwithstanding anything contained in this clause to the contrary, it is Company's intention to portray Owner's and Owner's Life Story as factually accurately as possible with the implicit and explicit understanding that Company has the right to deviate from the facts of the Life Story, including the insertion of purely fictional events or characters in order to enhance the dramatic value or effect. Owner shall be entitled to review and be consulted, on a meaningful basis, on the final shooting scripts of the motion pictures produced hereunder, it being understood that further changes to such final shooting scripts may be made by Company, in its sole and absolute discretion. No approval rights are granted whatsoever in connection with any scripts created or motion pictures produced hereunder, which rights shall be held solely and exclusively by Company and shall include, without limitation, control over all dramatic elements of the scripts and motion pictures.

7. **RESERVED RIGHTS:** The Owner specifically reserves literary publishing rights to the Life Story (other than literary publishing rights of up to 10,000 words for use by Company in advertising any motion picture based on the Life Story). However, if Company produces a movie hereunder and if Owner writes a book, Company owns all motion picture rights in the book without further payments.

8. **WAIVER:** Owner hereby waives and relinquishes any rights or remedies at law, in equity or otherwise, and further releases Company and Company's employees, agents, successors, licensees, and assigns from, and covenants not to sue Company, or any of them, with respect to any claim, cause of action, liability, or damages of any nature whatsoever arising out of or in connection with the exercise of any of the rights herein granted to Company. Such liabilities include, without limitation, defamation, libel, slander, false light, false advertising, intentional or negligent infliction of mental distress, or invasion or appropriation of any right of privacy or publicity in any jurisdiction. These waivers are hereby made by Owner, both on Owner's behalf and on behalf of Owner's next of kin.

9. **CONSULTING SERVICES:** Owner shall be available to Company as consultant in connection with the first motion picture produced hereunder at mutually convenient places, dates and times, to provide Company with information and materials regarding the Life Story and to assist Company in obtaining releases from any persons designated by Company. Such consultation will involve, among other things, cooperation with Company and any writers employed by Company or Company's assigns in connection with the writing of the teleplay or other forms of adaptation of the Life Story. Owner

shall be entitled to compensation for the above employment in the amount of _____ thousand dollars ($_____[2]), payable upon commencement of principal photography of said motion picture.

10. **COMPENSATION:** If Company exercises the Option, Company will own all rights as set forth in Paragraph 6 above, and as payment in full for the grant of such rights to Company and for all of the promises, representations, warranties, and agreements made by Owner hereunder, Company will pay Owner as follows:

 a. Purchase Price: The purchase price for the rights shall be an amount equal to _____ percent (___%)[3] of the final in-going production budget (less contingencies, financing costs, and bank/bond fees) less the Initial Option Fee (the "Purchase Price"); provided, however, that the Purchase Price shall not be less than _____ Thousand US Dollars ($_____)[4] nor greater than _____ Thousand US Dollars ($_____).[5] Company may exercise the Option by sending written notice to that effect and sending the Purchase Price to Owner, whereupon Company shall be the sole and exclusive owner of the Rights, provided that the Option shall be deemed exercised if and when Company commences principal photography of the Picture, with the understanding that in such instance, the Purchase Price shall be paid within _____ (__) business days after commencement of principal photography. Any Option Fees are an advance against and shall be deducted from the Purchase Price.

 b. In addition to the Purchase Price, provided Owner is not in material breach of this agreement, Company shall pay Owner an amount equal to _____ Percent (___%) of One Hundred Percent (100%) of the "Net Proceeds" of the Picture. When defining and accounting for "Net Proceeds," Producer shall use the same definition and accounting procedures as those which are set forth in the "Net Proceeds Exhibit" of the domestic distributor of the Picture, and shall not be calculated differently with regards to Lender than any other Net Proceeds participant, such definition to be supplied upon finalization of the Net Proceeds Exhibit.

 c. Remakes and Sequels: In the event Company, or a successor-in-interest, produces any sequel, and/or remake feature motion picture based on the first motion picture produced hereunder, Owner will be paid an amount equal to fifty percent (50%) of the amounts payable to Owner pursuant to 10(a) and 10(b) above in connection with each such sequel and/or remake.

11. **CREDITS:** The Owner shall be entitled to receive the following screen credit in the main titles of any and all motion pictures produced hereunder: "Based on the life of _____." Owner shall be entitled to an end-roll screen credit in connection with consulting services performed hereunder, the form and placement of which shall be at Company's discretion. Inadvertent

failure by Company to comply with these credit provisions shall not be deemed a breach of this Agreement. Within a reasonable time after receipt of written notice from Owner specifying a failure to accord proper credit in accordance with this Paragraph, Company shall use good faith efforts to cure prospectively any such failure with regard to positive prints and/or advertising materials created after the date of Company's receipt of such notice. Company will contractually obligate third party licensees and sub-distributors with whom Company is in privity of contract to comply with the credit obligations set forth herein, but shall not be responsible or liable to Owner for the failure of any such third party to comply with the same.

12. **REPRESENTATION AND WARRANTIES**

 a. Owner has the right, authority, and legal capacity to grant the rights granted to Company herein; and
 b. Owner shall not exploit the Life Story in a manner inconsistent with the terms of this Agreement, specifically, to not sell, license, exploit, or transfer any rights in the Life Story.

13. **REMEDIES:** Owner recognizes and confirms that in the event of a failure or omission by Company constituting a breach of its obligations under this Agreement, whether or not material, the damage, if any, caused Owner is not irreparable or sufficient to entitle Owner to injunctive or other equitable relief. Consequently, Owner's rights and remedies shall be limited to the right, if any, to obtain damages at law and Owner shall not have any right in such event to terminate or rescind this Agreement or any of the rights granted to Company hereunder or to enjoin or restrain the development, pro-duction, advertising, promotion, distribution, exhibition, or exploitation of the Picture and/or any of Company's rights pursuant to this Agreement.

14. **MISCELLANEOUS:**

 a. Arbitration. Disputes under this Agreement shall be settled pursuant to binding arbitration shall be resolved by mediation and, if Producer and Writer are unable to resolve any such Dispute by mediation, by binding and confidential arbitration under the JAMS/Endispute ("JAMS")[6] Comprehensive Arbitration Rules and Procedure in effect as of the date hereof, including the JAMS appeal procedure before a single arbitrator in _____. The prevailing party will be entitled to recover reasonable attorney fees and costs.
 b. Indemnification. Owner shall indemnify and defend Company from and against any and all claims and damages arising from the breach of any representation or warranty of Owner hereunder to the extent such claim or damage does not arise out of a breach by Company hereunder. Company shall indemnify and defend Owner from and against any and all claims and damages arising from the production, distribution,

exhibition, or exploitation of the Picture, or any element thereof, to the extent such claim or damage does not arise out of a breach by Owner hereunder.

c. Accounting. Company agrees to keep and maintain complete and accurate books and records relating to the Picture and the proceeds derived therefrom.

d. Assignment. Owner may not assign its rights or obligations hereunder. Company shall have the complete and total right to assign this agreement or any part hereof to a US or foreign, film, television or cable network or other bona fide industry recognized producer and production company purchaser, and any such assignment and transfer shall be made subject to the terms and conditions of this agreement.

e. Choice of Law. This Agreement shall be governed by and construed in accordance with the laws of the State of _____.

f. Notices. All notices under this Agreement shall be in writing addressed to the addresses first set forth above, or at such other address as either party may designate from time to time by written notice to the other. All notices shall be served by facsimile and US mail, electronic mail, recognized courier services such as FedEx, or personal delivery addressed as specified above. The date of receipt by fax, email, or courier, as the case may be, shall be the date of service of notice.

g. Further Documents. Owner agrees to execute, acknowledge, and deliver to Company and to procure the execution, acknowledgment, and delivery to Company of any additional documents or instruments that Company may reasonably require to effectuate fully and carry out the intent and purposes of this Agreement. If Owner shall fail to execute and deliver any such documents or other instruments, within ten (10) calendar days after such documents are delivered to Owner, Company shall be deemed to be, and Owner irrevocably appoints Company, the true and lawful attorney-in-fact of Owner, to execute and deliver any and all such documents and other instruments in the name of Owner, which right is coupled with an interest.

h. No Partnership. Nothing contained herein shall be deemed to create any association, partnership, or joint venture between the parties. It is understood that each party will perform its obligations hereunder as an independent contractor without any right to bind the other in any way, except as specifically set forth herein.

i. Acquisition Agreement. If the Option is exercised, it is anticipated that a more formal agreement inclusive of the standard and customary film and television industry provisions normally included in agreements of this type shall be negotiated and executed by the parties hereto. Unless and until another agreement is written this represents the full and complete understanding between Company and yourself.

j. This Agreement constitutes the entire agreement between the parties hereto with respect to all of the matters herein and its execution has not been induced by, nor do any of the parties hereto rely upon or regard as material, any representations or writing whatsoever not incorporated herein and made a part hereof. No amendment or modification hereto shall be valid unless set forth in a writing signed by both parties.

k. Severability. In the event any paragraph of this Agreement, or any sentence within any paragraph, is declared by a court of competent jurisdiction to be void or unenforceable, such sentence or paragraph shall be deemed severed from the remainder of this Agreement and the balance of this Agreement shall remain in full force and effect.

l. Counterparts, E-Copies. This Agreement may be executed in counterparts, each copy of which when signed and delivered will be deemed an original and all of which, taken together, shall constitute one and the same document. A facsimile or PDF file of any signature below will be deemed an original signature for all purposes.

IN WITNESS WHEREOF the parties hereto have caused this Agreement to be duly executed and delivered as of the day and year first above written.

COMPANY OWNER

_____ _____

By:_____ SSN:_____

Its: Authorized Signatory

Exhibit A

Assignment (Short Form)

FOR good and valuable consideration, receipt of which is hereby acknowledged, the undersigned Owner does hereby exclusively sell, grant, assign, and set over unto _____ ("_____") (and _____ heirs, successors, licensees, and assigns, forever, all rights in and to the life rights of _____ (the "Assigned Materials") not reserved by the Owners, throughout the universe, in perpetuity, in any and all media and by any means now known or hereafter devised, including, without limitation, all forms of theatrical and non-theatrical distribution and exhibition (including without limitation, free broadcast, pay television, cable, subscription, pay-per-view, streaming platform, video-on-demand, DVD, and Internet), which shall include, but is not limited to, the following: the rights to make one (1) motion picture, television program or series or other audiovisual work based in whole or in part on the Work on any part thereof; the right, for advertising and publicity purposes only, to prepare, broadcast, exhibit, and publish in any form or media, any synopses, excerpts, novelizations, serializations, dramatizations, summaries and stories of the Work, or any part thereof; and all rights of every kind and character whatsoever in and to the Work and all the characters and elements contained therein.

The undersigned and Producer have entered into a formal Option and Purchase Agreement dated _____ __, _____ (the "Agreement"), relating to the transfer and assignment of the foregoing rights in and to said work, which rights are more fully described in said Option and Purchase Agreement. This Assignment is expressly made subject to all of the terms and conditions of said Agreement.

IN WITNESS WHEREOF,
the undersigned has executed this assignment on ____, 20___

OWNER: _____
[Name of Owner]

Notes

1. Increments of six months are standard with the initial option period being longer than subsequent renewal periods.
2. This figure is negotiable and very often an owner can negotiate a consultation salary from the budget.
3. Like any other point of compensation, this is negotiable. Usually this ranges from 1.5 percent to 2.5 percent dependent upon the bargaining power of the Owner but also this could be as high as 5 percent.

4. This is known as a "floor."
5. This is known as a "ceiling."
6. JAMS is simply one of the companies that provide arbitration services such as the American Arbitration Association (AAA) or the Beth Din of America, all of which are privately run and will require each party to contribute toward the process. This clause can be amended so that courts are the sole arbiters of disputes.

Appendix E
Directing Agreement[1]

PICTURE: _____

This confirms the agreement (**"Agreement"**), as of _____, between
_____ (**"Company"**) _____ and _____ (**"Director"**), in
connection with the motion picture project known as _____ (the
"Picture") based on an original work by _____

1. **Services:** Company engages Director to render all services customarily ren-
 dered by directors in the motion picture industry and at all times comply
 promptly with Company's reasonable instructions with respect to directing
 the screenplay for the Picture ("Screenplay"). It is intended that Director
 shall direct the Picture, and, upon execution of this Agreement, be deemed
 to be attached to the Picture.

2. **Fixed Compensation:** Upon condition that Director shall fully perform all
 material services required to be performed by Director and that Director is
 not in default of this Agreement, Director agrees to pay to Director, as full
 consideration for all services to be performed by Director hereunder, and for
 all rights herein granted, and all representations and warranties made, the
 following sums in the following manner:[2]

 2.1 Total Fixed compensation of _____ ($_____) payable as follows:

 I. _____ Percent (_%) upon approval of the shooting budget of
 the Picture;

 II. _____ Percent (_%) in weekly installments beginning
 _____ weeks prior to commencement of principal
 photography;

 III. _____ Percent (_%) in weekly installments during principal
 photography;

 IV. _____ Percent (_%) due upon delivery of the director's cut
 of the Picture;

 V. _____ Percent (_%) due upon delivery of the final answer
 print of the Picture.

[Below is an alternative fixed compensation structure]

2.2 If the final production budget is _____ or more, a directing fee of _____ Percent (_____%) of the final production budget (less the Director guaranteed compensation, contingencies, actual third-party financing costs, and bank fees) provided, however, the directing fee shall not be less than _____US Dollars ($_____) nor greater than _____ Dollars ($_____).

2.3 Twenty Percent (20%) of the directing fee shall be made prior to travel to location of filming for Principal Photography; Sixty Percent (60%) of the directing fee shall be made during the scheduled period for principal photography of the Picture; Ten Percent (10%) of the directing fee shall be made upon completion of the dubbing and scoring of the Picture; Ten Percent (10%) of the directing fee shall be made upon complete delivery of Picture to Company in accordance with agreed-upon delivery specifications.

3. **Contingent Compensation:** In addition to the Fixed Compensation payable pursuant to the provisions above, subject to the production and release of the Picture and subject to the performance of all material obligations of Lender and Director hereunder Company shall pay Director an ongoing contingent compensation in the amount of ____ Percent (___%) of One Hundred Percent (100%) of the "Net Proceeds" of the Picture. When defining and accounting for "Net Proceeds," Company shall use the same definition and accounting procedures as those which are set forth in the "Net Proceeds Exhibit" of the domestic distributor of the Picture, and shall not be calculated differently with regards to Director than any other Net Proceeds participant, such definition to be supplied upon finalization of the Net Proceeds Exhibit. In the event that Company engages an independent collection account manager,[3] Director shall be a specified beneficiary for the purposes of Net Proceeds distribution.

4. **Travel and Expenses:**

4.1 If Company requires Director's services in connection with the Picture at a location that is more than Fifty (50) miles from Director's principal residence, Company shall furnish Director with (a) business-class round trip air transportation, (b) first class hotel accommodations, (c) exclusive ground transportation to and from airports, (d) non-exclusive ground transportation to and from hotels and locations, (e) a full-sized, fully-insured rental car (upon Director's request), and (f) a non-accountable per diem of One Hundred Dollars ($100) per day. In the event that any other above the line, non-cast staff rendering services with respect to the Picture receive more favorable travel, expenses, and accommodations, then Director shall also receive such favorable travel, expenses, and accommodations.

4.2 If the Picture is accepted to a major festival, i.e., Cannes, Sundance, Berlin, and Tribeca, that is more than Fifty (50) miles from Director's principal residence, Company shall furnish Director with (a) business-class round trip air transportation, (b) first class hotel accommodations, (c) exclusive ground transportation to and from airports, and (d) non-exclusive ground transportation to and from hotel and the film festival site.

4.3 If there is a major premiere that is more than Fifty (50) miles from Director's principal residence, Company shall furnish Director with (a) business-class round trip air transportation, (b) first class hotel accommodations, (c) exclusive ground transportation to and from airports, and (d) non-exclusive ground transportation to and from hotel and the major premiere.

5. **Credit:** As determined and required pursuant to the DGA Basic Agreement, including, but not limited to:

5.1 A credit in substantially the form "A film by _____ " as follows:

5.1.1 **On Screen.** Prior to title in main titles before the Picture, provided the main titles run before Picture, on all positive prints of the Picture.

5.1.2 **In Paid Advertising.** In the billing block of all paid advertising relating primarily to the Picture issued by, or under the control of, Company.

6. **Results and Proceeds:**

6.1 **Work for Hire:** Director does hereby acknowledge and agree that all results and proceeds of every kind of the services heretofore and hereafter to be rendered in connection with the Picture, including without limitation all ideas, suggestions, themes, plots, stories, characterizations, dialogue, titles, and other material, whether in writing or not in writing, at any time heretofore or hereafter created or contributed by Director which in any way relates to the Picture or to the material on which the Picture will be based (collectively, the **"Material"**), are and shall be deemed to be works made for hire for Company. Accordingly, Company is and shall be considered the author and, at all stages of completion, the sole and exclusive owner of the Material and all right, title, and interest therein (the **"Rights"**). The Rights shall include without limitation all copyrights, neighboring rights, trademarks, and any and all other ownership and exploitation rights in the Material now or hereafter recognized in any and all territories and jurisdictions including, by way of illustration, production, reproduction, distribution, adaptation, performance, fixation, rental and lending rights, exhibition

broadcasting and all other rights of communication to the public, and the right to exploit the Material throughout the universe in perpetuity in all media, markets, and languages and in any manner now known or hereafter devised. If under any applicable law the fact that the Material is a work made for hire is not effective to place authorship and owner-ship of the Material and the Picture and all rights therein in Company, then to the fullest extent allowable and for the full term of protection otherwise accorded to Director under such applicable law, Director hereby assigns and transfers to Company the Rights and, in connection therewith, any and all right, title, and interest of Director in the Picture and any other works now or hereafter created containing the Material. Director hereby grants Company the right to change, add to, take from, translate, reformat, or reprocess the Material in any manner Company may in its sole discretion determine. To the fullest extent allowable under any applicable law, Director hereby irrevocably waives or assigns to Company his so-called "moral rights" or "droit moral." If under any applicable law the above waiver or assignment of "moral rights" or "droit moral" is not effective, Director agrees to exercise such rights reasonably and in a way that will not have a material adverse effect upon any other individual.

6.2 **Further Documents:** Director shall, upon request, execute, acknow-ledge, and deliver to Company any documents consistent herewith and do any other customary acts as Company may reasonably deem neces-sary to evidence and effectuate all or any of Company's rights hereun-der. Director hereby irrevocably appoints Company as attorney-in-fact with full power to execute, acknowledge, deliver, and record in the US Copyright Office or elsewhere any and all such documents Director fails to execute, acknowledge, and deliver within a reasonable time after the written request therefor. It is acknowledged said appointment is a power coupled with an interest. Company shall provide Director with copies of any documents so executed (Company's failure to do so shall not be deemed a breach hereof).

6.3 **Publicity:** Director hereby grants to Company the right to issue and authorize publicity concerning Director, and to use Director's approved name, voice, likeness, and biographical data in connection with the dis-tribution, exhibition, advertising, and exploitation of the Picture. Not-withstanding the foregoing, Company shall not be permitted to use such Director's approved name, voice, likeness, and biographical data for merchandising, tie-ins, or endorsements, without prior written consent of Director, which shall not be unreasonably withheld. Director shall submit a pre-approved photograph and biography for Company's use in whole or in part, provided that if Director fails to do so within a reason-able period of time after request therefore, Company may prepare its own factually accurate version.

6.4 **Warranties:** Director represents, warrants, covenants, and agrees that, subject to any limitations thereof as required pursuant to Article 28 of the WGA 2011 Basic Agreement. The standard representations and warranties will be attached at Schedule 1.

 6.4.1 Director free to grant all rights herein granted and to make all agreements made by Director herein; Director has not made, and will not make, any grant or assignment which will conflict with or impair the complete and quiet enjoyment of Company's rights hereunder; and neither of them is subject to any conflicting obligations or any disability which will prevent or interfere with the performance of Director's services.

 6.4.2 The Material (other than any written material supplied by or on behalf of Company to Director or incorporated by or at the request of Company into any Material written by Director) is or will be original with Director (or is in minor part in the public domain, or is based on or otherwise derived from actual persons or events); any Material written by Director has not been copied in whole or in part from, or based on, any other work except that submitted by or on behalf of Company or Director as a basis for the Material; the Material has not been exploited in any manner and/or medium; the Material is not and will not be based in whole or in part on the life of any real person except as approved in writing in advance by Company; and any Material contributed in writing by Director does not and will not infringe upon the copyright of any person or entity, and any other Material contributed by Director, does not and will not infringe upon the copyright of any person or entity.

 6.4.3 To the best of Director's knowledge, the Material does not and will not constitute a libel or slander of any person or entity or infringe upon or violate the right of privacy or any other right of any person or entity.

6.5 **Annotation; Release from Liability:** Director shall fully and faithfully complete annotations of each draft of the Material prepared by Director pursuant to customary annotation requirements, and upon request shall furnish to Company any research materials prepared or gathered by Director and discuss the annotation, research, and fact-based nature (if any) of the Material with Company. Without limiting the annotation requirements referred to above, when turning in a writing step, Director shall notify Company (or at the request of Company, Company's legal counsel), in writing, of the extent to which characters and/or events depicted in the Material are similar to actual persons or events and the manner in which such persons or events have been fictionalized, it being understood that such obligation of Director applies to the

revisions to the Screenplay that are unique to Director and do not apply to the pre-existing material in the Screenplay not revised by Director. To the extent that Director does so and uses good faith efforts to accurately provide all information reasonably requested by Company for the purpose of permitting Company to evaluate the risks involved in the utilization of material supplied by Director, then (i) notwithstanding anything to the contrary in this Agreement, in no event shall Director be required to warrant or indemnify with respect to third party defamation, invasion of privacy claims or other similar claims based in or in part on any actual individual, whether living or dead, or any "real life" incident (and Company shall defend and indemnify Director from and against all claims and liabilities), and (ii) it shall not be Director's responsibility to obtain any grant, license, consent, release or other clearance of rights from any such actual person or other third party in connection therewith.

6.6 **Indemnities:** Director shall indemnify and hold harmless Company, the corporations comprising Company, its and their employees, officers, agents, assigns, and licensees from and against any and all claims, liabilities, damages, and costs (including reasonable outside attorneys' fees and court costs) arising out of or in connection with a breach of the foregoing covenants, warranties, and representations. Company shall defend, indemnify, and hold Director harmless from all claims, liabilities, damages, and costs (including reasonable legal fees and court costs) arising from the use of any material supplied to Director by or on behalf of Company or incorporated by or at Company's direction or from any claim arising in connection with the development, production, distribution, and/or exploitation of the Picture or element thereof, other than with respect to claims caused by or arising out of Director's bad faith, willful misconduct, or breach of any warranty, representation, or agreement of Director hereunder or under any other agreement with Company and/or any Company affiliate in connection with the Picture. The indemnified party shall cooperate fully with the indemnifying party and shall perform such other acts and deeds consistent herewith as may be reasonably necessary and prudent and requested by the indemnifying party in the performance of the indemnifying party's obligations to defend and/or indemnify hereunder.

7. **Approvals:** If engaged as director, Director shall have final approval of pre- and postproduction schedules and music. Director and Company shall have mutual approval, with tiebreaker to Company, with respect to decisions concerning key crew, cast, location, department heads, and shooting script.

7.1 **Cuts and Previews:** Director shall have two (2) cuts of the Picture (inclusive of the "Director's Cut" and screening required under the

DGA Agreement) and two (2) previews of each such cut (inclusive of the screening required under the DGA Agreement), which preview may be paid, public or private, as Company, in its sole discretion, shall elect. Director's cuts must be exercised consecutively.

8. **Insurance:** Company shall name Director as additional insureds under Company's Errors and Omissions and General Liability insurance policies in connection with the Picture, but solely with respect to and in connection with Director's services on the Picture, and subject to the limitations, restrictions, and terms of said policies. The provisions of this subparagraph shall not be construed so as to limit or otherwise affect any obligations, representations, or agreements of Director hereunder.

9. **Health, Welfare, and Pension:** Company agrees to contribute to the Directors Guild of America—Producer Pension Plan, with respect to the employment of Director at the requisite level. Similarly, Company shall pay the requisite amounts to the Directors Guild–Producer Health and Welfare Plan.

10. **First Negotiation:**[4] Provided Director directs the Picture and Director is still actively engaged as a director in the motion picture industries and is available to render directing services as, when, and where reasonably required by Company, then, if Company desires to produce a theatrical sequel, prequel, or remake (collectively, a "Subsequent Production") within seven (7) years after the release of the Picture, Company, its assignee, licensee, or designee will negotiate in good faith for Director's services as a director, with respect to the first Subsequent Production on terms to be negotiated in good faith and in accordance with industry standards for comparable engagements; provided, however, that in no event shall the financial terms of Director's deal be less than those terms contained herein. If such negotiations do not result in an agreement within twenty (20) days from the commencement thereof, Company shall have no further obligations to Director under this paragraph. The provisions of this subparagraph apply only to Director personally and not to any heirs, executors, administrators, successors, or assigns of Director.

11. **Remedies:** Director acknowledge and agrees that: (i) In the event of any breach hereunder by Company, money damages shall be sufficient, and Director will be limited to a remedy for actual damages, if any, and will not have the right to terminate or rescind this Agreement or to enjoin the distribution, advertising, or exploitation of the Picture or any other rights and properties of Company or its successors, licensees, or assigns; (ii) nothing herein shall obligate Company to use Director's services or the results or proceeds thereof in the Picture or to produce, advertise, or distribute the Picture; (iii) this Agreement shall be governed by the laws of the State of _____ [5] applicable to agreements executed and to be performed entirely

therein and they are subject to the jurisdiction of the courts situated in
_____ County, _____; and (iv) subject to the DGA Agreement, all
disputes, claims, or controversies ("Dispute") in connection with Director's
engagement with respect to the Picture shall be resolved by mediation and,
if Company and Director are unable to resolve any such Dispute by medi-
ation, by binding and confidential arbitration under the JAMS/Endispute
("JAMS") Comprehensive Arbitration Rules and Procedure in effect as of
the date hereof, including the JAMS appeal procedure.

12. **Conditions:** Company's obligations are conditioned upon (i) Company's
approval of the chain of title of the Picture (approval of which Company
acknowledges); (ii) Company's receipt, to Company's satisfaction, of all
documents which may be required by any government agency or otherwise
for Director to render services hereunder and to enable Company to effect
payment hereunder; and (iii) Company's receipt of this Agreement signed
by Director.

13. **Documentation:** Company and Director intend to enter into more formal
documentation (the "Long-Form Agreement"[6]) setting forth the terms
described herein together with the other terms customarily included in long-
form screen Director employment agreements (including, without limitation,
provisions regarding premieres and complimentary downloads), which
Long-Form Agreement shall be negotiated in good faith within customary
industry parameters for directors of Director's stature. Unless and until the
Long-Form is executed, this Agreement constitutes the complete and
binding agreement of the parties. Any Amendments to this Agreement must
be in writing, executed by both parties. This Agreement may be executed in
counterparts, each of which when so executed shall together constitute one
and the same instrument and shall be deemed an original for any purpose.
Electronic copies of this Agreement shall be deemed originals for all
purposes.

IN WITNESS WHEREOF the parties hereto have caused this Agreement to be
duly executed and delivered as of the day and year first above written.

Company

By: _____ By: _____

Director Its: Authorized Signatory

Notes

1. The director deal memorandum lays out the terms and all can be inserted into this agreement. It is very rare that a director will be engaged on just a term sheet. Like many of the other agreements the compensation will follow the same theme of guaranteed compensation, contingent compensation, and in certain cases box office or award bonuses. One of the major differences with directors is they have to be on location and those deal points feature heavily.
2. There are many different formulas to be used and those laid out here will be modified or deleted on negotiation.
3. Also known as a CAMA—a collection account manager which is a neutral third party that receives the revenues in a film project for distribution to multiple beneficiaries of a given film.
4. This is obviously negotiable and not always included but all of the terms can be varied.
5. Most agents and Hollywood lawyers insist that jurisdiction be in California, whereas a great deal of independent producers insist on New York as that is where the funding usually is coming from. Realistically it can be anywhere.
6. The Long-Form would include terms standard in DGA agreements, postproduction services, rights of Company to suspend, director's incapacity, termination rights, TV remake rights.

Appendix F

Actor Services Agreement

THIS AGREEMENT, effective as of _____, ____, is made by and between _____ [name of producer] ("Producer") whose address is _____ and _____ [name of actor] ("Artist")[1] whose address is _____ with respect to Artist's services on the feature-length motion picture currently entitled, "_____" (the "Picture").

14. **Services:**

 a. Artist is hereby engaged to render all services customarily rendered by actors in first-class feature-length theatrical motion pictures in the motion picture industry and at all times promptly comply with Producer's reasonable instructions in the role of _____ for the Picture. The Start Date for principal photography is on or about _____. Artist will be available for rehearsals and other preproduction services for approximately _____ (__) weeks before the Start Date. Artist's services during principal photography shall be exclusive and rendered consecutively until the completion thereof. After the completion of principal photography, Artist shall be available for customary postproduction services, subject to Artist's then-existing prior professional commitments.[2]

 b. The term of Artist's services pursuant to this Section shall commence _____, and shall continue until the full and satisfactory completion of all services to be rendered by Artist hereunder or the earlier termination of this Agreement.

15. **Artist's Guaranteed Compensation:** Upon condition that Artist shall fully perform all material services required to be performed by Artist and that Artist is not in default of this Agreement, Producer agrees to pay to Artist, as full consideration for all services to be performed by Artist hereunder, and for all rights herein granted, and all representations and warranties made, the following sums in the following manner:[3]

 a. A weekly salary of_____ US Dollars per "studio week" defined as a day week, with shooting hours per day, (with additional overtime payment of four (4) hours at straight time rate for each overnight location Saturday). Player accepts such engagement upon the terms herein specified. Producer guarantees that it will furnish Player not less than _____ weeks of employment. Player shall be paid pro rata for each additional day beyond guarantee until dismissal. In the event of two consecutive shooting days whereby the Player is scheduled for performance during overtime, the Player's schedule must be adjusted to include an uninterrupted period of at least eight hours for sleep before call time. (If Applicable: SAG-mandated fringes and residuals, including but not limited to pension and health and welfare, will be paid by Producer in addition to Artist's Guaranteed Compensation. The Guaranteed Compensation buys out all overtime, holidays, and other like terms to the maximum extent permissible under the applicable SAG Agreement.)

16. **Artist's Deferred Compensation:**[4] If the conditions are satisfied such that Artist's Guaranteed Compensation becomes payable, in addition to Artist's Guaranteed Compensation, subject to the inclusion of the Artist's performance in the Picture and subject to the production and release of the Picture, and subject to the performance of all obligations of Artist, the Artist shall receive an amount equal to _____ US Dollars, in first position ahead of any other contingent deferments, and payable out of no more than Fifty Percent (50%) of the Producer's gross revenues from the Picture after the deduction from gross revenues of recoupment by the investors in the Picture of 120% their entire investment, all costs of production, financing and repayment of loans, and, any deferments payable to any laboratories, postproduction services, and the cost of becoming a signatory to any Guild agreements.

17. **Artist's Contingent Compensation:** If the conditions are satisfied such that Artist's Guaranteed Compensation becomes payable, subject to the inclusion of the Artist's performance in the Picture and subject to the production and release of the Picture, and subject to the performance of all obligations of Artist, the Artist shall be entitled to a sum equal to _____ percent (___%)[5] of One Hundred Percent (100%) of the "Net Proceeds" of the Picture. When defining and accounting for "Net Proceeds," Producer shall use the same definition and accounting procedures as those which are set forth in the "Net Proceeds Exhibit" of the domestic distributor of the Picture, and shall not be calculated differently with regards to Artist than any other Net Proceeds participant, such definition to be supplied upon finalization of the Net Proceeds Exhibit. In the event that Producer engages an independent collection account manager,[6] Artist shall be a specified beneficiary for the purposes of Net Proceeds distribution.

18. **Credit:** Provided Artist is not in material breach of this Agreement, Artist shall receive a credit, in substantially the following form:

 a. [Name or Moniker] in the main[7] titles of the Picture on a single[8] card and shall appear in all positive prints of the Picture and all paid advertisements (subject to standard exclusions).

 b. Such credit shall be included in any paid advertisements for the movie, save for other award, nominations, or celebratory advertising crediting only another cast or crew member.

 c. All other aspects of credit and all other credits shall be at the sole and absolute discretion of Producer and no casual or inadvertent failure of Producer to comply with the above credit provisions shall constitute a breach of this Agreement. Within a reasonable time after receipt of written notice from Artist particularizing a failure to accord proper credit in accordance with this provision, Producer shall use reasonable good faith efforts to cure prospectively any such failure with regard to positive prints and/or advertising materials created after the date of Producer's receipt of such notice. Producer will contractually oblige third-party licensees and sub-distributors with whom Producer is in direct privity of contract to adhere to Producer's above credit obligations, but shall not be responsible or liable to Artist or obligated to pursue any such third-party for any failure of such third-party.

19. **Name and Likeness:** Producer shall have the exclusive right to use and to license the use of Artist's name, sobriquet, photograph, likeness, voice, and/or caricature and shall have the right to simulate Player's voice, signature, and appearance by any means in and in connection with the film and the advertising, publicizing, exhibition, to include the name, voice, and likeness of Artist in DVD extra or bonus materials, such as "behind the scenes" and "making of" and/or other exploitation thereof in any manner and by any means and in connection with commercial advertising and publicity tie-ups.

20. **Representations and Warranties:**

 a. Artist represents and warrants that Artist is a member of the Screen Actors Guild,[9] is free to enter into this Agreement, and will not do or permit any act which will interfere with or derogate from the full performance of Artist's services or Producer's exercise of the rights herein granted.

 b. Artist further represents, warrants, and agrees that he is free to enter into this Agreement and not subject to any conflicting obligations or any disability which will or might prevent Artist from, or interfere with, Artist's execution and performance of this Agreement.

 c. Artist has not made and will not make any grant or assignment which will or might conflict with or impair the complete enjoyment of the rights granted to Producer hereunder.

21. **Work Made For Hire:**

 a. Artist hereby acknowledges that all of the results and proceeds of Artist's services produced for the Picture hereunder shall constitute a "work-made-for-hire" specially commissioned by Producer and Producer or Producer's assignee shall own all such results and proceeds. Producer shall have the right to use Artist's name and likeness with respect to distribution and exploitation of the Picture. Producer may make such use of the Picture as Producer, in its sole discretion, shall deem appropriate.

 b. If Artist's services are not recognized as a "work-made-for-hire," Artist hereby irrevocably grants, sells, and assigns to Producer, its successors, and assigns, all of Artist's rights, title, and interest of any kind and nature, in and to the Picture, including, without limitation, all copyrights in connection therewith and all tangible and intangible properties with respect to the Picture, in perpetuity, whether in existence now or as may come into existence in the future.

 c. Artist waives the exercise of any "moral rights" and "droit moral" and any analogous rights however denominated now or hereafter recognized. All rights granted and agreed to be granted to Producer hereunder are irrevocable and shall vest and remain perpetually vested in Producer, its successors, and assigns, whether this Agreement expires in normal course or is sooner terminated, and shall not be subject to rescission by Artist for any cause whatsoever.

22. **Employment Eligibility:** All of Producer's obligation herein are expressly conditioned upon Artist's completion, to Producer's satisfaction, of the I-9 form (Employee Eligibility Verification Form), and upon Artist's submission to Producer of original documents satisfactory to demonstrate to Producer Artist's employment eligibility.

23. **Contingencies:** Producer shall have the right to terminate, suspend, or delay the Term during all periods in which Artist is in breach of this Agreement; Artist is prevented from or fails, refuses, or neglects to fully perform Artist's services; or the development, production, or distribution of the Picture is prevented by a "force majeure" event, by the death, illness, disability, or incapacity of a principal cast member, director, producer, or director of photography of the Picture, or for any other reason whatsoever.

24. **Insurance:** Producer has the right, but not the obligation, to secure life, health, accident, and/or other insurance covering Artist hereunder and Artist shall not have any rights, titles, or interests to such insurance. Artist shall fully cooperate with Producer regarding the securing of such insurance, including, but not limited to, submitting to usual and customary medical exams. Notwithstanding the foregoing, as between Artist and Producer, Artist is solely responsible for obtaining and maintaining any and all types of insurance desired by or required of Artist regarding Artist's services

under this Agreement, including, but not limited to, worker's compensation insurance, health/medical insurance, and liability insurance.

25. **Approvals and Controls:** Producer shall solely have all approvals and controls of all kinds and nature, with respect to the Picture, including, but not limited to, all decisions involving artistic taste and judgment.

26. **Remedies:** Artist acknowledges and agrees that: (i) In the event of any breach hereunder by Producer, money damages shall be sufficient, and Artist will be limited to a remedy for actual damages, if any, and will not have the right to terminate or rescind this Agreement or to enjoin the distribution, advertising, or exploitation of the Picture or any other rights and properties of Producer or its successors, licensees, or assigns; (ii) nothing herein shall obligate Producer to use Writer's services or the results or proceeds thereof in the Picture or to produce, advertise, or distribute the Picture; (iii) this Agreement shall be governed by the laws of the State of _____ [10] applicable to agreements executed and to be performed entirely therein and they are subject to the jurisdiction of the courts situated in _____ County, _____; and (iv) subject to SAG arbitration provisions, all disputes, claims, or controversies ("Dispute") in connection with Writer's engagement with respect to the Picture shall be resolved by mediation and, if Producer and Writer are unable to resolve any such Dispute by mediation, by binding and confidential arbitration under the JAMS/Endispute ("JAMS")[11] Comprehensive Arbitration Rules and Procedure in effect as of the date hereof, including the JAMS appeal procedure. The prevailing party will be entitled to recover reasonable attorney fees and costs.

27. **Indemnities:** Artist shall indemnify and hold harmless Producer, the corporations comprising Producer, its and their employees, officers, agents, assigns, and licensees from and against any and all claims, liabilities, damages, and costs (including reasonable outside attorneys' fees and court costs) arising out of or in connection with a breach of the foregoing covenants, warranties, and representations. Producer shall defend, indemnify, and hold Artist harmless from all claims, liabilities, damages, and costs (including reasonable legal fees and court costs) arising and against any and all claims and damages arising from the production, distribution, exhibition, or exploitation of the Picture, or any element thereof, to the extent such claim or damage does not arise out of a breach by Artist hereunder. The indemnified party shall cooperate fully with the indemnifying party and shall perform such other acts and deeds consistent herewith as may be reasonably necessary and prudent and requested by the indemnifying party in the performance of the indemnifying party's obligations to defend and/or indemnify hereunder.

28. **Assignment:** Producer shall have the complete and total right to assign this agreement or any part hereof to a US or foreign, film, television or cable network, or other bona fide industry recognized producer and production

company purchaser, and any such assignment and transfer shall be made subject to the terms and conditions of this Agreement. Artist may not assign its rights or obligations hereunder.

29. **Miscellaneous:**

 a. Artists will not be obligated to perform stunts, appear nude or semi-nude, or to depict sexual acts.
 b. If requested, Artist agrees to a medical examination during the duration of services rendered for purposes of meeting insurance requirements for the Picture.
 c. Artist verifies hereunder that Player is not a minor according to laws in the state of _____, and is over _____ years of age.

30. **Further Documents:** Artist agrees to execute, acknowledge, and deliver to Producer and to procure the execution, acknowledgment, and delivery to Producer of any additional documents or instruments which Producer may reasonably require to effectuate fully and carry out the intent and purposes of this Agreement. If Artist shall fail to execute and deliver any such documents or other instruments, within ten (10) calendar days after such documents are delivered to Artist, Producer shall be deemed to be, and Artist irrevocably appoints Producer, the true and lawful attorney-in-fact of Artist, to execute and deliver any and all such documents and other instruments in the name of Artist, which right is coupled with an interest.

31. **Entire Agreement:** This Agreement constitutes the entire understanding between the parties, supersedes all prior understandings whether written or verbal, and may not be modified except by a written instrument duly executed by the parties.

32. **Severability:** In the event any paragraph of this Agreement, or any sentence within any paragraph, is declared by a court of competent jurisdiction to be void or unenforceable, such sentence or paragraph shall be deemed severed from the remainder of this Agreement and the balance of this Agreement shall remain in full force and effect.

33. **Counterparts, E-Copies:** This Agreement may be executed in counterparts, each copy of which when signed and delivered will be deemed an original and all of which, taken together, shall constitute one and the same document. A facsimile or PDF file of any signature below will be deemed an original signature for all purposes.

IN WITNESS WHEREOF the parties hereto have caused this Agreement to be duly executed and delivered as of the day and year first above written.

[Producer]

By: _____ By: _____

[name of Artist] Its: Authorized Signatory

Notes

1. Sometimes there will be a loanout Producer, referred to as a Lender, in which case the agreement will have to include the Lender as a signatory to the agreement.
2. There are occasions where the artist may also be on the soundtrack. Such services can also be identified here.
3. The form and terms of a performer's agreement will depend upon whether the performer is a SAG member. If so, the terms of the agreement must be read in light of, or take note of, the relevant SAG agreement.
4. Payments of deferments are only included with leading performers or ensemble cast members.
5. This figure is subject to negotiation but a 5 percent profit participation would not be unusual.
6. Also known as a CAMA—a collection account manager which is a neutral third party that receives the revenues in a film project for distribution to multiple beneficiaries of a given film.
7. For principal roles, end titles for non-principal roles. Note, credits are hotly contested and some artists have their own preferences which may conflict with their fellow cast members. This is why credits such as "with" or "and" were created.
8. Shared for lesser principal roles.
9. If not, a clause stating "Artist warrants that Player is not a member of any union or guild, memberships in which would prevent the Artist from performing in the Picture."
10. Most agents and Hollywood lawyers insist that jurisdiction be in California, whereas a great deal of independent producers insist on New York as that is where the funding usually is coming from. Realistically it can be anywhere.
11. JAMS is simply one of the companies that provide arbitration services such as the American Arbitration Association (AAA) or the Beth Din of America, all of which are privately run and will require each party to contribute toward the process. This clause can be amended so that courts are the sole arbiters of disputes.

Appendix G
Product Placement Release

GRANTOR:

ADDRESS:

This Agreement, effective as of _____, _____ is made by and between _____ ("Producer") [address] _____ and _____ ("Grantor"), ") [address] _____ regarding the photographic reproduction of _____ ("Product").

The Grantor agrees to provide the following product(s) and/or services(s) for use in the motion picture currently entitled "_____" ("Picture"):

The Grantor hereby grants to Producer and Producer's successors, licensees, and assigns, the non-exclusive right, but not the obligation to use and include all or part of the trademarks(s), logo(s), and or identifiable characters (the "Mark(s)") associated with the above listed product(s) and/or services(s) in the Picture, without limitation as to time or number of runs, for reproduction, exhibition, and exploitation, throughout the world, in any and all manner, methods, and media, whether now known or hereafter known or devised, and in the advertising, publicizing, promotion, trailers, and exploitation thereof.

The Grantor warrants and represents that it is the owner of the product(s) or direct provider of the services(s) as listed above or a representative of such and has the right to enter into this Agreement and has not done and shall not do any act or make any grant of rights which would impair or interfere with any rights granted to the Producer pursuant to this Agreement.

Producer agrees that the Product will not be used in a disparaging manner, and Producer further agrees not to feature any competing brands of the same product. Digital alteration of the Product appearance, or the use of special effects of any kind which change the packaging, or the appearance of the Product in any significant way, are subject to Grantor approval.

__ectlmbodied

Provided that the product(s) is embodied in the Picture as released, Producer will use best efforts to accord Grantor screen credit in the end titles of the Picture in the following form:

The Producer shall not be obligated to use the product(s) in any manner whatsoever and have made no representations about the manner in which product(s) may be used. The Producer shall not be obligated to pay any monies to Grantor with respect to the exploitation of the Picture at all.

Grantor agrees to indemnify and hold harmless Producer, its officers, shareholders, assignees and licensees, distributors and sub-distributors, and each of their successors-in-interest from and against any and all liabilities, damages, and claims (including attorney's fees and court costs) arising out of (i) any breach of Grantor's warranties, (ii) Producer's use of the Product, as provided herein, and/or (iii) the rights granted herein.

The Grantor affirms that it did not give or agree to give anything of value, except for the product(s) and/or service(s) to any member of the production staff, anyone associated in any manner with the Picture for mentioning or displaying the name of the Grantor or any of its products, trademarks, trade names, or the like.

The sole remedy of Grantor for breach of any provision of this agreement shall be an action at law for damages, and in no event shall Grantor seek or be entitled to injunctive or other equitable relief by reason of any breach or threatened breach of this Product Release agreement, or for any other reason pertaining hereto, nor shall Grantor be entitled to seek to enjoin or restrain the exhibition, distribution, advertising, promotional activities in all media and forms, exploitation or marketing of the Picture.

I represent that I am a representative/officer of the Grantor and am empowered to execute this form on behalf of the Grantor.

I further represent that neither I, nor the Grantor which I represent, will directly or indirectly publicize or otherwise exploit the use, exhibition, or demonstration of the above products and/or services in the Picture for advertising, merchandising, or promotional purposes without the express written consent of the Producer.

PRODUCER Grantor

_____ _____
By: (print name) By: (print name)
An Authorized Signatory An Authorized Signatory

Appendix H
Script Readers Coverage Report Content and Format

Confidential:

Type of Material:

Title:

Number of Pages:

Author:

Date:

Submitted by:

Submitted to:

Circa:

Location:

Analyst:

Genre Category(ies): Date:

Elements Attached:

Log Line:

Brief:

Short Synopsis:

Comments:

Material Recommendation:

Writer Recommendation: Grade:

Budget: N/A

Each report should consist of a Log Line, Brief, Short Synopsis, and Comments.

1. LOG LINE: approximately 18–20 words long, and communicate broadly the essence of the work, including relevant details, as necessary. Character names do not need to be included.
2. BRIEF: 8–10 word distillation of your comments, either a phrase or sentence, or short description, highlighting various aspects of the script.
3. SHORT SYNOPSIS: 2 to 2½ pages, rough description of the script, include character names in capitals. Include major plot points and significant subplots, be explicit but do not include information unnecessary to the overall plot, and attempt to make the writing flow, mirroring the pacing and tone of the script, giving a thorough understanding of the plot and characters.
4. COMMENTS: First Paragraph: Brief synopsis, 5–15 sentences.

Comments, including overview, comparisons to other films, whether the script achieves its objective, and your reaction to the script. Answer the question, Is this project or writer something our production company should pursue?

Cover specific reasons why this script does, or does not, work as potential film material, covering:

* premise/concept
* plot/story/structure
* characterization
* commercial viability
* freshness of material/writer's approach
* pacing/dramatic stakes
* dialogue
* cinematic sensibility
* power to evoke emotional response
* surprising/unusual
* entertaining
* production values.

Brevity and objectivity are important in comments, avoid personal or derogatory statements about the writing.

Last Paragraph: Recommend, Consider, or Pass. Recommend is for a script you feel is outstanding and that few scripts deserve, Consider should be something you feel deserves serious attention.

Assess the writer's general abilities with a judgment of Recommend, Consider, Pass. Length of comments will vary, support your opinions succinctly.
Grade: Grade each of I—idea, S—story, C—characterization, D—dialogue, V—setting and production values with one of the following: E—excellent, G—good, F—fair, or P—poor.

Appendix I
Acceptable Genre Classifications

- Action Action/Adventure
- Action/Comedy
- Action/Drama
- Action/Thriller
- Adventure
- Animal
- Animated
- Autobiography
- Biography
- Biopic
- Black Comedy
- Blaxploitation
- Broad Comedy
- Caper Children's
- Combat
- Comedy/Drama
- Comic Book
- Coming Of Age Crime
- Crime Drama
- Cyber-Thriller
- Dark Comedy
- Dark Drama
- Detective Story
- Disaster
- Docudrama
- Documentary
- Drama
- Epic
- Erotic
- Espionage
- Family
- Fantasy
- Film Noir
- Foreign
- Gangster
- History
- Hong Kong Action
- Horror
- IMAX Interactive
- International Adventure
- International Intrigue
- Kung Fu
- Legal Drama
- Legal Thriller
- Martial Arts
- Melodrama
- Memoir
- Military
- Mockumentary
- Murder
- Murder Mystery
- Musical
- Mystery
- Mythology
- Noir
- Nonfiction
- Occult
- Performance Piece
- Period
- Period Adventure
- Period Comedy
- Period Drama
- Political
- Political Satire

- Prison
- Psychological
- Pulp
- Road Movie
- Romance
- Romantic Comedy
- Romantic Drama
- Romantic Thriller
- Satire
- Science-Fiction
- Self Help
- Serial Killer
- Sitcom
- Spoof
- Spoof Comedy
- Sports
- Sports Comedy
- Sports Drama
- Student
- Spy
- Superhero
- Supernatural
- Suspense
- Teen
- Thriller
- Thriller/Horror
- Tragedy
- TV Animation
- Twisted Drama
- Urban
- Urban Comedy
- Urban Drama
- Vampire
- Zombie

Appendix J
Film Festivals

Biggest Festivals

- Berlin
- Cairo
- Cannes
- India (Goa)
- Karlovy Vary
- Locarno
- Mar Del Plata
- Montreal
- Moscow
- San Sebastian
- Shanghai
- Tokyo
- Tallinn
- Venice
- Warsaw

Other Popular Film Festivals

- Austin Film Festival
- Cinequest
- Citizen Jane
- Edinburgh International Film Festival
- Flickers (Rhode Island)
- Gramado Film Festival (Brazil)
- Guadalajara International Film Festival
- Hong Kong International Film Festival
- International Documentary Festival Amsterdam
- Panafrican Film and TV Festival
- New York Film Festival (NYC)
- Rotterdam

- San Francisco International Film Festival
- South by SouthWest (Austin)
- Slamdance (Park City, Utah)
- Sundance Film Festival (Park City, Utah)
- Telluride Film Festival (Colorado)
- Toronto International Film Festival
- Tribeca Film Festival (NYC)

Festival Submission Platforms

- Withoutabox (owned by Amazon)
- Film Freeway
- Festival Focus

Appendix K
Online Film Distribution Platforms

- Bit torrent
- CreateSpace (owned by Amazon)
- Distrify
- Distribber
- FetchApp
- Flm.tv
- Gathr
- Indiboogie
- IndieReign
- KinoNation
- Pivotshare
- Stareable
- Vimeo
- YouTube

Appendix L
Popular Movie Industry Trade Magazines/Sites

- Ain't It Cool
- Box Office Mojo
- Cynopsis
- Deadline
- Done Deal Professional
- Filmmaker magazine
- Hollywood Reporter
- IMDb
- Indiewire
- ScriptMag
- The Film Collaborative
- The Numbers
- The Wrap
- Variety
- Wired

Index